1 MONTH OF
FREE
READING

at

www.ForgottenBooks.com

By purchasing this book you are eligible for one month membership to ForgottenBooks.com, giving you unlimited access to our entire collection of over 1,000,000 titles via our web site and mobile apps.

To claim your free month visit: www.forgottenbooks.com/free208386

ISBN 978-0-332-04801-7
PIBN 10208386

LIFE·OF

BY

HERMAN·GRIMM·
TRANSLATED·BY
FANNY·ELIZABETH
BVNNETT·
VOLVME·I·

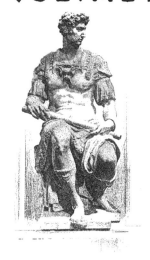

NEW·EDITION·WITH·AD-
DITIONS·ILLVSTRATED
WITH·PHOTOGRAVURE
PLATES·FROM·WORKS
OF·ART·* * * *

BOSTON·
MDCCCXCVII·

𝔘𝔫𝔦𝔟𝔢𝔯𝔰𝔦𝔱𝔶 𝔓𝔯𝔢𝔰𝔰 :
JOHN WILSON AND SON, CAMBRIDGE, U.S.A.

PUBLISHERS' NOTE.

In selecting the illustrations for a holiday edition of this favorite work, the publishers have confined the choice entirely to works of art, and have included reproductions of Michael Angelo's most famous statues and paintings, together with works by other celebrated Italian artists; the great range of the biography—which embraces nearly a century of Italian history—affording a wide field.

The publishers desire to acknowledge the courtesy of The William Hayes Fogg Art Museum, of Harvard University, in granting permission to copy from their collection of photographs of the originals made by Messrs. Braun, Clément, and Company, of Paris.

The photogravure plates have been specially made for this edition by Messrs. A. W. Elson and Company.

TRANSLATOR'S PREFACE.

THE life of Michael Angelo can never be considered entirely satisfactory until the Florentine papers have become accessible. It is for this reason that the translation of this work was for a time deferred. Occasionally the rumor spread that the Florentine papers would be thrown open to the public eye; and, while this appeared probable, Herr Grimm withheld the life of the great sculptor from translation into English, considering it incomplete until these documents could be brought to light.

On the other hand, the work contained so much information that had not before appeared; so many private letters of a domestic character were added to it; so much of the Buonarotti bequest had, as Herr Grimm remarks in his introductory chapter, passed into the possession of the British Museum, — that, with the certainty that the Florentine papers would not be

published for a still longer period, Herr Grimm
allowed me to undertake the translation of his
work.

As, however, with such a man as Michael
Angelo, new matter is ever coming to light,
and hence even a work of recent date may
appear stale in its information, I applied to
Herr Grimm, on the issuing of this new edi-
tion, to furnish me with any fresh particulars
he may have obtained. I received in reply a
letter, from which I will make the following
extract, informing me of all that has trans-
pired, respecting Michael Angelo, up to this
present time: —

" It is to be regretted, that the papers in Florence,
bequeathed by Count Buonarotti to the city, are still
withheld. The report is constantly circulated, that
they are soon to be made public; and yet this seems
never to be thought of seriously. The reason for
this delay I know not; for it has long been the
general opinion, that the condition under which
the Count bequeathed the papers — that is, ever-
lasting secrecy — is not entirely binding. The pres-
ent proceeding, therefore, is nothing but a simple
withholding of the papers. And this corresponds
with the ways and habits of the Italians generally.
There is a tendency constantly manifested by them
to conceal scientific matter, and this for no rational

reason, but simply for the sake of withholding things. We may suppose, however, that the newly awakened political life in Italy will produce the same liberality in scientific efforts as we are accustomed to meet with in Germany, England, and France.

" On the other hand, a new edition has appeared, in Florence, of the poems of Michael Angelo; and for this the Buonarotti papers were made use of. I gather this from the title of the book; but I have not yet received it. This edition will be of real importance if it throws light upon the date of the separate poems. The uncertainty that has prevailed, in this respect, has been the reason why, hitherto, Michael Angelo's poems have not been available as historical material.

" A new and interesting discovery to me has been a bas-relief, full of figures, about two feet high, and one and a half broad; casts of which I found in Basle and Berlin, and which may be regarded with tolerable certainty as Michael Angelo's work. I have not been able to discover the original. The subject is curious. It is a group of sick, possibly dying, people, on the banks of a stream, which is characterized by the river-god lying on it. In the air above hovers a Megæra-like form; the personification, it seems to me, of the plague. If this conjecture be right, the work may belong to that sad period in Florence during which we know so little, comparatively, of Michael Angelo.

" It must also be interesting, especially to those acquainted with Rome, that we have now gained

accurate information as to the position of Michael
Angelo's house in that city. A contract has come
to light, by which, after Michael Angelo's death,
Leonardo Buonarotti let his uncle's house to Daniele
da Volterra. The situation is accurately described
in this document. The house stood in what is now
Trajan's Forum, opposite Santa Maria di Loreto,
and probably was only pulled down in the last cen-
tury, on account of the enlargement of the square;
and, owing to the excavations in the Forum, we
may even say that the very soil has disappeared on
which the house stood. Lastly, some original re-
ceipts by Michael Angelo's hand, bearing the dates
1511 and 1513, have come to light. They refer to
the paintings in the Sistine Chapel, and to the
monument of Julius II. They were sent for my
inspection by Major Kühlen in Rome, who has them
in his possession."

In a periodical entitled, "On Artists and
Works of Art," Herr Grimm has published
the documents referred to in this extract; and
they appear to me too interesting, in the infor-
mation they afford, to be omitted here. I have
therefore added them to the appendix of the
second volume.

F. E. BUNNÈTT

CONTENTS OF VOLUME I.

CHAPTER FIRST.

CHAPTER SECOND.

CHAPTER THIRD.

1494—1496.

CHAPTER SEVENTH.

1508—1509.

CHAPTER EIGHTH.

1510—1512.

CHAPTER NINTH.

1512—1518.

LIST OF ILLUSTRATIONS.

VOLUME I.

LIFE OF MICHAEL ANGELO.

CHAPTER FIRST.

Florence and Italy — The Earliest Ages of the City — The Strife of Parties — Dante — Cimabue — Giotto — The Medici — Ghiberti — Brunelleschi — Donatello — First Appearance of Leonardo da Vinci.

THERE are names which carry with them something of a charm. We utter them, and, like the prince in the " Arabian Nights," who mounted the marvellous horse, and spoke the magic words, we feel ourselves lifted from the earth into the clouds. We have but to say " Athens!" and all the great deeds of antiquity break upon our hearts like a sudden gleam of sunshine. We perceive nothing definite; we see no separate figures: but a cloudy train of glorious men passes over the heavens, and a breath touches us, which, like the first warm wind in the year, seems to give promise of the spring in the midst of snow and rain. " Florence!" and the magnificence and passionate agitation of Italy's prime sends forth its fragrance towards us like blossom-laden boughs, from whose dusky shadow we catch whispers of the beautiful tongue.

We will now, however, step nearer, and examine more clearly the things which, taken collectively at a glance, we call the history of Athens and Florence.

The glowing images now grow cold, and become dull and empty. Here, as everywhere, we see the strife of common passions, the martyrdom and ruin of the best citizens, the demon-like opposition of the multitude to all that is pure and elevated, and the energetic disinterestedness of the noblest patriots suspiciously misunderstood and arrogantly rejected. Vexation, sadness, and sorrow steal over us, instead of the admiration which at first moved us. And yet, what is it all? Turning away, we cast back one glance from afar; and the old glory lies again on the picture, and a light in the distance seems to reveal to us the paradise which attracts us afresh, as if we set foot on it for the first time.

Athens was the first city of Greece. Rich, powerful, with a policy which extended almost over the entire world of that age, we can conceive that from here emanated all the great things that were done. Florence, however, in her fairest days, was never the first city of Italy, and in no respect possessed extraordinary advantages. She lies not on . the sea, not even on a river at any time navigable; for the Arno, on both sides of which the city rises, often affords in summer scarcely water sufficient to cover the soil of its broad bed, at that point of its course where it emerges from narrow valleys into the plain situated between the diverging arms of the mountain range. The situation of Naples is more beautiful, that of Genoa more royal, than Florence; Rome is richer in treasures of art; Venice possessed a political power, in comparison with which the influence of the Florentines appears small. Lastly,

these cities and others, such as Pisa and Milan, have gone through an external history, compared with which that of Florence contains nothing extraordinary; and yet, notwithstanding, all that happened in Italy between 1250 and 1530 is colorless when placed side by side with the history of this one city. Her internal life surpasses in splendor the efforts of the others at home and abroad. The events, through the intricacies of which she worked her way with vigorous determination, and the men whom she produced, raise her fame above that of the whole of Italy, and place Florence as a younger sister by the side of Athens.

The earlier history of the city, before the days of her highest splendor, stands in the same relation to the subsequent events as the contests of the Homeric heroes to that which happened in the historic ages in Greece. The incessant strife between the hostile nobles, which lasted for centuries, and ended with the annihilation of all, presents to us, on the whole, as well as in detail, the course of an epic poem. These contests, in which the whole body of the citizens became involved, began with the strife of two families, brought about by a woman, with murder and revenge in its train; and it is ever the passion of the leaders which fans the dying flames into new life. From their ashes at length arose the true Florence. She had now no longer a warlike aristocracy like Venice; no popes nor nobles like Rome; no fleet, no soldiers, — scarcely a territory. Within her walls was a fickle, avaricious, ungrateful people of parvenus, artisans, and merchants, who had been

subdued, now here and now there, by the energy or the intrigues of foreign and native tyranny, until, at length exhausted, they had actually given up their liberty. And it is the history of these very times which is surrounded with such glory, and the remembrance of which awakens such enthusiasm among her own people, at the present day, at the remembrance of their past.

Whatever attracts us, in nature and in art, — that higher nature which man has created, — may be felt also of the deeds of individuals and of nations. A melody, incomprehensible and enticing, is breathed forth from the events, filling them with importance and animation. Thus we should like to live and to act, — to have joined in obtaining this, to have assisted in the contest there. It becomes evident to us, that this is true existence. Events follow each other like a work of art; a marvellous thread unites them; there are no disjointed convulsive shocks, which startle us as at the fall of a rock, making the ground tremble, which for centuries had lain tranquil, and again, perhaps for centuries, sinks back into its old repose. For it is not repose, order, and a lawful progress on the smooth path of peace, which we desire; nor the fearful breaking-up of long-established habits, and the chaos that succeeds: but we are struck by deeds and characters whose outset promises results, and allows us to augur an end where the powers of men and nations strive after perfection, and our feelings aspire towards an harmonious aim, which we hope for or dread, and which we see reached at length.

Our pleasure in these events in no degree resembles the satisfaction with which, perchance, a modern officer of police would express himself respecting the excellent condition of a country. There are so-called quiet times, within which, nevertheless, the best actions appear hollow, and inspire a secret mistrust; when peace, order, and impartial administration of justice, are words with no real meaning, and piety sounds even like blasphemy; while, in other epochs, open depravity, errors, injustice, crime, and vice form only the shadows of a great and elevating picture, to which they impart the just truth. The blacker the dark places, the brighter the light ones. An indestructible power seems to necessitate both. We are at once convinced that we are not deceived. It is all so clear, so plain, so intelligible. We are struck with the strife of inevitable, dark necessity with the will, whose freedom nothing can conquer. On both sides, we see great powers rising, shaping events, and perishing in their course, or maintaining themselves above them. We see blood flowing; the rage of parties flashes before us like the sheet-lightning of storms that have long ceased; we stand here and there, and fight once more in the old battles. But we want truth; no concealing of aims, or the means with which they desired to obtain them. Thus we see the people in a state of agitation, just as the lava in the crater of a volcanic mountain rises in itself; and, from the fermenting mass, there sounds forth the magic melody which we call to mind when the names "Athens" or "Florence" are pronounced.

2.

Yet how poor seem the treasures of the Italian city, compared with the riches of the Greek! A succession of great Athenians appear, where only single Florentines could be pointed out. Athens surpassed Florence as far as the Greeks surpassed the Romans. But Florence touches us the more closely. We tread less certain ground in the history of Athens; and the city herself has been swept away from her old rocky soil, leaving only insignificant ruins behind. Florence still lives. If, at the present day, we look down from the height of the old Fiesole, on the mountain-side north of the city, the cathedral of Florence, Santa Maria del Fiore, — or Santa Liparata, as it is called, — with its cupola and slender bell-tower, and the churches, palaces, and houses, and the walls that enclose them, still lie in the depth below, as they did in years gone by. All is standing, upright and undecayed. The city is like a flower, which, when fully blown, instead of . withering on its stalk, turned as it were into stone. Thus she stands at the present day; and, to him who forgets the former ages, life and fragrance seem not to be lacking. Many a time we could fancy it is still as once it was; just as, when traversing the canals of Venice under the soft beams of the moon, we are delusively carried back to the times of her ancient splendor. But freedom has vanished; and that succession of great men has long ceased, which, year by year, of old, sprung up afresh.

Yet the remembrance of these men, and of the old

freedom, still lives. Their remains are preserved with religious care. To live with consciousness in Florence, is, to a cultivated man, nothing else than the study of the beauty of a free people, in its very purest instincts. The city possesses something that penetrates and sways the mind. We lose ourselves in her riches. While we feel that every thing drew its life from that *one* freedom, the Past obtains an influence, even in its most insignificant relations, which almost blinds us to the rest of Italy. We become fanatical Florentines, in the old sense. The most beautiful pictures of Titian begin to be indifferent to us, as we follow the progress of Florentine art, in its almost hourly advance, from the most clumsy beginnings up to perfection. The historians carry us into the intricacies of their age, as if we were initiated into the secrets of living persons. We walk along the streets where they walked; we step over the thresholds which they trod; we look down from the windows at which they have stood. Florence has never been taken by assault, nor destroyed, nor changed by some all-devastating fire. The buildings of which they tell us stand there almost as if they had grown up, stone by stone, to charm and gratify our eyes. If I, a stranger, am attracted with such magnetic power, how strong must have been the feeling with which the free old citizens clung to their native city, which was the world to them! It seemed to them impossible to live and die elsewhere. Hence the tragic and often frantic attempts of the exiled to return to their home. Unhappy was he who at eventide might

not meet his friends in her squares,—who was not baptized in the church of San Giovanni, and could not have his children baptized there. It is the oldest church in the town, and bears in its interior the proud inscription, that it will not be thrown down until the day of judgment,—a belief as strong as that of the Romans, to whom eternity was to be the duration of their Capitol. Horace sang that his songs would last as long as the priestess ascended the steps there.

Athens and Florence owed their greatness to their freedom. We are free when our longing to do all that we do for the good of our country is satisfied; but it must be independently and voluntarily. We must perceive ourselves to be a part of a whole; and that, while *we* advance, we promote the advance of the whole at the same time. This feeling must be paramount to any other. With the Florentines, it rose above the bloodiest hostility of parties and families. Passions stooped before it. The city and her freedom lay nearest to every heart, and formed the end and aim of every dispute. No power without was to oppress them; none within the city herself was to have greater authority than another; every citizen desired to co-operate for the general good; no third party was to come between to help forward their interests. So long as this jealousy of a personal right in the State ruled in the minds of the citizens, Florence was a free city. With the extinguishing of this passion, freedom perished; and in vain was every energy exerted to maintain it.

That which, however, exhibits Athens and Florence as raised above other States, which likewise flourished through their freedom, is a second gift of nature, by which freedom was either circumscribed or extended, — for both may be said of it, — namely, the capability in their citizens for an equal development of all human power. One-sided energy may do much, whether men or nations possess it. Egyptians, Romans, Englishmen, are grand examples of this; the one-sidedness of their character, however, discovers itself again in their undertakings, and sometimes robs that which they achieve of the praise of beauty. In Athens and Florence, no passion for any time gained such ascendency over the individuality of the people as to preponderate over others. If it happened at times for a short period, a speedy subversion of things brought back the equilibrium. The Florentine Constitution depended on the resolutions of the moment, made by an assembly of citizens entitled to vote. Any power could be legally annulled, and equally legally another could be raised up in its stead. Nothing was wanting but a decree of the great parliament of citizens. A counter-vote was all that was necessary. So long as the great bell sounded which called all the citizens together to the square in front of the palace of the Government, any revenge borne by one towards another might be decided by open force in the public street. Parliament was the lawfully appointed seene of revolution, in case the will of the people no longer accorded with that of the Government. The citizens, in that case, invested a

1*

committee with dictatorial authority. The offices were newly filled. All offices were accessible to all citizens. Any man was qualified and called upon for any position. What sort of men must these citizens have been, who formed a stable and flourishing state with institutions so variable? Sordid merchants and manufacturers?—yet how they fought for their freedom! Selfish policy and commerce their sole interest?—yet were they the poets and historians of their country! Avaricious shopkeepers and money-changers?—but dwelling in princely palaces, and these palaces built by their own masters, and adorned with paintings and sculptures, which had been likewise produced within the city! Every thing put forth blossom, every blossom bore fruit. The fate of the country is like a ball, which, in its eternal motion, still rests ever on the right point. Every Florentine work of art carries the whole of Florence within it. Dante's poems are the result of the wars, the negotiations, the religion, the philosophy, the gossip, the faults, the vice, the hatred, the love, and the revenge of the Florentines. All unconsciously assisted. Nothing might be lacking. From such a soil alone could such a work spring forth. From the Athenian mind alone could the tragedies of Sophocles and Æschylus proceed. The history of the city has as much share in them as the genius of the men in whose minds imagination and passion sought expression in words.

It makes a difference whether an artist is the self-conscious citizen of a free land, or the richly rewarded subject of a ruler in whose ears liberty

sounds like sedition and treason. A people is free, not because it obeys no prince, but because of its own accord it loves and supports the highest authority, whether this be a prince or an aristocracy who hold the Government in their hands. A *prince* there always is; in the freest republics *one* man gives, after all, the casting vote. But he must be there because he is the first, and because all need him. It is only where each single man feels him self a part of the common basis upon which the commonwealth rests, that we can speak of freedom and art. What have the statues in the villa of Hadrian to do with Rome and the desires of Rome? What the mighty columns of the baths of Caracalla with the ideal of the people in whose capital they arose? In Athens and Florence, however, we could say that no stone was laid on another, — no picture, no poem, came forth; but the entire population was its sponsor. Whether Santa Maria del Fiore was rebuilt; whether the Church of San Giovanni gained a couple of golden gates; whether Pisa was besieged, peace concluded, or a mad carnival procession celebrated, — every one was concerned in it, the same general interest was evinced in it. The beautiful Simoneta, the most beautiful young maiden in the city, is buried; the whole of Florence follows her with tears in their eyes, and Lorenzo Medici, the first man in the State, writes an elegiac sonnet on her loss, which is on the lips of all. A newly painted chapel is opened; no one may be missing. A foot-race through the streets is arranged; carpets hang out from every window.

Contemplated from afar, the two cities stand before us like beautiful human figures, — like women with dark, sad glances, and yet laughing lips; we step nearer; it seems one great united family: we pass into the midst of them; it is like a bee-hive of human beings. Athens and her destiny is a symbol of the whole life of Greece; Florence is a symbol of the prime of Roman Italy. Both, so long as their liberty lasted, are a reflection of the golden age of their land and people; after liberty was lost, they are an image of the decline of both until their final ruin.

3.

Nothing is known of how the ancient Florentia passed into the modern Fiorenza or Firenze, and whether it brought with it from the Romish ages the character of a manufacturing town. We do not even know, in the Hohenstauffen epoch, in what proportion the population were divided into noble and manufacturing classes. The city at that time lay on the northern bank of the Arno, within low surrounding walls, between which and the river there was a broad space. In that direction they soon extended themselves, made bridges across, and established themselves on the other side.

The conquest of Fiesole was the first great deed of the Florentine citizens. The Fiesolans were obliged to settle in the valley below. Pisa, nevertheless, which lay towards the west, on the sea-coast, was greater and more powerful. Pisa possessed a fleet and harbors: the Florentine trade was dependent on that of Pisa. Florence had nowhere free

communication with the sea; Lucca, Pistoia, Arezzo, Siena,—nothing but jealous and warlike cities,—encircled her with their territories. In them, however, as in Florence, there were houses of powerful nobles, in whose hands lay the sovereign authority.

The disputes of these lords severally, and those of the parties into which they were divided, continued in Tuscany so long as the Hohenstauffens ruled the world. Florence belonged to the heritage of the Countess Matilda, to which the pope laid claim, because the land had been bequeathed to him; and the emperor, because an imperial fief could not be so disposed of. This dispute furnished strong points of support for the party feeling in Tuscany. A part of the nobles stood up for the rights of the Church; the other, to defend those of the emperor. The future of the city depended on the issue of the war, which burst forth immediately in deeds of violence to decide the exciting question.

When the imperial party were victorious in Italy, their adherents in Florence triumphed also; when the national party gained the upper hand, the party of the pope conquered in Tuscany also. When the Lombard cities were subdued by Barbarossa, the imperial faction in Florence broke forth, and endeavored to drive away the public magistrates, who had been strengthened by their adversaries. When the fortune of the emperor afterwards suddenly changed, the power of his enemies in Tuscany also returned. Under the protection of the pope, the Tuscan cities formed themselves into a confederation, the capital of which was Florence.

Such was the condition of things at the beginning of the thirteenth century, when the names Guelfs and Ghibellines sprang up, and what had been hitherto a spiritless opposition became a contest with well-matured principles. In the year 1215, the Guelfs and Ghibellines in Florence began to make war on each other. In the year 1321, Dante died. The century between the two dates forms the contents of his poem, the verses of which just as naturally suit the heroic epoch which they depict, as the pure language of Homer does the deeds of the Hellenists before Ilion.

Registers of the families, as they stood on this side or on that, are preserved. We know the position of their palaces, — little castles, constructed for defence from storm and siege. We follow, from year to year, the calamitous circumstances. Old and famous houses decline; new ones rise from small beginnings to power and importance. Continually, in the midst of the internal discord, wars occur with the neighbors, — with Pisa first, who had command over the way to the sea; with Siena and Pistoia; soon with the entire neighborhood. In the moment of danger, reconciliation, armistice, or treaty unite the contending parties to common force against the enemies of the country. After the victory, however, the old dispute awakens to new evil within their own walls.

For the most part, the cause for the state of things abroad lay in those at home. The Guelfs of Florence, when they had the management of things in their hands, urged for war against the Ghibellines

of Pisa or Pistoia. The Florentine Ghibellines refused to take the field with them against their own party. Thus Tuscany stood in flames which were not to be extinguished. For, if one party succeeded in driving the other out of the city, the banished ones lay without in their castles, close at the very gates, awaiting the favorable moment for return. To be beaten was not to be overcome. In the worst emergency, supplies and money came from afar. The emperor himself sent German knights to the assistance of the oppressed Ghibellines.

To the manufacturing citizens, however, this situation of the great nobles was of essential service. The prosperous merchants formed a third element, which exerted a powerful influence in the contests of the nobles, and forced them to concessions. The city authorities grew strong: in the midst of the calamitous disorders, Florence increased in extent and population. In the year 1252, Pisa was already not half so important. A commercial treaty with the Pisans was concluded; they adopted the Florentine weights and measures. It was about this time that Manfred, the last Hohenstauffen king of Naples, supported the Ghibellines alone in Tuscany. When, for the last time, he sent assistance, his eight hundred knights — for the most part Germans — united with the Ghibellines of Florence, Siena, Pisa, Prato, Arezzo, and Pistoia, formed a body of three thousand armed men.

The Guelfs were defeated, and evacuated the land. Soon, however, after the fall of Manfred, they again attacked Florence, which was now abandoned

by the Ghibellines. Charles of Anjou, the new French king of Naples, undertook the protection of the city, and the citizens adopted a new constitution, the foundation of their subsequent independence. Whether the nobles concluded a peace or entered into dispute afresh, it was always a signal to the citizens to make a new attempt to extend their rights.

To make their rights, however, a still surer possession, they endeavored to destroy and to purchase the castles of the nobles outside the town, and to drive them back by the prohibition of a wide circuit of the city. In Florence herself, the dangerous towers were pulled down which had once been their watch-posts, and from whence they had hurled their darts. Too late the great nobles perceived the consequences of their furious self-destruction. The Ghibellines were crushed; but the victorious Guelfic nobility stood enfeebled before a body of proud citizens, whose rich families maintained themselves as bravely as the nobles. New constitutions gave greater and greater scope to the guilds, which were beginning to form; and at length the intention of admitting those alone to a share in the State who were members of these guilds stood forth as the aim of this powerful democracy. The old nobility were obliged to allow themselves to be admitted, or to be completely excluded.

All this, however, proceeded slowly; great commotions were brought about step by step. There were epochs of rest, — happier times, in which the parties joined for peaceful social life. Such a calm occured in the last decade of the thirteenth century,

when, with the decline of the Hohenstauffens, the idea of the old empire began to dissolve, and the new basis of European political life filled all minds : the divided people were now from henceforth to follow their own way. The jurisdiction of the old Roman-Byzantine power was then for the first time broken through. National consciousness penetrated art and literature, and revealed itself in new forms. These are the times in which occurred Dante's birth and youth.

Florence extended her walls for the third time. Arnolfo di Lapo, the famous architect, began to build the churches which yet stand there as the greatest and finest, and among them, most distinguished of all, Santa Maria del Fiore. He built in a new style, — the Gothic, or, as the Italians called it, the German, — the free upward-rising proportions of which took the place of the more heavy and wide-spreading dimensions in which they had built hitherto. As the rule of the Hohenstauffens may be regarded as the final development of the old Roman Empire, so art also appears up to their times as the last fruit of the ideas of the ancients.

Dante speaks of the days of his youth as of his lost paradise. But he was not a poet who, absorbed in narrow fancies, had led a secluded life. He was a soldier, statesman, and scholar. He fought in battle, took part in important embassies, and wrote learned and political works. In his youth a Guelf, he became a furious Ghibelline, and wrote and sang for his party, which even still built extravagantly ideal hopes on the advent of a German emperor

B

Henry of Luxemburg appeared in the year 1311. But to him the old party names had lost their meaning. He saw that Guelfs and Ghibellines alike wished to use him for their own ends; and, pursuing likewise the path which seemed to him the most advantageous for his own policy, he adhered to a middle course, which led him victoriously on, without giving the advantage to either of the contending parties. Death soon put an end to his efforts; and, after he was gone, scarcely a trace of his existence remained behind in the land.

His progress through Italy was described by Dino Compagni, a Florentine and friend of Dante. The chronicle of this man, in its simple and beautiful prose, forms a counterpart to Dante's poems. The symphony of two worlds — the ancient and the modern — fills both their works. They use the language naturally, as the best old authors did theirs, and without abusing its flexibility. Dante speaks of things and feelings plainly, as he sees them and experiences them. When he describes the heaven,. and the rising and setting of the stars, it is the heaven of Hesiod; if he takes us to the sea-shore, it seems to be the same shore as that on which Thetis lamented her lost son, or on which the waves had rolled at the. feet of Ulysses, when he looked out from the Island of Calypso, and the sweeping clouds reminded him of the rising smoke of his home. Dante ingenuously compares the scarcely opened, light-dreading eyes of the wandering band of spectres in the lower world with the screwed-up eyes of a tailor who wants to thread his needle.

His poem is the fruit of laborious study of the spirit of the Italian language. He must have toiled to catch and to manage its words, like a troop of wild horses which had never gone in harness before. His proud, weighty Italian is a strange contrast to the polished conventional Latin, in which he wrote more easily. In the latter, he is keen, cultivated, and elegant; while his Italian compositions sound as if he had written them half dreaming. In his light verses there lies something of the melancholy to which the sight of nature often disposes us, of that aimless sadness which a cool, glowing sunset in autumn calls forth in us. Dante's fate stands before us like the suffering of an exiled Hellenist, who enjoys hospitality at the court of a barbarian prince, whilst hatred and longing gnaw his heart. At times we see more than we have, perhaps, a right to see: while contemplating Dante's head, as Giotto has painted it, with a few wonderful strokes, on the wall of the chapel of Bargello, his whole life seems to lie in the soft, beautiful features, as if a presentiment of his future overshadowed his youthful brow.

Dante died in exile; none of his political ideas were realized. The nations were too deeply involved in their own disorder, to have power and enthusiasm left for general European policy. The popes removed to Avignon. Rome stood empty. Italy was left to itself. The hundred years during which this state of things lasted are the second epoch in the development of Florentine liberty, and form at the same time the first era of that unfolding art which finds its first great workman in Giotto.

4.

We are wont to call Cimabue the founder of modern painting. His productions belong to the time in which Dante was born. His works excited astonishment and admiration. Cimabue painted, in the manner of the Byzantine masters, stiff, bulky Madonnas. We would gladly, at the present day, consider this influence of Byzantine art upon the early Italian to have been of the most limited character, and assert rather a native development in direct connection with ancient art. It may have been so with Cimabue; but Giotto, whom he met with on the open field, as a shepherd-boy, drawing his cattle on the large flat stones, — whom he de- manded from his father, and took with him to Florence, and instructed, — can nevertheless be scarcely designated his disciple. From Cimabue to Giotto there is a steep ascent. Giotto seems alien to his master, and almost opposed to him.

At the period in which he worked, the intellectual centre of Europe was not in Italy. Dante, who had pursued his studies in Paris, freed himself with difficulty from the power of the Latin tongue and the Provençal dialect. It was from France that the new Gothic style came into Italy. It was in France also that Giotto painted. His tender figures, which seem to spring from the most simple examination of nature, still carry with them too much of miniature- painting for us entirely to deny the school in which their master learned to draw.

It is not easy to gain a clear idea of his work. It

embraced the whole range of art. Much of technical rule must have interfered with it. Yet he was not devoid of individual power. Dante's portrait, now indeed Giotto's most famous work, retains, even in its present sad condition, something grand and characteristic in the sweep of the lines. The sketch seems to have been produced by a strong hand, which traced with bold strokes what the eye saw and the mind perceived. No artist would have been able to draw with more meaning the rare outline of such a countenance, which, although destroyed, restored, and partly entirely renovated, is imbued with the elevating dignity of him to whom it belonged. The Madonnas which are ascribed to Giotto have an expression of sad loveliness. Heavy, almond-shaped eyes, scarcely open, a repetition of the Byzantine type of Madonnas, a sorrowfully smiling mouth, — these are their distinctive features. His principal works were not, however, his pictures with a few insignificant figures, but his fresco-paintings, with which he supplied the whole of Italy. Called by the King of Naples to his capital, he painted the churches and palaces there; he executed great works in Lombardy; he was summoned to Rome and Avignon by the popes. Wherever he was required, he was at once ready for service. He worked as painter, sculptor, and architect. He stood on good terms with the nobles, but showed them little deference. His personal characteristics, as depicted by Boccaccio, are not over-idealized. Giotto was small, mean-looking even to ugliness, good-natured, but endowed with a sharp tongue, like all

of endless disputes, the intricate nature of which acquired no nobler importance by the presence of distinguished men.

5.

In the north, the Visconti had established them-selves as the lords of Milan, and the emperor Henry had confirmed them as such. Through them the Ghibelline north of Italy remained in connection with the emperor and with Germany. Their best soldiers were German knights and fighting-men.

Towards the east, Venice was too strong for the Visconti; they turned therefore to the south, and brought Genoa into their power; by this, the whole Tuscan coast, Lucca and Pisa, once the aim of Genoese desires, became the object of the efforts of Lombardy. This, however, brought Milan into contact with Florence, to whom the possession of both cities was necessary. Besides this, there was the opposition of political feeling: Milan, the central point of the German-imperial Ghibelline nobility in. Italy; Florence, the nest of the popish-national citizens, in closest alliance with the French Naples, and with France itself, whose kings hoped to seize upon the Roman imperial dignity. Tuscany lay between the north and the south, as the natural theatre for the meeting of the hostile powers.

Florence was a manufacturing city, inhabited by restless masses. It was soon evident that a strong, independent power must defend the city without. None of her own citizens had or might have the ability to do this: we find Florence, therefore, in

the hands of powerful princes, for the most part Neapolitan, who for weighty gold gave their services and their troops. The idea indeed occurred to them of constituting themselves her settled masters. Then, however, the power of the citizens displayed itself, — they would submit to no other yoke than that which they had voluntarily taken upon them. Florence maintained herself free by her democracy, as Venice did by her nobles.

The other cities of Italy became subject, on account of their divisions, to separate families or to foreign rule. In such cases, things took their natural course. Two parties of nobles made war on each other, each with one family as head, which was the most powerful within their circle. If one of the parties conquered, those who had been its leaders endeavored to maintain themselves as masters at the head of the entire state. Relationship, murder, and the inheritance thus brought about, alliances with foreign houses who aimed at similar measures or had already carried them out, strengthened the new position. To convert this authority expressly into an hereditary one was scarcely necessary, as from the outset it concerned the whole family, whose duration was not interrupted by the death of its heads.

In Florence, from the earliest times, such outrages on the people's love of liberty had been frustrated, even in those days when there was still a nobility within the city. The victorious party perceived that the aim in view was not merely the subjection of their adversaries, but the elevation of their own

of endless disputes, the intricate nature of which acquired no nobler importance by the presence of distinguished men.

5.

In the north, the Visconti had established them-selves as the lords of Milan, and the emperor Henry had confirmed them as such. Through them the Ghibelline north of Italy remained in connection with the emperor and with Germany. Their best soldiers were German knights and fighting-men.

Towards the east, Venice was too strong for the Visconti; they turned therefore to the south, and brought Genoa into their power; by this, the whole Tuscan coast, Lucca and Pisa, once the aim of Genoese desires, became the object of the efforts of Lombardy. This, however, brought Milan into contact with Florence, to whom the possession of both cities was necessary. Besides this, there was the opposition of political feeling: Milan, the central point of the German-imperial Ghibelline nobility in . Italy; Florence, the nest of the popish-national citizens, in closest alliance with the French Naples, and with France itself, whose kings hoped to seize upon the Roman imperial dignity. Tuscany lay between the north and the south, as the natural theatre for the meeting of the hostile powers.

Florence was a manufacturing city, inhabited by restless masses. It was soon evident that a strong, independent power must defend the city without. None of her own citizens had or might have the ability to do this: we find Florence, therefore, in

the hands of powerful princes, for the most part Neapolitan, who for weighty gold gave their services and their troops. The idea indeed occurred to them of constituting themselves her settled masters. Then, however, the power of the citizens displayed itself, — they would submit to no other yoke than that which they had voluntarily taken upon them. Florence maintained herself free by her democracy, as Venice did by her nobles.

The other cities of Italy became subject, on account of their divisions, to separate families or to foreign rule. In such cases, things took their natural course. Two parties of nobles made war on each other, each with one family as head, which was the most powerful within their circle. If one of the parties conquered, those who had been its leaders endeavored to maintain themselves as masters at the head of the entire state. Relationship, murder, and the inheritance thus brought about, alliances with foreign houses who aimed at similar measures or had already carried them out, strengthened the new position. To convert this authority expressly into an hereditary one was scarcely necessary, as from the outset it concerned the whole family, whose duration was not interrupted by the death of its heads.

In Florence, from the earliest times, such outrages on the people's love of liberty had been frustrated, even in those days when there was still a nobility within the city. The victorious party perceived that the aim in view was not merely the subjection of their adversaries, but the elevation of their own

chief to authority; so they refused to render service. All hostility vanished at such moments. The expulsion of the Duke of Athens, who in 1343 had been appointed lord of the city, and who thought it easy to bring her under his dominion, is one of the most brilliant deeds of the Florentines. Misled by the hostility of parties, he believed he could maintain his high position with the help of the aristocrats. But he did so only for a short time. An insurrection broke out, in which every one, without distinction of party, took part; and the duke fled before the excited people, whom he dared not defy

It was in that same year that the last fearful contest against the nobles was fought, when, immediately after the expulsion of the duke, they again opposed the people. Their number was no longer large: they were annihilated; but they sold their ruin dearly enough. A great contest arose in the streets; the people took by force the palaces of the nobles. Wondrously does Machiavelli depict the rage of the citizens, and the desperate resistance of the lords, as one family after another fell; and, when the guilds had conquered, they began to divide among themselves for renewed contests. The higher guilds were now the "lords," the oppressors, against whom the lower guilds, "the people," took up arms. Again, there were powerful old families who formed the party of the nobles; while others, striving to rise, excited to rebellion the impatient desires of the lower classes.

It was from these revolutions that the Medici at length emerged. They began to rise towards the

end of the fourteenth century. Their progress was natural, and therefore not to be stopped. It was the result of the co-operation of two unconquerable powers, — the peculiarities of the Florentine people, and their own family character; and a power was thus formed which can be compared with that of no other princes.

The Medici were princes, and yet private people. They ruled with absolute sway, while seeming never to give a command. They might be called hereditary advisers of the Florentine people; the hereditary Florentine guardians; possessors, interpreters, and executors of public opinion.

The wealth of the family was only the outward instrument with which they worked; the true impelling power which allowed them to rise, lay in the talent for gaining confidence without demanding it, in the will to enforce without commanding, and to conquer their enemies without attacking them. Their successes alone came to light, rarely the ways in which they attained them. They spared no means in doing so. In a written apology, in which the character of the first Cosmo is passionately, or rather furiously, defended, we read, in *praise* of this father of his country, that he poisoned the Roman emperor to save Italy from his inroads. Treachery and violence were familiar to the Medici, as to every other princely family of their time; but that which distinguished them from others was the national, genuine Florentine manner in which they knew how to use them. They were more refined than the most refined in Florence, more pliable than the craftiest·

they seized their foes with unerring accuracy, for they understood how, with masterly power, to lull them into the feeling of security that led to their capture. Composure in moments of greatest difficulty was of more service to them than the valor which was never lacking. Linked with both, however, a marvellous success went hand in hand; and that which cast a true halo round them was the direction of their mind to objects of higher culture, — their delight in the beautiful, and the noble manner in which they befriended those who were the first in art and science. Their merits, and again their successes, — for fate richly favored their noble inclinations, — are, in this direction, so vast, that, as a lesson to the whole world, the genius of history has beautifully taken care that the Medici should stand alone as the protectors of art and science.

The first Medici, whose fate was thoroughly mixed up with the destinies of the city, was Salvestro, Gonfalonier of Florence in the year 1370. The Gonfalonier, the supreme magistrate, was one year in . office. The title may be simply and generally trans- lated as that of the ruling mayor; in its derivation it signifies standard-bearer; the Gonfalonier carried the banner of justice as an emblem of the highest authority which lay in his hands.

Salvestro, who was a leader of the democratic party, plunged the citizens into one of the most dangerous revolutions. Without openly compromis- ing himself, he stirred up the people until sedition broke out. In the midst of the commotion, he stood forth as a loyal man apart from all the dispute, and

manifested in his manœuvres that spirit of cunning and energy, which, in subsequent times, made his family so victorious, when they possessed power and boldness to use it unscrupulously.

The aim of the democratic party, at whose head the Medici placed themselves, was to oppose those families who had, from their common wealth, assumed the position of the ruling minority within the pure constitution. The Medici did not occupy the rank among them which they wished to occupy. Their family was not one of the most distinguished or the most ancient. Instead, however, of forming a party among those aristocrats with whom they wished to be on an equality, by the help of which they would have perhaps brought the great families and the entire people into subjection, they made the cause of the people their own; united with them, they annihilated the nobles, and entered upon their inheritance.

Much as the course they had adopted, and the expedient they made use of, tended to make the final result appear but as the successful execution of coldly planned intrigues, it required the greatest vigor to come off victorious. Moments of the greatest danger occurred, in which the Medici behaved with princely tact. The rise of these royal citizens consisted of a train of political events, which became increasingly comprehensive. Truth, however, turned the scale at last, and generosity and magnanimity triumphed over secret, calculating cunning. The Medici prevailed, not merely because they possessed the evil qualities of their fellow-citizens in their

greatest vigor, but also because in them might be perceived, more strongly than in any others, the counterbalancing excellences of the national Floren tine character. The evil is everywhere more plainly recognized, because, in single instances, it is conspic- uously evident'; while the good, regarded from a more general point of view, is dimly perceived, and, taken as a matter of course, is scarcely acknowledged as an advantage. For this reason, in Salvestro's case, there is less evident weight given to the fact, that the cause which he served was good and just in itself. We fancy we perceive, to too great an extent, that he only availed himself of it for personal ends. He came forth from the storms which he had stirred up, with the fame of a democrat whom the people loved; at the same time he remained the man whom the nobles could not dispense with. He died in 1388. After his death, Veri dei Medici became the head of the family. The disputes among the higher and lower guilds for a share in the Government still continued. There was no end to the insurrections. • They murdered; they stormed the palaces of the obnoxious nobles, they plundered and set fire to them. Executions, banishments, confiscations, or declarations of infamy, by which suspicious person- ages were for a certain time withdrawn from the exercise of political rights, were the order of the day. Throughout the whole of Italy at this time, here was a war without principle, of all against all. Emperor and pope interfered, but, like the rest, only cared for lower advantages. Noble thoughts had fallen into oblivion. In intellectual and political things, a

court of appeal was lacking, where arbitration might be sought for. The impulse to subdue and to gather together material possessions was the sole motive for action.

If we compare our own days, which are condemned by many as disordered and unsettled, with the occurrences of those times, the present condition of things seems an harmonious juncture, in which truth, worth, and forbearance wield the sceptre; in which every ignoble passion has lost its venom, and even gold its charm. We often imagine that every thing in the present day is to be had for money. How little, however, do *we* appear to be able to effect with this instrument, if we consider those bygone passages of history! What prince in the present day could so traffic with all within his power, as was the case at that time? The force of public opinion, which at the present day looks gloomily down on the actions of princes and peoples, did not exist. The cogent sense of political morality, which has been aroused in men's minds, was a thing of which then they had not even the remotest suspicion.

The rule of Cosmo dei Medici coincides with that rise which lifted Italy from its state of decay. Like islands of safety in the universal deluge, the ideas of the great minds of antiquity emerged; in the general confusion, they fled to them. The influence of Greek philosophy was animated afresh. The Medici participated most heartily in its revival. Nothing can be said of the art of that day, without the mention of their names. The advantages be-

stowed by nature on Florence and her citizens were perceived and increased by Cosmo; and thus the city became the central point of Italy, which now surpassed in culture the other lands of Europe.

6.

Four important artists appear in Florence at the beginning of the fifteenth century,— Ghiberti, Brunelleschi, Donatello, and Masaccio. Speaking figuratively, we might say that they were four brothers, who shared their father's glorious inheritance, and each of whom extended the limits of his portion into a great kingdom. These four are the founders of a new art, which became, after many years, the basis of that which is peerless in its perfection.

Ghiberti began as apprentice to a goldsmith. He worked at first in Giotto's manner. The transition to his own peculiarities is best seen on the doors of San Giovanni, which, even at the present day, except a few traces of destroyed gilding, stand pure and untouched in their place.

The church has three open gates; the fourth, towards the west, being walled up. The southern was supplied, by Andrea Pisano, with brazen wings, for which Giotto made the designs. At the beginning of the fifteenth century, the guild of merchants, to whom the church belonged, determined to have the eastern gate finished, and appointed a competition of the artists, who wished to set up their claims to the honor and the gain.

Ghiberti was at that time twenty years old. He had left Florence, where the plague prevailed, and

had painted the apartments of a palace in Rimini for Pandolfo Malatesta. He now returned to his native city. Six artists shared the contest with him; among them Brunelleschi, who, three years older than Ghiberti, disputed precedency with him for the first time as an adversary.

The task was so arranged that the one completed door was to serve as a model. Each wing is here divided into a series of compartments, one above another, each compartment containing a figure in bas-relief. The production of each separate bronze compartment was required, and the period of a year was allowed for it. Thirty-four foreign and native masters were appointed as deciding committee.

Ghiberti enjoyed the help of his father, with whom he had studied, and who assisted him in the casting of the bronze. In this competition, it was not of so much moment to prove himself the worthiest master by some device full of genius; but it was intended to test who, in whatever manner, was able to produce the most perfect piece of bronze casting. It depended on experience and a skilful management of the material. Ghiberti's work was considered faultlessly executed; and the task was conferred upon him, on the 23d November, 1403. A number of other artists were assigned to him as fellow-workers. How much was to be ready every year was accurately settled in the contract. The work lasted for twenty-one years. On the 19th April, 1424, both folding-doors were hung on their hinges. Ghiberti's fame now spread throughout Italy; his services were claimed on all sides: but in Florence it was

resolved that the third door should be consigned to him also.

He was no longer bound to any model: the single condition stood in the contract, that, so long as he was working at the door, he was to undertake no other commission without the consent of the guild of merchants; otherwise, so far as concerned time and cost, all was left to his will. It was, however, expected from him, that, as he had vanquished all other masters in the door already completed, he would, in this new one, surpass himself. On the 16th June, 1452, this work also was conveyed to its place. In the first, his father had helped him; this time, his son Vittorio could assist him in the gilding, which was done afterwards. Not long after, Lorenzo Ghiberti died: his whole life, amounting to seventy-four years, had been devoted to these two principal works.

The second door surpassed the first in every respect. The master followed freely, as he was bidden, his own creative genius. His work is tasteful in the highest sense; the most sublime which artistic workmanship could produce. The compositions of the different compartments are brought out in an effective manner, which, without such a thorough knowledge and appropriation of all the advantages so scantily afforded by the material, would have been impossible. We might call this door the colossal work of a goldsmith; we might, however, also say, that the separate compartments were pictures in relief, such as only the most skilful painter could devise. The door is a work in itself, which subse-

ıtion of Adam, Sistine

MICH ANGELO.

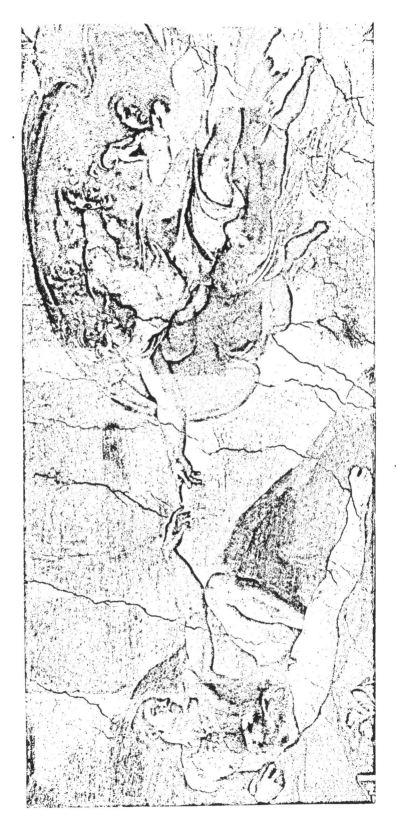

quent imitation has never been able to arrive at. The border enclosing the compartments — the real framework of the two folding-doors — is unusually rich in figure-ornament, in reclining and standing statuettes, which are executed with great freedom, and are placed in niches, with projecting heads and other ornaments, all exhibiting the same care. This door is the first important creation of Florentine art, the influence of which appears evident upon Michael Angelo. The creation of Adam on the ceiling of the Sistine Chapel, the drunkenness of Noah, and the death of Goliath, in the same place, owe their primary idea to the small figures of Ghiberti's compositions. Michael Angelo transformed them into gigantic size. In some figures of the framework, we find attitudes which Michael Angelo made use of by predilection. Thus, the recumbent position, in which the raised bust is supported sideways on the bent arm, so that the shoulder is a little pushed up, is a conception of the human form which is almost stereotyped among Michael Angelo's imitators. Michael Angelo said of these doors, that they were worthy to be the gates of Paradise.

What gave Ghiberti the first step in a new direction was the study of the antique. A sense of the value which dwelt within the remains of ancient art had never been utterly extinguished in Italy. The nation, however, lacked reverence and understanding. Petrarch laments that the degenerated Romans carry on a disgraceful traffic with the ruins of their ancient greatness, and impoverish the city. About the year 1430, there were, in the whole of Rome, six

ancient statues deserving mention. Ghiberti has left behind records of art; he speaks of the discovery of ancient works in marble as of rare events. He describes a hermaphrodite, which he saw in Rome in 1440, where a sculptor, who had to execute the monument of a cardinal, and was seeking for suitable pieces of marble, discovered it eight feet under the ground; a recumbent figure, which, placed with the smooth side of its pedestal over a common sewer, served as a coping-stone. In Padua, he saw a second statue, which was discovered in Florence, when they were digging out the foundation of a house. The third was in Siena: of this, however, he had only seen a drawing, which Ambrosio Lorenzetti (a pupil of Giotto's) had made of it, and which had been shown to him in Siena by its possessor, an old Carthusian monk, who was a goldsmith. The latter had also told him how, at the discovery of the statue, all the scholars, painters, sculptors, and goldsmiths of the city had met together, examined it, and had consulted where it should be erected. The fountain in the market-place had been at length selected for this purpose. The statue was a wonderfully beautiful work, with a dolphin at the one foot on which it stood, and on its pedestal was the name Lysippus.*

A short time after the erection of the statue, the war which Siena was carrying on against Florence took a bad turn. It must have been about the year 1390, when Siena was leagued with Visconti against the Florentines. The senate of the city deliberated

* See Appendix, Note I.

how this sudden misfortune could have been incurred, and arrived at the opinion, that, by the erection of this idol, which was contrary to all Christian faith, they had called down the wrath of heaven. The unfortunate work of Lysippus was thrown down and broken into a thousand fragments; and these, that advantage might even be reaped from the evil, they conveyed secretly to the Florentine territory, and buried in the earth there. Ghiberti knew well how to appreciate the excellences of ancient art. He said of a torso found in Florence, that it was executed with such great nicety that its delicate workmanship was not to be perceived by the eye alone, either by full or subdued light; it must be felt out by the tips of the fingers to be thoroughly discovered.

If in this way he learned the secrets of the old masters, and labored to apply them to the advantage of sculpture, Brunelleschi with equal success endeavored to bring the beauty of ancient architecture into honor. As the prize in the competition had not been awarded to him, he set out for Rome with Donatello, his younger friend. He, too, had begun as goldsmith, but had soon devoted himself to the study of architecture. Yet, as Ghiberti was an architect as well as a painter, so was Brunelleschi a painter, a sculptor, and a worker in bronze. All these studies formed a whole, which was called art; just as intellectual work in all its branches formed a whole, which was called science. This universality of talent is to be found also in Giotto, who, in addition to all, knew how to write poems.

In Rome the two friends began to survey the remains of ancient architecture. This interest in the ruins of their city was utterly incomprehensible to the Romans; they imagined the young Florentines were digging for gold and silver in the walls of the temples and imperial palaces, and they called them the treasure-diggers. At that time, much was still standing which lies in ruins at the present day, or has entirely disappeared. It was not till long after that period — more than fifty years later — that the Cardinal of San Marco destroyed the Coliseum, to build the Venetian palace out of its stone. Brunelleschi acquired in Rome those views with which he subsequently completely overthrew the Gothic style. His knowledge of the ancient dome, which he acquired by the most accurate examination of the Pantheon, enabled him to arch the dome of the cathedral in Florence, after the model of which Michael Angelo subsequently raised that of Saint Peter. Thus the course of Florentine art converges in him who was unparalleled among the . greatest.

Returning to Florence, he was found from time to time among those artists whose help Ghiberti required for his great work. Donatello also worked here with him. They went a second time to Rome, where they renewed their study of the ancients; and now Brunelleschi came forward well versed in his project for Santa Maria del Fiore. Opposed to him again stood Ghiberti, who had fame on his side, and was accustomed to take the lead in matters of art.

The cathedral had long been completed; its centre alone was open and roofless. No one knew how to close the immense opening. A competition was invited. The Florentine commercial houses in Germany, Burgundy, France, and England, received orders to induce all masters of importance to set out for Florence. The assembly was opened in 1420. Various opinions were set forth. One proposed the erection of detached pillars to support the dome. Another wished to wall up the dome with pumice-stone, on account of its lightness. Another proposed one single mighty supporting pillar in the centre of the dome. The most extravagant proposal of all was to fill the entire church with earth, in order to obtain a temporary firm support for the dome. In order that this earth should be removed all the more rapidly on the completion of the building, small silver pieces were to be mixed with it: all hands would then most readily carry it away.

Brunelleschi's project was a free dome. He wished to construct it with the aid of a scaffolding only. The enormous costs of the others he reduced to a small sum. Yet the more he promised, the more incredible seemed his words. Nobody listened to him; and he was already on the point of returning to Rome, and leaving his ungrateful native city, when it dawned at last upon the minds of the people that there might be something in his reasoning. He had wished not to exhibit his model to the company of architects: he allowed it to be seen secretly by those only upon whose votes the decision rested. A new assembly was called; there was

reiterated dispute, reiterated refusal to show the model: the victory, however, was at length Brunelleschi's, and his superior intelligence was evidenced by a comparison. He asked the assembly to place an egg on its point, and the history of Columbus' egg followed; all the architects combined not being able to place it upright, and Brunelleschi, years before Columbus was thought of, making it stand according to his method.

But once he had obtained the building, the jealousy of Ghiberti was awakened. Vasari's account of this affair seems mythical; but still, all that he brings forward affords an insight into the life and doings of Florentine artists, and shows not only how art rose against art, but also cunning against cunning. Ghiberti stood in the zenith of his fame. He succeeded at last in having the building of the dome assigned to him and Brunelleschi together. Brunelleschi, furious and beside himself at this trick, was again on the point of giving it all up. Donatello, however, and Luca della Robbia — the latter likewise an excellent sculptor — induced him, instead of tearing up his drawings and throwing them into the fire as he would have done, to come rather to an understanding with the directors of the building; in short, he allowed himself to be pacified, and the work was begun. His model, however, which he had constructed on a larger scale in wood, he kept carefully shut up from Ghiberti, who had on his side also prepared a model, which he computed at an expense of three hundred lire, while Brunelleschi only demanded fifty. For seven years they con-

tinued to build jointly till they reached the critical point, where Ghiberti's power failed. It was the beginning of the dome itself. Every thing depended on bringing into practice the right principle, according to which the stones were to be placed. Brunelleschi now feigned to be ill. Ghiberti, at first embarrassed and then helpless, could go no further alone, and was compelled to withdraw. At first, he retained his three golden florins monthly, which both he and Brunelleschi received; to the latter afterwards the salary was raised to eight, while Ghiberti's share ceased entirely. Equally wisely did Brunelleschi know how to treat the workmen, who were not always accommodating. His position in the city was an important one. In 1423 he appeared in the Signiory. Numerous other tasks occupied him, as well as the great building of the dome. Nor was Ghiberti less employed, and other masters also, whose names and works have, however, importance only for those who are able to study them on the spot.

Brunelleschi died in 1446. As an architect, he was not exactly the originator of the new style which supplanted the Gothic; but he was certainly the master, who, by his great power, stamped its superiority as a fact. Nevertheless, he, like Ghiberti, was rather a workman on a grand scale; for the days still lay in the far distance in which men appeared who carried their own nature into their art, and evidenced it in their works. This observation especially applies to painters, who soonest attained to this freedom.

The works of different masters are for the most part existing in abundance. We are able to distinguish their peculiarities, perhaps even their dispositions. One imitates here, another there; one is a degree more tender, another coarser. It is a delight to look with a practised eye on the series of collections, and the paintings in churches, palaces, and public buildings, and to recognize, or on examination to ascertain, the different masters. A great number of historical evidences, the completion of which is still unremittingly carried on, of letters, contracts, and testaments, confirm or correct the æsthetic judgment, and invest with higher value the works of art, which by this means are brought, even historically, into connection; yet, in spite of this, Florentine art, up to the middle of the fifteenth century, would have been in the highest sense little worthy consideration, had no masters subsequently appeared to develop it into ultimate perfection. Even Masaccio's works—who, with Ghiberti and Brunelleschi, is reckoned the third great reviver of art—scarcely approach the higher stage of art, but keep ever within the limits of the noblest workmanship. These men worked for definite ends in a superior manner; but in their productions there is that lacking which must belong to a work of art, before we can call its master a genius, and his manner of working a style. Every work of a great artist must, in its perfect completion, open the mind, as it were, to perceive a still greater work, which hovers invisibly above it, and fills us, while we know not whence it comes, with that ever unsatisfied curi-

osity, which, after fancying it has exhausted all, feels, at the very moment we turn away, that it has only seen the smallest part.

Donatello appears to us a man who attempted to produce such works. He was not at peace with himself. He had no desire that his work should surpass all others; but he aspired after the expression of an idea, to pursue which seemed to him more than to exhibit technical perfection. That cheerful satisfaction in the exercise of higher skill, which appears in Ghiberti's works, is lacking in his. For the most part, there is something unfinished and coarse in them; but they are life-like, and it is the spirit of their master which has breathed this life into them.

To Donatello, also, Ghiberti was a powerful rival, though they both took different paths. Whilst Ghiberti knew how to give a certain grace to his figures, and agreeable elegance to his ornaments, and, by equally finishing all detail, aimed at working the separate parts into the most favorable complete effect, Donatello gave himself vigorously to the regardless imitation of nature as she appeared in his eyes.

Respecting this endeavor, Vasari again brings forward one of those little stories,—the authenticity of which rests on a feeble foundation,—which, however, appears important and genuine in itself, characteristic as it is of the nature of the artist. In the early period of his work, he is said to have once asked Brunelleschi for a sincere opinion respecting a crucifix he had executed. "What you

have there done," said the other, " is no Christ, but
a peasant nailed to the cross." — " To find fault
is easier than to do better," answered Donatello.
Brunelleschi put up with it quietly, and secretly
executed a crucifix for himself, which he one morn-
ing took with him into the atelier. Donatello came
straight from the market, bringing with him in his
apron their mutual breakfast, — fruit, cheese, eggs,
etc. Brunelleschi held out the crucifix ; and Dona-
tello was so startled at the sight, that, raising his
hands in astonishment, he let every thing which was
in the apron fall on the ground. " How are we now
to breakfast ? " cried Brunelleschi. " Pick up what
you like," answered Donatello ; " I for my part have
had my breakfast for to-day. I see truly that you
are made for Christs, and my art is fit for nothing
more than peasants." Vasari relates the anecdote
twice at different places, and not quite in accord-
ance.

Brunelleschi was not wrong. A touch of coarse
reality marks the figures of his friend, not even the.
most delicate excepted. What a man is the St.
George in the niche of the Church of Or San
Michele ! He stands there in complete armor, stur-
dily, with his legs somewhat striding apart, resting
on both with equal weight, as if he meant to stand
so that no power should move him from his post.
Straight before him he holds up his high shield; both
hands touch its edge, partly for the sake of holding
it, partly in order to rest on it ; the eyes and brow
are full of expectant boldness. Ghiberti, too, has
furnished the niches of the outer walls of Or San

Statue of Saint George, Church of Or San Michele.

DONATELLO.

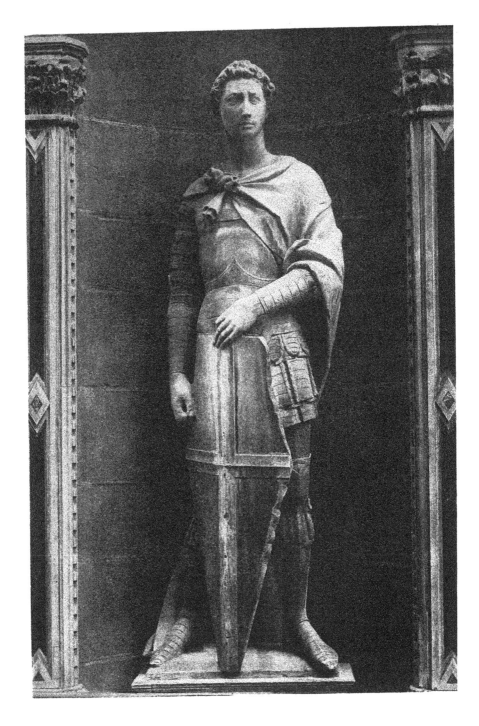

Michele with statues, the excellence of which de-
lights us: we approach, however, this St. George,
and the mere æsthetic interest is transformed sud-
denly into a more lively sympathy with the person of
the master. The technical part becomes secondary.
Who is it, we ask, who has placed such a man there,
so ready for battle?

Ghiberti and Brunelleschi stood in close relation
with the Medici; Donatello, it seems, to a higher
extent than either. He was the first great artist
whose fate depended on that of the family. They
presented him with a little estate; and, when the
management of this caused him too much trouble,
they changed the gift into an annuity. Cosmo dei
Medici commended him, in dying, to his son Piero,
who took care of him with affection, and had him
honorably buried in San Lorenzo.

Donatello was a simple man, with few wants. He
would not wear a mantle given him by Cosmo,
because it was too splendid. His money is said to
have always lain open in a basket, which hung from
the ceiling. His friends might at any time resort to
it when they wanted it. Old and paralyzed, he
spent the last days of his life in a small house, the
situation of which is accurately specified by Vasari,
but of which in the present day no vestige remains.
The whole city followed him to the grave at his
burial.

Ten years after Donatello's death, Michael Angelo
was born. Between the two there is a striking
mental affinity. The connection of an earlier master
with Michael Angelo, as regards externals, would be

easily imagined; but here the similarity of nature was so strong, that one of the witty Florentines of that day made the observation that either Donatello Buonarotticised or Buonarotti Donatellicised. Donatello also chiselled the marble boldly and with ease, like Michael Angelo; but at the same time, like the latter, produced, when required, the smoothest, most delicate work. His St. George is cast in bronze, and is designed for strong general effect; on the other hand, in the Carthusian monastery at Florence there is the monument of a bishop, which is unsurpassably delicate in its workmanship. In the centre of an apartment, the long extended figure, resting on its back, lies on the stone floor, with no other support than a pillow under the head. Protected by the sacred stillness and seclusion of the cloister, untouched by decay, scarcely covered with dust, the marble has preserved its early freshness for centuries. It is here we become convinced, that, if the master worked elsewhere with coarser touches, it was his will, and not because his hand refused the more ⋅ delicate work. Equally great with his art in marble was his skill in casting bronze. The Church of San Lorenzo, which Brunelleschi rebuilt for the Medici, is, in its interior decorations, the work of Donatello and his pupils. Michael Angelo completed there what was still wanting. And yet this church, filled with a series of works by both artists, each of which singly might have given a name to its author, is only *one* place among the many which is rendered glorious by the richness of their fancy.

Florence is full of Donatello's works; the rest of

Tuscany and Italy possess likewise a good share. If we consider the works singly, here and there, we see only the art of one man; but, if we calculate the whole sum, — the labor, the extent, the value, — we see in spirit the master in the midst of a great workshop, surrounded by numerous distinguished pupils, who are all busy under his name. The most excellent works alone are imputed to Donatello himself, whilst the more indifferent are assigned only to his atelier. Such activity, however, is not to be conceived apart from a people, unwearied in inciting their artists to renewed efforts.

7.

Donatello lived in times in which there was a greater abundance of the works of ancient art. He suggested to Cosmo the idea of collecting ancient statues, and erecting them publicly. If broken or mutilated, he repaired them. This was the beginning of those gardens of San Marco, which were filled with so many treasures, and in which Michael Angelo as a child pursued his studies. That which in the youth of Donatello had been rather the curious fancy of a single man, had risen by degrees to be the taste of the great public; and the advantages which he and others with him, following their instinct, had with labor gathered together in their youth, were transmitted henceforth to succeeding artists as an indispensable but easily obtained study.

The total change accomplished in Italy during the life and influence of these four artists pervaded every thing. Ancient art burst forth in fresh springs,

and fertilized the world. The popes offered no re-
sistance; they, and the temporal and spiritual lords
of Italy, vied in appropriating the revival of ancient
culture to their own intellectual enjoyments. The
art of printing extended the influence of the Roman
and Greek authors *ad infinitum*. In Florence, the
beginning of this period and the complete authority
of the Medici coincide with the enlargement of the
territory and the important extension of commercial
relations. From all ends of the world, wealth
poured into the city. The families of the great
citizens had princely means in possession. A new
generation grew up; but the first traces were also
exhibited of those views which regard the beau-
tiful enjoyment of life as higher than that furious
patriotism, and that yearning desire for liberty,
which hitherto had guided the destiny of the
city.

This period, however, is more familiar and intelli-
gible to us. It has nothing mythical in it, like the
preceding; it is full of characters, whose course of •
action we follow and understand; and the three
great artists who appear in it, and render it glorious
by their works, stand as living men before us. Cim-
abue, Giotto, and even Dante, are scarcely more
than great vague shadows of men, whose entire
works we cover with their names. Ghiberti, Bru-
nelleschi, and Donatello appear more tangible and
living, — Donatello almost as a character that we
know. Leonardo da Vinci, however, the oldest of
the three of whom we are now about to speak, casts
off all that is misty; and although we know least of

Portrait of Simoneta.

his fate, compared with the two others, and his course is often hidden in obscurity, we still feel his whole heart in his works, and stand close to him as though we met him.

Leonardo is not a man whom we could pass by at will, but a power which enchains us, and from the charms of which no one withdraws who has once been touched by it. He who has seen the Mona Lisa smile, is followed for ever by this smile, just as he is followed by Lear's fury, Macbeth's ambition, Hamlet's melancholy, and Iphigenia's touching purity.

When painters become as great as he, their works become personal deeds; and whatever in any way is remotely connected with their origin gains higher importance. Their travels are no longer mere business travels; their animosities or alliances are no outward circumstances; none of their experiences seem to have been without influence upon their works. Whether Donatello works in Venice, Padua, or Naples, in periods of war or peace, he is the same everywhere. Whether Ghiberti, when he was modelling, casting, and gilding his gates, lived happily or unhappily, is a question, the most accurate reply to which would affect us but little. Even with the lovely female profiles of Filippo Lippi, curiosity of this kind never arises. We contemplate with emotion the portrait of the beautiful Simoneta, who died so early, the loved one of Giuliano dei Medici, who was assassinated in his youth; but we reflect not with what eyes Botticelli himself glanced at her when he drew those tender lines. Leonardo's women, on

the contrary — what an atmosphere surrounds these forms! what a desire is awakened to know how much conscious art has done here, how much the charm of the portrait is indebted to the heart of the painter! Speculating curiosity becomes busy in our mind as soon as we begin to inquire and conjecture. We feel the same with Goethe's poems. It seems impossible for them not to have originated entirely as parts of his lived life. This enigmatical nature — this mystery, defying all explanation, yet continually exciting our ingenuity — is the exclusive possession of works which have been executed by great artists. This is what attracts us powerfully; and all that which is esteemed by lesser artists as such a principal matter, — their technical art, their learning, their progress in conception and treatment — become secondary things, and seem worthy of less consideration.

Leonardo was born in 1452, the illegitimate son of a rich noble. If we read Vasari's account of his life, we are tempted to regard it as a series of charming little stories, laid to the account of a great, but somewhat unknown man in Florence. For Leonardo was, for the greater part of his life, far away from his native city. But his works harmonize with the strange things of which Vasari tells. An abundance of his designs are preserved in London, Florence, and other places. It is scarcely to be described what caricatures are here seen to be executed with the utmost fineness and care by Leonardo's hand, — caricatures designed with scientific accuracy; each succeeding one more monstrous than the past.

These figures could not possibly have had an aim, like that perhaps of the distorted faces which Michael Angelo introduced in decoration, after the fashion of grotesque forms. They are merely attempts to carry ugliness as far as possible; fixed dreams, as it were, of a fancy directed to the distortions of the human form. So we readily believe Vasari, when he relates that Leonardo for days would follow a striking countenance, only for the sake of taking it in thoroughly, and committing it to paper. Or he would invite a troop of peasants to dinner, encourage them to feel quite comfortable, excite them to laughter, and, with the help of his good friends, keep them long enough to have their grinning faces engraven firmly in his memory. He would then depart in haste, and begin to draw; upon which a picture would be executed which no man could see without laughing himself. It is as if Leonardo had felt within himself the necessity for some glaring contrast to those truly heavenly forms which he was capable of producing. He himself, beautiful in countenance, strong as a Titan, generous, with numerous servants and horses, and fanciful furniture; a perfect musician, fascinatingly charming with high and low; poet, sculptor, anatomist, architect, engineer, mechanic; a friend of princes and kings; and yet, as citizen of his country, having an obscure existence, which, rarely emerging from its twilight, had no opportunity for employing its powers simply and freely for any great cause.

Such natures rarely but possibly appear, — natures which, with eminent talents, seem nevertheless

created only for fantastical things; which, in the most serious, deepest works of the mind, retain the inclination to a kind of childlike playfulness. Such men are born in a high position: genial, noble, independent, and with an undefined desire for action, they enter the world. All stands open before them; real, depressing care approaches under no form; they prepare for themselves a life which no one besides themselves understands, because no one has been born like them under the conditions which lead to these peculiarities, as a necessary fate from which they cannot escape.

Such a mind was Alfieri, with unusual, but perfectly absolute energy, if left to himself; incapable of taking any other course than that which his nature blindly discovered. Lord Byron also was similarly organized; carried here and there by the will of a demonlike restlessness. How came a man of Leonardo's genius, who had a great and powerful party on his side, to resolve to abandon his beloved Florence for so many years, and at length to go to • France, as if in exile? Superior to all others, he refused to assert his position. In contact with the most remarkable men of his day, he yet stands in natural public connection with none. Unfortunately, Vasari's biography, which overlooks entire epochs, and is obscure in detail, is almost the only source from which we learn any thing of Leonardo's external history. For, although he has himself left behind whole volumes of written works, we gain from them little worth knowing respecting the course he took.

The usual career of the Florentine artists was, that they began life as goldsmith apprentices. They thus obtained the most solid foundation. The difference between art and workmanship was well known; but it referred to the works themselves, not to those who produced the works. In France, in the fourteenth century, this was the distinction: what was executed for the Church and the king was a work of art; the rest was the work of mechanics.* The aim in all cases was to gain money.

Leonardo arrived at art in a different manner. Drawing and modelling were a delight to him. His father, by whom he was treated just like his legitimate brothers and sisters, gave some of his drawings to Andrea Verrochio, a pupil of Donatello's, and, after his death, the first painter in Florence. He urged Messer Piero da Vinci to let his son be a painter, and he admitted Leonardo into his atelier. There was painting, working in marble, and casting in bronze, going on there. Vasari asserts that he has seen some female heads modelled in clay, belonging to this early period, with a smiling expression. Thus, at the very beginning, we see that smile in Leonardo's female countenances, which is repeated in so many later pictures; and which at length became constantly adopted by his pupils, especially by Luini.

Besides the plastic art, he pursued mechanical and architectural studies. His mind was directed to extraordinary things; to all that was difficult; to the invention of ingenious mill-works, of an appara-

* See Appendix, Note II.

tus for flying, of machines to bore tunnels through mountains or to remove immense loads, of contrivances to drain marshes. The grandest of his projects was to raise as it stood the Church of San Giovanni, which, by the gradual elevation of the pavement round it, had sunk too deep into the soil; and to place a substructure with steps below it. Every one knew that this was impossible, remarks Vasari (who himself, however, in such matters, would gladly have accomplished even the impossible); but, when Leonardo demonstrated how he contemplated setting to work, they were compelled to give credence to him. At the present day, in such a matter, perhaps the expense alone would be the point in question.

Amid such pursuits, Leonardo enjoyed his life and youth. He was especially fond of beautiful horses and other animals, in which he took much pleasure. This inclination for animals of all kinds we find again in Alfieri and Byron. I should assign it to an entire class of men, whether they were minds of genius, or unproductive natures. A kind of ambition lies at the foundation of it. From their own restlessness of mind, they cannot assert lasting mental power over their equals; and since they can neither keep slaves, nor are born princes, they confine themselves to the unapproachable dominion over a people of animals, which, in their ability for showing fidelity, form a substitute for men; and because they bear no grudge for evil treatment, or otherwise assert themselves, they seem a preferable society, with whom it is easy to live peaceably. In

Vasari, we meet with other painters of lesser importance, among them pupils of Leonardo, who cultivated similar inclinations.

With such favorite amusements, botany, anatomy, astronomy, and astrology went hand in hand. From the latter especially, Leonardo is said to have formed heretical views to such a degree that he was regarded by every one rather as a heathen than a Christian. Yet we find this remark only in the first edition of Vasari's works. In the second he omits it, and does well in so doing, as his present excellent Florentine editors remark, since certainly such an assertion could have been owing only to a misunderstanding. Considered impartially, Leonardo's heresy seems, however, in unison with the character of the man, and the views of his age. Classical studies prevailed; and, in ethics, views equally indifferent to good and evil, faith and unbelief, in the Christian sense. The nobles and the higher clergy held them in reverence. The Academy of Florence — that court of the Medici, so cultivated in Greek literature — raised the Platonic philosophy to be the second religion of the State. Those who strictly preserved another line of thought stood isolated, as a little band in the midst of the throng; and it was not until long after Leonardo's death, that this state of things gave way before the prevalence of other opinions. Such, however, was the period in which Vasari prepared his work.

Leonardo soon surpassed his master, Verrochio. In a picture which the latter was painting for the monks of Vallombrosa, representing the baptism of

St. John, an angel by Leonardo's hand was so con-
spicuous from its beauty, that Verrochio from that
time forth is said to have completely given up paint-
ing. Similar catastrophes are, however, too often
related by Vasari, for us to receive them at any time
as literal truth. His next work was the design for
a tapestry to hang before a door, which was to be
woven in Flanders for the king of Portugal. We
must here observe, that the connection between Flor-
ence, Lisbon, and the northern part of the Nether-
lands, had long been general; there were Florentine
houses everywhere. Leonardo had represented on
the tapestry the fall of man. The landscape with
its plants and animals, and the tree with its branches
and leaves, were executed with such delicacy and
perfection, that the patience of the artist appeared
just as worthy of admiration as his art. This car-
toon was still extant in Florence in Vasari's time.

While especially commending care and complete-
ness in the management of the detail, we must at all
times keep in view the works of the Florentine mas-*
ters of that day, with whom miniature-like accuracy
was customary. Leonardo, however, stands highest
in this respect. Hence the reproach, that he was
never ready with his pictures, — that he had begun
so much, and left so much unfinished, — appears very
natural. The care with which he prepared his oil
and colors surpasses every thing which now seems
possible.

The origin of the fearful Medusa head, which was
also one of his earliest works, is very distinctly re-
lated by Vasari. Leonardo collected a brood of

venomous swelling toads; he put them in his house, provoked them to rage, and observed them till his imagination had absorbed enough for his painting. When completed, he brought the picture into a darkened room, cut a hole in the window-shutter, so that the ray of light exactly fell upon the head of the Medusa, and beamed upon it with lustrous brightness. With this the curious, who were mysteriously brought in, were filled with fright. He afterwards painted for one of his friends the god Neptune. In this picture, the naturalness of the dashing waves, the strangeness of the sea-monsters lashing them, and the magnificent beauty of the god-like form, produced an extraordinary effect. This predilection for the fanciful lay, however, not so much in the character of the artist himself, as in the general tendency of the world at that time; and many works of Leonardo's earlier associates correspond in spirit with his own, according to Vasari's description of them; for they are no longer preserved. Even in his latest pictures, however, he remained true to this fabulous mood, which is breathed forth from them as from the verses of Byron, a poet who always reminds me of Leonardo. So strong was the whimsical dreaminess of his nature, that he seriously advised his pupils to look attentively at the damp spots of old walls, at ashes, and other chance rubbish; as by so doing the noblest ideas of paintings occur to the mind. And so great was his art of perceiving and representing the hidden depths of the soul, that in this he has surpassed all others. To estimate this, we must see the female

3*

head in the Augsburg Museum, where passion is expressed with such truth that we fancy we know the fortunes which fashioned those lines, and we cannot tear ourselves from the fearfully beautiful mystery of the countenance.

The prime of his talent was not developed in his native country. He may have numbered somewhat more than thirty years when he went to Milan, where Ludovico Sforza was in authority. It would seem natural for Leonardo to have gone there for the sake of some important artistic undertaking, yet nothing is told us of such. Sforza liked stringed instruments; he had heard what a master on them Leonardo was, and he requested his presence. Leonardo obeyed the summons. He manufactured for himself a silver lyre, which he made in the form of a horse's head; and to its music he sang the verses he had composed, by which he enchanted the duke and his magnificent court. This was the first appearance of the handsome Florentine in Milan. Soon, however, work opened before him which fascinated him • quite as much as Sforza's good-will. He found full scope for his talents, and occupied the first position as a painter. We will leave him here. It was during these years that Michael Angelo's art began to develop itself.

CHAPTER SECOND.

The Great Men of History — The Sources of Michael Angelo's Life — Vasari's Connection with Condivi — The Italian Historians — The Florentine and London Papers — The Buonarroti Family — Birth and Early Youth of Michael Angelo — Francesco Granacci — The Brothers Ghirlandajo — Lorenzo di Medici — The Conspiracy of the Pazzi — The Gardens of the Medici — Life in Florence, and her Artists.

ACCORDING to the same laws by which that which we have experienced assumes a fixed form in our memory, the history of a nation moulds itself in the consciousness of its people, as the sense of the tenor of their past does in that of mankind generally. It would be natural, perhaps, as the result of comparative science, to waive entirely the question of creation, and to suppose a throng of human beings disappearing in a past of incalculable years, their origin never having been elucidated. This, however, is opposed to general feeling. Men desire to hear that a pair were created, suddenly, by the will of God; that from them the peoples are descended who are living at the present day. The further we look back, the more empty and the more bright the lands appear; more powerful, more beautiful, and more solitary beings dwelt in them. More and more populous grew the globe, more ordinary

its inhabitants, more rare its great men,—and these even of an inferior quality,—until at length we come down to our own time, in which no more heroes are produced,—in which the most pitiful fellow who lives, eats, and drinks, has in common with the noblest a name of his own which can call forth an echo from the four ends of the world.

This view of events seems to correspond with the general feeling. We meet with it everywhere. Thus we say, and thus it is said,—all that is pure and heroic lies in the Past; all that is common, in the Present.

But another view of things gains ground.

During the period in which a volcano cooled, and from its congealed streams of lava a wooded mountain was formed, while the crater became a calm, deep-lying lake, generation after generation died away. It required from three to four thousand years to complete this transformation. It is so distinctly to be perceived at the present day, that no doubt is raised how it was accomplished. Compared with such tardiness, the longest wars of men appear like the rapid blazing of a fire of brushwood; and the prolonged suffering of a human being seems short as the momentary death of a beetle whose tiny life we have by chance trodden out with our foot. The remotest mythical ages of history lie easily and palpably near us. Men lived then as at the present day,—they ate, they drank, they loved, and they quarrelled. In the lakes of Switzerland, the remains of a people have been discovered, whose existence seems to precede all that we now call the history of

Europe. Half-burned corn, potsherds, working-tools, and all sorts of bones, have been found. They appear no more gigantic than the tools and skulls of Indians who live at the present day, — probably under the same conditions as those people did, of whose end we know nothing.

What are we, with our measures of space and time? Of what consequence is this earth, if we consider it as one star amid countless others? How many revolutions did it experience before human beings were on it? how long were there inhabitants of earth, before they began to remember the past? The couple of thousand years, which we designate history, is a segment but a span long of an extent which could be measured by miles. We must cease to consider it as long, before we can obtain a just view of these proportions. The parts of Germany which lie on the other side of the Elbe were to the Romans just as misty fabulous lands, as were the islands of the calm ocean to the middle ages, at the time of the discovery of America. In the present day, the lowest classes speak of South America, Australia, and Japan, and of the epochs of the earth's formation. The heroic ages lie no longer in the past; but we expect them as the noblest fruit of the future: we go onwards, not backwards.

Our view of the world has reached its crisis. We look with contempt behind us, and expect new revelations of the human mind, greater things than the world has ever seen.

As certainly as the orbits of the stars intersect each other, each affecting the course of the other,

and influencing by its slightest peculiarity; so certainly do the human beings who live, who have lived, and who are yet to live, form in themselves an immense system, in which the smallest movement of each single one is for the most part imperceptible, but yet affects by its influence the general unceasing progress. History is the relation of the fluctuations which occur on a large scale, from the dissimilarity of the powers of individual men. Our desire to study history is the longing to know the law of these fluctuations, and of the distribution of power affecting them; and as currents, or motionless spots, or storm-tossed whirlpools, meet our eye, we discover men as the moving power, — mighty individuals, governing by the immense influence of their mind the remaining millions, who, of lower and duller intelligence, are compelled to yield to them. These men are the great men of history, resting-points for the mind as it gropes amid endless facts; wherever they appear, the age grows light and intelligible; where they are lacking, an impenetrable obscurity • prevails; and, when masses of so-called facts are communicated to us from an epoch deficient in great men, they are mere things without weight and measure, which, great as is the space they occupy when grouped together, form no whole.

Reverence for what is great is a universal feeling. Mankind has always known it; it needs not to be explained. The worth and influence of any man depends on how far he is capable of being called great himself, or of attaching himself to those who are so. That only which is apparent of the man, in

this point of view, forms his imperishable character. A ruler who with iron will forces nations to follow his caprices is soon forgotten; regarded for a time as a sort of ape of Providence, the idea of his character vanishes, and with it his name. A despised, obscure mortal, who, deeply feeling the condition of his people, conceived and uttered one fruitful thought, which the people needed ere they could advance a step forward, is immortal in his influence. And, if his name were to be forgotten, we should still ever feel, that a mighty man must have stood in that place.

Thus the study of history no longer awakens in us sorrow for the loss of nobler days, but a certainty of their future appearance. As we advance, we wish to know those who took the lead at all times. The study of history is the contemplation of events as they stand in relation to great men. These form the central point from which the picture must be studied. Enthusiasm for them enables us to occupy a just point of view respecting them. We desire to contemplate them, and to impart to others the gift of contemplation. This is what Goethe meant when he said enthusiasm is the one thing necessary to history.

Our desire is to obtain the noblest view of man. When we look at great men, it is as if we saw a victorious army, the flower of a people, marching along. As, in such a triumphal procession, even the lowest soldier of the army stands high above all spectators, so do even the least of those whom we call great men stand exalted above the immeasurable

multitude of mortals. The same laurel adorns them all. A higher fellowship exists among them. They are divided according to their position on earth; now they stand close together, — language, habits, position, and centuries separate them no more. They all speak one common language, knowing nothing of castes, of noble or pariah; and he who now, or in times to come, thinks and acts like them, rises up to them, and is admitted into their circle.

2.

Among the citizens of Florence, Dante, Leonardo da Vinci, and Michael Angelo must be designated great men. Raphael came from Urbino; yet he may be classed with them, because as a painter he might be considered a Florentine. Dante and Michael Angelo stand highest. It is not the result of one-sided predilection, if this book, the subject of which is the prime of Florentine art, bears Michael Angelo's name on its titlepage. A life of Raphael or Leonardo• would give only a fragment of that of Michael Angelo. His power surpasses theirs. ˡHe alone participates in the general work of the people. With all his works, he stands forth like a statue offering itself for contemplation on all sides; while the other two appear rather like magnificent pictures, exhibiting constantly the same living countenance, but always from the same side.

The feeling that Michael Angelo stood so high gained ground early in his lifetime, not in Italy alone, but throughout Europe. German nobles came

to Rome: the first thing they desired was to see Michael Angelo. Even his great age — living in two centuries — added to his celebrity. Like Goethe, he enjoyed in his old age the immortality of his youth. He became a part of Italy. Like an old rock, round which we make our way in the sea, without staying to think why it lies there blocking up the direct course, they respected in Rome his political firmness. They allowed him to live according to his own convictions, and desired nothing but the fame of his presence. He left behind him a vast possession, bearing his name: each of his works was a grain of seed from which countless others arose. Indeed the works are numberless which were executed in the sixteenth and seventeenth centuries after the model of his. As the thirteenth century and the beginning of the fourteenth are reflected in Dante, so the name of Michael Angelo embraces those which follow; and as, at the same time in Germany, Luther gained a similarly extensive influence, — in an entirely different manner, it is true, and in another domain,— the life of Michael Angelo forms a contrast to that of Luther, exhibiting the difference of the nations, in the midst of which the two powerful spirits were at work.

In this way Michael Angelo is scarcely known. We feel rather instinctively that his name is the symbol of a vast activity. The connection of his fate with that of his country, and the tenor of his works, has not as yet been generally perceived. In this respect I have felt that to attempt a description of his life would be a useful work.

E

We possess two tolerably bulky biographies of Michael Angelo, both written by artists who call themselves his pupils, and both printed during his lifetime. The one is by Ascanio Condivi, who lived in his house; the other, by Giorgio Vasari, known as a painter, architect, and man of letters at the court of the Florentine dukes. A book written by him appeared in 1550, called Biographies of the most distinguished painters, sculptors and architects. Michael Angelo's life forms the close of the first and last part.

Difference of opinion as to Vasari's character is scarcely possible. His virtues and faults are too slightly concealed. He was court painter, court architect, court agent in matters of art; whatever he did, he did with regard to the favor of his lords and masters, of whom he had many. Of himself he speaks ingenuously, as of a master standing on a level with the first. He discusses the faults of Michael Angelo and other painters, in a tone as if to intimate that he had derived the necessary advan° tage from the knowledge of their errors, and had avoided them. He praises his own works with a modesty which he hopes will meet with acknowledgment, and he speaks of himself and all his doings as of some estimable third person. Those who oppose him, or personally displease him, he treats badly without ceremony, somewhat as a theatrical critic would treat an actor, whom he wishes to show that he is an authority not to be trifled with In this respect Vasari allows himself to act most basely. He has cast such a slur over painters whom he did not

like, that they must have been with difficulty re-
stored to honor. No reliance can be placed on the
accuracy of his dates. He gives false dates, and at
times his description of pictures is totally opposed to
the truth. If we compare his statements with sure
documents, we find many errors; if we still possess
and can refer to the sources which he made use of,
we perceive that he omitted or added as he liked.

Nevertheless, his book is not without merit. He
wrote for the most part upon hearsay, and knew
nothing of the records which now stand at our dis-
posal. He and his century lacked the taste for
critical acumen which we exercise at the present
day. Still his book remains a treasure to the friend
of art. Its copiousness seems inexhaustible, and his
style is clear and concise, his views of life cheerful
and sensible; and, on the whole, the merits of Vasari
may be said to outweigh his faults.

It is, however, just to his censuring nature that
we are indebted for much of our information respect-
ing Michael Angelo. Vasari sent his book to the old
master when it was printed, who answered him with
a sonnet, in which the most complimentary things
were expressed. Another answer, however, of oppo-
site purport, appeared in the publication of Condivi's
work. Condivi lived in close proximity with his
master. Vasari, although he liked to represent it
otherwise, was a stranger to Michael Angelo, whose
flattering letter was intended rather for the court
agent than for the artist. That Vasari was a stran-
ger to the great man, is evident in nothing so much
as his book; for we can imagine nothing more super-

ficial, more false, and more careless, than this biog-
raphy in its first edition. He passes over important
events, represents facts falsely in themselves and
falsely arranged, shows himself especially ignorant
with regard to the period of Michael Angelo's youth,
and, for want of significant truth, resorts to empty
expressions of praise.

Michael Angelo evidently wished to inform the
world of a more truthful work, without offending
Vasari. For this reason, Condivi, in his preface,
did not once mention the latter by name. When he
denotes him indirectly, since this was not to be
avoided, he makes use of the plural, and speaks of
several doubtful persons, against whom he has some-
what to bring forward.

"From the hour," says Condivi in his preface, "in
which, by God's especial goodness, I was deemed worthy,
not only, beyond all my hopes, to behold face to face that
unique painter and sculptor, Michael Angelo Buonarroti,
but to share his affection, his daily conversation, and life;
conscious of my great happiness, and enthusiastic for my
art, and grateful for the kindness with which he treated
me, I began accurately to observe and to collect his rules
and precepts. What he said, what he did, how he lived, —
every thing, in a word, which seemed to me worthy of
admiration, emulation, or praise, — I noted down, and in-
tended, at a convenient time, to gather together in a book.
I wished in this way to thank him, as far as lay in my
power, for that which he had done for me. I hoped, more-
over, to give pleasure to others by my records, in setting
forth the life of such a man as a bright and useful example
to them; for every one knows how greatly this and every

other age must be beholden to him for the glory which his works will ever shed over them. In order to feel what he has done, we need only compare it with what others have done.

"While I was thus collecting my materials, part of which referred to the outward circumstances of his life, and part to works of art, unforeseen circumstances obliged me, not only to accelerate my work, but, as regards the biography, even to precipitate it. In the first place, some have been writing about this rare man who were not, I believe, so well acquainted with him as I am; thus they have asserted things which are purely imaginary, and entirely omitted many important circumstances. Secondly, others, to whom I communicated my plans in confidence, have appropriated them in a manner which evidences the intention, I regret to say, of not only depriving me of the fruits of my labor, but also of the honor of it. Therefore, to supply the defects of those first-mentioned authors, and on the other side to prevent the injustice which is impending from the last, I have resolved to give my work to the public, imperfect as it is."

Hereupon follow excuses as to the faulty style, he being a sculptor and no writer by profession. Lastly, the promise that an accurate catalogue of Michael Angelo's works will follow. Unfortunately, no trace of this is to be found. We do not even know whether it was really written or published. The " some " and the " others " of whom he speaks seem only to denote Vasari.

Condivi's book was dedicated to the pope, who received it graciously, and personally thanked the author for it. This act of courtesy was indeed

brought about by Michael Angelo. Vasari let the matter rest; but, after Michael Angelo's death, he avenged himself in his usual style.

He published a new edition of his biographies, and admitted into this, Condivi's work in its full extent, verbatim sometimes, and sometimes with words arranged intentionally differently. At the same time, he again proceeded so carelessly that he did not even take the trouble to correct the false statements to be found in his first edition, but intermingled these roughly with those of Condivi, so that he gives double information, — the false with the true, — resulting in further confusion with his subsequent editors. He makes no mention of Condivi's name, but in the most evident manner alludes to him as a liar and an untrustworthy man, while he has himself never written any thing but the purest truth. No one, he says, possesses so many and such flattering letters from Michael Angelo's own hand, and has been so intimately acquainted with him as himself. But, he says at the close of his biography, Michael was unfortunate in those who were daily with him. And, after having once more reverted to his own modesty, he now mentions Condivi as a pupil of Michael Angelo's. There is not a syllable of his writing; he only says that he produced nothing of his own; that the master had assisted, though that assistance was in vain; that Michael Angelo had expressed to him — that is, to Vasari — his pity for the fruitless efforts of the poor devil.

With this, however, he was still unsatisfied. He attempts to surpass as far as possible Condivi's simple

information. He now knows of things, which before Condivi's book appeared no one knew, much better than he from whom he copies them. Whether, in his desire to excel Condivi, his own imagination was alone constantly at work, is a question which remains open. Vasari certainly liked to color events by little episodes of his own, to produce a more lively effect; and much may have thus originated. In many cases, he, however, certainly succeeded in producing what was new, and in creating something of his own upon the foundation given by Condivi.

At all events, he obtained his object. He had taken his rival's work entirely into his own, and had rendered it superfluous. He was the famous Vasari. Condivi's book fell into such oblivion, that, in the year 1747, in which it was reprinted for the first time, hardly a copy was to be found. Even at the present day, the connection of the two authors with each other is uncertain; and the latest excellent Florentine edition of Vasari scarcely recognizes it, only briefly stating that Condivi was made use of by Vasari in many things, and his words are quoted below as some authority. Condivi's biography ought rather to have been entirely admitted into this edition; and it should have been shown, that the differences between the two authors are to be explained for the most part by the fact that Vasari tried to give Condivi's words another turn in order to conceal the plagiarism, while often nothing but his carelessness is blamed.

Little honorable as are the causes by which we possess Vasari's second work in such an improved

and ample form, and sad as is the fate of Condivi's, whose end was also tragic, — he was drowned before being able to provide for the immortality of his name as an artist, — both works are of great value. They contain letters which Michael Angelo had himself written; numerous poems by his hand, notes in his journal, contracts and public records which refer to him. Dr. Gaye, a Schleswig-Holsteiner, who studied in Berlin, and then went to Italy, deserves the greatest merit with regard to them. He examined the crowded archives of Florence, and many others have followed in his track. Gaye did not finish his work; he died in 1840; Herr von Reumond edited the third part of the book. The before-mentioned last Florentine edition of Vasari offered an excellent compilation of the material which had become known latterly; whilst the edition of Condivi, a century older, is provided also with good notes from various authors. Mr. Harford's Life of Michael Angelo — the latest work on Michael Angelo — contains some things not before known.

The sources from which the history of the times which produced Michael Angelo are drawn are numerous enough. Respecting no epoch of later history have contemporaries written so powerfully and so well; but they are sometimes guilty of giving importance and weight to events which, recorded by an inferior pen, would scarcely invite attention.

Foremost stand the works of Macchiavelli. With an impartial clearness — which is so great, that, even while acknowledging it, we are inclined to doubt it,

just because it is almost carried too far — he gives an account of the slightest convulsions of his time. Writing his language as the best ancient authors did theirs, conversant with the political ideas of the century, he gives the root of every opinion. A few years older than Michael Angelo (he was born in 1469, three centuries before Napoleon and Humboldt), he died when Michael Angelo had not completed two-thirds of his career. Had his personal life been in harmony with the loftiness of his mind, he would have been, next to Michael Angelo, the greatest man of his age; but we shall hear why only a smaller portion of this fame belongs to him.

After him comes Guicciardini, more vigorous and powerful in character, but inferior in diction, — a man who never, like Macchiavelli, in a subordinate position or in compulsory idleness, found leisure hours for reflection and study; but who, from the early part to the close of his life, occupied high posts. He knew, perhaps, more of men and circumstances than Macchiavelli; his mind could grasp many ideas at once, while that of the latter was of a contemplative turn: but he observed more superficially, and did not fathom character with Macchiavelli's discernment, which was quick and penetrating. Whilst Macchiavelli recognizes higher laws as the propelling power of all that happens, Guicciardini refers the entanglement of events to the evil passions of men. He knew their power, and had experienced it in himself. He, too, died before Michael Angelo. His violent death was the fruit of his own ill judged ambition.

4

Giovio, on the other hand, a dignitary of the Romish Church, had grown up as a flatterer at the courts of the popes, acknowledging that he threw a cloak over things for the sake of gain. But he knew how to wear the garment gracefully; and, initiated in all intrigues, he well understood in what light to exhibit the situation of political affairs. We possess from his pen, as small appendages to his tedious historical writings, two short biographies of Raphael and Michael Angelo, composed in Latin, and of much merit.

Next, Bembo, — in his old age a cardinal, in his youth an ecclesiastical adventurer, and a lover of Lucrezia Borgia, one of the many who rejoiced in her favor, — standing higher than Giovio, but cut from the same block. His letters, published in many volumes, are a sample of the mode of thought in the higher circles, and a specimen of that later elegant prose, which, adulatory and empty, offers pleasant words to both eye and ear, concealing its coldness by fervor of style. Like Giovio, he cringed to the nobles, till, from their servant, he became their confidant, friend, and at length their equal.

Nardi, on the contrary, was a Florentine democrat, of good family, writing in exile the history of his native city. Mild, discreet, not over-hasty in judgment, he was passionate against the enemies of liberty, the loss of which had cost him too dearly. He writes for Florentines, who, like himself, living in the midst of the politics of the city, were acquainted with affairs from the beginning.

Nerli, on the other hand, had long foreseen the annihilation of liberty. He drew his conclusions from the quiet order of things under the grand-duke. He stigmatizes uproar and revolution in themselves, yet he acknowledged the liberty of the past. It was well for him, and for others of his time, that the grand-dukes belonged to a line of the Medici, who had been oppressed and ill-treated by the other branch of the family, from which the two popes and the oppressors of freedom sprung. It seemed, in consequence, less inexcusable to speak of these people without regard, and thus to appear on the side of that ancient liberty, which, however, was never restored.

The last struggles for this liberty are described by Segni in a book, the existence of which no one surmised at the time it was written. He writes freely, accurately, and in a polished style, but not so distinctly and forcibly as Nardi and Guicciardini.

Varchi's book also remained unprinted, although compiled by order of the grand-duke. Permission for publishing it was never granted him. Varchi was an associate of Vasari's, the first man of letters at the court, and foremost in that Florentine life which had become accustomed to the new dynasty. Varchi delivered Michael Angelo's funeral oration. He also speaks with enthusiasm of the old independence, and bewails its decline: but his are the lamentations of an historian; and, enthusiastically as he mentions the old free Florence, the new Florence, in which he himself occupies so high a position, is not alluded to. He has collected only what he could

scrape together respecting the period of 1530; but he did not understand how to absorb the matter in his own mind, and to write freely from himself.

How little he availed himself of the material standing at his disposal, is shown by Busini's letters to him, who, living in Rome in exile, gave, at Varchi's request, free vent to his remembrances of the years 1527 to 1531, in a series of confidential letters. These are the most singular and careless expression of the Florentine mind. With bitter violence he gossips over events and men. A democrat of good family, proud, but resting in the indifference which the lapse of years had induced, Busini abandoned himself in Rome to that ironical apathy to political events, with which Michael Angelo also in his last years sacrificed his hopes. The times seemed then to have passed away for ever, in which free citizens might venture to indulge a powerful interest in the destinies of their country.

Next to these may be mentioned some of the reports of the Venetian ambassadors, writings advocating often the partial view of an individual, business-like and passionless, and only written for the use of the Republic of San Marco.

Then come two utterances of the human mind, a greater contrast between which could not be imagined, — the writings and sermons of Savonarola, and the diaries of Burcardo and Paris dei Grassi, both popish masters of ceremonies. In the one, we see the height of religious enthusiasm; in the other, questions of the ceremonial, and the most secret occurrences of the Vatican. In the one, the trans-

porting heroic eloquence of a nature, hastening for-
ward at full speed to a violent catastrophe; in the
other, only an eye fixed on stiff Chinese externals, in
the earnest contemplation of which the soul becomes
slowly petrified.

Added to these, we have, lastly, a series of dry
chronicles and records, and multitudes of books of
all kinds, which were published at the time. All
contain something. It is impossible to exhaust these
sources. We must content ourselves with knowing
accurately the report of those eye-witnesses of the
time, whose intellect rendered them conspicuously
distinguishable.

These were my resources in undertaking to write
the life of Michael Angelo. It was known that the
archives of the Buonarroti family contained numer-
ous letters and documents of every kind; but it was
at the same time known that it was impossible to
gain access to these papers. In the year 1860 the
last Buonarroti died. He bequeathed his archives
to the city of Florence. A committee published a
catalogue of the existing papers. It was a natural
supposition that they would now be open for use; but
a fresh impediment arose: Count Buonarroti had
made the acceptance of his legacy dependent on the
obligation to preserve continued secrecy, and to com-
municate to no one the slightest thing; and thus it
seemed, that, under existing circumstances, it was
not possible to continue the work.

Fortunately, however, the whole contents of the
Buonarroti bequest were not doomed to this seclu-
sion. A part of the heritage came by purchase into

the possession of the British Museum. Here, of course, there stood no hindrance to the use of it; and I came to a knowledge of three extensive correspondences, as well as a number of other documents, all in a state of excellent preservation, and lying plainly before me in the careful handwriting of Michael Angelo, legible as the pages of a printed book.

A hundred and fifty letters were thus made known to me, whilst two hundred still lay hidden in Florence. At all events, the London correspondence seemed more full than the Florentine; for no one stood nearer to Michael Angelo than his father and brother Buonarroti, and these are the letters in the possession of the British Museum. The Florentine papers undoubtedly contained important matters, the knowledge of which would spread light over much that had been hitherto dark. What has, however, induced me to feel less vexation at this loss, is an observation which I will repeat here, as I have expressed it before in the second volume of this book • in the first edition.

The more I advanced in my researches for the biography of Michael Angelo, the more numerous were the threads I discovered, emanating from this one man on all sides, or which, proceeding from the men of his age, were united in him. Not that his immediate influence was pre-eminent; but the connection of his progress with that which took place around him was evident. More and more plainly I felt the necessity of becoming acquainted with every thing which happened while he lived, that I might

approach nearer to himself. I have been reproached
with having called my book "The Life of Michael
Angelo," when I ought to have entitled it "Michael
Angelo and his Times." But in truth they were
one, — he and the events which he witnessed. The
more elevated is the mind of a man, the more exten-
sive is the circle which meets his eye; and whatever
meets his eye becomes a part of his being. And
thus, the further I advanced, the more imperfect
appeared my acquaintance with the things I was
considering. For, when I had at length grasped an
idea of them on one side, it became evident to me,
at the same time, from how many others I had yet
to view them, in order to form an impartial judg-
ment.

The insight into Michael Angelo's private rela-
tions, which was to be obtained for the most part from
his written remains, was thus only a small part of
what was wanting. A far greater want was the
limited time which I was able to devote in Italy to
the examination of his works. A continued resi-
dence in Rome and Florence; a more accurate
knowledge of the European museums; a deeper
study of the history of Tuscany, as well as of all the
political events which fill the sixteenth century, —
seemed necessary. In one word, to write a life of
Michael Angelo, as it might be written, presupposes
a life of study, knowledge, and experience, which
the years I have attained to would not allow me to
acquire.

What, therefore, would have deterred me from
carrying my work on, was far rather such reflec-

tions as these, than the non-possession of the Flor-
entine papers. They could not contain any thing
more important than the works which were open to
me, or the great events in which Michael Angelo
had taken a part, and respecting which other sources
lay open in fruitful abundance. The greatest de-
pendence was to be placed on these. The London
correspondence furnishes a number of new dates for
the origin of Michael Angelo's works, and gives in-
formation on family circumstances, about which pos-
sibly no one knew in his lifetime. And yet those
knew him best who lived with him, and these were
without the knowledge of these circumstances. It
is just the same with Goethe. We can at the pres-
ent day, as regards many of his works, state almost
the exact time when he first wrote them, laid them
aside, took them up again, and completed them.
We are almost better informed about them than he
was himself, if we compare the contents of many let-
ters with his autobiography. But of what avail is
this knowledge? Would all the notices as to the
origin of Iphigenia outweigh a dozen verses, if we
had to dispense with them in the poem? An artist,
as the creator of his works, leads a higher life than
his lower earthly fate exhibits to us; these produc-
tions of his mind, to which we cannot rise, spring
forth in a mysterious atmosphere. It would be a
vain undertaking to endeavor to form the results of
our researches into a ladder thitherward. And so,
if with a man like Goethe, who has hardly passed
away, who almost still breathes the air in which we
live, and ten letters of whom we could produce

where only one of Michael Angelo's is extant, — if with Goethe, after all, we require not his letters, but a knowledge of the period, and the profoundest understanding of his poems, to feel what he was, — this is to the utmost extent the case with Michael Angelo, whose profession was not writing, who for the most part in his letters is influenced by the person to whom he addresses them, and rarely exhibits his heart in them as he does in his works, his actions, or even his poems. These letters contain little of the course of time, of sorrow for his failures, of hope for the future. Special points of his character, scarcely surmised without them, are more manifest in them, though not for the most part in connection with events of any importance. His letters furnish much; they are, when once we know them, a part of him which from henceforth we cannot do without: and still, if we possessed nothing else but his works, Condivi's biography, and the history of Florence and Rome, — from the marble which these supply, the form of the man might be sculptured as he was; and all in addition to this are only helps to finish and to elaborate the portrait, without altering a feature of the original design.

3.

In the year 1250, Simone Canossa, the ancestor of the Buonarroti, is said to have come as a stranger to Florence, and, for the signal services rendered by him, to have obtained the freedom of the city. From a Ghibelline he had become a Guelf, and had therefore changed his arms from a dog argent, with

a bone in his mouth, in a field gules, to a dog or, in a field azure. Added to this, he received from the lords of the city five lilies gules, and a crest with two bull's horns, — one or, the other azure. So says Condivi.

In the veins of the Simoni, however, who were descended from the counts of Canossa, there flowed imperial blood, he writes further. Beatrice, the sister of the emperor Henry II., was the ancestress of the family. The arms just described are still to be seen in the palace of the podesta of Florence, where Simone Canossa had them sculptured in marble, like those of the other podestas of the city. Hence arose the family name Buonarroti, being the usual Christian name of the family. Each individual always bore it as such. It had thus become a characteristic of the house, and had at length crept into the roll of citizens instead of the name Canossa.

We may assume that Condivi received these communications from his old master, and that the latter believed, in consequence, in the imperial blood in his veins. The Buonarotti held fast to this tradition. Florentine historians have, nevertheless, been unable to discover any Simone Canossa who was podesta of the city in 1250.* Even in the family notices of the Count of Canossa, no such personage is mentioned. Still less do the arms of Canossa agree with those which Condivi describes, or with those of the Buonarotti. They consisted of two transoms or, in a field azure, with no trace of the dog or, with a bone in his mouth.

* See Appendix, Note III.

The dog gives, perhaps, the key to the explanation of how the fable arose. The middle ages had their own manner of explaining words symbolically. The dog, *canis*, with the bone, *os*, in his mouth, becomes Canossa, in the same way as the "dogs of the Lord," *domini canes*, became Dominicans. More important, however, than the exact explanation of the legend, is the circumstance that the old citizen, Michael Angelo, that arch-Guelf, begins his biography, in spite of it all, with a declaration, by which he boasts of his descent from the old Ghibelline nobles; and, as a letter still extant from a Canossa at the beginning of the sixteenth century proves, the count's family acknowledged the relationship.[*]

The Buonarotti, or, as they designated themselves, the Buonarotti Simoni, were one of the most distinguished Florentine families. Their name is often found in connection with offices in the State. In 1456, Michael Angelo's grandfather had a place in the Signiory; and, in 1473, his father was a member of the Buonuomini, a committee consisting of twelve citizens, who took part in the deliberations of the Signiory. In 1474 he was appointed podesta or governor of Chiusi and Caprese, two little fortified cities in the valley of the Singarna, a small stream which empties itself into the Tiber. The Tiber takes its rise in this region, and is itself an insignificant river where it joins the Singarna. The land is mountainous.

Michael Angelo's father, Ludovico by name, repaired from Florence to his post. His wife, Fran-

* See Appendix, Note IV

cesca, also of a good family, was expecting the birth of an infant; but this did not prevent her from accompanying her husband on horseback. This ride might have been dangerous to her and to the child; she fell with the animal, and was dragged along the ground. Yet it did her no harm: on the 6th March, 1475, two hours after midnight, she brought a boy into the world, who received the name of Michael Àgnolo. This is the true orthography, instead of the more usual Michael Angelo. He was the second child of his mother, who was nineteen years old at his birth, while Ludovico was in his thirty-first year. Ludovico's father was no longer alive; but his mother, Mona Lesandra (so well known as Madonna Alessandra), was still living, a woman of sixty-six years old.

In 1476, on the expiration of his official situation, Ludovico returned home. The little Michael Angelo was left behind at Settignano, three miles from Florence, where the Buonarotti had an estate. The child was entrusted to a nurse, the wife of a stone-mason. Settignano lies in the mountains. Michael Angelo used to say in jest, in after-years, it was no wonder that he had such love for his profession, since he had imbibed it with his nurse's milk. In the last century, the first paintings of the boy, on the walls of the house in which he grew up, were still shown there, just as on the ground-floor of his father's house at Florence the progress of these efforts was to be seen. He began to draw as soon as he could use his hands.

The family increased. Michael Angelo's brothers

were to be merchants, the usual and natural career in Florence ; he was himself destined to be a scholar, and was admitted into the school of Francesco d'Urbino, who kept a grammar-school in Florence. He, however, profited but little there. He employed all his time in drawing, and idled about in the ateliers of the different painters.

In this way, he became acquainted with Francesco Granacci, a noble youth, full of talent, who, five years older than himself, became his most intimate friend. Granaccio was a pupil of Domenico Ghirlandajo, or, as it is pronounced in Florence, Grillandajo. Michael Angelo could no longer be kept to his studies : he had only painting in his thoughts. His father and uncles, proud men, who knew well how to estimate the difference between trade and painting, which, being a less esteemed profession, held out but small advantages, remonstrated with him, and treated him harshly. Michael Angelo remained steadfast. On the 1st of April, 1488, Ludovico signed the contract, by virtue of which his son was articled to the masters Domenico and David Grillandaji for three years. During this time, he was to learn drawing and painting, and to do whatever he was desired besides. There was no mention of premium; the masters, on the contrary, bound themselves to pay him six gold florins for the first year, eight for the second, and ten for the third. Michael Angelo was fourteen years old when he thus, for the first time, carried his point.

Domenico stood at the head of the atelier, and belonged to the best masters of the city. He had

at that time undertaken an extensive work. The choir of the Church Santa Maria Novella was to be newly painted. Orgagna, the builder of the public hall next to the palace of the Government, the so-called Loggia dei Lanzi, had painted this choir in Giotto's manner. The roof had been injured, the rain had run down the walls, and the painting had been gradually destroyed. The Ricci family, to whom, as possessors of this choir, its preservation belonged, delayed its restoration on account of the great expense. Every family of importance possessed in this manner a chapel in one of the city churches, in which they interred their relatives, and the decoration of which was an affair of honor. As the Ricci did not give up their claims, and would not concede to others the repair of the injured walls, the matter remained for a long time in its old state. Orgagna's paintings fell into a more and more critical condition. At length, the Tornabuoni, one of the richest families in the city, made the proposal, that, if they would commit to them the renovation of the chapel, they would not only bear all the expense, but would even splendidly restore the arms of the Ricci. To this they acceded. The work was given, by agreement, to Grillandajo. The master stated his demand at 1200 gold florins, with an extra compensation of 200, if the work, when completed, should prove especially satisfactory to those who had given him the order. It was undertaken in the year 1485.

The chapel is a quadrangular vaulted space, open towards the nave of the church; separated from it, however, by the high altar, behind which it lies, and

which is raised to a considerable elevation. The
back wall is broken up by windows; the painting,
therefore, concerned only the two walls to the left
and right of the entrance. These, divided into long
strip-like partitions, were to be filled from top to
bottom with compositions. They are representations
of biblical events. That is to say, the names of the
different pictures are so called; but in truth we are
looking at groups of known and unknown Florentine
beauties and celebrities, men, women, and their chil-
dren, placed together just as circumstances demand-
ed, in the costume of the period, and in a manner as
if that which the picture signified had occurred a few
days before in the streets of Florence, or in one of
its most well-known houses. We find this manner
of conceiving the sacred writings unhistorically,
usual wherever art has developed itself naturally
and vigorously. Rembrandt makes Mary sit in a
stable, representing a Dutch cow-house of his time;
while Raphael gives her accommodation in old Ro-
man walls, such as he daily passed by.

Vasari's work cannot be too highly estimated for
Florence as regards these paintings. When he
wrote, these persons were still known in the city.
We recognize there all the Tornabuoni, from the
oldest members of the family down to the youngest;
we find the Medici, and in their train the learned
friends of the family, — Marsilio Ficino, the Platonic
philosopher, who had been brought up by the old
Cosmo; Angelo Poliziano, who was poet, philologist,
and tutor to Lorenzo dei Medici's children; and
other famous names. Among the women who are

present at the meeting of Mary and Elizabeth, there is the charming Ginevra dei Benci, at that time the most beautiful woman in Florence; around the bed of the holy Anna appear other Florentine ladies who visit the sick woman, all in full state, — one among them with fruits and wine, which she brings as a present, according to the custom of the period. Again, in another representation, Domenico has painted himself and his brothers.

We thus meet with the Medici family in many places. There is a picture in the Camposanto at Pisa, where the old Cosmo (or Chosimo, as the Florentines pronounce and write it) with his family, and the same train of scholars, represents King Nimrod, who built the tower of Babel. We see Babylon in the background; it is finished to the most accurate architectural details, and is very in- geniously composed of the buildings of Rome and the city of Florence.

Thus Michael Angelo came at once into the midst of a great work. One day, when the masters had gone away, he drew the scaffolding with all that belonged to it, and with those working on it, so per- fectly correctly, that Domenico, when he saw the paper, exclaimed, full of astonishment, " He under- stands more than I do myself." His progress soon appeared so great, that admiration was turned into envy. Grillandajo became anxious. That jealousy seized him, which has appeared on too many similar occasions to excite surprise in this instance.

Michael Angelo painted his first picture. From the constant intercourse of the Florentines with

Germany, it was natural that German pictures and engravings should have reached Italy. A plate of Martin Schongauer's, representing the temptation of St. Antony, was copied and painted by Michael Angelo on an enlarged scale. This picture is said to be still extant in the gallery of the Bianconi family at Bologna. According to the report of others, it is in the possession of the sculptor, M. de Triqueti, at Paris, without its being said how it came into his hands.* Schongauer's plate is well known. Considered as a composition, it is at all events his most important work, and is designed with an imagination which matches the wildest Netherland works of a similar kind. A band of distorted monsters have carried St. Antony into the air. We see nothing of the earth but a bit of rocky stone below, in the corner of the picture. Eight devils have taken the poor anchorite, and torment him. One pulls his hair; a second pulls his garment in front; a third seizes the book hanging from a pocket buttoned to his girdle; a fourth snatches the stick from his hand; a fifth helps the fourth; the others pinch and teaze wherever there is space to seize him: and at the same time the strange rabble roll and turn over him, against him, and under him, in the most impossible writhings. The entire animal kingdom is ransacked to compose the figures. Claws, scales, horns, tails, talons,—whatever belongs to animals,—is exhibited in these eight devils. The fishy nature, however, predominates; and, that he might not err here, Michael Angelo eagerly studied the goods exposed

* See Appendix, Note V.

to view in the fish-market. He thus accomplished an excellent picture. Grillandajo called it, however, one produced in *his* atelier; or he even named himself as the designer of it, as he was authorized to do according to the custom of the time.* On the other hand, however, Michael Angelo now most plainly showed that he understood more than his master.

Grillandajo made his pupils copy for practice the studies which he had himself incidentally drawn. Michael Angelo took one of these drawings from a fellow pupil; and, making his own thick strokes by the side of his master's lines, he corrected their defects, and this in a manner to which no objection could be offered. Grillandajo now refused him the plates when he asked for them. This also can be easily understood. It was time that an end should be put to the connection; and this occurred before the expiration of the three years of the contract, in a manner which could scarcely be more favorable for Michael Angelo. He became acquainted with Ldrenzo dei Medici, Cosmo's grandson, who about this time was at the head of the Government in Florence.

4.

Florence, considered as a State, consisted of an association of commercial houses, the first of which was that of the Medici. The position of the others was subordinate. The government of the city lay more securely in the hands of Cosmo, retaining as

* See Appendix, Note VI.

Statue of Lorenze dei Medici.

MICHAEL ANGELO.

he still did the appearance of an uninterested retired citizen, than if he had assumed the position of a prince, with the title of sovereign of Florence. Piero, his son, ruled after him. That he did so, was as much a matter of course as his inheriting the business. Physically and mentally a weaker nature, bearing the surname of the " paralytic," he yet remained all his life at the head of the State; and, after his death, his two sons, Lorenzo and Giuliano, entered upon the same position, — the change of proprietor causing no interruption in the business of the house.

At home the Medici were plain merchants; abroad they assumed another tone. Cosmo had been sent into exile. He appeared like a prince in Venice, whither he turned his steps; the Florentines soon observed that he had taken Florence away with him, and they fetched him back. He was now dictator; but he only interfered publicly in matters which were not affairs of State. He called together the learned, he built churches and monasteries, he founded valuable libraries, he bound every one to himself by voluntary loans. In political things, his friends were obliged to come forward. We need only look at his countenance, which has been transmitted to us in numerous portraits representing every stage of life. Eyebrows elevated on the delicately wrinkled brow, a long nose with the somewhat fuller tip turned down, a mouth with the delicate lips meditatively compressed, a firm, energetic chin, — presenting an appearance, on the whole, in which we seem to behold embodied wisdom.

Piero, his successor, committed errors, but held his ground against all aggressions, a proof that the party of the Medici was strong enough to maintain its position in the Government under a less superior direction. Lorenzo, on the other hand, trod in the footsteps of his grandfather, and raised his personal position considerably. The struggles amidst which he rose were vehement and perilous. They cost his brother Giuliano his life. They show what courage it required to stand at the head of a State like Florence.

The death of Giuliano occurred in the year 1478. Michael Angelo was at that time two years old, and was still at Settignano; the conspiracy of the Pazzi, which broke out with this murder, cannot therefore be the same as that which he witnessed. Its origin, however, and its whole course, are genuinely Florentine; and the narrative of the event is necessary to give an idea of Lorenzo's position at the time in which Michael Angelo came into contact with him.

Cosmo had before endeavored, in his way, to weaken the influence of the powerful families, by marrying his grand-daughter Bianca, the sister of Lorenzo and Giuliano, with Guglielmo, the future heir of the wealth of the Pazzi. In this way he hoped to bring about a blending of the family interests on both sides. But the Pazzi held back, and preserved their independence; so that Lorenzo and Giuliano, after they had become rulers of Florence, were obliged to consider more seriously how they might put an end to the threatened rivalry. On one point they observed no discretion, — they en-

deavored with jealous vigilance to prevent any other house from rising by its riches to an equality with themselves. If the power of a family threatened to overstep the limit, they interfered, and took the chance of what might happen.

Lorenzo managed that a series of measures humbling to the Pazzi should emanate from the Govern ment of the city. The great, so-called noble houses had been commonly treated with consideration, though this was not, however, constitutionally established: this consideration was now lost sight of with regard to the Pazzi. Angry words escaped the family: the Medici expected nothing else; they stood upon their guard, and observed them.

At length, however, it amounted to flagrant injustice. The wife of a Pazzi claimed to inherit the property of her deceased father. A cousin unlawfully kept back a part of the inheritance. A lawsuit ensued, which resulted in favor of the wife; a fresh trial awarded the right of possession to the cousin. Lorenzo carried his point, — he wished that the money should be divided. Giuliano himself remonstrated at this injustice; but the higher interest prevailed: Lorenzo was young, passionate, and courageous; he thought himself able to oppose the storm.

It did not fail to burst forth. In Florence the Pazzi kept quiet; but in Rome they began to forge their weapons. Like the Medici, and other Florentine houses, they had a bank there; and Francesco Pazzi, who conducted the business, stood on the best terms with the Riarii, the family of the ruling pope.

The Medici were hated by Sixtus IV., and were soon
to feel the weight of his vengeance. He had just
nominated another in the place of the deceased
Archbishop of Pisa, who was hostilely disposed
towards the Medici, and whom they in their turn pre-
vented from entering upon his office. It was agreed
in Rome, that, if the pope was to have rest, the Med-
ici must be annihilated in Florence. The Riarii
and Francesco Pazzi devised the first plan. The
Archbishop of Pisa was drawn in, and afterwards
the old Jacopo Pazzi, the head of the family in
Florence, whose scruples the pope himself undertook
to remove. Giovanbatista da Montesecco, the com-
mander-in-chief of the papal troops, came to Florence
to settle the details, — how, when, and where, the
brothers were to be murdered; whether singly, or
at the same time at the same place: after this he
arranged his army in small divisions, so as to sur-
round the city; and the troops, at a single breaking
in on all sides, were to meet in Florence. Cardinal
Riario brought the conspirators within the walls of
the city, himself conveying them through the gates
by mixing them with his numerous retinue.

The visit of this powerful man was an event. A
feast was prepared, to which both the Medici were
invited. It was here they were to be put to death.
But, shortly before, Giuliano sent an excuse. A res-
olution had now to be taken at once; for, with the
large number of those privy to the plan, and the
punctual preconcerting of all the other measures,
the shortest delay might have been fatal to the good
cause. It was decided, that the cardinal should read

mass in the cathedral on the morning of the day
following. The brothers would be obliged to appear
out of courtesy, and this would be the opportunity
for stabbing them. Giovanbatista Pazzi was to take
Lorenzo; Francesco Pazzi, Giuliano.

When all was settled, Giovanbatista declared sud-
denly that he could not execute murder in sacred
places. Two others were now appointed instead of
him,—the one a priest, who was instructing a natu-
ral daughter of Jacopo Pazzi's in Latin. This seces-
sion of Giovanbatista's was the beginning of the
failure, says Machiavelli; for, if ever courageous
firmness is indispensable, it is on such occasions.
Experience, he says, further teaches, that even those
who are accustomed to arms and blood lose their
courage in such a conflict as this.

The signal for the moment at which the conspira-
tors were to strike, was given by the bell, while mass
was being read. At the same moment, the Arch-
bishop of Pisa with his men was to storm the palace
of the Signiory. Thus, at one blow, they were to
effect the subversion of every thing, and to have the
power in their own hands.

The brothers vaguely surmised, that something
was designed against them; but in this instance they
proceeded unsuspectingly. Lorenzo came first;
Giuliano remained away: one of the Pazzi ran to
fetch him, and arm-in-arm they entered the Church
of Santa Maria del Fiore. The conspirators stood
in the midst of the throng, and awaited the bell,
while the words of the mass floated through the vast
dusky dome, over the silent multitude.

The bell chimed, and Giuliano received the first thrust in his bosom. He sprang up, staggered a few steps forward, and fell to the ground. Francesco Pazzi fell furiously upon him, and lacerated him so madly with his dagger, thrust upon thrust, that, not distinguishing his own limbs from those of his deadly enemy, he gave himself a dangerous wound.

Meanwhile, however, Lorenzo had kept his ground better. The dagger had struck his neck; he stood back, and defended himself. The conspirators were startled: his friends recovered themselves; they surrounded him, and carried him to the sacristy, against the doors of which Francesco, who had at length left Giuliano lying in his blood, stormed with his companions. A fearful tumult filled the church. The cardinal stood at the altar: his ecclesiastics surrounded and protected him; for the rage of the people, as they begun to understand matters, was now turned against him.

In the meanwhile, the Archbishop of Pisa had marched to the palace. The Signiory, who live* there as long as their office lasts, and might on no condition leave it, were just sitting at breakfast. The surprise was complete; but it was met with self-possession. Combined with the armed servants of the palace, they forced back the hostile bands, who had already followed the archbishop up the steps; while those who were above were cut down, or thrown from the windows on the square below. One of the Pazzi, however, and the archbishop himself, they executed on the spot. They threw a noose round the neck of each, and hung them out against

the window, between heaven and earth; while the rest lay on the pavement below with broken limbs. Still, however, the conspirators remained in the ground-floor of the palace, where they had barricaded themselves. Above, the Signiory sounded the alarm-bell; from every street armed citizens streamed towards the square.

In the cathedral, the sacristy was not to be gained by force. The metal doors with which it was furnished afforded good resistance. The adherents of the Medici poured in from without; but Francesco Pazzi did not lose courage. The thrust which he had given himself in the leg was so deep that his strength left him. He still attempted to mount his horse, in order that, riding through the streets, he might, as had been preconcerted, excite the people to revolt; but he could do so no longer. He crawled miserably home, and begged the old Jacopo to undertake the ride for him. He still had no idea of what was going on in the palace of the Government; besides, assistance from without was to appear speedily. Jacopo, old and infirm, appeared on the square with a hundred armed horsemen; but it was already occupied by armed citizens, none of whom would listen to him. He saw the two corpses hanging from the window above. So he marched from the city with his men, and turned towards the Romagna. Others, too, succeeded in getting away. Francesco lay on his couch, and awaited his fate.

This soon overtook him. Lorenzo, led by armed citizens, had arrived at his house: the palace of the Government had been emptied of traitors; the

name of Medici was proclaimed everywhere; and the broken limbs of their foes were carried by the people through the streets, impaled on pikes. The palace of the Pazzi was the object of general fury. They tore forth Francesco, dragged him to the palace of the Government, and hung him by the side of the two others. Not a sound escaped him by the way; he replied to no question; he only at times sighed deeply. Thus he was put to death, and the palace of the Pazzi was plundered. And then, when vengeance was accomplished, there was no Florentine citizen who did not appear before Lorenzo in arms, or in his best estate, to place himself with his life and property at his disposal. The old Jacopo also returned to the city; he had been pursued, and captured in the mountains. He, as well as another Pazzi, who had remained quietly at his villa, were condemned and executed within four days. But all this satisfied not the rage of the people. They tore Jacopo out of the family vault, placed a rope round his neck, and dragged the body to the Arno, into which he was thrown where the stream was deepest.

Lorenzo was now alone; but his position with regard to the people was no longer the same. The people felt more deeply than before how completely their destiny was entwined with that of the Medici. The wars with the pope and with Naples, which now ensued, contributed to make Lorenzo's new position a lasting one. His destruction was imminent; but he was saved by one of the most spirited adventures. With no guarantee of personal security, he repaired by ship to Naples, into the power of his enemies.

His appearance here, his wisdom, — especially, however, his money, — made him work wonders. He went as a lost man, who imprudently advances to destruction; he came back in triumph as a friend of the king, who soon also reconciled him with the pope. This lattter was the most furious of his enemies. It was not because the murderous design had been supported by himself. He had only in view the insult inflicted on him by the hanging of the archbishop, and the thwarting of his plans. Characteristic, however, of the time is the declaration of the Florentine clergy, who publicly declared, in the plainest words, that they despised his anathemas, and that the pope was a conspirator like the rest. However, all this bitter animosity turned into kindness and pardoning friendship; and the Medici came forth from the plots to which he was to have fallen a sacrifice, as the most distinguished prince in Italy.

Lorenzo well understood the art of making himself popular. It is true, since 1578 he had a kind of body-guard in the palace. His wife, too, was an Orsini, belonging to the proudest nobles in Italy, who imagined themselves no less than kings and emperors; yet he went about the city as one of his fellow-citizens. When there was any public festivity, he had either arranged it, or had the greatest share in it. He mingled in the throng, and was accessible to all. He wrote verses to the girls, who sang them in their dances in the public squares, at the spring festival in the month of May. Every child knew him; whoever desired it, he helped by deed and

counsel. But he shone brightest in the eyes of the young, when he arranged those splendid carnival processions, for which he himself wrote the songs. He spared no expense on such occasions; and only a few, who kept it secret, knew that in doing so he used the public money. Hitherto the Medici had defrayed their expenses out of their own property; Lorenzo began to limit the business of the firm, and to obtain means in another manner.

It was on occasion of one such carnival pageant, that Francesco Granacci, a noble, clever youth, possessing remarkable talent for such things, insinuated himself into Lorenzo's favor. The triumphal procession of Paulus Æmilius was being represented. Imitations of Roman triumphs were a favorite form of public pageant. Granacci soon found opportunity to avail himself of this kindly feeling both for himself and Michael Angelo. He obtained access to the gardens of San Marco, where the art-treasures of the Medici were placed.

Lorenzo had here a number of young people,* especially such as were of good family, instructed in art. The old sculptor, Bertoldo, Donatello's pupil, directed the studies. The works of sculpture were arranged in the gardens, and in buildings fitted for them were hung pictures and cartoons of the first Florentine masters. Every foreign work that could influence the improvement of young artists was placed there, and talent was soon developed under this favorable influence. Michael Angelo was now introduced by Granacci to the gardens of San Marco.

5.

The sight of the statues which he found here gave a new direction to his thoughts. As he had before, for Ghirlandajo's sake, neglected school, so now for the sake of the statues he slighted the atelier of Ghirlandajo. Lorenzo was at that time preparing marble works in his garden for the building of a library, in which the collection of books begun by Cosmo was to be placed, and the completion of which subsequently Michael Angelo himself directed. He now got upon friendly terms with the stone-masons. He obtained from them a piece of marble, and the necessary instruments, and began to copy off-hand the antique mask of a faun which he met with, as an ornament in the garden. At the same time he did not entirely adhere to the original; for he gave his work a widely opened mouth, in which the teeth could be seen.

This work caught the attention of Lorenzo, who was wont to have an eye on things himself, and visited the workmen in the garden. He praised Michael Angelo ; but he jestingly remarked, " You have made your faun so old, and yet you have left him all his teeth; you should have known, that, at such an advanced age, there are generally some wanting."

When the prince returned the next time, he found a gap in the mouth of the old man, which was so skilfully done, that no finished master could have managed it better. He now took the matter more

seriously, and ordered Michael Angelo to tell his father that he wished to see him.

Ludovico Buonarotti would not appear upon this order. The affair with the painting had come hard upon him; but that his son should now be a stone-mason also, seemed to him too much. Francesco Granacci, who had helped in the first instance, attempted to reconcile him now also, and prevailed so far as to induce him to set out to see Lorenzo. Michael Angelo's father was a straightforward, honest nature, — a man who adhered to old-established notions, — "uomo religioso e buono, e piuttosto d'antichi costumi, che no," says Condivi. Any thing out of the way was with difficulty made plausible to him, before he gave up his distrust of it. Thus he now lamented, that they had led his son into all sorts of errors; and he went to the palace with the intention of agreeing to nothing.

Lorenzo's amiability, however, soon disposed him to feel differently, and induced him to make avowals, on which he had certainly not thought at home. Not only his son Michael Angelo, but he himself, and all his family, were, with their life and property, at the service of his Magnificence. Medici inquired after his circumstances, and what business he carried on. "I have never followed any business," said he; "but I live upon the small income of the possessions left me by my ancestors. These I endeavor to keep in order, and, so far as I can, to improve them." "Well," replied Lorenzo, "look around you; and, if I can do any thing for you, only apply to me: whatever is in my power shall be done."

The matter was settled. Ludovico presented himself, after some time, with a request for a vacant post in the custom-house, which brought in eight crowns per month. Lorenzo, who had expected very different demands, is said to have laughingly clapped him on the shoulder, saying, " You will be all your life a poor man, Ludovico." He gave him the appointment. Michael Angelo, however, he had at once taken into his palace, had assigned him a room, provided him with new apparel, and settled upon him monthly five ducats pocket-money. Every day there was a public entertainment at the Medici's: Lorenzo sat at the head; whoever was first there, sat next him, without regard to rank and riches. Thus it was that Michael Angelo had oftener the place of honor than even the sons of the house, — all of whom, however, loved him, and regarded him kindly.

Lorenzo did not rest here. He often sent for Michael Angelo, looked over with him the cut stones, coins, and other valuable things, of which the palace was full, and heard his judgment. Or Poliziano conversed with him, and introduced him to a knowledge of antiquity. By his advice, Michael Angelo executed the battle of Hercules with the centaurs,— a work which astonished every one, and for which Poliziano gave him the marble. It is a bas-relief. Michael Angelo never would give it away, and took pleasure in it even in his old age. It is to be seen at the present day in the palace of the Buonarotti family; the faun's head is in the gallery degli Uffici.

Bertoldo, on the other hand, inclined him to Donatello, and instructed him in casting in bronze.

Michael Angelo executed a Madonna in the manner of this master, whose nature attracted him just as much as his works. He drew, besides, with Bertoldo's other pupils, after Masaccio in the Brancacci chapel, where Filippino Lippi had just finished the last painting required. Granacci is here introduced as a naked boy; Filippino's portrait, Botticelli's, who was his master, Pollajuolo's, and the likenesses of other men of celebrity, or well known in the city, are to be found there. In this manner of introducing himself and his friends into the pictures, the artist's power of characterizing became a part of the art; and the feeling that a great and ever-renewing community went on working in this way with all their energies, strengthened itself in the minds of the aspiring.

Nothing at that time was despised which advanced art itself. Every branch of art developed itself freely by the side of another. Ancient and modern times alike afforded models. The most careful study of nature was carried on besides, making the feeling for the living ever triumph over the desire for lifeless imitation, which in later times has unhappily so completely gained the ascendency. In these studies, as they were at that time pursued in Florence under Lorenzo's personal influence, we have the most beautiful example of an art-school before us, and perhaps the only one we are justified in asserting has borne good and rich fruit. There is no other kind of wholesome influence upon art on the part of a prince; for art is always lowered if princes attempt to raise it from external motives, and not from the

noblest yearnings of their own soul. Lorenzo's ex-
ample shows, that the resources he expended were
the least of the powers at work. It required, besides,
that Medici himself should be thus deeply initiated
in classical studies; that he should select the youths
with his own eye; that he should himself have the
greatest delight in the collections which he placed at
their disposal. He appointed the teachers; he fol-
lowed the progress, he discovered the brilliant future
in the first attempts of the beginner. He offered the
young people in his palace, intercourse with the first
minds of Italy, — for all streamed to Florence; and
the house of the Medici was not only the place from
whence the finest threads of policy were spun on all
sides, but religious movements, philosophical studies,
poetry, and philology turned thither to receive the
bias of his mind. Whatever great things happened
in the world were known, discussed, and estimated
there. What was indifferent was crushed under the
abundance of what was excellent. Excellence itself
was not blindly accepted, according to outward signs;
but it was tested by understanding before it was
admired. Stirring social life mingled uninterrupt-
edly with the most serious tasks; and, as a whole-
some contrast to the sweetness of this existence,
came the keen critical judgment of the Florentine
public, who allowed themselves neither to be deceived
nor bribed in matters of culture.

This state of society was only to be met with in
Florence, and chained the Florentines to their native
city, where alone they found the true, helpful
recognition of their own refined minds. Nowhere

were such evil things said, but nowhere such noble ones. The artists often saw themselves wronged, cut off in their payment with pitiful niggardliness, pursued with bitter words and nicknames, but ever, notwithstanding, understood and appreciated with that true justice, even in their most extraordinary works, for the sake of which they gladly relinquished all the rest. What is an artist without a public whom he feels worthy of him? Donatello, when in Padua, where they overwhelmed him with flattery, longed to be back in his native city. There, indeed, as he said, they ever found something in his works to blame; but they incited him also to renewed efforts, and to the acquisition of higher, more glorious perfection. He who allowed himself rest in Florence stepped into the background. Those artists, to whom the gaining of their daily bread was not the immediate ground for work, were stimulated by ambition; those, however, to whom the pay was a matter of importance, were obliged to strain every power, because the competition was so great. "In the air of Florence," says Vasari, "there lies an immense stimulus to aspire after fame and honor. No one desires to stand on a level with the rest; every one aims higher. Each man says to himself, Are you not as good as any other? Can you not achieve just as much and more? He who wishes to go on subsisting comfortably by the arts which he has learned, must not remain in Florence. Florence is like time, which creates things, and again destroys them when it has completed them."

I believe, if it is ever permissible to form a romantic idea of things, we may do so in considering the Florentine society of that period. The arts, which with us ever give a finer relish to life, without being a resource at all times, formed there such a necessary ingredient, that they were like the indispensable salt to food. Not only were poems written, but the songs composed were sung; dancing, riding, tennis, were daily enjoyments; and conversation, in which the choicest language was employed, appeared just as welcome as a refreshing bath or a repast. That which, however, must have enhanced this life, especially as regards Michael Angelo, is a peculiarity among the Romanic nations, which the Germanic lack. That awkward manner, which makes our German youth silent or heavy when they meet with their elders, is not known among the Italians. Young people of fifteen, sixteen, or seventeen years old, who in Germany cannot overcome the discomfort with which they regard themselves, standing between the older and the younger with no defined position, in Italy are free from such embarrassing feelings, and conduct themselves with ease towards men, women, and children.

Thus Michael Angelo, at that age in which the pliant mind of man is capable of the deepest and richest impressions, received an education which could scarcely have been acquired at a more fortunate period. Soon, however, those storms appear, the traces of which are as discernible in his character as were the brighter influences of those early sunny days. For Lorenzo's end was nearer than

any one anticipated; and the changes which had already begun in the latter period of his rule, developed themselves more and more rapidly into a total overthrow of the existing state of things.

CHAPTER THIRD.

1494 — 1496.

Savonarola — Lorenzo's Death — Change of Things in Florence — Irruption of the French into Italy — Michael Angelo's Flight to Venice — Expulsion of the Medici — Michael Angelo in Bologna — The New Republic in Florence under Savonarola — Michael Angelo's Return — The Marble Cupid — Journey to Rome..

SINCE the murder of Giuliano, the old joyful feeling, which had once prevailed at the Medicean court, had never returned. The feasts of Carreggi were past, when they wrote poems, made music, and studied philosophy under the shade of the laurels; when they had banished every thought of the future with that carelessness which is so necessary to the youthful, genial enjoyment of life. And, as a change had passed over the Medici, it was so also in the minds of the Florentines themselves. For a while, the clouds obscured not the sun; but it was felt by all, that the clouds were rising.

Two things were a matter of course, if we consider the position of the State: in the first place, the more Lorenzo was forced into a princely position by the mere power of circumstances, the more must the nobles of equal birth with him have feared to

fall into subjection, — such nobles as the Strozzi, Soderini, Capponi, and a whole series of the most powerful families; in the second place, Lorenzo himself, looking for opposition from this quarter as a natural result, no doubt endeavored the more skilfully to maintain the appearance of indifference, and thus to hold the common people more firmly on his side. Hence those constant public amusements, and the affability displayed at them. It might almost be disputed, whether it lay in his intention to make himself absolute master of the city. We know how impressively he recommended his son never to forget that he was nothing but the first citizen of the city. But granted that Lorenzo had perceived the dangers which accompanied an outward eleva-tion of his family to the rank of princes, and wished to defer the moment at which it would come to this, — that it would some day come to this was evident to him, and to every one who knew the circum-stances more closely, — financial affairs compelled the Medici to demand the money of the State for the advancement of their own plans. This necessity became increasingly urgent. It was this that must have led to tyranny.

Here, therefore, a collision threatened. The Flor-entines were too good merchants not to consider the case before them, and to calculate upon the end. They were only at first paths which might lead to danger; the men were needed who were to urge and to guide the contest. The ordinary feeling of the public did not yet suffer from these possibilities. Another power, on the contrary, rose in the city,

with a more dangerous and more convulsing influence; and here, too, was a man who possessed a powerful nature to put into execution the thoughts which had first originated in his mind. This man is Girolamo Savonarola: his idea was total reform, politically and morally, for the good of the freedom of Florence; and events favored him.

Savonarola was a native of Ferrara. He came to Florence in the same year in which Michael Angelo was admitted by Lorenzo into the palace of the Medici. He was thirty-seven years old, and had been before for a short time in the city; but his sermons had then. met with little success. He now appeared as a mature man, and began immediately to come forward in that spirit which he preserved steadily to the last. He had fostered his convictions as a child; and, up to his death, he never once acted contrary to them, or lost sight of them.

We might call this delicate, retired character, resting only on itself, and woven as out of iron threads, an incarnate idea; for the will which animated him, which urged him forwards, and sustained him, is so plainly to be perceived in all his actions, that the appearance of the marvellous but one-sided power has something awful in it. We men live in a certain indistinctness which is necessary to us. Goethe calls it obtuseness in himself. The passing time robs us of thoughts; the coming time supplies us with new ones: we can neither retain those, nor resist these. We pass from one to the other: carried now right, now left in our course, we fancy we have done much if we

at least occasionally use the rudder, — if we keep
ourselves, on the whole, from going backwards.
This man, however, cuts through the hazy sea of
life like a vessel which can do without sail and
favorable winds, which the storms cannot mislead,
possessing in 'itself the power which carries it for-
wards, straight on, deviating not an inch from the
line which it intended to keep from the first. At
three and twenty years of age, he flees by night
from the paternal house to enter a cloister. He
leaves a letter behind him, which expresses the calm
reflection of a mind thoroughly settled in itself.
He rather instructs his father than justifies himself.
He requests him to comfort his mother, and to take
care of the education of his brothers.

Savonarola's leading idea was the doctrine of the
chastisement which was immediately to overtake
corrupted Italy, in order that his country might
eventually enjoy a higher state of prosperity. The
world seemed to him to be hastening with great
strides towards the end. Savonarola saw heathenish
doings everywhere, — the pope and the cardinals at
the head. The punishment of these abominations
could not long delay; the measure was full. Thus
he thought; and, wherever he looked, this feeling of
his heart, which sought expression in words, was
confirmed by what happened.

It is true, the moral condition of the country
seems to our judgment insufferable. The conspiracy
of the Pazzi does not stand out conspicuously as an
especial case; but every thing that occurred was
fashioned after the same model. There was no man

of importance at that time, whose death did not give rise to a rumor of poisoning. In reading the historians of the day, we find that this cause is ever involuntarily supposed as the first and most natural. No stain was attached to illegitimate children; whether the mother was a maiden or a wife, scarcely a difference was made between them and the legitimate offspring. This is one of the things which Commines considers worth notice, when he expresses his sentiments with regard to Italy. Deceit was expected everywhere, and the deceiver alone was despised when he allowed himself to be circumvented. Cowardice was only a crime, when, united with too little cunning, it missed its aim. He was called wise who gave no credence even to the most true-hearted assurances.

There was no such thing as what we call, in our own sense, shame of the verdict of public opinion. One example will show how men lived and thought. Filippo Lippi, Masaccio's best pupil, was a Carmelite monk, who, like many other monks, carried on painting, and rarely had money in his house. Universally known by his disorderly conduct, he, notwithstanding, obtained the order to paint St. Margaret on the wall of a nunnery. He requests a model. The nuns give him for this purpose a charming novice, named Lucretia Buti. One fine day he is away with her. The parents of the girl give the alarm. Lucretia is discovered, but declares that she will on no condition leave Filippo. Pope Eugene himself now proposes to the painter that he will release him from his monkish vow, so that he may at

least marry Lucretia. Of this, however, Filippo will not hear ; and so it remained. And this same Filippo, who was subsequently poisoned by the relatives of another woman whom he was pursuing, is a master who has painted Madonnas with the expression of the tenderest innocence. Whilst, however, in his works he brought out his innermost and better nature, other ecclesiastics disregarded even this. Consecrated priests, bishops, and cardinals, wrote verses, and acknowledged themselves openly as the authors of them, compared with the purport of which, Ovid's *Amorum* are child's songs. And, in the bosom of families, crime was grafted upon crime, with an equal disregard of the light of day. The doctrines of religion were ridiculed and degraded. Astrology and soothsaying became established official systems, without the concurrence of which even the popes ventured not to act. We can readily conceive how the feeling could exist, that the end of all things was at hand.

Savonarola, however, was not driven by this· feeling, in spite of the restless power with which it worked in his mind, to despair of the possibility of a cure ; but he wished to proclaim what he saw threatening, that he might save whatever was possible. With this design he left his father's house, and sought to obtain a position from which his voice might be heard in Italy. He went through a long apprenticeship, filled with privations and discouragements. He prepared himself for his office by the severest studies. At first he preached so harshly and awkwardly, that he often thought he should

never learn to preach. At last the hour arrived in which he began to produce an effect. Lorenzo Medici himself urged his removal to Florence. Count Pico di Mirandula, a man represented by his contemporaries as the essence of manly perfections, conspicuous for beauty, gallantry, nobility, wealth, and extensive learning, had become acquainted with Savonarola in Reggio, where a general meeting of his order was being held. He drew Lorenzo's attention to him; and he, endeavoring to draw to Florence every thing of importance, effected his call to San Marco, the favorite monastery of the Medici, which they had themselves built anew, and had furnished with a valuable library.

Here Savonarola now began to preach. The church was soon too small, and they moved into the court of the cloister; standing under a Persian rose-tree, surrounded by listeners who caught every word from his lips, he spoke with agitating certainty of the things which filled his heart. He prophesied the future; but there was nothing vague or oracular in his manner. His imagination was not extensive, nor did bright images present themselves to him; he was rather of a cold nature, whose logical thoughts rose into rapture. Some truths he forced powerfully upon the world, and deduced others from them with keen intelligence. Politics were his true field, and he ever looked for immediate and practical application of the ideas he put forth.

At first his sermons contained nothing that could raise a suspicion of his object. The reform of the Church was an acknowledged necessity. The Med

ici, with all their Platonic philosophy, had never shown themselves unfriendly to public Christianity, — least of all to the clergy, who possessed, moreover, as little genuine religion as themselves. The ceremonies of the Church were indispensable. Lorenzo was himself at once the author of the most profane poems, of a religious drama, and of songs of the same kind. With a genuine philosophical feeling, he favored all that needed his favor. That these contrasts could be thus peacefully reconciled, is due to the peculiarity of the Romanic nature, which, without hypocrisy, can at the same time abandon itself to the most different tendencies, the union of which appears less natural to the Germanic mind. Heathen writers were quoted in the pulpit as if they had been pious fathers of the Church. Even Savonarola, who on this point had the strictest views, was far from condemning or prohibiting the reading of the ancient authors generally; but he named some of the worst writings, which he wished should not be given into the hands of children.

Lorenzo so strikingly favored the monastery, the prior of which Savonarola soon became, that gratitude and devotion would have been natural. But Savonarola never thought of seeing things in this light. Not Lorenzo, but Providence, had led him to Florence: was he now to submit himself to be its blind instrument? It never occurred to him, as newly elected prior, to make the usual visit to the palace of the Medici. God had given him this office, and he need thank no mortal man for it. Lorenzo allowed it to pass unnoticed, visited the monastery

as before, and endowed it. Savonarola immediately employed these benefactions for beneficent objects. He wished to bring back, in all its severity, the old rule of the order, which prohibited all possessions. In his sermons he alluded to these gifts. If a piece of meat, he said, is thrown to a watchful dog, he bites at it well, and is silent for a short time; but he quickly lets it fall again, and barks only the more loudly against the robbers and suppressors of liberty.

Lorenzo stood too high to be provoked. It would have been against all Medicean usage to interfere openly. He caused some of the most leading men in Florence to recommend another course to the prior of San Marco, as if entirely of their own accord. They inquired why he disturbed the people without reason. He did nothing, was Savonarola's reply, but attack crime and injustice in the name of God. This had been the custom in the early ages of the Church. He knew well whence the nobles came, and who had sent them. "But tell Lorenzo dei Medici," he concluded, "he had better repent; for God will call him to judgment for his sins. Tell him further, that I am a stranger here, and he a citizen of the city; I, however, shall remain, and he depart."

Lorenzo received it all as a man of the world. He allowed himself neither to take offence, nor to be induced to act hastily. He adopted another plan: Savonarola, with his prophecies, should be treated *ad absurdum*. Among the persons dependent on the Medici family, there was a learned Augustine

monk, Mariano, a Platonist, and a distinguished preacher. His passion was excited. He gave out a sermon on the text, "It is not for you to know the times and the seasons, which the Father has put in his own power." All the men of intellectual importance in the city were present; and, when he had finished, they approved of the excellent discourse.

Savonarola accepted the challenge. He preached on the same theme. But, while Mariano had laid stress on the point that it was not the times and the seasons for us to *know*, Savonarola conceived the words differently: it was for us to know, but it was not for us to know the times and the seasons. He excited those who heard him to tears. He drew over to himself Lorenzo's own party: the Count of Mirandula; Marsilio Ficino, who had a lamp burning before Plato's bust, as before that of a saint; Poliziano, the thorough classical scholar, — all felt themselves carried away by him. The streams of his eloquence poured forth as if from heaven. There was no opposition when he spoke. His words were commands. They rooted themselves indelibly in men's minds. It seemed as if it were possible to change the nature of men. Women rose up suddenly, laid aside their splendid garments, and appeared again in modest attire; enemies became reconciled; illegal gain was voluntarily given back. It even happened that a young and happy married pair separated, and went both of them into the cloister. Vivoli, who took notes in church of Savonarola's sermons, and published them, relates

that he often could not write further for weeping. And at length Lorenzo himself was to bend to the power of this mind, or at least to need its consolation.

It was during the Lent of the year 1492, that this storm of mental excitement seized upon Florence. The sermons had ended with the Easter feast. Suddenly Lorenzo was taken ill. He was only forty-four years old. Here, too, there was a rumor of poison. The sickness was short. He lay at Carreggi, his country house, not far from the city; he felt the approach of death, bid his friends farewell, and received the sacrament, full of humble resignation in the promises of the Church.

Then at last he asked for Savonarola. We know not what passed between them. Poliziano, in whose letters is to be found an exact account of his last moments, relates that they separated reconciled with each other, and that Savonarola blessed Lorenzo. Others, however, assert that he refused this blessing. They relate, that, after Lorenzo had consented to two of his requirements, — namely, that he should believe on the mercy of God, and should restore all property unjustly taken, — Savonarola at last demanded that he should give back freedom to the city. Then he turned his face silently to the wall, and Savonarola left him.

2.

Michael Angelo was probably among the servants and household, of whom it is recorded that they stood weeping round Lorenzo's couch during his

last moments. So annihilated was he by the loss, that it was a long time before he could collect his thoughts for work. He left the palace, and arranged for himself an atelier in his father's house. Piero, Lorenzo's eldest son, took possession of the government. Throughout Italy, the tidings of the death of the great Medici were received as the news of a misfortune that concerned every one; and the presentiment of evil times increased, as they looked forward to the future.

Lorenzo is recorded to have said of himself that he had three sons: the first good, the second clever, the third a fool. The good one was Giuliano, thirteen years old at the death of his father; the clever one was Giovanni, seventeen years old, but a cardinal already by favor of the pope, whose son had married a daughter of Lorenzo's; and the fool was Piero. Respecting him, Lorenzo spoke with apprehension whenever he expressed his opinion to intimate friends. His eye saw too keenly not to perceive the qualities of his son, who had not the art of• dissimulation.

Piero was young, haughty, and chivalrous; no Medici in mind, but an Orsini, like Clarice, his mother, and Alfonsina, his wife. It would have been impossible to the pride of these women and their imperious natures, to regard Piero dei Medici otherwise than as the legitimate prince of Florence; and he offered no resistance to the influence which they both exercised over him. The theory of indirect action, and of allowing himself to be urged, was not familiar to his unpractised mind. Full of bold

wishes, brought up in affluence like a royal child, he had no idea of concealing the thoughts which he cherished. His marriage had been celebrated in Naples by the king, as though it were in honor of the richest prince. At the marriage of the young Sforza in Milan, whither his father had sent him, he had appeared as nothing else ; now, when he had the power in his hands, and impelling circumstances and the powerful Orsini to urge him on, nothing remained but to constitute himself Duke of Florence.

Opportunity for so doing appeared at once. With Lorenzo's death, the power vanished which had hitherto kept Naples and Milan quiet, and which, with subtle diplomatic skill, had postponed the breach of the peace in Italy. We find the comparison used, that Florence, with Lorenzo at her head, stood like a rocky dam between two stormy seas.

Italy was at that time a free land, and independent of foreign policy. Venice, with her well-established nobles at her head ; Naples under the Aragonese, a branch of the family ruling in Spain ; Milan, with Genoa, under Sforza, — all three able powers by land and sea, — counterbalanced each other. Lorenzo ruled central Italy ; the small lords of the Romagna were in his pay, and the pope was on the best terms of relationship with him. But in Milan the mischief lay hidden. Ludovico Sforza, the guardian of his nephew, Gian Galeazzo, had completely usurped the power. He allowed his ward to pine away mentally and bodily ; he was bringing the young prince slowly

to death. But his consort, a Neapolitan princess, saw through the treachery, and urged her father to change by force their insufferable position. Sforza could not alone have resisted Naples. No dependence was to be placed on the friendship of Venice; Lorenzo mediated as long as he lived; but now, on his death, Naples was no longer to be restrained. The first thing that happened was Piero's alliance with this power, and at the same time Ludovico's appeal for help to France, where a young and ambitious king had ascended the throne. The death of Innocent VIII., and the election of Alexander Borgia to the papacy, completed the confusion which was impending.

Long diplomatic campaigns took place before war actually broke out. The matter in question was not the interests of nations, — of this there was no thought, — nor even the caprices of princes alone. The nobles of Italy took a passionate concern in these disputes. The contests of corresponding intrigues were fought out at the French court. France had been robbed of Naples by the Aragonese. The exiled Neapolitan barons, French in their interests, whose possessions the Aragonese had given to their own adherents, ardently seized the idea of returning victoriously to their country; the cardinals, hostile to Borgia, — foremost among these stood the Cardinal of San Piero in Vincula, a nephew of the old Sixtus, and the Cardinal Ascanio Sforza, Ludovico's brother, — urged for war against Alexander VI.; the Floren-tine nobles, anticipating Piero's violent measures, hoped for deliverance through the French, and ad-

vocated the matter at Lyons, where the court was stationed, and a whole colony of Florentine families had in time settled. Sforza held out the bait of glory, and his just claims to the old legitimate possession.

The Aragonese, on the other hand, proposed an accommodation. Spain, who would not forsake her belongings, stood at their side; the pope and Piero dei Medici adhered to Naples; and the French nobility were not in favor of an expedition to Italy. Venice remained neutral; still she might gain by the war, and she did not dissuade from it; and this opinion, that something was to be gained, gradually took possession of all parties, even of those who had at first wished to preserve peace.

Spain was a direct gainer from the first. France ceded to King Ferdinand a disputed province, on the condition that he would afford no support to his Neapolitan cousins. Sforza, as lord of Genoa, wished to have Lucca and Pisa again, with all that belonged to them; the Visconti had possessed them of old, and he raised their claims afresh. We have said what were the hopes of Piero dei Medici. Pisa hoped to become free. The pope hoped by his alliance with Naples to make the first step towards the attainment of the great plans which he cherished for himself and his sons; he thought one day of dividing Italy among them. The French hoped to conquer Naples, and then to drive away the Turks in a vast crusade. As if for a crusade, the king raised the loan in his own country, which he required for the campaign. The Venetians hoped to bring the coast cities of the Adriatic Sea as much

as possible under their authority. In the autumn of 1494, Charles of France placed himself at the head of his knights and mercenary troops, and crossed the Alps ; whilst his fleet and artillery, tho most fearful weapon of the French, went by sea from Marseilles to Genoa.

3.

During the two years in which these events took place, Michael Angelo, who was not yet twenty years old, pursued his art at his own expense. He purchased a piece of marble, and executed a Hercules four feet in height. This statue stood for many years in the Strozzi palace at Florence ; it was then sold to France, and has been lost.

A crucifix is besides mentioned which he executed, almost as large as life, for the church of the monastery of San Spirito, — a work which was of great advantage to him ; for the prior of the monastery, whose friendship he obtained, procured him corpses for anatomical studies. At the present day, a crucifix is shown in San Spirito, and passed off as Michael Angelo's work ; but wrongly so.

His removal from the palace of the Medici had therefore not broken up his connection with the family. A kind of dependent position continued ; Piero reckoned him among his family, and consulted him when art-matters were to be purchased. Intercourse, however, like that with Lorenzo, was not possible. The youth of Piero would have prevented this. It is true the latter had received a thorough scientific education ; Latin and Greek were familiar

to him: gifted with natural eloquence, amiable, good-natured, and condescending, he knew how, when he wished, to prepossess men in his favor: but he liked best to be pursuing knightly exercises, and he left it to others to concern themselves with the details of government and politics. He was a handsome man; his height exceeded the usual standard: he wished to be the first horseman, the best hand at tennis, the victor in the tournaments. He was proud of possessing a painter like Michael Angelo; he was, however, equally proud of a Spaniard, who served in his stables, and outran a horse at full gallop.

On the night of the 22d January, 1494, it snowed so violently in Florence, that the snow lay in the streets from four to six feet deep. Piero sent for Michael Angelo, and made him form a statue of snow in the court-yard of the palace. This order has been regarded as a mockery of his genius; it must not be forgotten, however, that Michael Angelo was at that time a poor young beginner, who had as yet done nothing. Just as little as the first artists of the city might hesitate to assist in the passing arrangements for public festivities, and to prepare paintings and sculptures which were not to last much longer than that snow statue of Michael Angelo's, could he have thought of conceiving the order of the first man in Florence as derogatory to his honor. It may be it was this work which turned Piero's attention to him to an increasing extent. For he took him again to the palace, gave him back the room which Lorenzo had once assigned to him, and made him sit at his

table as before. Who knows whether Michael Angelo may not have taken part in the feast, the magnificence of which, perhaps, his snow statue was to enhance? For Piero delighted in a merry life, as his father had done: the depressed feeling, which was by degrees' spreading over the city, could at first have only partially influenced men's minds, and the old life continued outwardly its accustomed course. Nowhere, however, were they more sanguine than in the palace of the Medici. Events were awaited there with childlike repose; and they doubted not the continuance of good fortune, even when the city was agitated by tidings which awakened the general feeling of a vast impending change. The news reached the city of the first defeat of the Neapolitans.

Naples had made infinite efforts to prevent the breaking-out of the war. When she had, however, perceived the fruitlessness of those efforts, she wished to have the advantage of being the aggressor. The Duke of Calabria, the son of the ruling sovereign, • advanced with an army through the Papal States into the Romagna; Don Federigo, the king's brother, set sail with the fleet towards Genoa. Naples was renowned as a martial power, well schooled in war. Federigo hoped to take Genoa, and to oppose the French vessels. He sailed into Livorno, the fortified harbor of the Florentines. He was splendidly received by Piero, and provided with provisions. The hope of Tuscany followed the course of his galleys.

At Rapallo, not far from Genoa, he landed three

thousand men. The garrison of the city marched out against them with a thousand Swiss, and the Neapolitans were completely defeated. Federigo ventured no second attack, but hastened back with his fleet to Livorno. The conviction thrilled throughout Italy at this first loss, that resistance was in vain.

This panic of fear was possible in a land in which peace had not been disturbed for generations. Distress and danger crush the influence of higher morality. Man must once in his lifetime feel himself thrown upon his own powers; a people from time to time must merit anew the possession of freedom; and the value of simple, noble courage, on which the general condition of things depends, must be publicly exhibited, if every thing is not to fall into disorder and decay. Nothing, perhaps, was so much to blame for the sad state of things which Savonarola opposed, as the fact that the spirit of the Italian people had become unaccustomed to all military discipline.

It is true we read, in the fifteenth century, of wars in Italy. They were carried on by hired sol diers. And how did they fight in these battles? A hundred men out of three thousand were left on the field at Rapallo; and the land trembled in consequence. "This number appeared enormous," says Guicciardini. At the present day it would appear hardly worth mentioning. But let us read what Guicciardini and Macchiavelli relate of the Italian warfare of the fifteenth century, — how long campaigns were made without one serious collision taking place, and how fearful battles were fought, in

which not a drop of blood was spilt. We hear of the old Mexicans, that they went to battle with wooden weapons that they might not kill their enemies, since they were sure to receive afterwards good ransom for their prisoners. Similar considerations had their weight at that time in Italy.

National troops were only in the rarest cases engaged in the combat. The rule was, that a prince or a city furnished the supplies necessary by hiring troops. They were not directly concerned in this; but they gave up the whole business, including the arming and payment, to one or more who undertook it, with whom they concluded a contract. This was the trade of the higher and lower Italian nobles. They carried on business in soldiers. The great nobles negotiated with the lesser ones, these with the still lower, and so down to a single man. Venice, Florence, Naples, Milan, and the pope, had their army-contractors, who undertook distinct wars, and promised to accomplish the defeat of the enemy in the time agreed. These armies for the most part · might not set foot in the cities for which they fought, nor even come into contact with those which they had conquered. They were common and despised instruments, and the soldiers were chiefly rabble gathered together from all countries.

Under these circumstances there could be as little enthusiasm for a good cause, as hostility against those whom they opposed. They fought with the utmost ease. For the most part, it was heavy-armed horse which took the field. These, on account of the horses, could only march out when there was

fodder in the land. In the winter, therefore, there was no war. When, however, spring was so far advanced that they could approach each other, and a suitable battle-field existed, what was the object of killing each other then? This could bring advantage to no one; while the undertakers of the campaign were only mutually ruining their business. In order, therefore, to do themselves no injury, yet to strike with valor, as they had bound themselves to do by oath, they transformed the battles into great tournaments. They made as many prisoners as possible, took away their horses and armor, and set them free. If they found new equipment at home, few were lost. Armies, completely defeated and annihilated, could in this way endure a hard fate without having any dead; and after a short time could again appear on the battle-field in full number, and uninjured, as if nothing had happened. But there was a still more simple means of defeating the foe. They could buy up his entire army before his face, and unite them either with their own forces, or induce them at least to retreat. If it came to a battle, there was no mention of tactics, still less of artillery; they pressed forwards on both sides, and endeavored to hold their ground. And this method of carrying on war was so usual in Italy, and appeared at the same time so simple and logical, that they scarcely considered any other possible. Even in Dante's time they fought in this way. " Men," said the general to the Florentines, before the battle of Campaldino, " a good attack is wont to decide the victory in our battles; the contest is short; few lose

their lives; it has not been usual to kill. To-day we will begin to do otherwise." But the old custom held its ground. What terror when they now met a nation, at Rapallo, who actually killed those who would not yield to them! The French fought like living devils, it was said. Equally new and fearful appeared the method of the Swiss, who, as their mercenary troops, stood in solid battalions like movable walls: the most terrible of all, however, was the French artillery. For the first time, they now saw in Italy cannons used otherwise than for sieges, or for mere state. Instead of the balls of stone, which used to be hurled from immense iron barrels, iron balls now flew out of brazen guns, which were not dragged along slowly on heavy oxen-drawn carriages, but, furnished with horses and used by well-practised troops, kept pace with the march of the army. They fired with fatal accuracy; one shot followed another almost without interval; and what had before occupied long days, was a matter of a few hours with them.

Scarcely had they heard in Florence of the engagement at Rapallo, than the tidings arrived that the king was at the head of the army in Lombardy, that a part of his forces had proceeded against the Romagna, and that the Duke of Calabria had retreated. Piero had no army in Tuscany. The French were advancing. Charles could have passed through the Romagna; yet he declared, that every deviation from the direct road from Rome to Naples was opposed to his kingly dignity. A feeling expectant of evil filled all minds. With Michael

Angelo, however, a strange personal adventure was added to this general cause for anxiety, the influence of which completely overpowered him.

Piero had a certain Cardiere with him, — an excellent lute-player and improvisatore. Piero himself was considered a master in this art, and was accustomed every evening to practise it after supper. One morning, Cardiere came to Michael Angelo in the court of the palace, pale and troubled, drew him aside, and told him that Lorenzo had appeared to him in the past night, in black tattered garments, through which his naked body might be seen, and had commanded him to tell his son Piero, that he would shortly be driven from his house, never again to return! What did Michael Angelo think he ought to do?

The latter counselled him to obey the command. Some days after, Cardiere came to him, beside himself with agitation. He had not ventured to speak to his master; but now Lorenzo had appeared to him a second time, had repeated what he had before said, and in confirmation, as a punishment of his disobedience, had given him a terrible blow on the face.

Michael Angelo now spoke to his conscience so urgently, that Cardiere at once resolved to tell all. Piero was not in the town, but at Careggi. Cardiere set out to go there. After having gone some way, he met Medici riding with his suite. The unfortunate poet and lute-player stopped his horse, and begged him for God's sake to stay and listen to him. Upon this he laid the matter before him

Piero laughed at him, and the rest of the company likewise. His chancellor, Bibbiena, whose rule had made him especially hated (he was afterwards the cardinal whom Raphael painted, and whose niece Maria he was to have married), said scornfully to Cardiere, " Fool! do you think Lorenzo gives you so much honor before his own son, that he would not appear to himself, instead of to you, to communicate such important things, if they were true?" With this they left him standing, and rode on. Cardiere then returned to the palace; and, deploring his fate to Michael Angelo, he gave him once more the most lively description of his vision.

Michael Angelo was just as much agitated at the infatuation of the Medici as at the meaning of the apparition. The ruin of the Medici seemed to him unavoidable: a sudden fear seized him. Belief in supernatural signs of Providence, which belonged by nature to the Florentines, had been increased to the greatest extent by the late events. What they were now undergoing was the fulfilment of the events which Savonarola had preached. And this was only the beginning! More terrible things he had predicted, the realization of which they had to expect. And Heaven had not intimated the momentous future by *his* mouth alone. Tokens of unmistakable meaning were added: sacred pictures and statues emitted blood; in Apulia three suns were seen at once by night in the sky; in Arezzo, day by day, troops of armed men were seen fighting on immense horses, and marching along with terrible noise. The people believed in these

appearances with the same confidence as they had done a thousand years before. As in Suetonius we find flashes of lightning foretelling Cæsar's death, we read in Florentine authors how, just before the death of Lorenzo Medici, a deafening thunderclap burst, and shattered the spire of Santa Maria del Fiore; how the lions which were kept by the city attacked and lacerated each other; how a bright star stood over Careggi, the light of which grew fainter and fainter, until it was extinguished at the same moment that Lorenzo's soul took flight.

If we add to this the death of Poliziano, who, about this time, ended his career half insane, while Marsilio Ficino was devoted to Savonarola's doctrines; if we see the whole world under the influence of the supernatural fear which oppressed all minds, and Piero alone, with a few adherents, opposed to the universal feeling, — we understand how a young man, who is sufficiently independent as a free Florentine to acknowledge no lord over him, abandons the family who seemed sinking to ruin, and that he might not be involved in the great destruction, or obliged to fight for a cause which he could not acknowledge as the right one, is at length driven, by these special tokens, to resolve to seek safety in flight. Two days he hesitated whether to remain; on the third he left the city with two friends, and fled to Venice.

4.

Had they ridden straight on, on good horses, the journey would have occupied about a week. But

the French were in the Romagna. A longer time, therefore, must be given to it. All the quicker did they intend to get settled in Venice, once they reached it. Michael Angelo was the only one who had money; his funds soon declined, and the party resolved to return to Florence.

Thus they again arrived at Bologna, where the Bentivogli were the ruling family. They had only a short time before risen into decided superiority, and they knew how to keep so. The houses hostilely disposed to them had been rendered harmless by banishment or even murder; the citizens were kept in check by severe laws and taxes. Among these laws there was one which was executed in a strange manner. Every foreigner entering the gates had to present himself, and receive as permission a seal of red wax on his thumb; whoever neglected this ·incurred a considerable fine. Michael Angelo and his friends entered the city gaily, but with no seal on their thumbs: they were seized, brought before the tribunal, sentenced to pay fifty lire; and, as they could not afford this, they were for the time detained.

By chance, in this distress, they were seen by one of the first men in Bologna, M. Gianfrancesco Aldovrandi, a member of the council, and head of one of the most distinguished families. He had the case represented, set Michael Angelo free, and invited him, when he heard he was a sculptor, into his own house. Michael, however, declined the honor. He was not alone, and could not leave his friends, who were thrown upon him; with them,

however, all three, they would not intrude upon
him " Oh!" cried Aldovrandi, "if things stand
so, 1 must beg you to take me also, to roam about
the world at your expense." This jest brought
Michael Angelo to a more practical view of things.
He gave his travelling companions the rest of his
money, bade them farewell, and followed his new
patron. And this was about the most sensible thing
he could have done; for scarcely had a few days
elapsed than the Medici, — Piero and his brothers,
— and as many of their adherents as still followed
them, arrived at Bologna on their flight; for Lor-
enzo's prophecy had been fulfilled in Florence.

About the same time that Michael Angelo had
made his escape to Venice, the French had set foot
in Tuscany. The king, who well knew how disposed
the citizens were to the French, wished to try his
uttermost before appearing as an enemy. He had
once more demanded a free passage; Piero had
again refused it. This was a challenge. A part of
the army came from Genoa along the sea-shore; the
main forces marched with their king southward from
Pavia to the Apennines, and crossed them just where
the Genoese and Florentine territories meet on the
narrow coast-land.

Here lay a number of fortified places, which
Lorenzo had obtained; and which now, occupied by
Piero's men, had they afforded resistance, could
have kept the whole of Tuscany shut out. The
neighborhood was marshy, cold, and unhealthy.
Provisions had to be brought by ship from a distance.
The forces of the king consisted for the most part of

hired troops, well disposed to mutiny, among whom violent commotions had already taken place ; a sojourn at this spot would have been as fatal to the French as a lost battle.

Piero's condition was therefore not utterly hopeless. He had the Orsini with some troops in the country to bring relief to the threatened fortresses. Mountain passes, easily defended, protected him from Obigni, who was approaching from the Romagna. He need not have lost courage.

But he was not master of his city. Florence perceived more and more that the king was waging war only against the Medici, and not against her citizens. Charles, from the first, when Piero had declared against him, had left the Florentine merchants in Lyons unmolested ; he had compelled the Medici alone to close their bank. It is said that the Florentine nobles in France even urged to the war. They looked to Charles as a liberator. As early as the year 1493, Savonarola, at the invitation of the Government, had given his opinion of the best form of government for the city, and had exhibited, in so doing, with cutting severity, Piero's cupidity, when, instead of mentioning any name, he had only generally described a prince, as he would rule and must have ruled, to constitute himself the tyrant of a free city. It is a brilliant piece of writing, which, composed with cold, statesmanlike perception, but also with the passionate energy of party feeling, as truly characterized the present position of things, as Macchiavelli's book, " The Prince," twenty years later, afforded a picture of circumstances entirely different.

Savonarola's power increased visibly at that time. Politics and theology were equally important with him. He forced himself upon others no more than he was sought. Hatred of the Medici was less and less concealed. Piero was obliged to resolve upon extreme measures, if he would hold his ground.

The Duke of Montpensier, with the vanguard of the royal army, had just arrived on this side of the Apennines, and had joined the troops advancing from Genoa. He bombarded Fivizzano, the first of those small Florentine forts; he made breaches, stormed the place, and completely cut to pieces the garrison and the inhabitants.

Still, nothing was lost, and Tuscany was as safe as before under the protection of the remaining fortresses; but the tidings of the outrages of the French placed Florence in commotion. Piero per ceived his position for the first time in its true light. He saw himself abandoned and betrayed. He wanted money: he wished to borrow; but his best friends made difficulties, and appeared inexorable. No succor was to be expected from Naples; no reliance could be placed on Alexander Borgia: Milanese agents excited the people to revolt in Pisa; for Sforza wished to bring under his authority the entire coast of Tuscany, Lucca, Livorno, and Pisa, and he it was who had most of all incited the king to advance upon Tuscany. In Pisa they were prepared for nothing. Piero ordered in great haste that the citadel at least should be provided with ammunition. But what could he do in Florence herself, who had no other garrison than her own armed citizens, and

where rebellion was showing itself? In this state of things, Piero took a step which, if it had had better success, would have been esteemed the act of a resolute man, who, feeling his position, ventured to make use of his last expedient; but which, as it unfortunately ended in evil, has been judged of differently: he gave himself unconquered into the hands of the king.

Had he fled to Naples or Venice, the only places that were open to him, the Florentines would have immediately made peace with Charles VIII., would have transferred to him the old dignity of Protector of Florentine liberty, and have concluded an alliance which would have deprived the Medici of sovereignty for ever. Far better to place at the feet of the king what he yet possessed, and perhaps demand, as a reward from him, what Naples could now no longer supply.

Piero wished to return to the city as Duke of Florence, when he undertook the direction of an embassy, which was to treat with the king in the name of the Government. On the way they heard how Paolo Orsini had in vain attempted to throw himself upon Sarzana with three hundred men. At Pietrasanta, Piero left his companions behind, and repaired alone, under French escort, to the head-quarters at Pontremoli.

The appearance of the great Lombard, by which name Piero had been, like his father, known in France, where all Italians were considered as Lombards, excited astonishment in the camp. Still more so the disgraceful offers made by him. Sarzana,

won by his father, and fortified at immense expense; Montpensier, which had been blockaded in vain; the other fortresses, besides Livorno and Pisa, — he was willing voluntarily to give up. Florence was to unite with Charles, to place herself under his protection, and to lend two hundred thousand ducats for carrying on the war.

On these conditions, Piero was admitted to favor. What he demanded for himself, and obtained, is shown by his appearance in Florence, whither he now prepared to return, accompanied by his troops, whom he no longer required against the French. But the embassy, at the head of which he had set forth, had arrived there before him, and had given information of what had happened. Piero's independent proceedings, which could not be at once known in their full extent, excited indignation even among the most faithful adherents of the Medici. Nevertheless, they kept their feelings towards him within bounds. A second embassy was at once appointed, and during Piero's absence its members were chosen. It consisted of five men, among them Savonarola. He it was who in Lucca, where they met the king, was appointed spokesman. He spoke of the freedom and innocence of the Florentine people, and demanded positive security. Charles gave an evasive reply. Savonarola's fame had long ago penetrated to France, and the king feared the man, perhaps honored him; but he had gone too far with Piero. The latter, who was still with him, as soon as he saw the five, knew how things stood in Florence. Under pretext of hastening forwards and

preparing the reception of the king at Pisa, he withdrew, and hurried on to Florence. Paolo Orsini gathered together whatever soldiers were to be raised at the moment, and followed him.

At evening, on the 8th November, Piero was back in the city; on the morning of the 9th, he appeared before the palace of the Government. He wished to enter, to sound the great bell, convoke the parliament, and overthrow the constitution. One of the most distinguished citizens, Luca Corsini, met him and drew him back. What business had he here? he asked. Piero saw himself and his suite driven out: the people stood in dense groups round, and looked on to see what would follow. Single voices called to him, that he might go wherever he liked. Suddenly there rose a clamor, a cry of " Libertà, libertà! popolo, popolo! " the children called, and threw stones at the Medici and those who accompanied him. No one had arms; but the deportment of the people and the cry agitated Piero, so that he withdrew. Then came the minister of police with his men, and attempted to clear the place. This was the signal for the outbreak. The fury turned against him, the palace of the police was stormed, and the prisoners were set at liberty.

Piero had again arrived at the palace of the Medici, and sent messengers to Paolo Orsini, who was encamped in the neighborhood of the city. But even the nobles of the Government felt that they must act. The tocsin was sounded; and, from all parts of the city, the citizens poured forth in arms

to the square. Once more the Medici attempted to advance.

Giovanni, the cardinal, afterwards Leo X., whose affable behavior had at all times contrasted agreeably with the proud bearing of Piero, and who was the most beloved by the citizens of the three brothers, was the first to appear, and address the people. Piero, with Giuliano and Orsini, intended to follow with the troops. But Giovanni was thrust back before he reached the square; upon the others, as they appeared with the troops, stones were hurled from the windows, and they ventured not to advance further. The people led the attack. Giovanni fled to San Marco; refused admittance there, he saved himself disguised as a monk, and passed through the city gates. Piero and his party followed him. Once more in the suburbs, they attempted to distribute money, and to excite the lower classes of the inhabitants to revolt; but, as they met with only stones in return, they hastened quickly forwards, until speed became actual flight. And thus they proceeded to Bologna.

5.

Thus Michael Angelo again met his patrons, who were received with reproaches from Bentivoglio. Personally they had injured their cause by fleeing without active resistance; and, by their defeat, they had at the same time set the worst example to all other families who were in a similar position. Bentivoglio thought of his own house. In later times, the Medici could have retorted upon him

word for word; for his fate proved no better than
theirs. The brothers, who did not feel themselves
safe in Bologna, proceeded on to Venice after a
short sojourn. Michael Angelo remained in the
Aldovrandi palace; for it was not now expedient
to return to Florence. Gianfrancesco treated him
in the most honorable manner. Michael Angelo's
whole conduct, and the versatility of his nature,
pleased him. Of an evening he sat at his bedside,
and read to him Dante or Petrarca, or something
from Boccaccio's tales, till he went to sleep.

He found also artistic occupation. In the Church
of San Petronio, an immense Gothic building of the
fourteenth century, there is to this day the marble
coffin which contains the bones of St. Domenico.
It was executed by Nicola Pisano, a contemporary
of Cimabue, the earliest sculptor, whose works are
regarded as the commencement of modern sculpture.
The bas-reliefs surrounding it exhibit a certain rude
magnificence, and are superior to any thing pro-
duced by painting at that time. For, while the latter
was compelled to keep to the forms of the living By-
zantine masters, sculpture imitated the few remains
of the ancient artists, and in so doing flourished.
So widely divided were the sources from which the
two arts drew new life.

Nicola's work became subsequently enlarged.
Above, on the sarcophagus, two kneeling figures
were to be placed, only one of which, however, ex-
isted; and this was unfinished in its drapery. The
first sculptor in Bologna at that time, Nicolo Schiavi,
had been occupied with this work, when death had

Kneeling Angel.

MICHAEL ANGELO.

put a stop to it in the spring of 1494. Aldovrandi took Michael Angelo to San Petronio, and asked him whether he could venture to undertake the whole. He could well trust himself to do so. They gave him thirty ducats for it; twelve for the completion of the one figure, and eighteen for that which had to be newly executed, — a kneeling angel holding a candelabrum. This work is the only one which he accomplished during almost a year's residence at Bologna. It was the cause of his being obliged to leave the city.

The jealousy felt by native workmen towards foreign ones is well known; but, in matters of art, it frequently amounts to hatred. Vasari speaks often of this. The Bolognese artists were notorious for their hostile feeling to strangers, a blame which attaches also to those of Perugia. The honorable commission which fell to the lot of Michael Angelo, the Florentine adventurer of twenty years of age, excited such rebellion that it came to threats. One Bolognese sculptor declared, that this work belonged to him, that it was first promised to him, and had been now purloined by Michael Angelo, and that he had better look to it. Nor was this the only one who interfered with him; so he preferred returning to his native city.

What must have strengthened him in this resolve was the more settled state to which Florence had been restored during his absence. But how changed did he find every thing! He had left the city when but a slender branch from the power of the Medici had been violently broken off; and now

he saw the full tree, which had spread out its shadow
so far, destroyed to the very root. The palace of
the family stood empty, and robbed of its art-treas-
ures. A party was in authority, in whose ears it
sounded like treason, if the name of Medici was
uttered with any but the most hostile accent. The
gardens of San Marco were laid waste; their statues
and pictures sold to the highest bidder, and dis-
persed over the world. Many of the artists had
left; others, as followers of Savonarola, condemned
what they had before executed so freely and joyfully.
Lorenzo da Credi, Verrochio's pupil and Leonardo's
friend; Baccio della Porta, well known as Fra Bar-
tolomeo; Cronaca, the architect; and Botticelli,
Filippo Lippi's pupil, — struggled with their con-
sciences whether the exquisite works which they had
produced were not works of the devil. And, in
keeping with this, public morality was watched over
by the Government with the keenest surveillance,
even in the interior of families.

Such was the result of the events which had
occurred during the year spent by Michael Angelo
at Bologna.

At the same moment in which Florence had
revolted and Piero had fled, the insurrection in
Pisa had broken out. Here, however, they were
not rebelling against the Medici, but against the
Florentine yoke, which had pressed insufferably
upon the unhappy city. It was the declared policy
of Florence to ruin Pisa by degrees. Her citizens
now turned imploringly to the King of France, and
begged for protection; which he promised them.

Charles never considered consequences, or weighed promises made by him in the impulse of the moment. He was young, good-natured, and intoxicated by the success which, with unwearied fidelity, accompanied his steps. Guicciardini calls him small and dwarf-like, with six toes on each foot, — a monster; but, he adds, his bold glance betrayed the king. Accessible to every influence, continually surrounded by powerful, intriguing men, who hated and endeavored to ruin each other, and to all of whom by turns he lent a favorable ear, he contradicted himself constantly in resolves and solemn promises; and, in spite of this, so long as his good fortune lasted, he succeeded in that impossible thing of accommodating himself to all. He now guaranteed to the Pisans their freedom; and, in the same breath, he insisted that the Florentine justiciaries should remain at their posts there, and that they should be obeyed. He had promised the very same thing to Piero dei Medici.

The French army divided at Pisa. Cardinal Vincula went with the fleet to Ostia, his city, which he kept garrisoned, that he might from thence attack Borgia in the territory of the Church. Of the land forces, the greater part of the army marched south to Siena; the other half accompanied the king to Florence to make a solemn entry there. Thither came also Obigni across the mountains from the Romagna.

While Charles was staying in Pisa, the Medici in Florence had been declared rebels and enemies to the country. Their palaces, and those of their counsellors, had been stormed and plundered by

the people, and only with difficulty was the principal palace of the family saved, in which Lorenzo's widow and Piero's consort still remained. Into the hands of these two women the king fell, when he alighted at the palace of the Medici, and appropriated to himself and his suite all the valuables which had been saved from the first storm. For the sake of form, the old claims were urged which France had upon the Medici. Nevertheless, the tears and entreaties in favor of Piero, and the accusations against the fickle Florentine people, had their effect. Charles had surely promised the citizens, before he entered the city in a magnificent and solemn procession, that he approved of all that had been done. He had allowed himself to be received by the new Government of the city, and conducted to the cathedral, surrounded by the people, shouting " Francia! Francia!" and then, having alighted at the palace of the Medici, and being alone with Clarice and Alfonsina, he allowed himself to be prevailed on so far, that messengers were dispatched to Bologna to bring back Piero, whom the king was to re-instate in his position. But the Medici had long ago fled to Venice. He now demanded from the city their formal re-installment, and the reception of a standing French garrison. The position was a critical one. Florence was filled with the king's knights and mercenary troops, whose insolence led to disputes. Italian prisoners, whom the French dragged through the streets like driven cattle, were liberated by force by Florentine citizens. The negotiations in the palace led to no end. With regard

to the Medici, Charles at length yielded; but the sum which he required as a contribution to his military chest was exorbitant. He persisted in his demands. "If you do not consent," he cried, abruptly, "I shall order my trumpets to blow." "And we shall ring our bell!" cried Pier Capponi, in a tone which sounded no less threatening, as he tore in pieces the contract which had just been drawn up, and turned to go away with the other citizens, none of whom denied his boldness.

The king allowed them to reach the great steps of the palace; then he called back Capponi, who had been known to him in Lyons, made a jest of the matter, and behaved as if he let his words pass unnoticed for the sake of the old friendship, — words which have since acquired such celebrity in Florence, that there is no Florentine of the present day who cannot tell of that retort. They agreed to a more just treaty, and solemnly swore to it. Charles assumed the title of " Restorer and Protector of Florentine liberty;" the city bore his standard; he withdrew, only retaining the cities given up by Piero until the conquest of Naples. One hundred and twenty thousand gold florins were contributed; a new commercial treaty with France was established. The Medici were to have the right of regulating their affairs in the city, but not, of course, in person. On the 28th November, 1494, Charles withdrew to Siena. A fermenting chaos of enthusiasm, ambition, self-interest, fanaticism, and goodwill, was left behind, struggling in itself for stability and form.

It was no easy matter to obtain this. They had driven away the Medici, and yet the Government, which had been formed by themselves from their own adherents, was left in office. These men had indeed placed themselves at the head of the tumult in the storm of general rebellion; their conduct in so disinterested a course of action appeared all the brighter. After the departure of Charles, they called a parliament, which, according to custom, provided a number of men with dictatorial power on behalf of the new appointment to the offices of the State. The members of the old Government were chosen, and in this way the highest confidence was shown in them. In the meanwhile, these men, and the friends of the Medici in general, came to their senses. They felt that they had acted over-hastily, and saw themselves in possession of power. Notorious characters, known as enemies of the Medici, were now passed over in the allotment of places. A number of the greatest families, with powerful men at their head, felt themselves injured. The citizens began to be restless. Savonarola had his plans also. Others thought only of themselves, — he, however, of the subjects to which he had devoted himself.

His sermons began again in the Lent of the year 1495. He urged for a total change of things. He wished to remodel the city morally and politically. He pointed unremittingly to her evils. He had in view the grandest object, — a remodelling of Italy; and his first effort towards its attainment was the reformation of heart in each individual listener.

He preached kindness and reconciliation, but woe to those who did not obey his words! According to his idea, the will of an assembly of all the citizens entitled to vote ought to stand at the head of the State as the supreme power. There would be in the whole of Florence about two thousand men, who in this sense would be in the enjoyment of the right of citizens. These should assemble in the palace of the Government as a great council, — *consiglio grande;* and the decree of the majority should be absolute in Florence.

Before the middle of the year, the party of the Medici had been driven from their position in the Government, and the consiglio grande had been constituted. Savonarola had done it all. He ruled the majority, to whom he communicated his peremptory commands in the name of God. Francesco Valori and Paolantonio Soderini, adherents of his doctrine, and bitter enemies of the Medici, both of whom had at first been passed over in the distribution of places, stood with him as leaders of the ruling party, as the mightiest men in the State. They had two aims before them, — at home, the accomplishment of reform ; abroad, the recovery of Pisa and the other cities which were in the power of the French: for, although Florence had no French garrison within her walls, so long as Pisa and Livorno belonged to France, Florence was also dependent on her.

Charles's advance to Naples was a triumphal procession. Almost all French wars in Italy have begun with the dazzling splendor of victory, and

ended in ignominious defeat. Macchiavelli says of the French of his time, what Cæsar had before expressed respecting the old Gauls : at the first attack they were more than men, at the final retreat less than women.

In Rome the king concluded a tender friendship with the pope. From thence he went on to Naples. At the end of February, he made his entrance; the people had rebelled in his favor, and expelled the Aragonese. " The Neapolitans have a necessity for new kings," remarks Guicciardino. Charles was received with great attestations of joy.

Until now he had fought no battle. The gates had opened wherever he appeared. But now came the re-action. All had made way before him; behind him that way was closed. Ludovico Sforza was the first who revolted. Instead of giving him Livorno and Pisa, the French had retained the towns themselves. Venice, the Roman king, Spain, and the pope, made common cause with Milan. A moment before, the whole of Italy had lain smoothly and placidly at the feet of the King of France, and now it was necessary to make his way back by force through a hostile land. Charles engaged in the contest. He left a part of his army behind in Naples, where communication with France was kept up by the fleet; with the other half he turned back, and advanced again upon Rome. Just now he had been exchanging kisses and embraces with the pope; this time there was no talk of it. In the whole of Italy, the king had but one ally; and this was the Florentine citizens, led by Savonarola, who had resisted

every effort of the other powers to draw them to join the great league.

Charles's courage, however, and his pride suffered not under this change of circumstances. In Siena an embassy of the Florentines awaited him. They offered him money and troops. He replied, that his own people were sufficient for him to master his foes. Once more Savonarola met him. Holding the Gos pel in his hand, he conjured him to fear the punishment of Heaven, and to deliver up Pisa. He gave an evasive reply. He could not keep his word with both parties at once. Even with the Medici he stood anew in communication. Piero was at that time in his train, and hoped through him to reach the city, in which his friends, as an organized party, opposed Savonarola's, and prepared for the return of their former master.

Without coming in contact with Florence, the king advanced further north. At last the first contest in this war took place. The army of the allies opposed him at Fornuovo on the Taro, and endeavored to detain him. Both sides ascribed the victory to themselves, — the French with the greater right; for they thrust the enemy aside, and made themselves a free passage to Piedmont. This was taking place in the north of Italy, on the 6th July; in the south, on the 7th July, Naples fell again under the power of the Aragonese. The cause of the French was in a critical position. The Floren tines had just obtained their desire, that orders should be given to the garrisons of the Tuscan cities to withdraw.

The commandant of Pisa, however, refused to obey. The entreaties of the Pisans; their money; the tears of a beautiful girl who made the preservation of liberty the price of her love; lastly, opposing orders from the king himself, — succeeded so far, that the gates remained closed to the Florentines. Livorno alone was conceded to them; the other fortresses were sold by the French to Lucca or Genoa. Florence was compelled to obtain her right by force. They adhered to the alliance with France, but Pisa must be conquered. Savonarola encouraged this; he promised the recapture of the city in the name of God, who stood on the side of the people.

The Pisans, prepared for the withdrawal of the French, — which, notwithstanding, must follow sooner or later, — turned to Venice, and Ludovico Sforza. Both supported the supplicating city, because both hoped to win her for themselves. This struggle of the Pisans for their liberty, their desperate effort to rise above the weakness in which they had been plunged deeper and deeper by the Florentines, must touch the hearts of all who closely consider the events. Few cities have thus defended their walls to the uttermost. But it moved not Savonarola. Pisa was his Carthage, and it must be destroyed. There is no trace of sympathy in his words when he speaks of the subjugation of the city as the reward of Heaven, and incites the citizens to hold out, and to remain true to the French policy. He held the State like soft dough in his hands; whatever he wished was approved of. He possessed a wonderful power of linking together the most natural and

coldest language with irresistible fluency. Proverbs; questions with replies, interrupted by pathetic enthusiasm; scriptural passages; practical applications of a surprising kind, but ever open to the plainest understanding, — these stood in plentiful abundance at his disposal. He was the soul of the city. As a well-written journal at the present day gives vent to the thoughts of its party, so Savonarola took upon himself to satisfy the daily demand for thought among the Florentines; and his stores seemed inexhaustible. He spoke in short sentences; without ornamental epithets, quick and practical as we speak in the streets, but uniting his ideas together in a current that carried away his hearers. And, as there were only a few points to which he continually reverted, and which he had preached from the beginning, so he told the people nothing which they had to apprehend and consider afresh; but he only repeated with ever-new power their own old convictions. In the midst of his prophecies, and explanations of the highest things, he issued commands about apparel, habits, and behavior, and gave political instructions for the days following, just as the position of things required. Savonarola possessed the old tact of popular men, who know how to deal with the multitude, and in the midst of their enthusiasm never lose their common plainness. Only that, in his case, enthusiasm became fanaticism.

Such was the state of things Michael Angelo found on his return from Bologna. It was gloomy and depressing; but artists still executed, and the rich

purchased. He at once prepared an atelier He found, too, a patron for his genius; and it was again a Medici who interested himself in him. The old Cosmo had had a brother who died early, and who had been a great friend of learning. His descendants lived in Florence, and had always been regarded with mistrust by the ruling branch. Piero went so far as to have his two cousins, Lorenzo and Giovanni, imprisoned, — for they certainly intrigued against him at Florence, as well as at foreign courts, — and had only with difficulty been brought to change the prison into banishment to a villa, the limits of which were not to be transgressed. Having escaped to France, they returned in Charles's train. After the overthrow of Pisa, they again entered the city, laid aside the name of Medici for the sake of flattering the people, and called themselves Popolani; just as Orléans under similar circumstances called himself Egalité. Rich, and related through their wives to the highest nobles of Italy, they had. lived since that time in Florence, and endeavored to distinguish themselves by their zeal for her liberty.

Lorenzo took an interest in Michael Angelo, and gave him work. He had him execute, so Condivi says, an infant St. John, and a St. Giovannino. Filippino Lippi also worked for him. Michael Angelo, besides this commission, began to cut on his own account a Cupid in marble, which he represented as a child from six to seven years old lying asleep. During the winter of 1495 and 1496, however, in which he was engaged on these works,

events occurred in the city, to which the former ones had been but a gentle prelude. On all sides, matters had remained in an undecided state. The conduct of the allies to obtain Florence was ever biassed by the certain prospect, that the efforts to bring the city to revolt from France would be successful. The parties became in some degree confused together. Savonarola, violently as he spoke, still retained a certain moderation ; and, if Rome had changed her conduct, this would have been possible.

In the end of the year 1495, however, occurred the first armed expedition of the Medici to take possession of the city by force. Piero, who had nothing to obtain from the French, had applied to the League, and found a hearing. The Florentines were to be compelled to follow them, and to discontinue the attacks on Pisa. In league with Sforza, the Bentivogli, the Orsini, and Siena, the brothers hoped to seize Florence as in a snare, and to bring her to obedience. But the disunion of the allies frustrated the undertaking ; its sole result lay in strengthening Savonarola's party in the city, and his own authority.

Now occurred the carnival at the beginning of the year 1496.* It was wont to be celebrated with extravagant noise. Day and night, wild tricks took place in the streets, from the graceful jest to the misdemeanor which ended in bloodshed. Every one must come forward. The crowning feature of the festival was always magnificent processions with

* The Florentine chronology is throughout disregarded.

singing, and on the last day the burning of the trees, which, hung with tinsel extorted or given, were placed on the open squares, and set on flame, while the people danced round them.

As Christianity had once usurped the old heathen festivals, and, instead of exterminating them, had monopolized them for herself, Savonarola now did so likewise. Processions were to be made, songs to be sung, gifts to be solicited, and trees burned down; the people were to dance round them, but all with a higher meaning, as he should devise and appoint. Children went through the streets, knocked at doors, and begged with gentle words for " objects of con- demnation," which should be burned to the honor of God. Instead of the merry pageants, there were processions with pious songs. On the last day a pyramid was erected, made of the products of the collection. Musical instruments, books with love- poems (Tuscan as well as heathenish), pictures, dress, perfume, — in short whatever could be thought, of among the unhallowed superfluities of daily life, — were gathered together into a structure of the most valuable specimens, which was set on fire, and, amid the singing of strange songs in the praise of Christ, " the King of Florence," was danced round by the excited people. Old and young took part in it. It was here that Fra Bartolomeo and Lorenzo da Credi delivered their own works to the flames, in which valuable editions of Petrarca and Virgil were de- stroyed.

Lent followed, — this time a true period of re- pentance and contrition. Day after day, Savonarola's

sermons were preached among the people, kindling the glowing fanaticism into fresh flame. Twice already had the pope prohibited his preaching; but the Government of the city, and the Romish friends of Savonarola, had demanded a repeal of the inter diction. They had hoped he would become more moderate; but what he had hitherto said had been little: he now unreservedly gave himself up to the impulse to be plain-spoken, and showed more distinctly the ultimate consequences of his doctrine. "I ask thee, Rome," he exclaimed, "how can it be possible, that thou shouldst still exist upon earth? Eleven thousand courtesans in Rome is too deep an evil. By night the priests are with these women; the morning after, they read mass and administer the sacraments. All is venal in Rome: every position, and even Christ's blood, is to be had for money." He stood there, and feared not. His friends and denouncers might report what he had said: he was a fire that was not to be extinguished.

Much had happened of that which he had predicted; but that was the least. Rome and Italy were to be annihilated to the root; fearful bands of avengers were to overflow the land, and punish the arrogance of the princes; the churches, which had been degraded by their priests into public houses of infamy, would be stables for horses and impure cattle; plague and famine would appear, — thus he thundered forth on the fourth Monday of Lent, in a sermon which even at the present day makes an exciting impression.

We know not to what extent Michael Angelo

abandoned himself to these feelings; but he certainly belonged to Savonarola's adherents. In his declining age, he still studied his writings, and remembered the strong voice in which he had preached. When, in July, 1495, the hall for the consiglio grande in the palace of the Government was begun to be built at Savonarola's urgent request, Michael Angelo was among those who were consulted about it. The Sangalli, Baccio d'Agnolo, Simone del Pollajuolo, and others, formed this committee. Simone del Pollajuolo, known under the name Cronaca, obtained the direction of the building. Fra Bartolomeo undertook the painting for the altar erected in the hall,—they were all adherents of Savonarola, and Michael Angelo among them. On the 15th July, Cronaca was chosen. This date affords at the same time a point for Michael Angelo's return from Bologna. He must just have arrived at Florence, as he took part in the affair.*

In spite of this, he still remained worldly enough to execute a Cupid. In April or May, 1496, he had finished it. Medici was delighted with the work, and informed him in what way the best price could be obtained for it. He told him to give the stone the appearance of having long lain underground. He would himself send it to Rome, where it would be paid for highly as an antique. We see that the Medici, in spite of their rank, had not lost their mercantile spirit. Lorenzo proved this on other occasions. He understood well how to make use of the scarcity which soon occurred in Florence, by

* See Appendix, Note VII.

having corn from the Romagna, upon which he gained considerably.

Michael Angelo agreed to the proposal, gave the marble a weather-worn and ancient appearance, and soon received information, through Lorenzo, that the Cardinal San Giorgio — that same Rafael Riario who had read mass in Florence, when Giuliano had been murdered by the Pazzi — had purchased it for thirty ducats. M. Baldassare del Milanese, by means of whom the matter had been concluded in Rome, paid Michael Angelo the sum in Florence, which must have appeared to him a reasonable price.

The secret, however, of the real origin of the antique was not kept. Various rumors of it reached the cardinal; he was offended at having been deceived, and sent a nobleman of his household to Florence to investigate the matter. This man appeared as if he were in search of a sculptor, who could be employed in Rome, and invited Michael Angelo to visit him among others. He came; but, instead of showing works which he brought with him, he took a pen, and drew a human hand boldly on the paper, to the great astonishment of the Roman. He then enumerated the sculptures he had already completed; and among them, without further ceremony, he named the sleeping Cupid.

The man now explained why he had really sent for him: instead of the thirty ducats which M. Baldassare had sent, he told him of two hundred which the cardinal had paid for the work, so that Michael Angelo saw himself just as much deceived as the cardinal himself. Invited by the Roman nobleman,

who promised to receive him into his own house; impressed with his assurances that Rome presented a vast field for the exhibition of his art, and for obtaining money; principally, however, with the intention of making M. Baldassare pay the remaining hundred and seventy ducats, — he set out for Rome, where he arrived on the 25th June, 1496.

CHAPTER FOURTH.

1496 — 1500.

Arrival in Rome — The City — Alexander Borgia and his Chil-
dren — Pollajuolo — Melozzo da Forli — Mantegna — Cardinal
Riario — The Madonna of Mᵣ· Labouchère — The Bacchus —
The Pietà — State of Things in Florence — Savonarola's Power
and Ruin — Return to Florence.

THE oldest piece of writing in Michael Angelo's
hand which we possess, is the letter in which
he informs Lorenzo dei Medici of his arrival in
Rome : —

" I beg to inform your Magnificence, that we arrived
here safely last Saturday, and went at once to the Cardinal·
di San Giorgio, to whom I delivered your letter. He
seemed well inclined to me, and desired at once that I
should look at different figures, which I spent the whole
day in doing, and have therefore not yet delivered your
other letters. On Sunday the cardinal came to the new
building, and sent for me. When I came, he asked me
what I thought of all I had seen. I gave him my opinion
respecting them. There are indeed, it seems to me, very
beautiful things here. The cardinal now wished to know
whether I would venture to undertake any beautiful thing.
I answered that I would make no great promises, but he
would see himself what I was able to do. We have

K

purchased a fine piece of marble for a figure as large as life, and next Monday I begin to work at it. Last Monday I gave the rest of your letters to Paolo Rucellai, who paid me the money I required, and that for Cavalcanti. I then took Baldassare the letter, and demanded the Cupid back, promising to give him his money in return. He answered very impetuously that he would rather break the Cupid into a thousand pieces; he had purchased it, it was his property, and he could prove in writing that he satisfied him from whom he had received it. No man should compel him to deliver it up. He complained of you, that you had calumniated him. One of our Florentines here interposed to unite us, but proved ineffectual. I think now I may carry the point by means of the cardinal; Baldassare Balducci has given me this counsel. I will write you whatever takes place further. So much for this time. Farewell. God keep you.*

<div style="text-align:right">" MICHELAGNOLO in Rome."</div>

How vividly do these few words introduce us to the intercourse of the men who disputed with each other in the affair of the statue! An irritated noble; a furious, cheating merchant; interposing friends, — and yet all this was secondary to Rome itself. Michael Angelo rambles through the city; and, at the sight of the works of art, he neglects to deliver his letters of introduction.

He was twenty-one years old when he went to Rome.

As the Romans once said " The city," in designating Rome, so in the present day we say " Rome," in naming that which, to any one who has seen it,

* See Appendix, Note VIII.

must appear as the ideal of a city. One could fancy, when the world was created, with its trees, rivers, seas, mountains, animals, and lastly with men, — that, on that spot of earth where Rome stands, a city must have grown up from the soil, springing up without human interference. We could imagine of other cities, that there was once a waste desolate plain, a wood, a swamp, a quiet far-stretching meadow; that then men came, and built huts out of which houses grew; that one followed another, until at length there became an immense number, interspersed with churches and palaces, but all destructible; and that, centuries after, fresh trees might have stood there, among which only shy wild animals crept. But of Rome such thoughts are almost an impossibility. We cannot believe, that here, at any time, there was marshy ground in whose humid waters Romulus and Remus could have been exposed as children, or that the rudest force could ever have succeeded in clearing the seven hills of buildings. At Berlin, Vienna, Paris, I could imagine a storm cutting down every thing to the ground as with a scythe, and casting it aside as dead; but, in Rome, it seems as if the stones themselves must again unite into palaces, if any violent shock tore them asunder; as if it were against the laws of being, that the height of the Capitol should be without palaces, temples, and towers.

It is a drawback, that, to express thoughts of this kind, we are obliged to make use of fixed images with a limited meaning. Taken practically, the thoughts which we have just brought forward are

valueless; for Rome may one day be destroyed root and branch, just as well as Babylon and Persepolis. And yet in these fancies there lies a meaning of a higher kind, and there is a necessity for giving expression to them. The feeling of eternity, of imperishableness, which steals over us in Rome, must be expressed; the feeling, as if the earth was a vast empire, and here its central point; love for this city of all cities. I am no Roman Catholic, and I perceive nothing in myself of romantic veneration for pope and church; but I cannot deny the powerful feeling of home which seizes me in Rome, and the longing to return there which I never lose. The idea that the young Michael Angelo, full of the bustle of the fanatically excited Florence, was led by fate to this Rome, and trod for the first time that soil where the most corrupt doings were nevertheless lost sight of in the calm grandeur of the past, has something in it that awakens thought. It was the first step in his actual life. He had before been led. hither and thither by men and by his own indistinct views; now, thrown upon his own resources, he takes a new start for his future, and what he now produces begins the series of his masterly works.

2.

What was the nature of the beautiful things which he mentioned to the cardinal as existing in Rome, can hardly, at the present day, be decided. The ransacking of the rich soil had begun, and much had been found; but the discovery of most of the antiques, which are known at the present day as

the gems of the collections, occurred in later times: on the other hand, much of that which had been accumulated in Rome in the fifteenth and sixteenth centuries, was subsequently carried away in every direction. The present condition of things affords no guide in considering the past; it was another Rome into which Michael Angelo entered. The existing works of art were not as now coldly arranged together in museums, but were distributed throughout the city, placed in open and favorable places, for the adornment of buildings, and the delight of men. These buildings were constructed in a style, only small remains of which are still existing. When Michael Angelo ascended the rock of the Capitol, he little anticipated that it would be one day studded with palaces, which would change its entire form. When, sitting down on the bare ruins of the old temple of Jupiter, he gazed around him, he never anticipated that one day the eye would look from thence over St. Peter's dome, which he devised, and the countless smaller domes, all built after the same pattern. We could not, at the present day, imagine *Rome* without this prospect. Nothing of it then existed. The old Basilica of Saint Peter was at that time still standing; the magnificent spacious square of Bernini, with its rushing springs, and the vast colonnades which surround it, was covered with an irregular cluster of small houses. A square lay in their centre, on which tournaments and running at the ring were held. The wide-stretching palace of the Vatican was scarcely a quarter so great as at the present day, and was shut in like a fortress-

From hence the pope had a covered walled way to the castle of St. Angelo, which, closely connected by fortifications with the bridge that leads under it across the Tiber, presented more evidently than at the present day the form of a castle, the possessor of which was lord of the city, in that he could completely separate at his will the two halves of Rome, — the new papal city to the north of the river, and the grand old Rome to the south of the Tiber.*

The castle of St. Angelo formed the citadel of Rome, though only one of the less distinguished fortresses, with which, like Florence in old times, she was filled. In Florence, a freer, lighter style had long before produced free, beautiful palaces; in Rome, where the public condition of things gave precedence to strength before beauty, few of the long and splendid façades, filled with rows of windows, were to be seen. The palaces of the cardinals and of the higher nobility, the Orsini, the Colonna, and others, appeared like dark, shut-in buildings, well fitted for defence, and provided with • every means for warding off sudden attacks. The Roman and Florentine palace architecture belongs to the age and its history. The façade lay within; the court-yard was the real centre of the building,— a space surrounded on every side, where shady coolness prevailed at all hours, where fountains played, and where statues stood in the most favorable light. The rude and gloomy mass of palaces opened round the court-yard in light open colonnades. It was safe

* See Appendix, Note IX.

here, and yet the open sky was overhead. The Loggie of the Vatican, which Raphael painted, are the open arcades which surrounded the court of the papal palace.

Around these castles of the temporal and spiritual princes lay the dwellings of their servants, and of those generally who adhered to the lord thus enthroned in their midst. The narrow streets between these houses were closed by night with chains. Thus every powerful noble had his city to himself within the city, — his court, his church, his subjects, his nobles, soldiers, artists, and scholars; and between these courts and the pope's there flowed an eternal stream of intrigues, with concealed or openly exhibited hostility. At that time more than the half of Europe was ecclesiastical property, paid tribute to Rome, and received her precepts. The city is a desert at the present day compared with those times. The palaces stand empty; the cardinals — men possessing power and importance only in exceptional cases — drive in heavy carriages through the streets, old and often feeble men, whose names are scarcely known in the city itself. At that period they galloped in complete armor with their attendants to the Vatican, past their churches, at which, at the time of the papal election, they publicly put up to auction the golden and silver vessels, because they needed money to bribe their friends and foes. These were men of the first princely families, young, warlike, and with ardent passions. Cardinal Ascanio, Ludovico Sforza's brother, had staked immense sums to effect his election

to the papacy after Innocent's death; Cardinal Vin-cola also, who, like Ascanio, could lead his own army into the field, so powerful were they both; yet this time they were conquered by Alexander Borgia, who had the greatest influence, and who governed Rome at the period of Michael Angelo's arrival there. He was the first pope who spoke openly of his children; before, there had only been mention made of the nephews and nieces of the popes. Lucrezia Borgia was his daughter. She was purchased from her first husband, separated from her second, her third was struck to the ground before the Vatican itself, and, when likely to recover, he was strangled on his sick-bed by Cæsar Borgia, Lucrezia's brother, who had ordered the attack.

This Cæsar Borgia, Alexander's favorite son, was at that time twenty-five years old, beautiful in figure, and strong as a giant. In a square before the Vatican, surrounded with barriers, he killed six wild bulls, against whom he fought on horseback. He struck the first a blow on the head. The whole of Rome was in amazement. His wildness, however, was no less than his power. He stabbed Messer Pierotto, the favorite of his father, under the mantle of his patron, whither he had fled, so that his blood was sprinkled in the face of the pope. Every morning from four to five corpses were to be found in the streets, among them bishops and eminent prelates. Rome was in terror of Cæsar.

At that time he must have murdered his brother, the Duke of Gandia. He had him stabbed, and thrown into the Tiber. He then communicated to

the pope himself, that the deed had originated with him. The head of Christendom, beside himself with rage and grief, appeared in the college of the cardinals, cried aloud over his son, reproached himself with all the crimes he had committed, and promised improvement. This continued for some days; then it passed away, and the reconciliation with Cæsar was not long delayed. This fearful family was too much thrown upon each other, to be able to remain long at variance with themselves. False, shameless, deceitful, without faith, insatiable in his avarice, criminal in his ambition, and cruel even to -barbarity, — thus Guicciardini sums up the crimes of the pope. Such a character seems impossible in our own day; it would find no scope for extending its vulture wings, nor prey upon which it could light. So completely, however, do the Borgias suit their age, that they only stand out conspicuously, when we consider their qualities by themselves, taken out of the frame of that which surrounded them. If we study the deeds which emanated from others around them, their crimes appear almost reconcilable; and we feel ourselves at liberty even to estimate their good side, — that is, the power, by means of which they surpassed others who stand less stigmatized, perhaps from their weakness alone.

" The pope is seventy years old," says the Venetian ambassador of that period; " every day he seems to grow younger; he discards every care from his heart at night; he is cheerful by nature; and whatever he does, turns out to his advantage."

Alexander possessed a gigantic frame; his penetrating glance saw the bearings of things, and the right means towards an end: he knew how to convince people in a wonderful way that he meant honestly towards them. Equally clever was Cæsar; but Lucrezia possessed so much beauty and such gifts of mind, that some of her admirers, even at the present day, will not believe in her crimes. They appeal to her letters, to her intercourse with the first men of Italy, to her subsequent career, when, as Duchess of Ferrara, she was for years the best of wives and mothers.* Thus do mental gifts give a lustre to the darkest actions of which we are guilty. Yet I cannot believe that the crimes of this family can be ever glossed over.

3.

Such were the men who dwelt in the Vatican, when Michael Angelo arrived in Rome. Among the artists whom he met there, were the two great Florentines, — Antonio Pollajuolo, who had worked at the golden gates under Ghiberti, and his younger • brother Piero, — both completely naturalized there, wealthy in their circumstances, and intending to end their days in Rome. Piero must have died about the time of Michael Angelo's arrival; Antonio, however, the greater of the two, lived till 1498. He began life as a goldsmith; grew famous for his designs, which many artists copied; became desirous to paint himself; modelled, sculptured, and moulded in bronze. After the death of Pope Sixtus, he was

* See Appendix, Note X.

called to Rome by Cardinal Vincula, to execute a monument for him. This occurred in 1484. After the completion of the work, — a highly tasteful thing in bronze, representing the pope lying stretched on a basement, decorated in a masterly manner with Corinthian ornament, — a similar work was assigned him for Innocent VIII., who died in the same year with Lorenzo dei Medici, and whom he represented in a sitting posture. Besides these, many works of his hand are to be found in the smaller churches in Rome; those two monuments were placed in the Basilica of St. Peter, where they are still to be seen.

Pollajuolo's strength lay in strictness of design; his color is cold and opaque. In the figures, however, there is a touch of greatness and simplicity, which had before belonged less to the Florentine masters than to those of the Umbrian school. In San Miniato, at Florence, there is a St. Christopher twenty feet high, by his hand, which Michael Angelo is said to have repeatedly copied. It may therefore be supposed, that he was personally attached to Pollajuolo in Rome, — all the more so, perhaps, as he was acquainted in Florence with Cronaca, his pupil and near relative.

However that may be, the brothers Pollajuolo were not the men to raise him a step higher in his art. On the other hand, he now became acquainted in Rome with the works of two masters, whose style and manner lay far removed from the conceptions of Florentine art, and whose works could not remain without an influence upon him, — Mantegna and Melozzo da Forli.

Mantegna belonged to the foremost rank. There is such a depth of sentiment in his pictures, such a nobility in his features, that we feel at once that he was not a man to be surpassed or imitated, but a nature whose animating influence must have been felt by all who were capable of being touched by it. Mantegna lived in Mantua, where the Gonzaga were his patrons. He came to Rome at the close of the century. The chapel, which he painted for the pope, no longer exists; but we may suppose that this work, for which he required a series of years, was not less than his others. While in Florence the influence of antique works upon art was not apparently strong, but the free movements of life and nature were the sources from which they drew, Mantegna permitted the style of the old masters to exercise a striking influence upon him; though he met their power over him with such decided peculiarities of his own, that even in his case we cannot speak of imitation. His coloring is simple, almost cold, and is always subordinate to the outline ; this outline, however, brings out the figures so intensely, that they almost acquire a typical force. We feel it would be scarcely possible to conceive the scene otherwise than he has done. If we stand before that of Christ taken down from the cross, which is in the original at Berlin, the feeling of the most cruel death, leaving nevertheless behind it a smiling, heavenly repose, seems to be so exhausted by the art of the master, that we forget all other artists, who may have succeeded in it better, and who penetrate still deeper into our souls. Mantegna is a victim to

a certain formality, which was only overcome by Leonardo and Michael Angelo, through whose two-fold influence Raphael afterwards obtained his happy freedom. But this does not prevent us from ranking Mantegna with those three. And this was the opinion in Italy also from the first.*

Melozzo da Forli does not come up to Mantegna in what he produced ; but, in his designs, he perhaps surpasses all artists previous to Michael Angelo. But few of his works are left, and only small fragments of the greatest. His birthplace, Forli, lies in the Romagna, not far from Urbino, where Giovanni Santi, Raphael's father, lived. The latter, an intimate friend of Melozzo's, exhibits the same severe forms in his pictures, the same material tone, which points rather to Mantegna than to the Florentine school. The Romagna, separated from Tuscany by the mountain range, received greater impulse from the north than from the neighboring lands. Forli belonged to the Count Girolamo Riario, the nephew of Pope Sixtus. Through him Melozzo was brought to Rome. His appointment to be painter to the pope followed, and finally his elevation to the order of knighthood. † This was accompanied with a rich allowance and magnificent commissions. There is a picture of his in the Vatican, representing the pope surrounded by his nephews. They are the same as would have killed Lorenzo dei Medici in the Pazzi conspiracy ; it was just at that time that Melozzo painted them. Among them, too, is the Cardinal Vincula, young and beardless. The pope

* See Appendix, Note XI. † *Ibid.*, Note XII.

himself is in profile, a large severe face, the man who inspired the Italians with respect, because he had so energetically raised his own family. Melozzo's principal work, an Ascension of Christ, which of old occupied the altar wall of the church San Apostoli, is now destroyed; and only single pieces, which were preserved in the sacristy of St. Peter and in the Lateran, afford an idea of the grand combination of colossal figures of which the painting consisted. I can place nothing of the same date by the side of these figures as regards boldness of composition. For an imagination, before which human forms hovered in such bold foreshortening, and a hand such as the painter possessed who could sketch so freely and firmly what his mind perceived, I find combined in no painter hitherto. Yet Melozzo scarcely occupies a place in the history of art, because the existing remains of his works are too insignificant. Vasari only mentions him in the second edition of his work, and even there, to say little more than that he knows nothing of him. Yet, from the remains that exist of him, the man appears to me equally great as a painter and character, and does not merit the forgetfulness into which his name has fallen. We can understand, that this wild pope, with his equally wild nephews (or sons, if we like), had respect for Melozzo's genius, and acknowledged it not with money only, as in Pollajuolo's case, who at his death could leave each of his daughters five thousand ducats. How small does Pollajuolo appear, with all his extensive works, by the side of Melozzo, whose Christ and Apostles soar aloft as if they would

Sixtus IV surrounded by his Nephews.

MELOZZO DA FORLI.

pierce through the church roof! A number of frag-
ments of angels are still preserved, which probably,
in full choir, received the Son of God in the clouds.
They are playing on different instruments, and
singing to them; they, too, bend in beautiful fore-
shortenings, and are nothing but noble, beautiful,
girlish forms. Two appeared to me especially charm-
ing. One with both arms holding up a tambourine,
which she is striking; her body is bent backwards;
a lilac dress over a green under-garment floats round
her in free large folds; nothing is commonly natural,
and yet there is no trace of empty, conventional
grandness. The other is sitting on the cloud, looking
down below, and bending forwards, while she plays
upon a lute. She has brown blunt wings, like an
owl, just as if painted from nature. Melozzo had
been dead two years when Michael Angelo came to
Rome. The nephews of the former pope were at
war with Alexander Borgia and his sons. Cardinal
Vincula was at his residence in Ostia. Michael
Angelo cannot therefore, at that time, have been
acquainted with him who was subsequently celebra-
ted as his great friend and patron.

If we were to reckon up the works of Florentine
artists alone, which he found in Rome, besides those
of Mantegna and Melozzo, they would fill a long
catalogue. Almost all had worked here from Giotto
to Ghirlandajo, and the churches were full of monu-
ments of their labors; none, however, of these artists
were then present. Still we are not sufficiently in-
formed, to know all who were working in Rome at
that time. There is in the museum at Berlin a bust

as large as life of Alexander VI., which must have originated at that time. The work is in every respect worthy of the greatest master: indeed, its excellence is such, that it seems too good for Polla-juolo. For want of information, however, he still remains the only artist of importance who, we may venture to suppose, met with Michael Angelo.

<div align="center">4.</div>

The Cardinal di San Giorgio, by whom Michael Angelo had been so well received, proved himself subsequently not a man from whom any thing was to have been expected. At the time of Michael Angelo's arrival in Rome, he had an immense palace, building in the neighborhood of the Campo del Fiore, on which he could have easily employed him. This must have been the " new building," of which mention is made in the letter to Lorenzo dei Medici. If the cardinal seemed at first willing to make use of Michael Angelo in this work, as also appears from the letter, he nevertheless gave him subsequently no commissions. He even withdrew himself from the affair with Messer Baldassare, and that in a manner not very princely. He compelled the merchant to restore the money and to take back the statue. Michael Angelo had expected that the cardinal would have obliged Baldassare to pay him the intercepted remainder. Now he was perhaps glad to be able to retain his thirty ducats.* Nothing further, too, is said of the figure as large as life, for which he had purchased the marble on his first arrival, and which

<div align="center">* See Appendix, Note XIII.</div>

apparently had been bespoken by the cardinal. Something must have occurred between them both, which gave a blow to their connection; for Condivi, who wrote after Michael Angelo's own words, expresses himself severely at the conduct of the cardinal, without, however, specifying it more closely.*

Michael Angelo's influence in San Giorgio's house was of a very indirect character. Vasari relates, that San Giorgio had a barber who was devoted to painting, but who knew nothing of drawing. For this man Michael Angelo made a cartoon of St. Francis, in the ecstasy of receiving the stigmata. The picture is praised by Varchi also in his funeral oration on Michael Angelo. As, however, Condivi is silent respecting it, and Varchi does not say whether he saw it himself in Rome, or only read of it in Vasari's book (Vasari mentions the work even in his *first* edition), the matter remains uncertain. All the more so, since, at the present day, nothing to be referred to Michael Angelo exists in San Piero in Montorio, where the painting is said to have been found in the first chapel on the left hand.

I might, on the other hand, impute a work to this early period in Rome, of which indeed no one speaks, but which undoubtedly was produced by Michael Angelo, and perhaps is best inserted here, — the Madonna in Mr. Labouchère's possession, and which was first generally known by the Manchester Exhibition.

It is a picture *a tempera*, and is unfinished. The composition falls into three parts: in the centre

* See Appendix, Note XIV.

8*

the Madonna; on her right and left two pair of youth-
ful figures close together, angels if we will. Those
on the left are only in outline; those on the other
side, however, are completed, and are so touching in
their beauty that they belong to the best produced
by Michael Angelo. They stand close together, —
two boys between fourteen and fifteen years old, the
one standing in front seen in profile, his whole figure
bent down; the one behind him *en face*. The latter
has placed both hands on his companion's shoulder,
and is looking with him on a sheet of parchment,
which the other holds before him with both hands,
as though he were reading it: he, too, has his head
somewhat inclined, and his eyes are fixed upon it.
It is a sheet of music-paper, perhaps, from which
both are singing; the half-opened lips might indicate
this. The bare arms, the hands holding the sheet,
both showing the delicacy of youth, but painted with
an observance of nature which it is impossible to
praise or to describe, would suffice in themselves
to give this figure the highest value. But, besides
this, there is the head, the delicately slender form;
the light garment falling below the knee in close-
lying broken folds, then the knee and the leg and
the foot, — it is all a representation of nature which
is almost too touching; we feel deep within our
hearts a love for this child, and are assured of his
purity and innocence. The garment of the other is
dark; a shadow lies over his eyes; and, in the eye
itself, there is quite a different character, but no less
charming. The hair, too, is different; the locks are
thicker, darker, with the ends sticking out: while

Madonna and Child, with the Infant Saint John and Angels.

MICHAEL ANGELO.

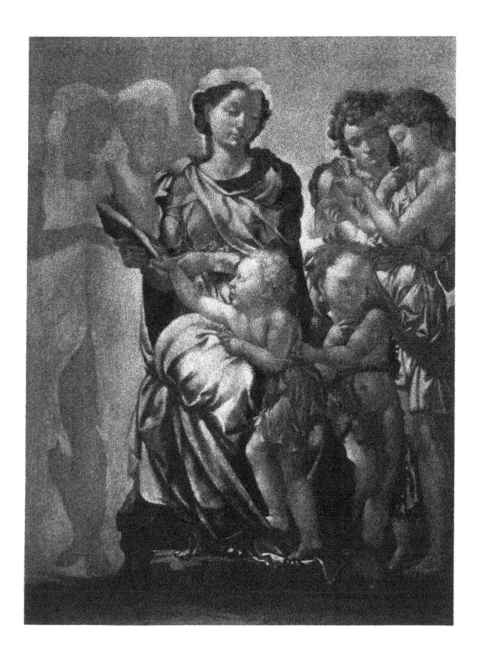

those of the first are softer and fuller, passed behind the ear, and lying on the neck.

The Virgin is entirely in the front. A clear mantle is fastened together with the ends into a strong knot on the left shoulder; it almost conceals the right arm, and is wrapped around and under the knee in many folds. A white veil lies upon her dark hair, yet so that it is visible all round. The Holy Child is reaching across her lap for the book; while his mother, holding it in her left hand, withdraws it from him, and in this the right, appearing under the mantle, assists her. It is as if she had also herself joined in the chorus, and had just wished to turn over the leaf, when the child seized the book, which she gently holds up on the left. John stands more in the background on the right, by the side of the Holy Child; the skin of an animal is wrapped round the little body, yet almost without concealing it anywhere. The light comes from the left, so that the shadow cast by the figure of the holy Virgin falls slightly over him.

The two figures indicated by a few lines on the other side, next to the Madonna, were perhaps girls, in contrast to the boys on this side. Of the coloring I can say nothing, as I have only seen a photograph.

Michael Angelo has left behind many unfinished works. His vehement, often desultory, nature was to blame for this. In this instance, perhaps, special circumstances may have concurred to efface from his memory the picture itself, and the whole remote period. If we knew where the picture came from,

we might possibly by that means obtain more light upon it.*

Michael Angelo's first notorious work, which he executed in Rome, is his statue of the drunken Bacchus. Jacopo Galli, styled by Condivi "un gentiluomo Romano e di bello ingegno,"—a noble and cultivated man therefore,—gave him the order for this work, which is still preserved uninjured. It is a figure as large as life, of which Michael Angelo's contemporaries speak with admiration, whilst moderns do not accord with this unqualified appreciation.

It is no godlike intoxication, by which we see the god overcome; no sacred fire of drunkenness, by the breath of whose flame the old poets have shown us Dionysus traversing the world; but the intoxication of a man under the influence of wine, striving to support himself, with smiling mouth and exhausted limbs. Still there is no corpulency, nothing bloated; but a youthful, well-formed figure. Compared with the antique, it is an almost disgusting imitation of earthly weakness; compared with nature, it is, in spite of all, an ideal picture of joviality produced by • wine, and rising into the clouds.

Let us hear what Condivi says. " In every respect," he writes, " this Bacchus, both as to form and expression, corresponds with the words of ancient authors. The countenance full of merry happiness, the glance wanton and craving, as is the case usually with those who love wine, he holds in his right hand a cup as he were going to drink, and looks at it as if he already in fancy sipped the wine, of which he is

* See Appendix, Note XV.

the originator. For this reason there is a wreath of vine-leaves on his brow. Over his left arm hangs a tiger-skin, because the tiger, who loves wine, was sacred to him. With his hand he has grasped a bunch of grapes, from which a little satyr, standing behind him, adroitly and cunningly steals away the berries. The satyr is like a child seven years of age, the god himself like a youth of eighteen."

That Condivi appeals only to the ancient writers, and not to the ancient sculptures, is a token of the unconcerned manner with which, even in his days, antiquity was regarded. They used what it offered; but to be influenced by it occurred to no one. Scenes from the Greek mythology were transferred to the most modern history, just as had before been the case with the biblical narrative. Mars is a naked Florentine; Venus, a naked Florentine girl; Cupid, a child without clothes. It never entered into the artist's mind to wish to improve the nature which he saw before him by any antique model, — to " idealize," as the technical term is at the present day. It would have been contrary to nature, had Michael Angelo wished to represent a drunken Bacchus otherwise. He is a naked youth intoxicated with wine. The statue is executed in the finest manner. His limbs are pure and blameless. We might say, that the nature of the old Donatello prevailed in the young Michael Angelo. But, if the countenance of the statue has something in it commonly natural, the ground for this lies in his wish to give it a mild, but evidently Silenus-like tone.*

* See Appendix, Note XVI.

But we are recalling to mind once more the rev-
elling god of the Greeks, whose brilliant beauty
restrained the rebel mariners, and dried the tears of
the forsaken Ariadne. Penetrated by feelings of this
kind, and biassed besides by the remembrance of the
works of the Greek sculptors, nothing of which was
known in Michael Angelo's time, we must at the
present day carry ourselves back to his point of view
to do him justice. Michael Angelo's statue is placed
in the gallery of the Uffici, in a dull, uniform side
light. Shelley, the great English poet, calls it in
one of his letters a revolting misunderstanding of
the spirit and the idea of Bacchus. Drunken, brutal,
foolish, it is, he says; a picture of the most detestable
inebriety. The lower half is stiff; the way in which
the shoulders are placed with the neck and breast is
inharmonious, — in short, it is the incoherent fancy
of a Catholic, who wished to represent Bacchus as a
god.

Thus unjust does ignorance of the more imme-
diate circumstances make us. Shelley knew none
of the conditions under which this work originated. •
Yet he revokes his judgment himself. " The work,
however, considered in itself, has merits," he re-
marks further. " The arms are perfect in their
manly beauty; the frame is powerfully modelled,
and all the lines flow with boldness and truth, one
into the other. As a work of art, unity alone is want-
ing; he should be Bacchus in every thing." This
appearance of lack of unity, of which Shelley com-
plains, arose from the fact that the statue was badly
placed. In the court of the Palazzo Galli, in Rome,

Statue of Bacchus.

MICHAEL ANGELO.

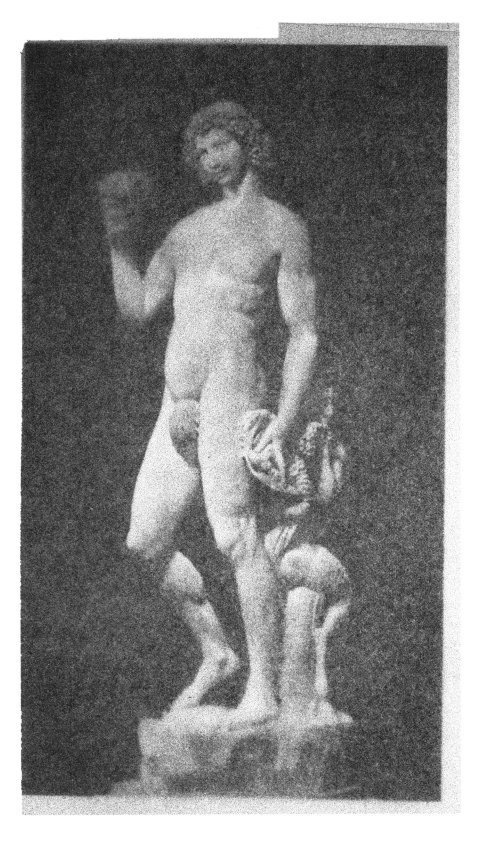

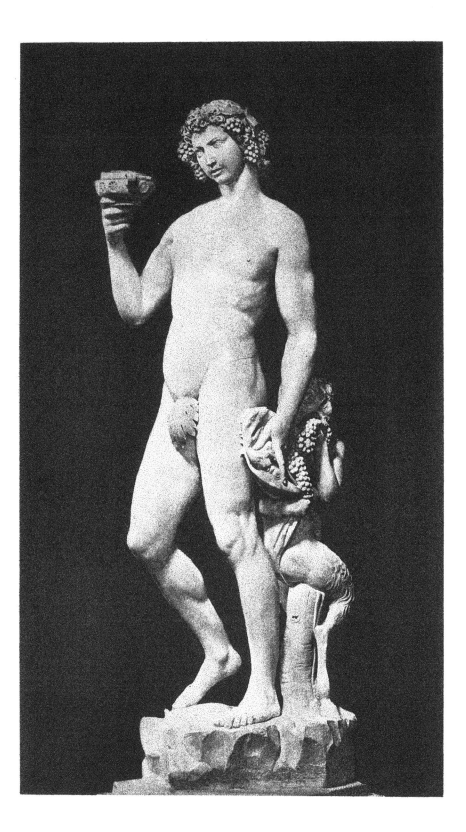

where it was even in Condivi's time, the cool bright-
ness streaming down upon it from the open sky must
have given it a very different effect.

For the same Galli, Michael Angelo executed a
Cupid, which was likewise to be seen in the palace
of the family, and was then lost, till it seems to have
come to light again in a statue in the Kensington
Museum.

5.

If the Bacchus stands in a disadvantageous light,
it is at least visible. Michael Angelo's principal
work, however, — that work by which he suddenly
passed from being an esteemed artist to be the most
famous sculptor in Italy, — is at the present day as
good as veiled: the mourning Mary with her dead
son in her lap, — " la Pietà," as the Italians call the
group. The Cardinal of San Dionigi, a Frenchman,
commissioned him to do it. Placed at first in a side
chapel in the old Basilica of St. Peter, it received
another place on the rebuilding of the church, and
now again stands in a side chapel of St. Peter's, so
high, however, and in such a fatal light, that it is for
the most part impossible to obtain a sight of it,
either near or at a distance. Copies, which differ-
ent sculptors executed for Romish and Florentine
churches, are out of consideration. There is noth-
ing left but to stick to the plaster cast.*

The material, however, is an essential element in
sculpture. Wood, marble, and bronze, require each
peculiar treatment. A work in bronze cannot be

* See Appendix, Note XVII.

mechanically copied in marble, without losing a part
of its meaning ; still less can a work in marble en-
dure the mechanical imitation in metal. Gypsum
is, however, scarcely a material, but a negative dead
substance, which only gives a motionless heavy
repose, instead of the tender, transparent, almost
moving surface of the marble. That ideal similarity
with the human skin, — the soft, lightly-changing
surface and lines of which the beautiful stone is
capable of assuming, — is lost in gypsum ; still it
is indispensable, as is well displayed on the .very
occasion in which it is inveighed against as bad.

A closer examination of the Pietà shows us how
the unusual finish of the detail is linked with a won-
derful harmony in the whole. On all sides, the group
presents noble lines. The position of the two figures
with regard to each other is the usual one ; many
painters before Michael Angelo have so represented
Mary and Christ. But how far does Michael Angelo
surpass them all ! The position of the body resting
on the knees of the woman ; the folds of her dress,
which is gathered together by a band across the •
bosom ; the inclination of the head, as she bends
over her son in a manner inconsolable and yet
sublime, or his, as it rests in her arms dead, ex-
hausted, and with mild features, — we feel every
touch was for the first time created by Michael
Angelo, and that that, in which he imitated others
in this group, was only common property, which he
used because its use was customary. Only workmen
and bunglers speak of stolen ideas. Mental property
consists not in that which may be taken from a mas-

ter, but in that of which no one can rob him, even if he himself would allow it. Michael Angelo would not have been able to make use of the ideas of others. They would have burdened him instead of advancing him.*

Our deepest sympathy is awakened by the sight of Christ. The two legs, with weary feet, hanging down sidewards from the mother's knee; the falling arm; the failing, sunken body; the head drooping backwards, — the attitude of the whole human form lying there, as if by death he had again become a child whom the mother had taken in her arms; at the same time, in the countenance, there is a wonderful blending of the old customary Byzantine type, — the longish features and parted beard, and the noblest elements of the national Jewish expression. None before Michael Angelo would have thought of this; the oftener the work is contemplated, the more touching does its beauty become, — everywhere the purest nature, in harmony both in spirit and exterior. Whatever previously to this work had been produced by sculptors in Italy, passes into shadow, and assumes the appearance of attempts in which there is something lacking, whether in idea or in execution; here both are provided for. The artist, the work, and the circumstances of the time, combine together; and the result is something that deserves to be called perfect. Michael Angelo numbered four and twenty years when he had finished his Pietà. He was the first master in Italy, the first in the world from henceforth, says Condivi; indeed they

* See Appendix, Note XVIII.

go so far as to maintain, he says further, that Michael Angelo surpassed the ancient masters.

How was it possible, that, at a period when the breaking-up of all political, moral, external and internal religious things was to be expected, that in Rome, the centre of corruption, a work like this Madonna could be produced, could be deeply felt in its beauty, and paid for dearly by one of those very cardinals?

Questions were at that time started respecting the work, on which no one now-a-days would have thought. Mary was considered too young in relation to her son. Both figures stand so remote from us, as regards their external earthly life, that this would scarcely occur to us at the present day; but the matter was important to the Italians at that time, and was much disputed. Condivi applied to Michael Angelo himself; and the latter gave him an explanation which we find noted down in his own words. " Do you not know," he answered me (says Condivi), "that chaste women remain fresher than those who are not so? How much more, then, a virgin . who has never been led astray by the slightest sinful desire? But yet more, if such youthful bloom is thus naturally retained in her, we must believe that the divine power came also to her aid, so that the maidenliness and imperishable purity of the mother . of God might appear to all the world. Not so necessary was this in the Son; on the contrary, it was to be shown how he in truth assumed the human form, and was exposed to all that can befall a mortal man, sin only excepted. Thus it was not

necessary here to place his divinity before his humanity, but to represent him at the age which, according to the course of time, he had reached. It must not, therefore, appear amazing to you, if I have represented the most holy Virgin and mother of God much younger in comparison with her Son, than regard to the ordinary maturing of man might have required, and that I have left the Son at his natural age."

It is peculiar to the Romanic nations to feel religious things more materially than is possible to us. With us, religion and morality coincide ; with the Romans, they are separate territories. The kingdom of God, which in our minds resists all form, is to the Romans a kingdom situated above the clouds, containing an ideal copy of human actions. Around the throne of God (the *sommo Giove*, as Dante calls him), the saints are encamped in different degrees of rank, down to the baser souls ; just as the princes, the nobles, and the common people gather round the pope. Rapture is the path that leads them there. The necessity of obtaining a sure place one day in this paradisaical state, is innate in every Roman ; and the Romish religion contains teachings as to its nature, and the ways that lead to it. Thus the Roman sees his immortality represented to him beforehand. More veiled, when he reflects upon it distinctly ; more certain, when his fancy-filled longing raises him towards it, when he dreams of splendor and gold and jewels, when he trembles before a sea of burning fire, or bathes with eager sensuality in the bright streams of knowledge. What do we

possess on the other hand? Each has to seek his way there alone. A calm expectation, with the certainty of knowing nothing, but yet of fostering no vain hope of a higher existence,— this is all that we profess, instead of those sure, glorious images. The saint shows himself to us more in thought and deed; and Christ himself, when we read how he walked and lived upon earth, still does not appear to us with a firm countenance and in an earthly form,— so that we desire to see in exact lines his hands, the folds of his garments, and the motion of his feet: but we seek to surmise the thoughts which he cherished, and to accompany him mentally to his very last moments. The outward image of his sufferings is almost too touching for us to bear its representation.

With the Romans, this inner life stands more in the background. In the same degree as they see the material more distinctly, their thoughts vanish into more general feelings. With us, exactly the opposite is the case. And these feelings, which spring less from that which is done and thought daily, but which hover over their hearts like a constant higher atmosphere, are as necessary to them as the air they breathe. Even in those times of the greatest corruption, they were not wanting. Only those clergy who were at the helm, and represented religion, were reprobate; the longing after the pure and the divine ever existed; and the attention of all Italy to the voice of Savonarola proves most plainly what an ardent desire filled men's minds to free themselves from the burden of those parasitical representatives

of God upon earth, and to return to the pure mean-
ing of true Christianity.

It may indeed be maintained, that those times
were more capable than our own of conceiving the
characters and events whose connection is related
in the New Testament. What is not requisite to
express that glory on the countenance of Christ,
which appeared after that conflict which has for eigh-
teen centuries moved the world to tears? We hear
of it first as children, when we cannot know what
treachery and desertion, what life and death, signify.
And even our subsequent life, though we may suffer
shipwreck, never lets us strike against the rock so
plainly. It is ever only mingled feelings which move
us: few of us are by personal fate reminded of the
tragedy of Christ's sufferings, which exhaust all
the sympathy of which our imagination is capable.
To die as the lowest malefactor, between malefactors;
to be betrayed and denied by those among his nearest
friends; to doubt himself at last, and to feel himself
forsaken of God for a moment; and to be obliged to
do without consolation in him who alone remained
faithful! And all this the reward of what? That
men should calmly and purely follow in his steps, who
was helpful to all, and injured none. Who endures
circumstances at the present day, which lead to
the experience of even a reflection of this fearful
destiny?

Such were the times, however, in which Michael
Angelo lived. The prophecies were now fulfilled
which Savonarola had declared respecting himself.
He had more than once foretold that his course

would bring him to death. Step by step he approached this end, until it was realized. And in Rome, where tidings from Florence, in its most accurate details, was received daily, these events must have unceasingly filled Michael Angelo's thoughts, while engaged in his Pietà.

The year 1496, in which he left Florence, had been quiet compared with the following. The Piagnoni, the name borne by Savonarola's party,* were in the ascendency; and neither plague nor famine in the city, nor war with Pisa, nor the threats of the Italian league, could confound them. They relied upon France, where a new campaign was in course of preparation. Even the arrival of the King of Rome alarmed them not.

The Italian campaign of Maximilian sprang from one of those romantic ideas which led this prince to undertakings, out of which nothing arose. He had acknowledged Ludovico Sforza as Duke of Milan, after the young Visconti, with whose life the posses sion was connected, had at length perished. Ludovico, who attempted in every manner to regain Pisa, . and felt himself not strong enough against the Venetians, who pursued the same object, both being united for a while against Florence, wished to engage Maximilian in his interests, and knew how to make it evident to him that an expedition to Italy must have the most splendid results. Pisa and Florence were old imperial fiefs; if he came, he would have to decide. The allies would naturally submit to his verdict, and even Florence would yield to him; and

* See Appendix, Note XIX.

so, while he strengthened his own authority by the settling of the most important dispute, he would help him, his most faithful confederate, to the possession of Pisa, which in other hands would be but an increase of power to his enemies. Maximilian had neither money nor troops; Ludovico held out to him a promise of both. So he appeared, and sailed from Genoa to Livorno, which was held by the Florentines. The result did not meet his expectations. The Venetians, instead of yielding, sent fresh troops to Pisa; the Florentines absolutely repulsed him, and he was obliged to march back to Germany as he had come.

When, however, they learned in Florence that the new military expedition of the King of France was advancing with no definite aim; that the corn-vessels of the Florentine merchants, which arrived from Provence, had been captured or frightened away close by Livorno; and that the pestilence increased,— the different parties opposed each other with greater rigor. There were three of these in the city,— the friends of the Medici, the enemies of Savonarola, and his adherents. The first were called Palleski, from the arms of the Medici, which consisted of a number of balls, *palle.* The enemies of Savonarola were called the Arrabbiata; that is, the infuriated: he himself had given them the name. The Piagnoni, however, exceeded both. Their processions filled the city; their prayers, and the sermons of their leader, were the main weapons with which they conquered. He, however, ruled, and every thing tended only to strengthen his power and authority. When

the offers of the Italian league became more and more enticing, and the prospect of the coming of the French army grew more and more uncertain, he held fast to hope, and persisted in his purpose. In the midst of the famine which spread over the city and the surrounding neighborhood, so that the country people came in in troops, and lay in the streets half dead with hunger, he organized the charity of his party. The carnival processions, in which children with wreaths of flowers, in white garments, and with red crosses in their hands, collected gifts, concluded with a distribution to the modest poor. Once, when in the year 1496 the distress was greatest, he arranged an immense procession; and, just as all the streets were full of people, a courier came at full speed through the gate with the tidings that one of the expected corn-vessels had arrived. There is something touching to read how the horseman, holding a green bough in his hand, worked his way through the excited throng, over the Arno bridge, along the banks, to the palace of the Government. Such apparent wonders increased Savonarola's power. to an unlimited extent. There is no trace left of his having misused it.

At Christmas, 1496, he gathered together, in Santa Maria del Fiore, more than thirteen hundred boys and girls up to eighteen years old, that they might receive the sacrament. The piety of the children in the midst of this threatening period touched the people around so deeply that they burst forth into loud weeping. The carnival of 1497 brought a repetition of the religious plays of the

former year. A pyramid was again raised of objects of condemnation, and set on fire; and the houses which had contributed to it received a blessing. There were again dances, singing of religious songs, and the cry, "Viva Cristo il re di Firenze! Viva Maria la regina!" At times, however, this cry became too infuriated even for Savonarola; and he warned from the pulpit against the misuse of the sacred words.

The enthusiasm which he excited had its more sober side. When we hear of dances, and see the songs which were written at these festivals of greater frenzy,—*maggior pazzia*, as he himself called them; when we think how young and old were drawn into them; how he incited the children against their worldly parents, formed them into a public guard of morals, so that they might accost people in the streets, and walk into houses; how prayer and song unceasingly interrupted daily life, — all seems carried to extreme, and the dominion of morbid ideas appears brought to a point which must gradually lead to madness: but, more closely considered, things wore a different aspect. The basis of his doctrine is no puritanical code of morals, but the opposition of crime and the maintenance of public morality, such as is carried out with us everywhere at the present day without resistance. He never required aught that was extraordinary from men; but public life was indeed of such a nature, that instructions which seem natural to us appeared insufferable to the Florentines. His instructions,

how the day was to be begun, and business carried on, how decorum was to be attended to, both at home and abroad, are scarcely worth mention; all that seems strange in them lies rather in the general habits of the time, than in the fact that new, unprecedented things were devised by him. He never appears categorically imperative; but he explains logically the detestableness of vice and of immoderate passions. He never gives pedantic directions, but appeals to his hearers' own judgment. He thunders against his enemies, and invites men to turn against them, as he himself has done; but no word can be proved in which he alludes to violence against them. Indeed, it appears from his sermons, that, even at the time when he could really have done any thing, he used no compulsion. When he calls upon honorable women again and again to dress themselves modestly, and not to make way in the streets for worthless girls and courtesans, but to push them proudly and fearlessly aside, we see how little he could do to overcome luxurious life in Florence; for he gives these admonitions incessantly in his sermons, — a sign that the worthless girls and courtesans were not prevented from playing a part in 'the streets.

As the strife of parties thus continued, that in the consiglio grande incessantly ebbed and flowed. It shows what freedom existed, and how cautiously the Piagnoni, in spite of their superior power, kept themselves from any hostile collision. Even their dances have something natural in them. It was an old idea to think of eternal blessedness as a dance.

Fiesole paints the joys of Paradise in a dance of angels, who form long chains, hand in hand alternately with pious monks, and soar upwards, singing. This was the idea of the pageants which the customs of the city demanded of Savonarola. When in earlier, calmer times, he had gone out into the country with the monks, as prior of his monastery, and they, sitting in the wood, had disputed learnedly over theological matters, and had listened to his words, he had made them dance when their exercises were finished. Lastly, the songs sung, with their strange words, were not to be taken in a common sense: they harbored a deeper mystical purport, as was natural to the theological views of the time.

It was just this restraint of the Piagnoni which made a more effective opposition possible on the part of the Arrabiati. Emissaries from Florence directed their efforts in Rome towards putting a stop to Savonarola's proceedings. At the end of 1496 came the third admonition from the pope to abstain from preaching. Savonarola had answered it in writing, and had kept quiet for some time; then, however, at the request of the Florentine Government, he again ascended the pulpit in spite of the pope. He might perhaps have carried his point; for the necessity of a reform was felt most deeply at Rome, and they wished at the same time to attract the Florentines by concession. Savonarola, however, now acted somewhat decidedly on another point. He began to interfere more deeply in the government of the city; his party committed

errors in this department, and themselves contributed to his fall.

The union of the Arrabbiata and Palleski had gradually become so complete, that they formed the majority in the consiglio grande. The consiglio had the right of filling the offices of the State, and the majority gave the casting vote. Hitherto the Palleski had voted with the Piagnoni, because, with the Piagnoni in power, they could excite the public mind for the Medici better than under the Arrabiati, who turned energetically against both sides, and, demanding liberty without Savonarola, demanded it also without the Medici. The Piagnoni, on the contrary, would constantly admit some of the Palleski into the Signiory, in gratitude for help afforded; and upon this Piero dei Medici had based his plans.

The Piagnoni knew this. They determined to admit no more Palleski into the Signiory. The Arrabiati, whose rage against Savonarola increased daily, made concessions to the Palleski, and thus the two ultra parties became united against the middle one.

The Piagnoni saw themselves in the minority, and reflected how they could strengthen their side. Francesco Valori, who was gonfalonier for January and February, 1497, effected a change in the constitution, which was intended to restore to his party their lost superiority. Valori stood in such close connection with Savonarola, that it is to be presumed that the plan was devised by him, or at least that he approved of it.

Hitherto, thirty years of age had been necessary

to obtain entrance into the consiglio. From hence-
forth, four and twenty was to be sufficient. Savon-
arola reckoned upon the enthusiastic youths, upon
the young men, who belonged to him as children,
and upon the children who yet heard him, and were
rapidly growing up.

In order to carry out the proposed plan, the Pal-
leski had shown themselves ready once more for
union with the Piagnoni; but they required, in re-
turn, that they should be chosen in considerable
number in the Signiory for March and April. They
had their secret plans. Famine kept the city in
tumult; on the 10th March, the market-place was
stormed by the common people. The masses had
always been favorable to the Medici; and the Pal-
leski did their best not to let the remembrance of
the old indulgent lords be lost.

In order not to excite the smallest suspicion, the
Government recommended Savonarola's cause to the
pope. In secret they negotiated with Piero. Secret
messengers passed hither and thither with letters.
It was settled when he was to arrive before the city,
when he should find the gates open. The Orsini
had levied the necessary troops. On a feast-day,
when every one was in the country, the attack was
to be carried out. It took place on the 28th April.
Piero appeared with his horsemen before the gate of
San Piero di Gattolini; wide open stood the portals,
and he could see along the street far into the city,
which no one defended. For four hours he thus
stood, and ventured not to enter; for not a soul
stirred in his favor.

In the meanwhile they had had time within to re-
cover themselves. The Signiory had before appeared
suspicious ; the nobles were now secured in the
palace, the gates of the city were closed, and the
cannons mounted. Piero turned back with his horse-
men, and arrived again at Siena at evening, just as
he had ridden forth in the early morning. There
was no evidence in Florence against the Signiory.
Their period of office had expired ; they resigned,
and their successors took their place. This time,
however, it was the Arrabbiata who came to the
helm !

Valori's measure was to blame for this. The new
youthful members of the consiglio had voted for the
first time. Instead, however, of being ardent for
Savonarola, they manifested quite another feeling.
Young men are no longer children. Hitherto they
had been compelled to endure quietly the prohibition
of their old merry life ; now they possessed voice,
power, and influence ; and, though entering the hos-
tile camp with drums and fifes, they caused the
situation of things suddenly to change ; and, while
every thing had been done for Savonarola by former
governments, nothing was now neglected by which
they could crush him. Lampoons and satirical
poems appeared against him. In Rome, where the
Florentine ambassador had hitherto contrived most
artfully to keep back the intended excommunication,
contrary instructions suddenly arrived. Fra Mari-
ano di Ghenazzano, who once had preached against
Savonarola, at Lorenzo's order, and had been
recently banished from Florence because he had

helped to organize the unsuccessful rising in favor
of Piero, urged at the Vatican for decisive measures.
The Franciscan and Augustine monks at Florence,
the old enemies of the Dominicans, rose with un-
wonted boldness; and matters soon reached such a
height in the city, that Savonarola's personal safety
seemed endangered.

Among the younger nobles of the Florentine citi-
zens, a union was formed, called the Companions, —
gli Compagnacci. Their object was to restore the old
Florentine street disorders. On the 1st May, the
new Signiory entered on their office; and on the 3d,
when Savonarola was preaching in the cathedral,
the Compagnacci proceeded to open scandal. He
was going to mount the pulpit, when he found it
hung with an ass's skin, and defiled with dirt. It
was removed; the sermon began; in the midst
of it a hellish noise broke out; he was obliged to
leave off. Surrounded by his adherents, who fol-
lowed him armed, he turned back to San Marco;
and, with the same imposing escort, he appeared
daily in the cathedral, where the peace was not dis-
turbed.

On the 12th May, Alexander Borgia signed the
excommunication. Forbearance was exhausted;
Savonarola's ejection was to be made publicly
known, and preaching was to be prevented by force.
But the pope's commissioner ventured not to bring
the excommunication personally to Florence; he
communicated it to the Signiory from Siena, and
they likewise possessed not the courage to proclaim
it publicly. They excused themselves by saying that

they had not received it direct, but second-hand. The Augustine and Franciscan monks, on the other hand, declared they would not take part in the great procession of the Feast of St. John, if the Dominicans were admitted. It was therefore intimated to the latter to keep at home on that day.

But Savonarola, after the blow had at length fallen, felt himself free from all fetters. He published an answer to the pope's bull of excommunication, in which he represented Fra Mariano, the author of this letter of condemnation, as a man who had expressed the most shameful things against the pope himself, and had acted treacherously towards him. In a letter, addressed to all Christians, he protested against the reproach of having preached heretical things, and of having refused obedience to the pope and the Church. He called the excommunication invalid. We are only to obey our superiors, he asserted, so far as their commands accord with God's word.

In saying this, however, he at any rate cast aside all obedience. Yet, to prove how necessary his • course of action was, he now thundered against the vices of Rome with a severity and candor, compared with which his former sermons appeared but as faint intimations. And the literary friends on his side attempted to question the competence of the pope.

May and June passed away. The Arrabbiata, in spite of their energy, had been able to effect nothing decisive. The Palleski separated from them again, and, united with the Piagnoni, created a Signiory for July and August, who at once overturned every thing

which the Arrabbiata had done. Every effort was
made in Rome to effect a revocation of the ecclesi-
astical punishment. Influential cardinals used their
interest. The monks of San Marco drew up a
defence, which, furnished with a long list of signa
tures, was sent to Rome.

Borgia, however, had his own method. He insisted
that Savonarola should personally appear before him.
If he exculpated himself sufficiently, he would dis-
miss him with his blessing; if he found him guilty,
he would punish him justly, although mercifully.
But every one knew what blessing and mercy signi-
fied here. The means which Cardinal Piccolomini
proposed were more simple. Five thousand golden
florins, he thought, would alter the pope's senti-
ments. The sum could have been easily raised.
Savonarola declined this, as he had before declined
the cardinal's hat, with which his silence was to have
been purchased.

Thus they negotiated between Rome and Flor-
ence, when suddenly secrets came to light, which
stirred up the strife of parties into fury. The con-
spiracy by which Piero had designed in April to
make himself master of the city was discovered.
It was proved that the Signiory for March and April
had plotted for the subversion of things; and, worse
still, that, in the middle of August, a new rising in
favor of the Medici was in contemplation.

Five men of the first families, among them the
former gonfalonier himself, were apprehended, and,
after a short examination, were sentenced to death.
The plan was evident, the guilt was not to be denied.

All was betrayed, — not only the day, but the lists of the families whose houses and palaces were to have been given up to the destruction of the common people. Still more, two of the condemned ones, Gianozzo Pucci and Lorenzo Tornabuoni, who had hitherto appeared as the most devout adherents of Savonarola, had, as it now came to light, assumed this mask that they might intrude themselves into the conferences of the Piagnoni, and possess themselves of their secrets.

The latter felt as if they had rested on a volcano. To avenge themselves, they had only to demand justice.

But one way of escape stood open to the condemned, — an appeal to the consiglio grande. Valori had introduced this appeal himself. Now for the second time it occurred, that regulations which his party had made, in their own favor, had an opposite effect. The Tornabuoni, Pucci, Cambi, and Ridolfi belonged to the first families in the city, and could reckon on their adherents among the people. Bernardo del Nero, the treasonable gonfalonier, — an • honorable man, but for his old friendship and grateful attachment to the Medici, — pure and unblamable, and seventy-five years old, might not appeal in vain to the pity of the citizens, to whatever party they might belong.

The Signiory were in the most difficult position. The acquittal of the accused by the consiglio grande might have induced the Piagnoni to rise in arms, to execute the vengeance which the Government refused. But not to permit the appeal was against

the law. In Rome, in Milan, in France, the Medici strained every nerve to raise an interest for the victims of their policy. Francesco Valori, however, baffled every attempt at rescue. His house had been among those which was to have been stormed and plundered. Giovio asserts that the burning hatred of this man against Bernardo del Nero decided the matter. The remaining four had been his friends; but, for the sake of striking this one, he sacrificed all. After the most impetuous scenes among the members of the Government, it was declared that the higher consideration for the welfare of the State made the suspension of the law under the present circum stances necessary; and the five were put to death.

Whether Savonarola brought about this deed, or could have prevented it, and neglected to use his influence, is not to be said. It is only certain that they wavered, and that Valori's energy turned the scale. He, as the most zealous adherent of Savonarola, threw a greater responsibility upon him. It lay in the nature of the matter, that it should thus be judged of. Savonarola appeared as the author of the resolution; and his guilt reflected on the sect of the Piagnoni. They had made the law, — they had evaded it. There could be no heavier accusation in this commercial State, so strict in its regulations as to the observance of its laws. A reproach from henceforth could be raised against it which allowed of no excuse. Circumstances might have been ever so cogent, but the law had been disregarded. "From this moment," says Macchiavelli, " it fared ill with Savonarola."

Still the Government remained until March, 1498, in the hands of his adherents. In Rome, matters continued the same. The pope demanded his personal appearance; Savonarola replied by books and letters. The clergy of Santa Maria del Fiore, the archbishop at their head, would not suffer that an excommunicated person should mount their pulpit; the Government ceased to oppose. The crowd of people was immense when Savonarola preached. The carnival was celebrated for the third time according to the rites he had prescribed. Never did the power of the man appear so great as at that period; and yet the crisis was near at hand which was to be the end of his work and of his life.

6.

I find, wherever mention is made of Savonarola, his decline is too much represented as the result of the efforts of his enemies and of papal anger. The constraining cause of his fall was the waning of his magic power. The people grew weary, — their minds needed fresh stimulus. For a long time he •
succeeded in exciting the declining enthusiasm. But, while it seemed outwardly even to increase, its vast strength was consuming. Savonarola arrived at a point where he must have been a god to hold his ground further.

The great families of the State belonged, from the first, to the adherents of the Medici, or to Savonarola's systematic adversaries, the Arrabbiata; only a few joined the Piagnoni, and these were such as ambition as well as internal conviction placed on

Savonarola's side. Since the introduction of the consiglio grande, in which every citizen, poor or rich, had his one vote, the nobles daily felt how much they had lost in the re-organization of the State. People of low degree — artisans coming from their workshops — attained to the highest offices of the State by the majority of votes on their side. The severity with which the laws against luxury were enforced, appeared like a revenge on the part of the less wealthy against the rich. The execution of the five conspirators also assumed the appearance of revenge. It was to be shown, in a striking manner, that neither their rank nor their wealth protected them. More and more, such feelings mingled with the first pure religious enthusiasm. They were for Savonarola; but they were also for Valori, and for others who with him led the multitude. Thus it was again a few noble familes, who usurped, through Savonarola, the direction of the State, and drew the lower people after them.

Outwardly, things advanced not. Pisa was lost; Charles VIII. returned not; no agreement was to be come to with the pope. Famine and pestilence had severely attacked the city; commerce could not longer endure the continued insecurity. And thus the clouds gathered together against Savonarola, as before against Piero; and the feeling gained ground, that the general state of things was not the right one.

Savonarola surveyed the position of affairs. He had anticipated and predicted his fall; but he was not willing to yield without a struggle. He could

subdue the opposition in Florence; but his enemies at the Vatican remained invulnerable so long as Alexander was there: he must strike him. By forcible letters to the highest princes of Christendom,— to the emperor, the kings of England, Spain, and France,— he demanded, while he appealed to the acknowledged depravity of Borgia, and the necessity of a reform in church government, the forming of a council by which the pope should be judged and deposed. One of the letters, addressed to Charles VIII., was intercepted by Ludovico Sforza, and sent by him to the Vatican.

The severe sermons of Savonarola had caused the pope no uneasiness hitherto. Borgia troubled himself but little about concealing his actions, or about that which was said of them. He had greater things in his mind than this dispute with the prior of San Marco. A council, however, was the tender point in his power,— it was the only thing which the popes feared. For the opinion prevailed at that time, that the assembled cardinals could call the pope to account, and depose him.

Alexander called upon the Government of Florence to prohibit the preaching of Savonarola, and to deliver him up to Rome. He expected no written justification, but actual obedience. In case of refusal, he threatened to lay the city under an interdict. Savonarola from henceforth preached no longer in the cathedral; but he did so all the more vehemently in the church of his monastery. This took place early in March, 1498. He urged from the pulpit that a council should be called. The

pope, infuriated, issued a new summons to Florence; he threatened to make the Florentine merchants in Rome suffer for it! but the new Signiory, although for the majority formed of Arrabbiata, ventured not to interfere at once. After stormy conferences, Savonarola, however, was at length forbidden to preach in the monastery. More against him they ventured not. On the 18th March he preached for the last time; and, while predicting divine punishment against the pope, the Romish economy, and the Florentines, moved at the same time by anticipation of his own speedy fall, he took farewell of his congregation.

Reading these last sermons, we cannot do otherwise than admire the man who, in the midst of wild and vague passions, keeping to his own pure convictions, voluntarily resigned himself as a victim to his doctrines. He could still have excited the people to fury, and have called forth a contest, the issue of which would have been doubtful. Yet he scorned other weapons than those which lie in the mind of man. He only wished to express what stood clearly before him, trusting that good would be the result. His political views were always clear and simple. He knew nothing of intrigue and self-interest. He dismissed his brother with severity, when he wished to use his interest in pushing his fortune. He led the simplest mode of life. A tone of truth pervades his words, the power of which is felt even at the present day in a manner sadly strange, converting our opposition into sentiments of pity.

We perceive so thoroughly the delusion to which

he resigned himself. At first he inspired the people, filling them with the anticipation of a nobler exist- ence. He forgot that human nature is only capable of passing moments of elevation, though these mo- ments are sometimes prolonged, and endure for a time. He, however, wished to change their sudden flames into lasting fervency; he poured into the veins of the Florentines that fire which was even consuming himself; he called forth a fanaticism, and, deceived by its power and continuance, he con- sidered it the actual beginning of a purer nature. And then at length, when, wearied himself, he wished to lean upon this strength, he was compelled to per- ceive that he, solely and singly, had possessed power, and that the echo was not a voice which could con tinue to speak when his own words were dumb. His observant mind was too clear not to have always a misgiving of this end of things: his keen eye now at once discovered it. For this reason he spoke with such certainty of his fall; and at the end of a letter to the pope, composed with perfect self-possession, and written at a time when he had no reason for apprehension, he expressed the earnest longing with which he awaited death.

After Savonarola's voluntary resignation, the Sig- niory imagined themselves spared further steps. They notified to the pope, through their envoys, that they had acted according to his wishes; and they pacified themselves for the moment. But now in Florence, and within the party of the Piagnoni them- selves, the seed which Savonarola had scattered began to bear fruit, yielding the poison to which he owed his death.

He had never set himself up as a prophet; but he had certainly exhibited himself as a chosen instrument of God, by whom the future was predicted. He had truly only declined the *name* of a prophet, that he might not be accused of arrogance, of having wished to rank himself with the prophets of the Old Testament. In his sermons, he addressed men as if he penetrated completely into their souls; he had spoken of miracles by which the city would be saved; he had communicated visions which revealed to him the will of God, and had not disclaimed the idea that miracles might be worked by himself.

In this the Piagnoni believed as an irrefragable truth. They trusted implicitly in his personal power. When Piero had appeared before the city, which stood open and undefended, and they had rushed with the tidings to Savonarola, he calmly answered that they need not close the gates on account of Piero; for he would not venture to set foot within the city. And Medici had returned to Siena! To the people, Savonarola was prophet, magician, saint, — the man to whom God had revealed the government of the city; who knew every thing, could do every thing, and whom no power could affect. His enemies, however, considered him as a deceiver, who understood cunningly how to force this superstition upon the people.

It lies, however, in the nature of the multitude, that from time to time they require to see striking proofs of the power of the man whom they consider so mighty. Savonarola had predicted the coming of the French; had announced beforehand the arrival

of vessels of corn during the famine; had said and known many things, which those concerned considered the result of his inmost mysterious power: but all this had grown old, and they desired fresh deeds. They required something with which they could intoxicate themselves anew, the mere mention of which would crush every thing which Savonarola's enemies brought forward. The Signiory had prohibited his preaching, and he had withdrawn. They cherished the hope that he would suddenly distinguish himself anew by some prodigious act, and, as had so often happened, triumph splendidly over his enemies.

Thus they thought during the Lent of 1498, when Domenico da Pescia, his most faithful adherent and companion, preached instead of him at San Marco; whilst, in the other churches, the clergy, who were otherwise inclined, raised their voices loudly against him. Francesco da Puglia, a Franciscan, who was preaching in Santa Croce, challenged Savonarola to prove by a miracle the genuineness of his doctrines. Domenico at once replied that he would go through fire for Savonarola. The word once spoken gained ground demoniacally; and soon the matter was so wrested, that Savonarola himself was to pass through the flames. His friends urged just as much as his enemies; and so sure were the Piagnoni of their cause, that all the three hundred monks of San Marco, with a number of nuns, men, women, and children, desired in common with him to stand the test.

The Signiory took the matter in hand. They in-

quired of Savonarola. He refused the test; but, urged by friends still more than by the adverse party, he at last declared himself ready. A stake was to be set up on the Piazza; and on one side Savonarola, on the other the Franciscan who was willing to lay down his life for him, was to step into the flames.

The tenets for which Savonarola was thus to answer with his life were the following: " That the Church required remodelling and reviving. That the Church would be chastised by God; that, after that, she would be remodelled, and revive and flourish. That the unbelieving would then be converted. That Florence would be punished, and then revive and bloom afresh. That all this would take place in our own days. That the excommunication decreed him was invalid; that not caring for it was not a matter of sin." The last sentence was alone important, as a denial of the papal power in an especial case; which, however, might be urged in all cases.

Savonarola imagined not, when he appeared on the Piazza on the 7th April, that at the same hour King Charles of France was breathing his last. Apoplexy carried him off at Amboise. Had matters gone as Savonarola hoped, he would once again have liberated Italy; he would have given back Pisa to the Florentines, called a council, appointed another pope, and then opposed, conquered, and converted the unbelieving. Many men of power shared this idea, though from less noble motives. Nothing of this had, however, taken place; the king had died, and fate regarded not the thoughts of those who had

supposed they could form the future according to their own will.

Across the Piazza, a raised path had been prepared, which, piled upon both sides with inflammable matter, could be converted into an avenue of flames. Armed men closed in the square; the people crowded round it, and filled the windows of the surrounding buildings. Franciscans and Dominicans appeared in procession, — the former silent, the latter singing religious songs. The test was to begin. The Franciscans raised objections. Savonarola ought, they said, to change his garments. They conjectured that some magic might rest in them. They examined him to the bare skin. They would not permit that he should take the host with him into the fire. He would not, however, give it up. They disputed; the time passed; impatience and hunger tired out the people; it began to rain: the day was wasted without any thing taking place; the report spread, that Savonarola's cowardice was the cause of the delay. At length it was announced that the fiery test was at an end for that day.

It was the Piagnoni who suffered most deeply from the feeling of having been undeceived. They had reckoned on the splendid satisfaction of their pride; they were now laughed at for it, and had nothing to rejoin. It occurred to no one, as has been often subsequently asserted, that the delay was artfully brought about by the Signiory, in concert with the Franciscans; and that the effect was just what had been expected. Without having a hair singed, the Franciscans retreated in triumph; whilst Savonarola

was obliged to be defended with arms against the crowding multitudes on his way to San Marco. Arrived there, he entered the pulpit, related all that had happened, and dismissed his adherents.

So far is an ascertained fact, that, on the 30th March, — three weeks, therefore, before these events, — the Signiory had taken the secret resolution, that the brethren of San Marco, or the Franciscans, according as the ordeal should turn out, should leave the Florentine territory. On the 6th April, — while as yet there was only mention of Domenico da Pescia, and not of Savonarola, — they had come to the second determination, that Savonarola, in case Domenico should perish in the fire, should leave within three hours. Lastly, a third resolve *is said* to have been brought about, to this effect, — that under no circumstances should the Franciscan be allowed to stand the test. They feared, therefore, the realization of the miracle ; and, in the camp of the enemy itself, they believed in Savonarola's divine power. Still it has never been possible to produce proofs of the existence of this last resolution.

Many of the Piagnoni fled at once; others remained armed in their houses, or repaired to the monastery of San Marco, where they placed themselves in a state of defence. It was not at that time a rare occurrence, that monasteries should be converted into fortresses. The sons of the most distinguished families had entered San Marco, to consecrate themselves to the Church ; their relatives now came, to await and repulse the storm for their sake.

The following day, the 8th April, was Palm Sun.
day. The decree of the Signiory, that Savonarola
was to be banished from Florence, bears this date.*
Early in the morning, he preached in the church of
the monastery. At the close he foretold what was
to happen, took farewell of his people, and gave them
his blessing. It was not till evening that the stir
began among the Arrabiati. A Dominican was
preaching in the cathedral. The Compagnacci burst
open the doors, crying, and pressing upon the Piag-
noni, who fled. Outside there stood an immense
multitude. The cry sounded suddenly on all sides,
"To arms, to arms! To San Marco, to San Marco!"
The church was filled; they knocked down the doors
from without, and rushed in; within they resisted,
and defended themselves. The guard of the palace
appeared. They found the entrances to the monas-
tery barricaded, and desperate defenders behind the
gates; monks with coats of mail over their cowls,
and with arquebuses, from which they fired; and, in
the midst of them, women and children who had not
been able to leave the church, and whose cries •
answered to the roar of the multitude without. A
young, light-bearded German, named Heinrich, was
the bravest among the monks of San Marco, and
used his rifle with especial skill.

When the messengers of the Signiory had found a
hearing, they announced the order, that all those
who belonged not to the monastery were to leave it.
Whoever did not go, would be considered guilty
of high treason. Many obeyed. Savonarola would

* See Appendix, Note XX.

have voluntarily given himself up; but his party held him back against his will. They feared that the people would have torn him in pieces. The monastery had a little garden door, through which some of the most distinguished Piagnoni endeavored to escape; among these was Francesco Valori. He was watched, however, by the Tornabuoni, Pucci, and Ridolfi, with others who had so ardently awaited this day of vengeance. He was at once surrounded, and struck dead to the ground; and they now proceeded to his palace. His wife, who was standing at the window above, was killed by a shot from a cross-bow in the street below; they stormed the house, plundered it, and strangled a grandchild of Francesco's, who lay in the cradle. Soderini's house fared better. Here the archbishop of Volterra, who was a Soderini, advanced to meet the approaching multitude in the full robes of his order; and, by his appearance and thundering words, brought them to a different mind.

In front of San Marco, it had become more peaceful; the night had long ago fallen upon the monastery, before the infuriated people returned there. They set fire to it; the doors were burned down and broken through; and Savonarola was conveyed to the palace by the messengers of the Signiory, without whose protection he would have been lost. With him was Domenico da Pescia, and a third Dominican, named Silvestro. They could scarcely protect him from the ill-usage of the mob. They struck him, and cried in derision that he ought to prophesy who had done it. They called, " Physician,

heal thyself!" Dead and wounded lay on the square in front of the monastery. The monks came out, and carried them within, to help them or to bury them.

And now began a procedure, which was short, but which seems endless if we follow step by step the torments which Savonarola had to endure. The pope required him in Rome, but condescended to send a commissioner. Savonarola was put to the torture; it is accurately recorded in what manner. His powers forsook him under the hands of his tormentors; for he was a tender, sickly nature: hardly was he set free, than he revoked every thing. The torture was repeated at different times. Nardi, who is conscientious in his statements, protests that he heard from the best sources, that the reports were falsified when written down. The pope's commissioner carelessly acknowledged, subsequently, that Savonarola had been guiltless, and the procedure had been contrived, which the Florentines had had printed for the sake of their own justification. Savonarola was sentenced to death; and, on the 23d May, 1498, on Ascension Day, the sentence was · carried into execution.

The stake was erected on the square in front of the palace of the Government. In the midst of it projected a high pole with three arms, stretching out in different directions. As the three men were to reach this gallows across a kind of flying bridge, the Florentine mob stuck pointed wooden nails between the boards along the passage, upon which they trod with their bare feet.* Savonarola's last words were

* See Appendix, Note XX.

consolation to his companions, who were suffering with him. There they hung all three, and the flames enveloped them. A powerful gust of wind drove them suddenly aside; for a moment, the Piagnoni believed that a miracle was about to happen. But the fire again covered them; and they soon fell, with the burning scaffold, into the flames below. Their ashes were thrown into the Arno from the old bridge. What thoughts must have moved Savonarola's soul, when the people whom he had for years stimulated or curbed, whom he had so completely ruled by his words, stood around dull and indifferent!

7.

The severest thing of which Savonarola has been charged is the reproach of having incited his party to remove their enemies by force. So says Macchiavelli. It all came to nothing, he asserts, because the people did not understand his insinuations sufficiently. We may answer to this, that the Piagnoni were on the point many times of striking, and that Savonarola restrained them. We may further rejoin, that Macchiavelli, whose impartiality in other cases appears so admirable, allowed himself to be led by party hatred into one-sided statements concerning this man. He belonged to those who looked upon Savonarola as a well-known deceiver, and reported of him at Rome in this light. The oldest written document of Macchiavelli's which we possess is a letter respecting the incidents of those stormy days. The most thorough hatred pervades this document. Macchiavelli was at that time

10

scarcely thirty years of age, and had just entered upon civil employment.*

Whence comes it, however, that such a dark shadow is cast across the veneration which this man inspired? Let us compare him with another monk of San Marco, who lived long before him, and who has made the monastery no less famous than he. The walls of its passages, its chapels, even those of its low dark cells, are covered with the paintings of Fiesole, one of Giotto's followers, whose works, filled with a charming purity of sentiment, and elevated by a kind of sweet, calm enthusiasm, belong to the most remarkable and affecting monuments of an artist's soul.

His works, indeed, are scarcely to be numbered. In uniform gentle outbursts of fancy, he seems unceasingly to have represented his dreams. His figures have something ethereal in them. He paints monks falling down before the cross, and embracing it with trembling fervency; he paints troops of angels, who, crowded together, hover through the air, as if they were all one long outstretched cloud, the sight of which fills us with longing. There is such a direct connection between what he wished to represent and what he succeeded in painting, and at the same time that which he wished to produce was always so simple and intelligible, that his pictures make a direct, lasting impression upon all; and thus many natures are capable of being raised into the same degree of enthusiasm as that in which his paintings seem to have been created.

* See Appendix, Note XXI.

Crowning of the Virgin.

FRA ANGELICO DA FIESOLE.

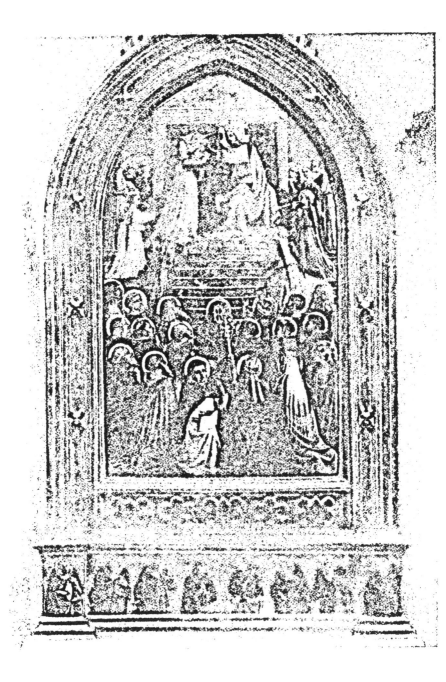

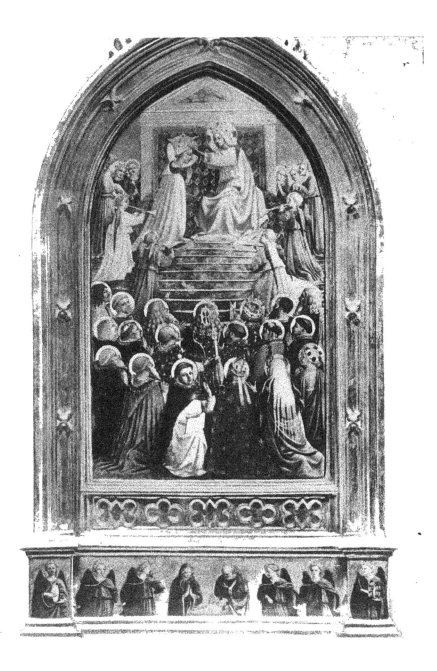

Born in 1387, — a contemporary, therefore, of Ghiberti's and Brunelleschi's, — Fiesole cast aside his vows when he was twenty-one years old ; he died at the age of sixty, in Rome, where his monument still exists. He was really a miniature painter ; this is to be seen even in his great fresco paintings. His life, according to Vasari's description, reads like a legend of the old pious ages. He was to have been prior of the convent: he, however, humbly declined the dignity ; and his whole history and his works evidence the feeling that made him so modestly draw back. And yet his influence was great, and still lasts.

If we compare the spirit of these paintings with that of Savonarola's sermons, preached by him in the hall of the monastery, from the walls of which Fiesole's works look down upon us, we perceive most keenly what Fiesole possessed, and what Savonarola lacked, — what made him so fearfully hated by his enemies. A holy zeal for the Good, the True, the Moral, and the Great, kindled his heart ; but he failed to see that without beauty the Good is not good, the True is not true, the Holy even is not holy. Thus he, the tenderest mind, became implacable, and compelled his enemies to become so also ; and thus he destroyed himself. He forgot that that which subdues and forms men most is not conscious obedience, the inclination to evil repressed by force, — that it is not the violent self-guiding persistency in one rigid line of conduct which is to lead to God ; but that the unconscious reception of a kindly example, gentle compliance with what the Good and

the Beautiful alluringly offer, and that habitual turning to the Divine, as a butterfly to the sunlight, are the true powers which lead men mysteriously but surely on. And thus Fiesole's soft, silent pictures have done more than Savonarola's thunderings, the sound of which has passed away, leaving scarcely a trace behind.

Hardly was Savonarola dead, than a halo of glory surrounded his form; the incidents of his last days were borne from lip to lip as the glorious sufferings of a martyr, and intermingled with stories of miracles. It was told how his heart had not been burnt, but was thrown up again from the depths of the Arno, and was picked up undestroyed by his admirers. His yielding in the torments of torture was compared with the example of the apostle Peter, who, under less pressing circumstances, had denied his Lord. On the other hand, the miserable death of the King of France, who was snatched away after his child had preceded him, appeared as the direct punishment of Heaven, which Savonarola had foretold. His picture, with a crown of glory round his head, was exposed for sale in the streets of Rome itself.

It is impossible to avoid the thought, that his sufferings and death were not without their influence upon the creative mind of the painter.

Michael Angelo completed the Pietà in the year 1499, or in the succeeding one, and returned to Florence.

CHAPTER FIFTH.

1498 — 1504.

Louis XII., King of France — Position of the Florentines in Italy — The Madonna at Bruges — The Madonna in the Tribune at Florence — Cæsar Borgia before Florence — The David at the Gate of the Palace of the Government — The Twelve Apostles — The Copy of the David of Donatello — The Erection of the David — Leonardo da Vinci — Perugino — Michael Angelo's Adversaries — Death of Alexander Borgia — Leonardo's Cartoon of the Battle of the Cavalry — Leonardo contrasted with Michael Angelo — Cartoon of the Bathing Soldier — Raphael in Florence.

THE death of the King of France had been favorable for Florence. His successor, the Duke of Orleans, who ascended the throne as Louis XII., possessed the mental capabilities which Charles VIII. had been devoid of. There was an end to the *dilettante* struggling for fame and empire. Louis, when he came to the throne, was a matured man, whose long-cherished plans were now to be systematically carried out. His thoughts had long ago been much turned to Italy. His grandmother had been a Visconti. Upon this he urged his claims to Milan ; and at the same time he prepared to renew with fresh vigor the war with Naples.

The fidelity of the Florentines to France was now rewarded. Two enemies threatened the city, — the

Medici, and Cæsar Borgia, who could not do with-out Florence for the central Italian kingdom, which he was on the point of founding for himself. Medici and Borgia both stood on excellent terms with France, and hoped for the help of the king, who held out to them just as many hopes as were neces-sary to chain them to his policy, but allowed neither of them seriously to attack the Florentines. For the French tendencies of the free citizens appeared justly to the king a surer pledge for the adherence of the city, than the gratitude of either Piero or Cæsar, which he knew by experience.

Matters were therefore prosperous in Florence. She had joined with Venice. Pisa was supported no further; and Louis even sent auxiliary troops. Among the citizens, too, a change for the better had taken place. The Piagnoni at first fared but badly, and the poor friars of San Marco worst of all. Peti-tions to the pope, of the most abject submission, were required to effect a pardon. Their bell, called the Piagnona, was legally condemned as a malefactor, and was taken from the monastery; and the unfortu- . nate Cronaca was charged with the execution of the sentence. Thus the adherents of the ruined prophet were not spared, but were made active against themselves. The Arrabiati fumigated the polluted churches with brimstone ; they chased a horse through Santa Maria del Fiore, and killed it at the entrance. The Piagnoni themselves — depressed, at variance, and full of dread — scarcely ventured to show themselves in the streets, where the old luxury of splendid attire again appeared triumphant.

Yet scorned as they were at first, and annihilated as a political party by the death and exile of their heads, the books were soon given back to those who had been obliged to deliver up the writings of Savonarola. The Signiory justified the execution to the King of France, and threw the blame from themselves. The dissolution which befel the Piagnoni sundered the bond which united the Arrabiati against them. The parties fell immediately into other combinations : it was important to oppose the Palleski, and to prevent their obtaining the upper hand. Savonarola's consiglio grande was continued.

For the moment, the Medici ventured nothing against the freedom of the Florentines ; but the latter had still to conquer Pisa, and to keep on good terms with France. To this end they directed their policy to the utmost. The circumstances were of a difficult nature ; dark clouds often hung heavily and threateningly over the city. Gold, good fortune, and dexterity, however, carried the lightning-strokes harmlessly aside ; and, in the midst of the warlike commotions which filled the whole of Italy close to their own walls, there prevailed the old inevitable pursuit after wealth, honor, and enjoyment.

As Michael Angelo's first work, after his return from Rome, I must mention a Madonna, which appears as a kind of echo of his Roman Pietà, and which at that time he was alone able to complete. For that he repaired from Rome to Florence, on account of the David, his next immense work, is an invention of Vasari's, to whom Condivi's simple

statement, that he returned on account of his domestic affairs, was not sufficiently piquant. We must again and again repeat, that it is impossible to Vasari to relate facts simply one after another: he endeavors to connect them in an interesting manner. He has by this means succeeded, indeed, in giving the appearance of living truth to his biography; but, unfortunately, it is too often to be proved, that things are the work of his fancy alone.

With regard, however, to the Madonna of which we are now speaking, I differ even from Condivi. Fifty years, when he wrote, had elapsed since Michael Angelo had last seen the Madonna. Either the latter was himself in error respecting it, or Condivi had falsely understood him. He writes of a cast in bronze, representing a Madonna, and of the Moscheroni, Flemish merchants, who purchased it for a hundred ducats, and sent it to their own country. This Madonna, however, is not bronze, but marble; it is in the Church of Notre Dame at Bruges; and what makes the tradition indubitable as to its being a work of Michael Angelo's is, besides • its whole appearance, the fact, that, under the altar on which it stands, Pierre Moscron — one of the Moscheroni, therefore, whom Condivi mentions — lies buried. He had built the chapel at his own expense, and had placed the Madonna over the altar. He was, as his epitaph bears witness, *Licentié és droit* and *greffier* of the city; and he died in 1571. Until this year, therefore, Michael Angelo's work seems to have remained in the house of the Moscron family.*

* See Appendix, Note XXI.*

Vasari's frivolous method is shown, moreover, most plainly on this occasion. We know for certain that he never saw the Madonna, and that Condivi was his only source. In the first place, from his own opinion, he makes the work a round bas-relief; and he says, in the second place, that Michael Angelo executed it by *order* of the Moscheroni. He was induced, perhaps, to make the first alteration, by the natural consideration, that a hundred scudi would have been too small a price for a detached bronze statue; but he tells a falsehood as to its having been ordered, only because it sounds better than Condivi's simple words, that Michael Angelo had executed the statue, and the Moscheroni had purchased it.

This Madonna is one of Michael Angelo's finest works. It is life-size. She sits there enveloped in the softest drapery; the child stands between her knees, leaning on the left one, the foot of which rests on a block of stone, so that it is raised a little higher than the right. On this stone the child also stands, and seems about to step down. His mother holds him back with her left hand, while the right rests on her lap with a book. She is looking straight forward; a handkerchief is placed across her hair, and falls softly, on both sides, on her neck and shoulders. In her countenance, in her look, there is a wonderful majesty, a queenly gravity, as if she felt the thousand pious glances of the people who look up to her on the altar. If we wished, as is the custom, to surname her from some distinctive mark, we might do so from the tightened folds of her gar-

ment, which is drawn down sideways from the point of the left knee, by the child stepping on it. The child, however, throughout resembles the little John in the picture in Mr. Labouchère's collection. The similarity appears so striking, that the affinity of the two works, like a double blossom, springing from the same idea, is scarcely to be disclaimed.

As a second work belonging to this period, we may place the picture which Michael Angelo painted for Messer Agnolo Doni, an almost miniature-like painting, yet belonging to the early period of his artistic career. Condivi's chronology respecting this, also, is of such a general nature that it scarcely stands in the way of my supposition. It is to be seen in the present day in the Tribune at Florence. The Virgin is kneeling towards the spectator, with both knees on the ground; and, turning backwards, receives in her arms the child, which Joseph reaches to her from behind, over her right shoulder. The figures are about half the size of life. John is coming forward; he is small, and without connection with the principal group: the background is filled. with a number of naked male figures, which, in different positions, standing or sitting in a semicircle, have nothing at all to do with the Holy Family in the foreground. They are far off and small, but are painted with great care, and are excellently designed. The grouping of the Holy Family itself appears to me, on the contrary, artificial and unnatural. The colors are laid on with the greatest care imaginable; but the coloring has nothing in it fresh and florid. The picture alto-

gether is rather a work which we study with admi-
ration, than one which irresistibly attracts and
fascinates us. Agnolo Doni paid seventy ducats for
it. Condivi's statement of this sum refutes the
anecdote which Vasari relates on this occasion,
according to which Michael Angelo must have
received a hundred and twenty ducats from Doni.
This is the same Doni whose portrait, together
with that of his wife, was subsequently painted by
Raphael, who was well received in his house,—
faces which would have little in them to awaken the
curiosity of the world, had they not been snatched
from oblivion by the hand of such a man.

While Michael Angelo was engaged with these
works, the Florentines were overwhelmed, in the
year 1501, by a sudden calamity, which might have
annihilated at one blow all the advantages gained in
having surmounted their late difficulties. Cæsar
Borgia had been victorious in the Romagna, and
intended turning against Bologna. The Bentivogli,
however, purchased the protection of France; and
the king ordered the duke to withdraw from his
plan. Instead of this, Cæsar now prepared to set
out for the conquest of Piombino; and, to do this,
it was necessary to march straight through Tuscany
and the territory of Florence. He negotiated re-
specting it in the most friendly manner; for the
Florentines kept the passes of the Apennines occu-
pied, and might refuse him entrance. Scarcely,
however, had he obtained what he desired, than he
assumed another aspect; and, laying the land under
contribution, he descended into the level country.

He was now suddenly joined by the Medici, who, with their friends in Florence, deemed this as the most favorable moment. Preconcerted measures had been taken with the Palleski in Florence; and the surprise of the city, the convoking of a parliament, and the overthrow of the constitution, were the three steps which they hoped speedily to obtain. And as the Medici always endeavored to hit the right moment, by choosing a time when the common people were excited, they now appeared during a fearful dearth, when the fruits in the field were dried up, and a bad harvest and scarcity were to be expected.

Cæsar demanded that the proscription of the Medici should be withdrawn. He stood there so threateningly, that the Government hesitated what answer to give. The Medici had only put forward a humble request, that residence in their paternal city should again be allowed them; they possessed friends in all circles of the citizens, who supported their petition. Uneasiness seized the people: they could not understand that the answer to be given to• Cæsar should even be taken into deliberation. The houses were placed in a state of defence, and arms were in readiness. One day, one of the members of the Government came angrily out of the gate of the palace. They asked him in the square below what was the matter. He would not be present, he answered, when they were negotiating up there whether they should betray their country. These words spread through the city. They knew that near relations of the Medici sat among the Signiory.

The state of feeling became so dangerous that
Cæsar's proposal was rejected. But they told him,
in reply, that they would treat with him as to the
sum for which, as commander-in-chief of the Floren-
tine troops, he would henceforth remain the friend
of the citizens. In other words, they would buy
themselves off.

Cæsar, who had not been quite serious as to the
restitution of the Medici, consented to this. Per-
haps he had only threatened them with their old
foes, that he might draw from these the sums with
which they must infallibly have paid for his assist-
ance, besides the more favorable conditions which in
that case might be demanded from the city. They
agreed to thirty-six thousand florins ; for this he
appeared as commander-in-chief of the Florentine
troops, nominally in the service of the city, and
marched on to Piombino, which he took in the begin-
ning of September.

Piero had nothing left but the hope of better
times. It is strange how the failure of this *coup*,
also, was brought about by the pride and arrogance
of his character, although indirectly. At the time
when he was firmly established in Florence, and
Alexander Borgia was archbishop of Pampeluna,
Cæsar, whose future was not at that period very
promising, was studying canon law at the University
of Pisa. In the cause of a friend who had become
involved in a difficult lawsuit, he came over to Flor-
ence, and asked to be admitted to the presence of
Piero. He was allowed to wait some hours, and at
length to go away ; so that he returned to Pisa with-

out having obtained his object. He is said never to have forgiven Piero this.

At the time that Cæsar left the Florentine territory and invaded that of Piombino, the order for the David of Michael Angelo may be dated.

Many years before, a marble block, eighteen feet high, had been conveyed from Carrara to Florence; and the consuls of the wool-weavers' guild, to whom the Church of Santa Maria del Fiore belonged, intended to have a prophet executed out of it, as one of the figures designed to surround the outside of the dome of the church. This order was subsequently withdrawn; the stone, however, had been already embossed or prepared for the first design, and was not to be applied to any other figure. They had once offered it in vain to Donatello: no sculptor considered himself able to make any thing out of it; and thus it had lain, ever since the memory of man, in the courtyard of the workshops belonging to the cathedral building.

Now, however, it was announced that some one wished to attempt it. Among the number of those• who had studied in the gardens of the Medici, there was a sculptor who had been sent by Lorenzo to the King of Portugal; and, after he had completed some magnificent buildings and sculptures there, he had again returned to Florence about the year 1500. Andrea Contucci del Monte Sansovino — thus the man was called — begged that the marble should be given up to him. But the consuls, before they acceded to this demand, wished first to hear Michael Angelo's opinion, whether he could not, perhaps,

himself produce something good out of the marble. Michael Angelo had just undertaken another work. Cardinal Piccolomini, whose family came from Siena, wished to decorate a funeral vault in the cathedral there with works of sculpture, and ordered Michael Angelo to execute fifteen marble statues of a small size. The contract, a very interesting record, containing the most accurate and minute statements,* was signed by him on the 19th June, 1501. Jacopo Galli, his Roman friend, pledged the eventual restitution of the money paid in advance, in case the time of completion was not adhered to, or the quality of the statues did not appear to correspond with the agreement. But Michael Angelo, when he saw the immense and magnificent block, and considered the fame which he might acquire in Florence by a work of this extent, left the fifteen statues for Siena, subjected the marble to a careful examination, and undertook the work. Sansovino had only wished to set about it on condition that he might complete the block by joining to it other pieces of marble. Michael Angelo, however, declared that he would execute it without any addition. This, perhaps, decided the matter. On the 16th August, 1501, the order was issued.

Two years were allowed him for its completion, dating from the 1st September; and, so long as he worked, he was to receive monthly six gold florins. What was subsequently to be paid on its completion was to be left to the opinion and conscience of those

* See Appendix, Note XXII.

who had ordered it. On the 13th September, early in the morning, — it was on a Monday, — he began upon the stone.* The only preparation for his work was a little wax model which he moulded, and which is still extant in the Uffici. Thus he chiselled away, confident in his own good eye; and at the end of February, 1503, so much was already done, that he could produce the work as half completed. He begged, upon this occasion, to have the statement of the entire price; and they agreed upon four hundred gold florins.

While Michael Angelo was thus absorbed in his work, — for he did not consign the stone, as is the case in the present day, to other hands until the final finish; but from the first touch to the last he did the whole by himself, — a new attempt was made by the Medici, in the year 1502, to establish themselves as masters of the city. This time they advanced further; they had better allies and greater means. The Petrucci, the ruling family in Siena, the Baglioni of Perugia, the Vitelli, and the Orsini, stood on their side. They had already taken Arezzo and Cortona, two Florentine cities; and the pope, with Cæsar Borgia, seemed to place no obstacle in the way of their advance. In this distress, the republic applied to France; and their representations of the importance of their own independent existence so convinced the king, that, at his threatening command, they received the lost cities back again. This new debt of gratitude to France, however, resulted in a new work for Michael Angelo.

* See Appendix, Note XXIII.

Among the means used to obtain influence at the court of the king, there were not only enticing sums of money, but also works of art which they applied as gifts. In the year 1501, the two Florentine ambassadors at the court of the king had written from Lyons, that the Duke of Nemours wished to possess a bronze copy of the David, executed by Donatello, which stood in the court of the palace of the Government: the noble, it is true, would refund the expense; but he seemed by no means disinclined to receive the work as a gift. The duke had besides, in 1499, obtained a number of bronze and marble busts as a gift from the city, among them one representing the Emperor Charlemagne.

On the 2d July, this letter, dated the 22d June, was replied to by the Signiory, to the effect that for the present there was a lack of good masters in the city, who were able to execute such a cast, but that they would at all events keep the thing in view. There the matter rested. Now, however, when in the summer of 1502 the danger from the Medici approached, and more depended than ever on the good-will of France, a good master for this cast was at once found. Michael Angelo undertook it on the 2d of August of the same year, just as the French were entering Arezzo on behalf of the Florentines.

The statue was to be five feet high,* and was to be completed in six months. The Government gave the metal. Fifty florins were paid on account; the final price, as usual, was to be decided after the

* See Appendix, Note XXIV.

completion of the whole. Nevertheless, even after this contract, the desire of the Duke of Nemours for the David was not realized. The ambassadors reminded, the Signiory excused themselves; at last the statue was definitely promised by midsummer, 1503, provided the master, Michael Angelo, kept his word; but it was certainly "the way with such people," not to set much value upon promises. This proviso proved well grounded. The duke obtained nothing; he fell into disgrace with the king; and when, years after, the work was at length completed, it was presented to another high noble at the French court. At the present day, nothing is known of it. Just as little is known of a second bronze work, which Michael Angelo completed at the same time for Piero Soderini, the gonfalonier of the city, and which also went to France. Condivi does not even say what it represented.

More important was the order for the twelve apostles, each eight feet and a half high, respecting which the same consuls of the wool-weavers' guild, for whom Michael Angelo had executed the David, • concluded a contract with him in the spring of 1503, just one year after the completion of the David. People knew him now in some measure; and they devised an ingenious means for making him to be depended on. Every year one apostle was to be produced: Michael Angelo was to go to Carrara, and choose the blocks at the expense of those who had given the order. The price was to be submitted to an arbitration. On the other hand, with every completed statue, Michael Angelo was to receive a

twelfth part of the property in a house, which the church-directors, at the commencement of his work, were having built into an atelier expressly for him, so that, with the completion of the last apostle, it was to fall entirely into his possession. This was certainly enticing; yet, in spite of this, nothing was accomplished but the coarsest sketch of the apostle Matthias, which stands at the present day in the court of the academy of Florence.

Michael Angelo wished to complete his David. In this he kept his word. It is true he did not complete it, as Condivi says, in eighteen months, nor even in the stipulated two years, — the work lasted some months longer; but when we consider the disorders of the time, and the intermediate orders which he could not avoid, this interval appears small enough. He worked so industriously that he often slept at night with his clothes on, as he lay down from his work, that he might go on with it again at once on the following day. At the beginning of the year 1504, the statue was completed. On the 25th January, the consuls of the wool-weavers' guild called together a meeting of the first Florentine artists. The David of Michael Angelo was as good as finished; it was to be taken into consideration where it would be best placed.

The record with its signatures still exists, giving the tenor of the opinions brought forward; and it is important as affording information of importance with regard to the personal position of the artists to be found in Florence in the year 1504. It carries

us into the excitement of the day on which Michael
Angelo exposed his work for the first time to the
eyes of the masters. The men met together in
the atelier in view of the statue. Michael Angelo
had latterly placed boards round his work, and had
allowed admittance to none; now, however, the
youthful giant stood unveiled before the eyes of all,
challenging praise or blame from those who were
the most qualified in the whole city to give a
verdict.

Messer Francesco, first herald of the Signiory,
opened the council. " I have reflected on the mat-
ter again and again, and well weighed it in my
mind," he began. " You have two places where the
statue can stand, — either where the Judith now
stands, or in the court of the palace where the David
stands." He was here interrupted by the observa-
tion, that both works were Donatello's. The Judith,
a bronze cast, which is now placed under an arch
of the Loggia dei Lanzi, — a strange rather than
an attractive work, — was removed from the Medici
palace in the year 1495, and set up at the entrance •
to the palace of the Government. The David, with
one foot treading on Goliath's head, and holding a
sword in his hand, is the same statue as that which
Michael Angelo had to copy for the Duke of
Nemours.* The court of the palace, in which it
was at that time placed, is narrow, from the height
and beautiful architecture of the building; and the
light that falls from above has a peculiarly bluish
lustre. " As regards the first place," continued

* See Appendix, Note XXV.

Messer Francesco, "it may be urged that the Judith, as a bad omen, ill suits it. For our insignia are the cross and the lily; and it is not well, that a woman should stand there who killed a man. Besides, the statue was placed there under unfavorable auspices. Matters have therefore gone worse and worse with us since that time, and Pisa has been lost. With regard to the David, on the other hand, in the court of the palace, it is imperfect; for, looked at from behind, its one leg presents an ugly appearance. My advice is, therefore, to give the giant one of these two places, but by preference that where the Judith stands."

How strange sounds the political superstition of the man! This was the nature of the soil on which Savonarola believed he had found firm footing. A confused mass of such ideas floated in the atmosphere of those days, and high and low were entangled in its web.

The architect Monciatto was the second to offer his opinion. "I think," he said, "that every thing has its object, and is made for it. As, therefore, this statue has been made to have a place on one of the pilasters outside the church, or on one of the pillars within, I see no ground for not placing it there now. It seems to me, that it would be an honorable ornament to the church; and, standing there, would be, moreover, in a place of constant resort.* However, as you have once departed from the first opinion, I say it might be placed either in the palace, or in the interior of the church. As I am not sure where it

* See Appendix, Note XXVI.

would stand best, I will adhere to what the others say: the time is too short to think of a better place."

Next to him spoke Cosimo Roselli, one of the older masters, who appears somewhat stiff and wooden in his figures. He expressed himself as much perplexed as his predecessor. He agreed with both gentlemen. The statue would stand well in the interior of the palace; otherwise his opinion would have been, that it ought to be placed on a highly decorated platform, on the steps to the right in front of the church. He would have removed it there, if he had had to decide.

Sandro Botticelli declared, upon this, that Roselli had just hit upon the place of which he also had thought. All passers-by would see the David best there. To match it, on the other side, a Judith might be placed. Yet he thought a good place for it would be under the Loggia by the side of the palace of the Government.

Giuliano di San Gallo next spoke; he was one of the most famous architects and engineers in Italy. · He and his equally famous brother Antonio were in the service of the republic, and had often been commissioned with the erection of fortifications or city buildings. He was in favor of placing the statue under the middle arch of the Loggia. The marble was tender, and had been already injured by exposure; it ought to be under cover. Still it might also be placed against the inner wall of the Loggia, in a niche painted black.

This opinion, that the David ought to have a roof

THE PLACING OF THE DAVID. 239

over it, seems the more important, because similar scruples have of late been promulgated. San Gallo at that time was not listened to. For three centuries the statue stood in the open air; now, however, its condition has become so critical, that the idea has been again suggested of removing it under the Loggia. The Florentines, however, of the present day are against this, because they like it to remain in its old place.

At that time, on the 25th January, 1504, other scruples existed respecting the Loggia. The second herald of the Signiory protested at once against it. The Loggia were used for public ceremonies: if it was necessary to place the David under cover, it could be set up under the public arcades leading to the palace. There it would stand under a roof, and, at the same time, be in nobody's way. He moreover suggested that the gentlemen assembled might prefer, before coming to any decision, to apply to the lords of the Government, among whom were many who had a knowledge of such matters.

After a number of other artists had brought forward nothing new, we come upon a man, who, although certainly in this assembly he did not distinguish himself by his words, acquired high importance a short time after, as the greatest of all living artists, rivalling even Michael Angelo himself. This man was Leonardo da Vinci.

Leonardo had returned to Florence in the year 1499, and was perhaps already there when Michael Angelo arrived from Rome. Ludovico Sforza, his master, whom he had served for almost twenty years,

fell a victim to his own intriguing policy. The French took away his land; he fled to Germany, came back, but was again defeated, and recognized as he was attempting to escape in miserable disguise; he was dragged to France, where, after ten years, he died in wretched imprisonment.

Leonardo had occupied a position at the duke's court, and at Milan, such as he could nowhere hope to find again. Consulted upon all artistic undertakings, appointed architect of the cathedral, founder of an academy of painting, engineer in aqueducts and military matters of the highest importance, he painted picture after picture with increasing fame; and at length crowned all he had done by the Last Supper, in the monastery of Santa Maria delle Grazie, where this painting occupies one wall of the refectory. It was customary, in Italian monasteries, to apply such a subject to this precise place.

At the present day, when the work has almost disappeared, it still produces an irresistible effect, from the attitude of the figures, and the art with which they are formed into groups. Christ forms the centre; on the right and left are two groups, of three figures each. By this means, while the greatest, almost architectural, symmetry prevails in the whole, and there is in the detail a freedom by which the whole character is expressed in the position of each figure, an effect is produced, which, in moments of admiration, forces from us the assertion that it is the finest and sublimest composition ever produced by an Italian master. It is certainly the earliest work of that magnificent new style, in which

Michael Angelo and Raphael subsequently painted; who, nevertheless, never saw this painting, as neither of them was ever in Milan.

Leonardo's favorite work, however, was the statue of a horseman, representing Francesco Sforza, the father of the duke Ludovico. He required sixteen years to prepare the model. In the year 1493, when Bianca Sforza married the emperor Maximilian, and the wedding was celebrated with splendor in Milan, it was exhibited under a triumphal arch. And now, on the conquest of the city by the French, it had served as an aim for the arrows of Gascon archers.* The duke was taken prisoner, the work was destroyed, and Leonardo left the city. His fame met with misfortune. For it was but an ill freak of fate, that this work, on which he had at last been allowed to work at his own expense, because the duke's money failed, should now be so miserably destroyed; and that the Last Supper should flake away from the damp wall on which it was painted, while far older paintings have remained uninjured in the same hall.

Still we possess pictures enough of this great master to prevent us from considering the accounts of the magic of his art as empty exaggeration. We are ever inclined to be incredulous. Leonardo's paintings, however, possess such a charm, that the truest description falls far short of them. We should scarcely consider them possible, if we did not see them with our eyes. He possesses the secret of letting us almost read the beating of the heart in

* See Appendix, Note XXVII.

the countenance of those whom he represents. He seems to see nature in constant holiday brightness, and never otherwise. Our feelings become gradually so deadened, that, perceiving the same loss among our friends, we at length believe, that the fresh, spring-like appearance of nature and life, which opened before us so long as we were children, was only the delusion of happiness, and that the dimmer light in which they appear to us subsequently, affords the more true view. But let us step before Leonardo's finest works, and see if the dreams of ideal existence do not appear natural and significant! As splinters of metal are drawn to the magnet as it moves through iron filings, and adhere to it in a thousand fine points, while the grains of sand fall powerless away; so there are men, who, passing through the lifeless throng of constant intercourse, carry away with them, involuntarily, only the traces of the genuine metal in it, in this following their nature alone, which absorbs it on every side. They are rare, privileged men to whom this is awarded. Leonardo belonged to these favored ones of fate.* He now appeared in Florence, accompanied by Salaino, a beautiful youth, who had followed him from Milan, from whose crisp, curling locks (*begli capelli ricci e inanellati*, says Vasari) he painted the golden hair of many an angel. Salaino was his pupil; but the principle, that like attracts like, appears still more evidently in another of his pupils, — a beautiful Milanese of good family, Francesco Melzi by name, — whose paintings are scarcely to be distinguished from those of Leonardo. But he

painted less, because he was rich. Much the same may be said of Boltraffio, another of his pupils, and a Milanese nobleman.

When Leonardo came to Florence, he was the first painter in Italy. Filippino Lippi transferred to him an order for an altar-picture in the church of a monastery, in which Leonardo lodged with his attendants; but he was long before undertaking the work. He had done just the same in Milan before beginning the Last Supper. For days he sat before his new work without moving his hand, lost in deep reflection, awaiting the moment when the countenance of Christ would be revealed to him in the manner in which he desired to see it in his mind. It was of no avail that the prior of the monastery complained to the duke himself.

At length he achieved something in Florence also, — a cartoon, — Christ, Mary, and St. Anna.* The people of Florence streamed to the monastery to admire this work. His highest triumph, however, was the portrait of Mona Lisa, the wife of Francesco del Giocondo, a creation which surpasses every thing that art had produced in that direction. Francis I. purchased it for France, where it is still to be seen in the Louvre. All description of it would be vain. As the countenance of the Sistine Madonna represents the purest maidenliness, so we see here the most beautiful woman, — worldly, earthly, without sublimity, without enthusiasm; but with a calm, restful placidity, with a look, a smile, a mild pride about her, which makes us stand before her with

* See Appendix, Note XXVIII.

endless delight. It is as if all thoughts were at rest
in her ; as if love, longing, hatred, every thing which
can excite a heart, lay summed up in a feeling of
satisfied happiness. Four years he worked at it, and
gave up the picture, which seemed to have reached
the highest stage of perfection, as unfinished. When
he was painting it, he always had music and singing
in his room, or he invited witty people to come and
enliven the beautiful woman, and to disperse the
trait of melancholy which creeps so easily over a
face keeping quiet to be painted. Such a portrait
had not been executed so long as there had been
artists in Italy. And thus the fame which Leonardo
brought with him out of Milan, was increased by
that which he now acquired anew in his native
city.

Michael Angelo could not even be remotely com-
pared with him as a painter. As a sculptor, how-
ever, he occupied the first place. Yet it was not
possible that the two departments should remain
strictly divided, as each of them was at once a sculp-
tor and painter. There was the difference, moreover, •
of their age and nature, — Michael not yet thirty,
proud and conscious of what he had done and would
do ;. Leonardo a man almost fifty, who had for many
years occupied the first place at the court of the
richest prince of Italy, sensitive by nature, perhaps
even irritated by his late experiences, and not in-
clined to share the field with another, which he had
been accustomed to rule alone.

It was respecting the block of marble, which San-
sovino had asked for, that Michael Angelo (if Vasari

speaks truly) first quarrelled with Leonardo, for whom the stone had been also intended.* It would, however, be venturing too much, if we were to suppose that Leonardo's absence in the year 1502, and the following one, had been brought about by jealousy of Michael Angelo. During this period he was in Cæsar Borgia's service as architect and engineer-general of the Romagna. Leonardo thoroughly understood fortification, and all that belongs to it; he had a longing for work which demanded all his powers; in short, he was accustomed to serve a prince. He could not have found a better master than the duke, whose noble qualities suited his own. Leonardo, too, possessed the power to bend a horse-shoe like lead. Cæsar was royally generous, and was the handsomest man possible. His distinguished qualities as a general were recognized by all; his army, especially his infantry, was considered the best in Italy. His future seemed secure. He wished to conquer a kingdom; and the commencement he had made allowed great things to be expected.

At the time when the Medici had failed with their expedition in the year 1502, and the Florentine territory had been declared by the King of France to be unassailable even to him, he had turned towards Urbino, and had brought this dukedom within his power. Still he ever appeared as a friend of the republic, who even supported him with troops; Leonardo's service, therefore, was no treason to his native country, although it is not to be denied that

* See Appendix, Note XXIX.

Cæsar's designs with regard to the city had not changed, but were only postponed.

How long he remained with the duke is not to be accurately stated. In 1503, we find him in the Florentine camp before Pisa; and in 1504, at last, again in the city itself, where, with many other works, he was still engaged on the portrait of Mona Lisa.

At the meeting he spoke only a few words, in which he declared himself of San Gallo's opinion, that the statue ought to be placed under the Loggia; it could indeed be so arranged, that public ceremonies would not suffer from it. It seems that this opinion was held by the majority on that day; still it was not adopted. One of the gentlemen, the goldsmith Salvestro, came forward with the proposal, that the place which it should occupy in future should be left to him who had executed the statue. He would best know what place it suited. Upon this they seem at length to have settled. Michael Angelo's views, however, agreed with those of the first herald of the Signiory. He desired the place next the gate of the palace; and upon this they decided.

Among those who were assembled, I must still name Filippino Lippi, Granacci, Pier di Cosimo, Lorenzo da Credi, and, lastly, one next in importance to Leonardo, Pietro Perugino. He and Leonardo were early friends, and had studied together with Verrochio.* Perugino, now sixty years old, had won fame and wealth, and possessed a house in Florence, where, surrounded by pupils and

* See Appendix, Note XXX.

Christist giving the **Keys to Saint Peter.**

PERUGINO.

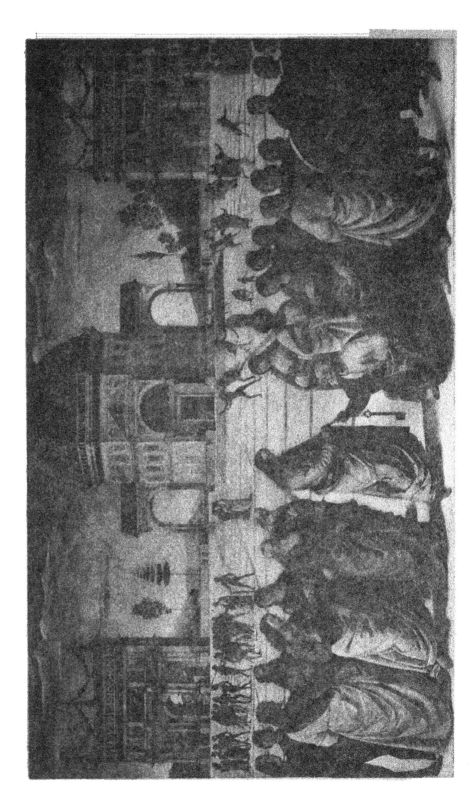

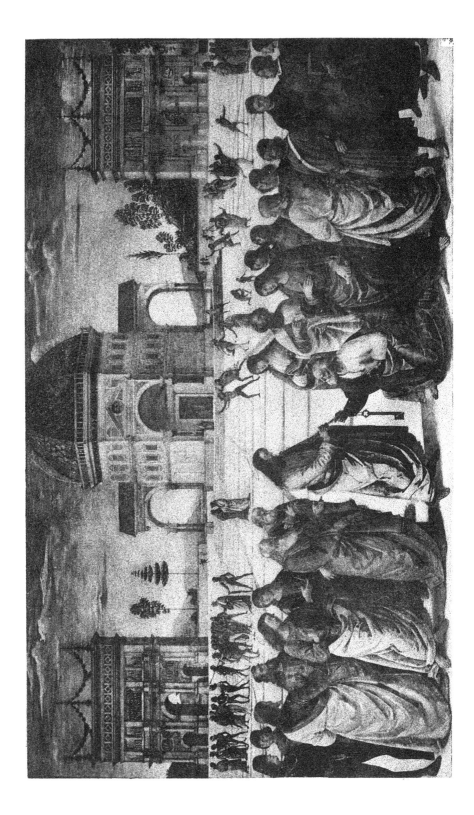

overwhelmed with orders, he led the most active life. He had introduced a new vigorous manner in the place of the customary nicety, and is considered as the founder of that branch of painting in which Raphael produced so much that is great. He rounded off his figures with strong shadows, and brought them out from the background; instead of the ordinary crowd of figures which generally fill the pictures of the Florentine masters, he produced well-arranged groups, which appeared less numerous, but more complete. He was by nature rough, more strongly inclined to the technical perfection of his art, and without the gift of endowing his works with that mysterious charm which belongs to the productions of the greatest masters.

If we take him again in connection with Leonardo; if we reckon up, moreover, the pupils and followers which adhered to both, and imagine them in opposition to Michael Angelo, — we see this man standing opposed by himself to a powerful body of rivals. It would not be allowable to conjecture this, and to date back to this period the feelings which were excited by subsequent events, if the most distinct intimations did not lie before us, to justify us in so doing. For the David was not yet placed; and all the fame that Michael Angelo gained from it, and which might have awakened the envy of others, was scarcely in embryo, when the bitterest hatred burst forth against him.

The statue weighed eighteen thousand pounds. Cronaca devised the scaffolding to remove it, — a wooden framework, within which it was suspended

on abundant ropes. It thus remained in a gently swinging motion, whilst the whole thing, lying on fourteen oiled beams, was slowly drawn along by pulleys. Forty men worked at them. Vasari praises the peculiarly twisted knot of the rope, which was placed in the most convenient place, and grew tighter and tighter of itself.

On the 14th May, in the evening, about Ave Maria, the statue was drawn from the atelier into the open air. The wall about the door had been obliged to be broken down to render the exit possible. The figure hung upright, swaying in the midst of the scaffolding. It advanced slowly, and was left at nightfall, to be carried further on the following day. It was now shown, what Giovanni Piffero, one of the masters in the council, had probably intended when he had said, that, if it stood in the Loggia, any one evil inclined might give it a blow with a stick; for, during the night, stones were now thrown at it. A watch was ordered to protect it. The progress through the streets lasted for three days, and the attacks were repeated every night. • They attacked the watch; and eight of those who were apprehended were thrown into prison. There was no idea of Leonardo or Perugino having had a suspicion of this disgraceful conduct; but the supposition arises too naturally, that the subsequently open animosity of the two artist factions was not without its influence even here.

On the 18th May, 1504, at dawn of day, they arrived at the square. The Judith of Donatello was moved aside, and the David was placed in its stead.

Michael Angelo had so completely used the whole block, that on the head of the statue a little piece of the natural crust of the rough stone remained visible. The David stands simply there. His glance is so keen, that he seems as if he had an aim in view. The right arm, in the hand of which lies the sling, falls in natural repose by his side. The left is raised in front of his chest, as if he were going to place a stone in the sling. There is otherwise nothing unusual in him: entirely naked, he is the immense statue of a youth of about sixteen years old.

The erection of this David was like an occurrence in nature from which people are wont to reckon. We find events dated so many years after the erec tion of the giant. It was mentioned in records, in which there was not a line besides respecting art. For centuries the David has now stood at the gate of the dark, powerful palace, and has passed through the various fates of the city. Various points are found fault with; and he is either considered too immense for expression, or the expression too insignificant for the size. Some think an almost boyish youth ought not to be represented as colossal. Works of this extent, however, need more frequent contemplation. The natural majesty of pure youthful beauty beams forth from his limbs; and the Florentines are right in considering the David as the good genius of their city, which ought to remain where the master himself placed it. As a Florentine, I should not myself be free from the superstition, that to move its position would be an evil omen.

2.

The completion of the David concurs in a manner with the deliverance of the city from her three most dangerous enemies, so that its erection thus became a memorable period.

The two first who perished were the Borgias, father and son. Cæsar Borgia, or, as he was commonly called after his marriage with a French princess, the Duca Valentino, stood at the climax of his power in the year 1503. The Romagna, Urbino, and Piombino belonged to him; Ferrara belonged to the consort of his sister; Pisa, Siena, and Florence were falling into his snare; he was on terms of good understanding with Venice; Naples was the last great capture which he hoped to make. He had also, in the autumn of the year, cast his eyes upon Pisa, against which Florence was fruitlessly toiling.

He strengthened his troops, and gathered more money together. Father and son made use of various means for this end. They poisoned the rich, * whom they could get at, and placed themselves in possession of their inheritance. The poison usually applied for this purpose by the highest priest of Christendom was a snow-white powder of great fineness and agreeable taste, which, slow in its operation, effected surely the end desired. In other cases, they had recourse to quicker means. The most popular of all was simple murder, which appeared necessary when any one they had in view used precaution in eating and drinking. For in this people

grew suspicious. It frequently happened that noble lords, who had been imprisoned by the popes, almost starved to death, because they refused to touch the foreign dishes.

The 15th August, 1503, was fixed for one of these more silent executions; the Cardinal of Corneto being the destined victim. The pope repaired, towards evening, to his villa, the Belvedere, close by the Vatican, where he liked to refresh himself after the heat of the day. Some bottles of poisoned wine were given by the duke to one of the servants in waiting, with the order to pour out for the cardinal from them, and for no one else.

The heat was great; the pope felt weary and thirsty; the repast was not yet ready; even the provisions expected had not arrived. He wished to drink; only some bottles of wine were to be found; no one knew how fatal they were, or those who knew did not choose to call it to mind. He drank, and Cæsar, who happened to come in, was also enticed. The pope fell down at once as dead, and was carried dying back to the Vatican. Three days after, his corpse lay in St. Peter's. Immense rejoicing filled the city; the Romans crowded thither, and could not satisfy themselves with the sight of the man, who, livid and bloated, was at last powerless, and who lay destroyed like a serpent that has killed itself with its own poison.

Cæsar recovered. He knew remedies, and was provided with them in time. His giant nature overcame the attack; but now, at the most important, most decisive moment of his career, he saw himself

sick and almost incapable of bringing his power into action. That the pope must have died, he had seen beforehand; the Spanish cardinals were on his side; he wished to elect a pope such as he could make use of. He now bewailed his fate; he had calculated upon all possibilities, that only excepted, that sickness might fetter his hands.

Cardinal Piccolomini was chosen, the same for whom Michael Angelo had worked in Siena; an aged sickly man, to whom they had recourse because they could come to no other agreement. He ascended the sacred chair as Pius III. During his rule, the cardinals became united; he was poisoned, and, with rare unanimity, Cardinal Vincula was elected in his place. The Cardinals d'Amboise and Ascanio Sforza were competitors. Vincula entered upon the papal dignity under the name of Julius II., — an old man, a prey to passions, and a victim to the sickness which at that time affected Europe. We obtain at a glance an insight into his character, when we consider that he, the unwearied, deadly foe of the Borgias, succeeded, in spite of all that had happened, in bring- • ing Cæsar by promises over to his side. After such a masterpiece, the other cardinals were easy work. His promises exceeded all belief, and were considered true. Whoever could be useful to him in any way, received according to promise whatever he desired. Vincula had been known all his life as a man who kept his word. Even Alexander Borgia had acknowledged that. He now turned to good account a reputation won with such difficulty. Yet it was not avarice which made him act thus; for

what he possessed he gave away. He wished, under any circumstances, to be pope.

The worst he dealt with was the duke, who, being in possession of the Castle of St. Angelo, ruled the city, and whose troops lay threateningly in the Romagna. Cæsar received a promise that all should be preserved to him; further, that his daughter should be married to Maria Francesco della Rovere, the nephew of the pope; lastly, that he should remain captain-general of the pope's army, which his father had constituted him. Julius took him into the Vatican; they dwelt together; they concerted the future, while living in the greatest intimacy with each other. At length Cæsar set out to reach his States. At Ostia, however, the pope's messengers overtook him with the tidings that he was to return with them. He suspected evil, and saved himself from violence on board a Spanish vessel, which brought him to Naples, where he was splendidly received by Gonsalvo di Cordova, the Spanish viceroy. From thence he wished to go into the Romagna; but, just as he had got on board the vessel, he was suddenly declared prisoner, and conveyed to Spain, from whence he never again returned to Italy. As the end of Borgia corresponded with his life, so the death of Piero dei Medici was in harmony with his. After that last retreat from Tuscany, which had been so disgraceful to him, he had for a time given up Florence, and had joined the French army at Naples. But here also misfortune followed. The Spaniards were beginning to obtain the upper-hand. On the 28th

December, there was a battle on the Garigliano. The passage of the river was disputed. The French were beaten, and Piero drowned.

One care alone now remained to the Florentines: Pisa was yet to be conquered. Delivered, however, from the pressure of apprehension arising from the Borgias and the Medici, they could now continue the war with the best hopes for success.

3.

After Michael Angelo had distinguished himself in such a splendid manner, it was felt, it seems, in Florence, that opportunity should also be given to Leonardo da Vinci, to produce something great. Soderini — who had been elected gonfalonier for life since the autumn of 1502, because the city owed to him and to his brother, the Bishop of Volterra, the saving assistance of France — was Leonardo's especial friend. It was well for Soderini that an order of importance was esteemed a peculiar distinction. He proposed to cover with paintings the empty walls of the hall in which the consiglio • grande sat. In the beginning of February, 1504, a short time, therefore, after the discussions respecting the David, Leonardo received the order to paint one great wall of the hall. The so-called Hall of the Pope, in the Monastery Santa Maria Novella, was appointed him for the preparation of his car· toon, — a hall which in former times the popes and other royal company were wont to occupy.

Respecting the subject of the picture painted by him, we are not quite clear, as it has perished with

the cartoon, and the existing copy accords not
with the description which has reached us from
Leonardo's own hand. His words describe a com-
plicated work, with many groups, united into a great
whole; the copy, on the contrary, presents only a
single group, — a fight of horsemen, who are biting
one another like furies. Men and horses are falling
upon each other, forming a tangled mass, the central
point of which is a warrior defending his standard.
A kind of cannibal blood-thirstiness fills the coun-
tenances, and the entire figures; they are covered
with strange armor, after the fashion of the ancient
Romans; the bodies are turned in the boldest posi-
tions; the whole is masterly in its design. At all
events, these fighting horsemen formed the central
point of the painting. The copy preserved to us is
by Rubens; it is engraved very effectively by Ede-
linck. Yet we know not how far Rubens may have
added of his own, and how faithfully he adhered to
the original. The Florentines must have stood
startled before the work. It was something per-
fectly new. No one could have expected, that the
same artist, whose softly dreaming fancy had hither-
to produced such tender pictures, would have rep-
resented, in these colossal figures, the unchained
passions of furious soldiers.

Michael Angelo spent the summer of 1504 —
in which Leonardo was engaged in this task — with-
out any intense work. He read the poets, and
himself wrote, says Condivi. He had, nevertheless,
so much to do that he could have worked from
morning till night. The bronze David awaited its

completion; the pedestal for the David in front of the palace had yet to be executed, — it was not till September that all the work on it was finished; the twelve apostles for Santa Maria del Fiore were expected from him; and, lastly, the works for the cathedral at Siena. He seems to have thought first of these, actuated, perhaps, by Piccolomini's election to the papacy. In October, 1504, four statues were completed, and others had been already paid in advance. The contract was renewed, and more time allowed. In two years, the remaining eleven were to be executed. Should Michael Angelo be ill, — so the document stated, — the time lost was to be deducted.

This clause seems to have arisen from some special apprehension, rather than from general precaution; for, although Michael Angelo's constitution was very delicate in his youth, this was not the case afterwards. His frame became more and more robust. He was thin, but he possessed strong sinews and firm limbs; he had broad shoulders, but was rather to be called small of stature than tall. Abstemiousness in every • respect, and work, steeled him. He need have wanted for nothing, for he gained great sums; but he let the money lie, or he supported his family with it. " Rich as I am," he said once in his old age to Condivi, " I have always lived like a poor man." In this, too, he formed a contrast with Leonardo, who, conscious of his beautiful form, needed luxury around him, and travelled about with a retinue.

Fiery eyes and a magnificent beard gave the latter a peculiarly imposing appearance. Michael Angelo's

head, on the contrary, was almost out of rule. His forehead projected strongly; his head was broad; the lower part of his face was smaller than the upper; he had small light eyes: but what seriously disfigured him was his nose, which Torrigiano, one of his fellow-pupils, crushed by a blow of his fist, in the gardens of the Medici. Michael Angelo is said to have provoked him; it is, however, asserted on the other side, that it was mere envy. He was carried home at the time as dead. Torrigiano was obliged to flee, and could not for many years return to Florence. He was a coarse man, who openly boasted of his deed (according to Benvenuto Cellini), and subsequently perished miserably.

It was, perhaps, this disfiguring of his face which increased Michael Angelo's natural inclination to melancholy and solitude, and made him bitter and ironical. He was in the utmost degree gentle, tolerant, and kind; he had a natural dread of giving pain to people: but, in matters of art, he would allow none to detract from his good right. He acknowledged the merit of others impartially; but he was not inclined to submit that even these should estimate him below his actual value. He possessed a strong feeling of self-reliance; wherever it seemed to him that he could be the first, it was not his fault if this remained concealed.

This feeling, perhaps, gave rise to the motives which now made him resolve to show what he could do as a painter. Leonardo was the greatest: he must compete with him. Leonardo was painting one wall of the great hall: he would paint the other.

Q

We are not informed whether *his* desire, or the opinions of others, gave the first impetus; but, in the autumn of 1504, he received the order to furnish the second wall of the hall with a painting. Soderini requested him to do it. Michael Angelo accepted the task. This commission shows, more plainly than any thing else, what an exalted idea they had of his capabilities.

He had hitherto painted as good as nothing; the two Madonnas were scarcely to be reckoned. These pictures, though the one was nearly finished, must, under ordinary circumstances, have been insufficient to awaken confidence; and he was now to produce a colossal work, worthy of being placed opposite a painting of Leonardo's. And yet they ventured to trust him with it! Leonardo, to whom the other wall must have fallen by right if he worthily discharged his task, must have felt mortified, and almost unfavorably prejudiced beforehand; for his cartoon was ready when Michael Angelo began his. A great hall in the hospital of the dyers at St. Onofrio was allowed the latter for his work. Some dates from• accounts which Gaye discovered are very useful here. On the 31st October, 1504, the bookbinder Bartolomeo di Sandro received seven lire for fourteen sheets of Bolognese royal paper for the cartoon of Michael Angelo; the bookbinder, Bernardo di Salvadore, five lire for gluing it together; in December, the workmen were paid who had stretched the paper on the frame; there exists also the account of the apothecary for wax and turpentine, in which paper was steeped that was to serve for windows. Thus

we see Michael Angelo designing here; Leonardo painting there; and Florence, within and without, in satisfactory circumstances. Never did the prosperity of a city develop itself more calmly; never had art in Florence done or promised greater things than at this period.

4.

To heighten the splendor of this aspect of things, Raphael now appears also. He came to the city for the first time in the autumn of 1504. He was eighteen years old, and came from Siena, where he worked with Pinturicchio in the library which Cardinal Piccolomini was building as an addition to the cathedral. Close by its entrance, which leads into the interior of the cathedral, is the chapel, for which Michael Angelo had undertaken the fifteen statuettes. This library, a wonderful place, is adorned with extensive fresco paintings by Pinturricchio, a pupil of Perugino's, for which Raphael is said to have furnished the designs. He had been allured to Florence, says Vasari, by the admiration with which he heard Leonardo's and Michael Angelo's works spoken of.*

Giovanni Santi, Raphael's father, — a man who, as painter, and author of a rhyming chronicle containing the history of his sovereigns, the Dukes of Urbino, had himself produced something deserving honor, — died in the year 1494. Raphael had been early obliged to help him at his work; he had been subsequently placed as a pupil under Perugino; and

* See Appendix, Note XXXI.

at length, when the latter worked here and there, and became more at home in Florence than in Perugia, he had been obliged to make further progress alone. The ducal family protected him in Urbino. Compelled from his youth up to accommodate himself to the world, and endowed by nature with the gift of pleasing men, he found in Florence the most favorable soil for his further development; and his works show what an unusual success fell to his lot there.*

Patrons and friends appeared at once. Raphael was amiability itself, — *la gentilezza stessa*, says Vasari; the younger artists joined him; he was gladly received in the best families; in gratitude for kindness shown, he painted pictures, and left them in the houses in which he had been well received. How valuable would be more intimate information as to the Florentine life of this one autumn, when the three greatest artists of modern times met together! Leonardo, on the point of entering upon a contest with Michael Angelo, involving immense spoils of glory; Raphael between both, still without fixed · plans and thoughts of his own, and only with a foreboding in his heart of the great future towards which he was advancing! A closer acquaintance with this period would be important, because in it seem to lie the germs of that subsequent personal relation between the three masters. Raphael's deceased father had been intimately acquainted with Leonardo. Perugino, Raphael's teacher, had been his friend. Raphael — young, ardent, insinuating —

* See Appendix, Note XXXII.

saw for the first time the amazing works of Da Vinci, and fell into the very midst of the jealous excitement of party feeling. Was it not natural, that, instead of believing in that which the enemy of all his friends and patrons was only *intending* to do, he should adhere to that which these had already produced? So much is said of the cause of Raphael and Michael Angelo's subsequent division; such, however, were the circumstances under which they met for the first time.

How different is the youth of these three men, and the manner in which they entered upon art! Michael Angelo, against the wishes of his parents, through his own inflexible will; Leonardo, as a rich young man, playing with his talent; Raphael, as the son of a painter, among whose painting implements he grew up as if there were but this one work in the world. Michael Angelo, from the first independent, pursuing his own ideas, in opposition to parents and teachers; Leonardo, not less self-willed, following his own fancy, and roaming over the whole range of art in search of wild tasks, which should entice him to test his powers; Raphael, so biassed by a quiet imitation of given models, that his works are scarcely to be distinguished from the productions of those with whom he met. And the future also which awaited the three is only the product of the one prominent characteristic in each, — of the capriciousness of genius in Leonardo, of violent will in Michael Angelo, and of an almost womanly resignation to the circumstances which fashioned his destiny in Raphael.

All three were soon to reach a decided turning-
point ; and first of all, Michael Angelo, who, in the
year 1505, became acquainted with the men by
whom he was recognized in all his greatness, and
was forced to the highest development of his tal-
ents.

CHAPTER SIXTH.

1505—1508.

Julius II. — Giuliano di San Gallo — Call to Rome — Bramante —
The Pope's Mausoleum — Remodelling of the Old Basilica of
St. Peter — Journey to Carrara — The Pope's Change of Mind
— Flight — Julius's Letter to the Signiory of Florence — Offer
on the Part of the Sultan — Return to Rome as Ambassador of
the Republic — Campaign of the Pope against Bologna — Cap-
ture of the City — Cartoon of the Bathing Soldiers — Leonardo's
Painting in the Hall of the Consiglio — Call to Bologna — Statue
of the Pope — Difficulties in Making the Cast — Disorders in
Bologna — Erection of the Statue — Francesco Francia —
Albrecht Dürer in Bologna — Return to Florence.

THE policy of the Vatican had suffered no great
alteration in the change of persons. Cæsar
Borgia's aim had been the establishment of one
national kingdom; Julius II. desired nothing else.
He too had a family whom he sought to aggrandize;
he too was assisted by poison, murder, dissimulation,
and open violence. Like the Borgias, he had to
endeavor to keep the most advantageous middle
course between Spain and France. In two points,
however, he differed from Pope Alexander, — he
did not allow others to carry on war for him, but
he marched himself into the field; and what he
conquered, was to belong to the Church, and not
to the Rovere, his family. He limited these to

Urbino, their dukedom. When he died, he left behind him a treasure in the vaults of the Castle of St. Angelo, which his relatives were not to touch, and which was to be possessed by none other than the succeeding pope. A rough, proud dignity lies in Julius's appearance; and his fierceness never degenerated into cruelty. That which ennobled him, however, beyond all the popes before him and after him, is his delight in the works of great artists, and the discernment with which he recognized them, and drew them to himself.

Among the men whom he at once summoned to Rome, Giuliano di San Gallo was one of the most eminent. This man had in earlier times fortified Ostia for him when he was Cardinal Vincula. These buildings were erected at the beginning of the last twenty years of the century. San Gallo, when he was at that time called to Ostia, came from Naples, where he had built, by order of the old Lorenzo dei Medici, a place for the Duke of Calabria, the son of the king. He belonged to those fortunate people who meet everywhere with fame and prince- • ly favor. In Milan he was splendidly received by Ludovico Sforza; in Rome he was to build a palace for Vincula; Alexander VI. employed him, Cæsar Borgia also; in Savona, the birthplace of the Rovere, he again built for Vincula, whom he subsequently followed to France, where the king took an affection for him; lastly, having returned to Florence, he was provided by the Government with continual commissions, until his old patron now again ordered him to Rome.

Pope Julius II.

RAPHAEL.

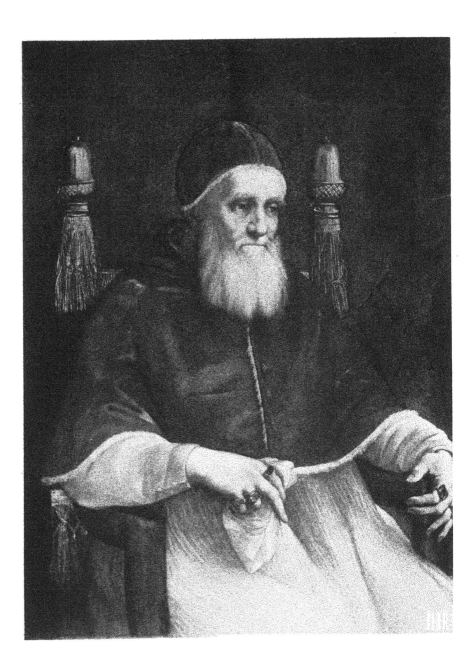

San Gallo drew the pope's attention to Michael Angelo, and, in the midst of his work on the cartoon, he was now summoned to Rome. He was paid at once a hundred crowns for his journey. He must have arrived in Rome at the beginning of the year 1505.

In spite of the haste with which he had required him, Julius did not at once know what he should give him to do. Some time elapsed before he gave him the order for a colossal mausoleum, which he wished to have built for himself in St. Peter's. Michael Angelo sketched a design; and the pope, delighted with it, ordered him at once to discover the best place for the monument in the Basilica of St. Peter.

This church, a vast work belonging to the earliest ages of Christendom, had been enlarged during the century, and possessed an abundance of art-treasures. Giotto had executed mosaics for it; the Pollajuoli had been among the last Florentines who had worked in it. In one of its side chapels, in that one dedicated to the holy Petronella, stood Michael Angelo's Pietà. With all its out-buildings, cloisters, and chapels, the dwellings of the clergy, and the Vatican palace itself, which closely adjoined it, the Basilica of St. Peter formed a kind of ecclesiastical fortress; having been more than once defended with force, and conquered. In it the emperors were crowned, the tribute of the lands was received, anathemas were pronounced or revoked. Two long rows of antique pillars supported the framework of the roof. In the court-yard before

12

it, surrounded by corridors, there stood the immense bronze pine-apple, which once had surmounted the mausoleum of Hadrian, and which now served here as a fountain, the water gushing down between the leaves. The façade of the church, with' its six entrances, was adorned with frescoes. There was incessant work on it; and, on a large or small scale, the old was altered, and new was added to, as was usually the case everywhere in the Italian churches.*

Nicolas V. first conceived the idea of its rebuilding; he wished thoroughly to renew both palace and church. A model was prepared, and the building was begun in the year 1450. Five years afterwards, however, the pope died, and no one thought of carrying on his work; all that had been built was the beginning of a new tribune, the walls of which were raised a few feet from the ground behind the old Basilica.

Michael Angelo looked at the work, and declared that it would be most advisable to complete this tribune, and to place the monument within it. The pope inquired how much it would cost. " A hundred thousand crowns," Michael Angelo suggested. " Let us say two hundred thousand," exclaimed Julius; and gave orders to San Gallo to view the locality.

Not only to San Gallo did he give this commission, but he joined with him a second architect, whom he had also taken into his service, and who enjoyed the reputation in Rome of being the first architect of his time, — Bramante di Urbino. He was of the

* See Appendix, Note XXXIII.

same age as San Gallo. In Milan, and afterwards in Rome, he had built churches and palaces for the Borgia and various cardinals. Bramante was one of those employed in that palace which the Cardinal di San Giorgio was building when Michael Angelo had arrived in Rome for the first time. The pope had now magnificent works in store for him, — the enlargement of the Vatican palace, which was to be connected by a passage with the Belvedere, now separated from it by a valley.

Bramante and San Gallo, who had to do with a man equal to the greatest designs, carried matters to such a point, that it was decided to overthrow the whole Basilica, and to place a colossal temple in its stead. Both sketched designs for it. Bramante's proposals pleased the pope better than those of San Gallo, to whom the building, however, had been already promised. Bramante's plans were eminently perfect. Michael Angelo, long afterwards, gives him this praise, — he says that every one who deviated from his designs deviated from the truth. San Gallo, however, not the less deeply offended, took his farewell, and, without allowing himself to be detained by promises, returned to Florence, where he was received with open arms by Soderini.

Bramante held his ground. His character may be sketched with a strong outline. Inventive, indefatigable, and versatile, he knew well how to accommodate himself to the whims of his master, whose impatient haste to perceive a sensible progress in the extensive works undertaken, he understood how to satisfy by unusual efforts, often even by artifice. As

long as the pope lived, he remained in favor with him; and for a long time it never came to light that he had placed too weak a foundation, and had furnished bad building for high pay. He was fond of pleasure, and wanted money; and, suspicious from the sense of his own weakness, he endeavored to remove those whose quick eye he expected might detect him.

He was suspicious of Michael Angelo, from the fact, that, while so young, he had produced such great things; and suspicious to a still greater extent, because the pope took pleasure in him. He had been recommended and brought to Rome by San Gallo. What was more natural than that he should endeavor to bring him back? Intriguing natures perceive countermines everywhere. Bramante's first care was to get rid of Michael Angelo also.

Of the pope's mausoleum, as it was projected by Michael Angelo, we have the descriptions of the biographers, and an Indian-ink drawing, by his own hand, it seems, which, after being possessed by various people, is now preserved in the collection of the Uffici in Florence. Many designs were indeed required before the pope decided; and it is not certain whether the plate lying before us is the very one upon which Julius ordered the entire work for ten thousand crowns. But, as the sketch agrees with Condivi's description, and no different conception is known, we may meanwhile consider it as the authentic one.

The mausoleum consisted of three parts, rising one above another. First of all, there was a sub-

structure thirteen feet high, upon a base of thirty-
six feet by twenty-four.* The Florentine sketch
represents the work as seen from one of the two
narrower sides, and gives only two of the three over-
lying parts. The paper seems to be divided above;
the pinnacle, therefore, is wanting. We see the sub-
structure in this drawing divided into two archi-
tectural groups, which, lying side by side, form the
surface turned towards us. On the right and left,
there are two niches with statues in them; on both
sides of each niche, on quadrangular projecting
pedestals, are naked youths, resting their backs
against the flat half-pillars to which they are chained
as prisoners, and which, above their heads, after the
fashion of the Hermæ, become figures of Romans
armed with mail, upon whose heads again lies the
strongly projecting cornice, enclosing the whole
lower structure. The statues in the niches are gods
of victory, with the conquered cities under their
feet.† The naked youths denote the arts and
sciences, which, at the death of the pope, expire
also.

If we see, therefore, on the side turned to us, four
youths, four pillars terminating above in human
figures, and two Victories; and if we think of this
number four times repeated, corresponding to the
four sides of the monument, — we obtain forty stat-
ues for this colossal pedestal of the whole work.

Each of the two niches, with statues, base, and
cornice, forms a whole; the two wholes next each
other form one side. Yet they do not directly

* See Appendix, Note XXXIV. † *Ibid.*, Note XXXV.

touch each other; but a space lies between them, which somewhat recedes, and appears like a smooth surface in the sketch. On the two broader sides, this space must have been considerably broader; almost as broad as the two architectural groups themselves, between which it lay. I suppose that on this flat surface the bronze tablets with bas-reliefs and inscriptions were to be inserted, which Condivi mentions generally as belonging to the work.*

In the middle of this lower structure rises the second story, the actual funeral vault, in which the sarcophagus with the corpse was to rest. It is open at the side, so that the sarcophagus within might be seen. We see the head of it in our sketch. At each of the four corners of this vault sit two colossal figures, two turning to each side, and so placed that each stands in the centre over one of those architectural groups of the lower building. The whole might therefore be thus described: There were four immense pedestals tolerably near each other, on each of which were two sitting figures, on the four corners • of a monument, which, placed in the midst, rested with one corner on each of the four pedestals.

The eight sitting statues are Moses, St. Paul, Active·ànd Contemplative Life;† more are not mentioned. Vasari and Condivi assert that there were only four statues in all,—one, therefore, at each angle. The drawing, however, indicates eight distinctly; and this seems also in accordance with the idea and the proportions.

* See Appendix, Note XXXVI. † *Ibid.*, Note XXXVII.

Of that which, lastly, was to crown the whole of this second building, we have only the description. Two angelic forms were to be seen there, bearing on their shoulders an open sarcophagus, with the figure of the pope falling into the sleep of death; Vasari gives them the names Cielo and Cybele, — Cybele, the genius of the earth, weeping because the earth has lost such a man; Cielo, the heaven, smiling because the happy one falls into rapture on his entrance.*

If we reckon the height of the lower structure at thirteen feet, that of the second part resting on it as nine, that of the uppermost at about seven, thirty feet would be rather too low than too high for the whole work. With more than fifty statues, rich works in bronze, and the finest architectural decoration in arabesques, flowers, and other ornaments, a human life seems hardly sufficient for the accomplishment of such a project. But calculations of a similar kind frightened neither the artist nor the pope, who, full of years, appeared as if he would begin anew a long and glorious life.

2.

Julius urged upon an immediate journey to Carrara. Michael Angelo received a bill of a thousand ducats upon a Florentine house, and left Rome.

Carrara lies in the most northern part of Tuscany, on the borders of the Genoese territory, where the Apennines run close down to the shore of the Tyrrhenian Sea, not far from Sarzana and Pietra

* See Appendix, Note XXXVIII.

Santa. Michael Angelo remained eight months in
the quarries there. He had two servants and a pair
of horses with him. Two of the figures chained to
the columns he had rough-hewn there; the rest
of the marble was conveyed away in blocks. The
contract with ship-owners of Lavagna, a Genoese sea-
port town situated to the north, speaks of the 12th
November, 1505. The people undertook, for sixty-
two gold ducats, to convey the marble to Rome. He
sent, however, a part of the stone to Florence, where
the work was to be had more cheaply and easily.
Here, too, the transport was to be effected by water
to the very spot.

When in January, 1506, he again arrived in Rome,
a part of his blocks lay already on the banks of
the Tiber; yet it fared ill with the transport of the
marble, as a letter written on the last of the month
to his father bears witness. "I should be quite con-
tented here," he says in it, "if only my marble
would come. I am unhappy about it; for not for
two days only, but as long as I have been here, we
have had good weather. A few days ago, a bark, •
which has just arrived, was within a hair's-breadth
of perishing. When, from bad weather, the blocks
were conveyed by land, the river overflowed, and
placed them under water; so that up to this day I
have been able to do nothing. I must endeavor to
keep the pope in good humor by empty words, so
that his good temper may not fail. I hope all may
soon be in order, and that I may begin my work.
God grant it!"

"Be so good," he continues, "as to take all my

drawings, — that is, the sheets which I packed up together, and told you to make a parcel of them, — and send them to me by a carrier. But take good care that the damp does no harm, and see that the smallest sheet does not escape: lay strong injunctions upon the carrier; for there are matters there of great importance to me. Write also through whom you have sent it, and what I have to pay the man. I have begged Michael (probably one of the workmen at the monument) by letter to have my chests conveyed to a safe and covered place, and then to send them here to Rome, and under no circumstances to leave me in the lurch. I know not what has befallen them; pray remind him of it; and, at all events, I beg you particularly to be careful of two things, — first, that the chest stands quite safely; and, secondly, that you will have my marble Madonna conveyed to your house, and that no one shall get a sight of it. I send no money for the expenses, because they can be but unimportant. But, even if you have to borrow, be quick. As soon as my marble arrives, you shall have money for every thing.

" God grant that my affairs here take a good turn! and invest, if possible, about one thousand ducats in land, as we have decided."*

We see how he at once gives a considerable sum of his money into his father's hands. The Madonna is probably that now to be found at Bruges, which was either at this time not entirely finished, or not sold.

* See Appendix, Note XXXIX.

12*

It seems soon to have fared better with the marble. Michael Angelo had the stone brought upon the square in front of the Basilica of St. Peter behind St. Katarina, where he dwelt. The whole city was amazed at the blocks which covered the entire square; but the pope above all took delight in it; and of this he made Michael Angelo sensible by an excess of condescending familiarity. He often visited him in his atelier, sat with him there, and discussed his work or other things. At length, to make it easier, he had a passage, with a drawbridge, constructed between the atelier and his own palace, which lay quite near; and he thus came to him without any one perceiving it.

Michael Angelo was considered at that time the first sculptor in Rome. We only find one rival named in Cristoforo Romano, — a name which, if it were not casually mentioned in another place (the Cortigiano of Count Castiglione, in which he belongs to the witty society assembled at Urbino, of whose conversations the book consists), would have been long ago lost and forgotten in the history of art. At* the same time it occurs in connection with Michael Angelo's in a letter which Cæsar Trivulzio wrote to Pomponio Trivulzio on the latest antiquarian dis-covery, — the finding of the Laocoon.

In the spring of 1506, the famous group was discovered in the ruins of the palace of Titus,* by the owner of the place, a Roman citizen. It was still hidden in the ground when the pope was in-formed of the discovery. He sent to Giuliano da San

* See Appendix, Note XL.

Gallo, that he was to go and see what was there. Francesco, Giuliano's son; tells the story. "Michael Angelo," he says, "who was almost always at home with us (my father had made him come, and had obtained for him the order for the mausoleum), was just there. My father begged him to go too; and so we all three set out, I behind my father. When we dismounted where the statue lay, my father said at once, ' That is the Laocoon which Pliny speaks of.' They now enlarged the opening, so that it could be drawn out. After we had examined it, we went home and breakfasted."

The owner of the figure wished to sell the work to a cardinal for five hundred crowns, when the pope interfered, paid the money, and had a " kind of chapel " constructed for the group in the Belvedere. It was now to be tested, whether Pliny's assertion, that the group was executed from one single block, accorded with the truth. Cristoforo Romano and Michael Angelo,* " the first sculptors in Rome," were called. They declared that the group consisted of several pieces, and showed four seams, which were, however, so well concealed, and the cementing of which was so excellently done, that Pliny is absolved for having fallen into so excusable an error, although he may have intentionally told an untruth to make the work more famous.

The Laocoon at that time occupied the minds of all in Rome. Verses were enclosed in the letter, which were made in its praise by the first scholars, — Sadolet, Beroaldo, and Jacopo Sincero. Of one

* See Appendix, Note XLI.

of these poems Trivulzio says, that it was so excellent, that, in reading it, one could have done without a sight of the work itself. Probably he meant the poetical description of the work by Sadolet (published in some annotations to Lessing's Laocoon), in praise of which Lessing also incidentally remarks, that it would stand in the stead of a representation.

At the present day there lies by the side of the group, as it stands newly restored in the Vatican, a rough-hewn arm with serpents, which is said to have been a work of Michael Angelo's, and which, so far as regards movement, is more correct than that which has been joined by another hand to the shoulder of the Laocoon. Yet, as this attempt of Michael Angelo's is nowhere mentioned, I doubt the truth of the statement. If the arm, however, should, in spite of this, have been his work, it must have been produced at a much later period.

In May, 1506, Michael Angelo was already working again at Carrara. The first transmission of marble was insufficient. Had he had his will, he would have at last required whole mountains. His ideas even surpassed the aspiring mind of the pope. A rock, which, rising on the coast at Carrara, is visible far out to sea, he wished to transform into a colossus, to serve as a mark to mariners. In this he did not fall far short of the ideas cherished by a certain Greek artist, who wished to convert a mountain into a statue of Alexander the Great, holding a city in each hand.

This second absence of Michael Angelo was, how-

ever, made use of by Bramante. He suggested to the pope, that it was an evil omen to build himself a mausoleum during his lifetime; and he succeeded in essentially cooling his ardor. The vessels with the new marble arrived; Michael Angelo was on the spot; he wanted money to pay the sailors. The pope had directed, for greater convenience, that Michael Angelo should be admitted unannounced to his presence at all times. Objections were now made; and, when he did gain admission, he received no money. He was compelled to apply to Jacopo Galli, who advanced him from a hundred and fifty to two hundred ducats, as he required.

The marble-cutters now appeared whom he had hired in Florence. He took them into his house; the work was to proceed; but Julius was as if changed, — he urged no longer, nor would he give any money. One day, Michael Angelo resolved to clear up the matter. Without further ceremony he determined to enter the palace. One of the servants of the pope refused him admission. The Bishop of Lucca, who just then arrived, said to the man, " Do you not know the master ?"—" Excuse me," replied he; " I have express commands not to admit you, and must carry out what I am ordered, without troubling myself why."

Michael Angelo knew what he had to do. He turned round, went home, and wrote in the following manner to the pope: " Most Holy Father, — I was this morning driven from the palace by the order of your Holiness. If you require me in future, you can seek me elsewhere than in Rome." He deliv

ered this letter to Messer Agostino, the pope's cup-
bearer, to give to him; and ordering one of his
workmen to find out a Jew, to sell all his possessions
to him, and to follow him with the money to Flor-
ence, he mounted his horse, and rode without stop-
ping until he was on Florentine ground.

Here the people who had been sent after him from
Rome reached him. They were to bring him back
by force; but in Poggibonsi, where they were now
treating with him, they could venture nothing.
Michael Angelo was a citizen of Florence, and
threatened to have them slaughtered if they touched
him. They had recourse to solicitation; but they
could gain nothing more than such a reply to the
pope's letter as they themselves pleaded as impos-
sible. The pope had written that he was at once to
repair to Rome, or expect his displeasure. Michael
Angelo replied, that he would not return, now or
ever; that he had not deserved such a change for
the good and true service he had rendered, as to be
driven from the presence of his Holiness like a crim-
inal; and, as the erection of the mausoleum was no •
longer of importance to his Holiness, he considered
himself released from his engagement, and had no
desire to enter upon others. With this he dis-
missed the pope's messengers, and proceeded to
Florence. It must have been the end of June, or
the beginning of the following month, when he again
arrived there.

Work he found in plenty; tho cartoon occupied
the first place. Scarcely had he begun, than a
letter arrived from the pope to the Government,

" All health and my apostolic blessing to our
dearly beloved sons," writes Julius to the Signiory.
" Michael Angelo the sculptor, who has left us capri-
ciously and rashly, fears, we hear, to return. We
entertain no anger against him, as we know the
habit and humor of men of this sort. That he
may, however, lay aside all suspicion, we remind
you of the submission you owe to us ; and we invite
you to promise him in our name, that, if he will
return to us, he can come free and untouched, and
that we will receive him with the same favor as he
enjoyed before he left us. Rome, the 8th July, 1506,
third year of our pontificate."

Soderini answered to this, that Michael Angelo
feared to such an extent, that, in spite of the assu-
rances contained in the letter, he required an espe-
cial statement from his Holiness, that he should be
safe and uninjured. He had tried every thing to
move him to return, and he still continued to do so ;
but he knew too well, that, if they did not deal very
gently with Michael Angelo, he would have recourse
to flight. He had been twice on the point of it.

We do not imagine here, that that which is
usually called fear is meant, when Soderini speaks
of Michael Angelo as *impaurito*, — filled with fear.
He had full cause not to trust the pope. Similar
promises, nay, even the most sacred oaths upon
honor and conscience, were the ordinary stratagem
for alluring into the snare those whom they desired
to get into their possession. Julius had too openly
and too frequently shown what value was to be set
upon his protestations ; Michael Angelo followed

the simplest dictates of prudence, when he refused to trust his mild language. A second letter arrived from Rome. Soderini sent for him. " You have treated the pope in a manner such as the King of France would not have done!" he said to him. "There must be an end of trifling with him now! We will not for your sake begin a war with the pope, and risk the safety of the State. Make arrangements to return to Rome." *

Michael Angelo, since matters had taken this turn, now thought seriously of flight. The sultan, who had heard of his fame, had made him offers. He was to build a bridge for him between Constantinople and Pera. A Franciscan monk had been the negotiator in this appointment. The Florentines had been on the best terms with the sultans since the conquest of Byzantium. With no fleet and policy of their own in the Levant, like the Genoese and Venetians, they inspired no suspicion; they had, on the contrary, won confidence from having betrayed at a convenient time the plans of these two rivals. A great number of Florentine houses were • established in Constantinople; and the intercourse between Florence and that city was very lively. Italian masters had been already often invited there. Michael Angelo would have found employment, favor, and friends.

The gonfalonier reported to Rome that nothing was to be done with him. The pope must offer him sure guarantees; otherwise he would not come. He would do, however, what he could, as the capricious

* See Appendix, Note XLII.

nature of the man afforded perhaps hope of a change of resolve.

Julius's third letter seems to have contained what was desired. Soderini, too, now heard of Michael Angelo's Turkish journey. He represented to him how much better it would be to go to Rome, were it even to die there, than to spend his life with the sultan. But he assured him he had nothing to fear. The pope was clement by nature; he desired him back because he wished him well; and, if he still put no faith in all his promises, the Government would let him travel in the capacity of ambassador. Whoever then harmed him in any way offended the Florentine republic. As Michael Angelo, from his birth and age, had long ago been a member of the consiglio grande, and as such was qualified for any office, Soderini's proposal appears thoroughly practical. In the present day, perhaps, a distinguished man would in a similar manner be attached to a foreign embassy.

Michael Angelo acceded to this. The Government gave him an especial letter of recommendation to the Cardinal of Pavia, the pope's favorite, through whom the negotiations on his behalf had been chiefly carried on. In this letter there is certainly nothing of his coming as ambassador; but, as he was to be designated *ambasciadore** only for the sake of the name, this is, on the other hand, no proof that he acted in this capacity generally. The letter is dated the 21st August, 1506; but, on the 27th, the pope had already left Rome to begin the war, which

* Appendix. Note XLIII.

was the commencement of those contests, in which he again resumed his old military career with all the energy of which he was capable.

3.

Men had been astonished at the peaceful begin-ning of his pontificate. Judging from his character, they expected him long ago to have taken up arms. Yet his nature seemed to have changed, and to exhibit no symptom of the old vengeance that he had wished to take on so many foes. But he was secretly gathering together money to raise an army. The papal election had cost him too much. He must first of all have his coffers full again. Hitherto he had endeavored privately so to guide matters, that, when he should at length appear in arms, there would be no difficulty in his way.

Thus, for a time, peace had prevailed in Italy, ex-cepting always the everlasting war of the Florentines against Pisa. Yet, while the pope was making his secret plans, others were making theirs also.

Milan belonged to France; Louis XII. had been • invested with it by the emperor. Florence enjoyed the protection of France in the first instance; and yet, with the possession of Genoa and Lombardy, Louis had been obliged to adopt the policy of Sforza and Visconti, which clung as it were to the soil, — he was obliged to strive for the possession of the western coast of Italy, and to endeavor to obtain Pisa. At the same time, there yet remained the usual pretensions to Naples, which Gonsalvo, the great captain, had gloriously reconquered for Spain,

and ruled as viceroy. Behind all this, however, there lurked the greatest thought of all,—the empire! Louis wished to be crowned in Rome as emperor; this, too, had been the old longing of his predecessors, which had been transmitted to him, and which his successors cherished fruitlessly, until Napoleon at length realized it.

So long as Julius was in power, this was not, however, possible. He must therefore be set aside. The Cardinal d'Amboise, Julius's rival at the election (with Ascanio Sforza, who, a prisoner in France, had died rapidly of the plague, that is, he was poisoned), was to be serviceable to him in this. He reckoned that a council would depose Julius, and elect Amboise in his stead. He entertained at present no fixed plans, only a few leading ideas; but, as it was natural that they should come into the king's mind, it was equally natural that Julius himself should be aware of them, and endeavor to protect himself.

And this for a while appeared not very difficult. Two powers were opposed to the king, who took care that not a step should be taken by France, to which they had not given their assent beforehand. Spain, in the first branch,—that is, Aragon, which, after Isabella's death, was again separated from Castile, and was now united with Naples,—obeyed the old King Ferdinand. Then there was Maximilian, the King of Rome, whose son, Duke Philip of Burgundy, now possessed Castile. He governed there for his son Charles, afterwards Charles V. The Castile nobles, fearing for their rights, had called him to their country. For King Ferdinand also wished

to govern in Castile for Charles, who was his grand-
son. The relationship stands briefly thus: Maxi-
milian married Mary of Burgundy; Philip, the son
of this marriage, was united to a daughter of
Ferdinand and Isabella. Thus Charles, who was at
once the grandchild of both Ferdinand and Maxi-
milian, had a right to the two Spains, to Burgundy,
and to the imperial crown,—all of which subse-
quently devolved upon him.

At that time, however, when Charles's mother had
just died mad, and he was himself a delicate child,
these prospects only caused Maximilian to turn more
vigorously to the south. He wished to restore the
German empire to honor, to win back Milan some
day for Charles, to humble Venice, and to drive
back the pope into his old dependent position.

Such were the Hapsburg ideas of that day. And,
perhaps for the sake of reconciling them with those
of France, a marriage was proposed between Charles
and Claude, the daughter of Louis.

Standing between two such powers, whose policy
embraced the whole of Europe, small scope remained
for the popes. They must be subject to the one or
the other. It was a repetition of those centuries
long ago, when France and Germany each endeavored
to appoint her own pope. Things, however, moulded
themselves into form. The existence of Venice and
Ferdinand of Aragon caused four to be always
fellow-players in the game; England also interfered.
Thus opportunity was given for coalitions; and, in
the general confusion, battle-fields for Julius's ambi-
tion presented themselves.

His nature needed violent excitement, and this was the real ground of his actions. He threw himself upon whatever lay nearest. After Borgia's overthrow, the Venetians had again seized upon a part of the Romagna, — Ravenna, Cervia, and Rimini, three important seaports, and Faenza in the interior. The two first possessed salt-mines, which yielded unusual revenues. Venice offered Rimini voluntarily in the year 1504; but Julius replied that he hoped to obtain possession of all by force. In the beginning of 1505, the Venetians appeared still more willing: they were now ready to give up every thing as far as Rimini and Faenza, so long as the pope would again receive into favor at Rome the ambassadors of the city which had been excommunicated. To this he acceded for a time. Without France, he could do nothing against Venice; and, willingly as Louis would have seen the Venetians humbled, he little wished to bring Maximilian into Italy, whom a war against the city would have at once placed in motion.

Julius could, therefore, for the present, undertake nothing on this side. But he wished to have war. He resolved to bring back under his authority Bologna and Perugia, — two papal cities which had many years ago risen into independence· under the Bentivogli and Baglioni. Against these two families he cherished a personal enmity; and France showed herself here more inclined to afford active assistance, for she feared an alliance of Julius with Venice.

Accompanied by the cardinals, the pope marched with his army from Rome, — first to Perugia, which

lay half-way to Bologna. He had with him not more than five hundred lances, — that is, five hundred heavy-armed horsemen, who, with their retinue, represented a far greater number. The reinforcements of allies were to join them on the way. Gianpagolo Baglioni, on the other hand, long accustomed to war, was so well provided with soldiers, that he could have confidently defended his city. Nevertheless, he met Julius at Orvieto, tendered his submission, and was taken into service with his people. In the midst of court-state and cardinals, the pope made a solemn entrance into Perugia; his only protection being his body-guard round him. Baglioni might have now taken him, with his whole retinue. It would, perhaps, have been a good business. But this man, who had, assassin-like, murdered all his relatives, felt himself paralyzed by Julius's appearance, and allowed the beautiful opportunity, as Macchiavelli calls it, of gaining the admiration of his contemporaries, and everlasting glory, to pass by unused, only because he lacked the courage to be as wise as the moment required. And, that this ° opinion may not appear as a strange view of Macchiavelli's, be it observed that Guicciardini also censured in Baglioni this want of energy at the right moment. Such was the age. It never occurred to either to call to mind what a disgrace it would have been to have seized by artifice the head of Christendom.

In Perugia, the Cardinal of Narbonne appeared in the name of the King of France, desiring Julius at least to defer his undertaking against Bologna

The pope had left Rome before Louis had surely promised him his help. The Bentivogli were on good terms with France. But the reminder had no other effect than that the pope gathered together soldiers on all sides, that he might advance the more speedily. The king yielded. Julius was obliged to promise not to attack Venice; and, upon this con dition, Louis furnished six hundred horse and three thousand infantry. Baglioni led a hundred and fifty horse; the Florentines sent a hundred under Marcanton Colonna; the Duke of Ferrara, another hundred; stradioti (a kind of mounted Greek mercenaries used by Venice for the most part) came from Naples; and, lastly, two hundred light-horse were led by Francesco Gonzaga, who was appointed commander-in-chief of the army.

The old Bentivoglio and his sons, seeing themselves attacked on all sides, awaited not the storm. When they heard of the hostile advance of the French, they fled to meet them, and for good pay were taken under their protection. The people destroyed and plundered their palace. Julius entered the city with a splendid escort. The citizens received all their liberties back again. The pope came as the liberator of Italy. At the same time, however, he took the necessary measures to keep Bologna thoroughly papal. He established himself there for a time, and looked around him. The Venetians' turn came next. For the moment, however, matters rested; and leisure was found for remembering art and Michael Angelo.

While the pope was carrying on war, the latter had

been progressing in his cartoon in Florence, and had completed it. The contests with Pisa completely claimed the public interest at that time. Michael Angelo had chosen his subject from the sphere of the war, which had for centuries continued between the two cities. About the time in which Salvestro dei Medici lived, there came to Italy an English enterpriser named Hawkwood, — or Aguto by the Italians, — a famous and brave man, whose monument is still to be seen in Santa Maria del Fiore. He interfered in the contests of his time; the work, and not the cause which he served, signified to him. Before he had joined the Florentines, he had waged war against them in the pay of the Pisans; and, during this period of his activity, the incident occurred which Michael Angelo has represented.

The armies stood opposite to each other in the neighborhood of Pisa. It was very warm; the Florentines laid aside their armor, and bathed in the Arno. Aguto used this opportunity for an attack. Manno Donati, however, hastened forward in due time, and announced the threatening danger. Thé bathers rushed to the shore, and to their arms, — young and old promiscuously. This was the moment which Michael Angelo seized. Some could not get their wet limbs into the clinging garments; others had their armor already on, and were buckling fast the leather straps. We see one just scrambling up the bank, supporting himself on both arms, and looking into the distance. The whole figure is visible in its wonderful attitude, with the back turned towards us. Another, who is already

The Cartoon of the Bathing Soldiers.

MICHAEL ANGELO.

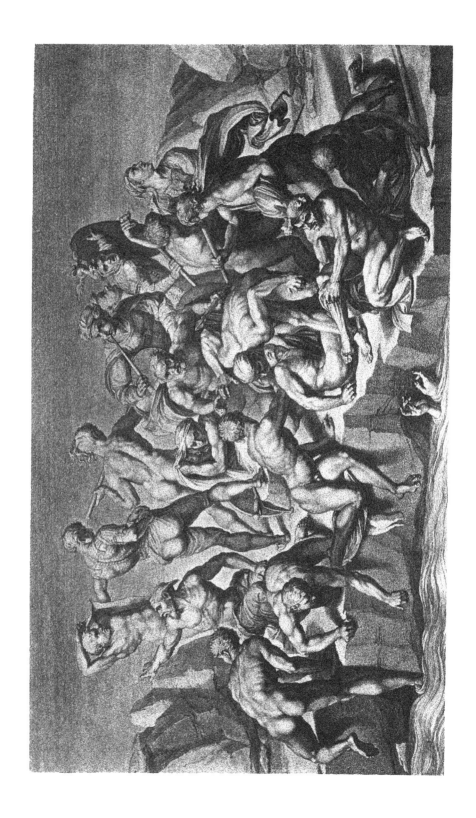

occupied with his garments, suspends the action of pulling them on for a moment, and, turning his head round in the direction where danger threatens, he points to it.* One, again, who is still quite naked, is kneeling on the top of the bank, and stretching his left arm deeply down towards another arm, which rises from the waters with the fingers moving imploringly. With his right arm and his knees he is endeavoring to afford resistance above. It is not possible to describe all the separate figures, the foreshortenings, the boldness with which the most difficult attitude is ever chosen, or the art with which it is depicted. This cartoon was the school for a whole generation of artists, who made their first studies from it.

It was never finished. There exists at the present day nothing but a copy of small size, which only shows the position of the figures generally. Some figures, on the other hand, forming a group, have been engraved by Marc Anton. It is one of his finest plates, and allows us well to surmise what a splendid work the cartoon must have been. A second engraving, giving another and greater part of the whole, is by Agostino Veneziano, Marc Anton's pupil. But, whilst the former plate might have been drawn after the original in the year 1510, we know not, as regards the latter, where the drawing comes from. As a peculiarity of composition, the old Florentine mannerism is conspicuous, representing rather a vast throng than a symmetrically organized arrangement from a centre. The beauty of the

* See Appendix, Note XLIV.

work, apart from its intellectual significance, lay in the abundance of attitudes in which the uncovered bodies are exhibited. Leonardo had long ago produced great things; anatomy and the study of fore-shortenings had been carried on by him with masterly power before Michael Angelo's appearance; still, he must have seen himself now far surpassed by the latter.

Opinions were naturally divided in Florence. The two masters were disputed for and against with violence. If a great power once excites the feeling that it can be unhesitatingly relied on, a party is at once formed round it. The cartoon must have given the friends of Michael Angelo this necessary feeling of security. He stood no longer alone opposed to Leonardo's school; and he had fortune on his side.

It fared ill with Leonardo's painting in the hall of the palace, to which he applied oils, instead of painting *al fresco*. The composition with which the wall had been prepared by him for this purpose did not stand; the work perished under his hands.* Added to this, the project failed, of digging a new bed for the Arno, and thus compelling the Pisans to surrender, by turning aside the river that intersected their city. Two thousand workmen had been employed; at last it turned out that errors had been made in the levelling. Leonardo had, it seems, taken part in this. Points of irritability between him and Soderini made life in Florence thoroughly uncomfortable. He had sent for his pay, and had received nothing but packets of copper

pieces. With a proud reply, he sent the money back: he was not a painter to be paid with three-penny-pieces. It reached such a pitch, that the gonfalonier uttered the reproach, that Leonardo had received money without producing work. The latter now brought a sum, corresponding to what he had ever received, and placed it at the disposal of Soderini, who declined receiving it. Pressing invitations came, on the other hand, from Milan. Leonardo asked for leave of absence, went away from Florence without having finished his painting, and returned to the old scene of his fame, where he was splendidly received by the viceroy of the King of France. The invitations of Soderini, to return and fulfil the promises entered upon, were met by that noble himself with the most courteous refusals. Leonardo received the title of Painter to His Most Christian Majesty; and returning once more to Florence, in the year 1507, in this capacity, he arranged his affairs, and repaired to France, whither his new master had called him. The gonfalonier could only show himself opposed to such wishes. Leonardo's picture in the hall of the palace was never finished; and the part that was completed gradually perished.*

Michael Angelo remained master of the battle-field; but he, too, was now called away from Florence by the will of the pope. Scarcely was Bologna taken, in November, 1506, than a letter arrived from the Cardinal of Pavia, stating that the Signiory of Florence would do his Holiness a great favor if they

* See Appendix, Note XLV.

would at once send Michael Angelo to Bologna, and that he should have nothing to complain of as to the reception awaiting him. A week afterwards, Michael Angelo set out, provided with an extraordinary letter of recommendation from the gonfalonier to his brother, the Bishop of Volterra. "We can assure you," he says, "that Michael Angelo is a distinguished man; the first of his art in Italy, indeed perhaps in the whole world. We cannot recommend him to you sufficiently urgently: kind words and gentle treatment can gain any thing from him. It is only necessary to let him see that he is loved, and is favorably thought of, and he will produce astonishing works. He has here now made the design for a picture, which will be quite an extraordinary work; he is likewise occupied with twelve apostles, each nine feet high, which will turn out a beautiful thing. Once again I commend him to you." And in conclusion: "Michael Angelo comes relying on our given word." So little, therefore, did they trust the gentle manner of the pope.

With this letter, Michael Angelo received a second, of a more energetic character, to the Cardinal of Pavia. He remained irresolute to the very last. Only a few days previous to the date of that letter, the gonfalonier had written, "that he hoped to induce Michael Angelo to take the journey." At the end of the month, he may have arrived at Bologna.

His first errand was to San Petronio, to hear mass. Here he was recognized by one of the papal servants, and at once carried to his Holiness. Julius sat in

the palace of the Government, at table, and ordered Michael Angelo to be admitted. At the sight of him, he could not, however, subdue his rising anger. "You have waited thus long, it seems," he said harshly to him, " till we should ourselves come to seek you." Bologna lies nearer Florence than Rome does; and the pope, if he meant this, had come to meet Michael Angelo.

Michael Angelo kneeled down, and begged his Holiness would pardon him. He had remained away from no evil intention, but because he had felt himself offended. It had been insufferable to him to be driven away as he had been. Julius looked down gloomily, and gave no reply, when one of the ecclesiastics, who had been begged by Cardinal Soderini to interpose if necessary, took up the word. His Holiness, he said, must not measure too severely Michael Angelo's faults; he was a man of no education; artists knew little how they ought to behave, except where their own art was concerned; they were all alike. The pope now turned furiously towards the officious mediator: "Do you venture," he exclaimed, "to say things to this man, which I would not have said to him myself? you are yourself a man of no education, a miserable fellow, and this he is not. Out of my sight with your awkwardness!" And, as the poor man stood there as if stunned, the servants were obliged to carry him out into the hall. Julius's anger was satisfied with this. He beckoned graciously to Michael Angelo, and gave him his pardon. He was not to leave Bologna again, until he had received his instructions.

Giuliano di San Gallo was with the pope in Bologna. Perhaps Michael Angelo owed it to the influence of this man, that the favor of the holy father was awarded to him again unimpaired. San Gallo suggested to Julius to have a colossal bronze statue erected in Bologna. Michael Angelo received orders to execute it. The pope wished to know the cost of it. It was not his trade, replied Michael Angelo, yet he thought he could furnish it for three thousand ducats. Whether the cast, however, would succeed, he could not promise. " You will mould it until it succeeds," answered the pope; " and you shall be paid as much as you require." The three thousand ducats were assigned to him at once, and Michael Angelo set himself to work.

Respecting none of his works have we so much information from his own hand. The intercourse between him and Florence was lively; and a great part of this correspondence may now be read in the British Museum.

The first letter is dated the 19th December, 1506;* written, therefore, a few weeks after his arrival, and this to his favorite brother, two years younger than himself, who, according to a custom in the family, bore the name Buonarroto as a Christian surname. Michael Angelo begs him to tell Piero Orlandini (a Florentine, respecting whom I know nothing further), that it is impossible for him to execute the dagger blade ordered. Orlandini wished to have something quite extraordinary; but, in the first place, the commission, he says, does not lie within

* See Appendix, Note XLVI.

his art; and, in the second, he lacks the time to exe-
cute it. Yet the blade was to be procured within
a month, and that as good as it is to be had in
Bologna. Inlaid sword and dagger-blades were, at
that time, like costly suits of mail, the necessary
possession of a rich noble; and great sums were
expended on them. These blades were worked in
different patterns; in Lombardy, the goldsmiths im-
itated the ivy and vine in their shoots and tendrils;
in Rome, the acanthus; and other plants, again,
are to be seen in the arabesques of the Turkish
dagger.

Michael Angelo hoped at that time, as early as
Easter, 1507, to have finished in Bologna, and to
return to Florence.

The letter exhibits him as the true centre of his
family. Buonarroto had written to him about Gio-
vansimone, a brother about a year and a half
younger, who, it seems, was just starting on a
definite career. Michael Angelo replied, that he
rejoiced that Giovansimone exhibited good intentions
in the shop with Buonarroto. He would always
assist him, and all of them, if God enabled him to do
so; and would fulfil what he had promised. If Gio-
vansimone, however, entertained the idea of coming
to seek him in Bologna, he must seriously dissuade
him from doing so. His dwelling was mean; he
had only a single bed in it, in which they slept four.
Giovansimone must have patience till the cast was
finished; he would then send a horse to him, and
fetch him. Until then they must pray God that all
should have good success. This is the usual con-

clusion to his letters; but it is no mere phrase, as is evident in other places. Somewhat strange does it sound, this sending for a brother, who at that time numbered about twenty-eight years. I could almost suppose, without doing injury to the memory of a name not intended to be immortalized, that it had been designed by fate, as may be often observed in similar cases, to compensate for Michael Angelo's extraordinary gifts by a corresponding lack of them in the family.

A considerable part of the three thousand ducats was at once sent away to Florence. This was subsequently the whole payment received, although Michael Angelo thought himself entitled to strong after-claims on the pope. On the 22d January, 1507, Michael Angelo was already answering a letter of Buonarroto's, in which the latter had informed him of the purchase of a piece of ground by his father. Giovansimone persists in coming to Bologna; Michael Angelo again refuses; he must complete his cast first. In mid-Lent he hopes certainly to have arrived so far; in Easter he goes to Florence. The dagger-blade for Orlandini has been ordered of the best master in Bologna; if it does not turn out good, he will have it made again.*

Such were the things which incidentally filled Michael Angelo's mind while he worked at the model for the statue. The pope must have sat to him occasionally. How different the thoughts which passed through Julius's soul during this time! He was transacting at Bologna the alliance with France

* See Appendix, Note XLVII.

against the Venetians. He desired to have back the entire Romagna. The king now showed himself more inclined. Philip of Burgundy had suddenly died in Castile. Maximilian's plans of attacking Italy, and of appearing as lord and emperor, supported by Castile, lost their terror. Louis could venture to think of advancing against Venice, and of taking from the republic the parts of the Milanese territory which it had taken possession of. A meeting between him and the pope in Bologna was arranged, in which the details were to be agreed upon by word of mouth.

Very different things, however, now reached the ears of the pope. Genoa had risen against the King of France. The people had driven the nobles, who were supported by him, together with the French garrison, from the walls. As an old imperial fief, they had raised the standard of the imperial eagle, and had placed themselves under the protection of Maximilian. Julius, by birth a Genoese, by inclination a democrat, having even appeared in Bologna as protector of the people against the oppression of the nobles, secretly supported the insurrectionists. He urged the king to an accommodation, instead of taking violent steps against the city. He now heard that Louis, under cover of reducing Genoa to obedience, was making extensive preparations, the true aim of which was a vigorous expedition to Italy. Tuscany was to be taken; a council was then to meet in Pisa; and the Cardinal d'Amboise was to come forth from it as pope. These tidings, and at the same time the report that Maximilian was acting

13*

partly in concert with Louis, were transmitted by the Venetians to Bologna.

Julius at once united with them. Mutual steps with the emperor were agreed upon, to obtain protection against France. On account of the threatening council, the pope's presence in Rome seemed necessary. The Cardinal di San Vitale was appointed legate in Bologna; Julius laid the foundation-stone of the new citadel which he intended to build, and withdrew to Rome at the end of February, 1507. As a pretext for this, he made his physicians assert that the air of Bologna was not good for him. He was also obliged to leave, they maintained, because the revenues were discontinued in Rome when he was not there in person.

Before he set out, he saw Michael Angelo's model once more. "Last Friday the pope was with me in the atelier," he says, in a letter dated the 1st February. "He gave me to understand that the work met with his approval. God grant it may turn out well; for, if so, I hope to gain great favor with the pope. He is going to leave Bologna during this' carnival; at least it is so rumored. I will send the blade by a safe opportunity as soon as it is ready."

Michael Angelo had represented the pope in a sitting attitude, three times as large as life. His right hand was raised; with regard to his left, it was a matter for consideration what might be best placed in it. "Your Holiness, perhaps, might like a book?"—"Give me a sword in it," exclaimed the pope; "I am no scholar. And what does the raised

right hand denote?" inquired Julius; "am I dis-
pensing a curse or a blessing?" It was customary,
in representations of the Last Judgment, that Christ
as judge, with his right hand raised, should form
the centre of the picture. The pope might have
remembered this. "You are advising the people
of Bologna to be wise," replied Michael Angelo, and
took farewell of his master, who, on Palm Sunday,
again entered Rome, where he was received with
great festivities. In front of the Vatican stood a
triumphal arch, an imitation of the arch of Constan-
tine at the Coliseum, the inscription on which hailed
him as conqueror and liberator.

Genoa, where the lowest class of the people were
masters, was now encouraged to hold her ground.
The pope had hoped to draw Ferdinand of Aragon
over to his side. He had at that time gone to
Naples, because Philip of Castile had called upon
Gonsalvo, the viceroy, to refuse obedience to the
King of Aragon, and to deliver over the kingdom
rather to himself. Gonsalvo thought, after Philip's
death, to retain Naples for himself; but he swore
allegiance to Ferdinand when the latter appeared in
person, and followed him to Spain. Julius thought
to have seen the king at Ostia, where the Spanish
galleys had to pass by. He had, it is true, as the
bestower of the investiture of Naples, incited Gon-
salvo to revolt, and to make common cause with
himself; in spite of this, he now wished to treat
with Ferdinand. The latter, however, sailed on,
without landing, to Savona, where he met Louis,
who came victoriously from Genoa. The pope sent

the Cardinal of Pavia to Savona; but he was not admitted to the secret negotiations here. This only he brought with him back to Rome, that the two sovereigns were on the most intimate footing with each other, and that the feared Cardinal d'Amboise was the only third person present at their negotiations.

We must here observe, that, with regard to Naples, there had been for a long time an understanding between Aragon and France. The barons in favor of France had returned, and received back their possessions; Naples remained to Ferdinand, who, on the other hand, had married a French princess, old as he was, and gave compensation in ready money.

The collision of interests between France and Maximilian saved the pope. Both were opposed to Venice; they were united as regarded Burgundy and Castile, where Maximilian claimed the government in the name of his grandson, while Ferdinand raised pretensions to it; but the fact that Louis's final aim was the empire for himself, and the papal dignity for Amboise, while Maximilian conceived the strange idea of not only being crowned as emperor in Rome, but of becoming himself pope there at the same time, made agreement impossible. Julius negotiated constantly with both; he hated them equally, and would have liked, best of all, if they had destroyed each other for the advantage of Italy. He always demanded help from the one when the other threatened; he always, nevertheless, resisted when one of the two wished to appear in arms in

his defence. Whilst he was endeavoring to negotiate in Savona through the Cardinal of Pavia, he sent another cardinal to the diet at Costnitz, which Maximilian had convoked, because he needed money and soldiers for the Italian campaign.

These events occupied Julius during the summer of 1507. The probability which Michael Angelo had foretold, had happened meanwhile to his work, — the cast had failed. From the first he had had disappointments in his work. In that letter which mentions the pope's visit to him, he alludes at the conclusion to vexations caused him by his men. "If Lapo," he writes, "and Ludovico, who were here in my service, should say any thing to my father, tell him he must not trouble himself with what they state, especially with what Lapo brings forward, and must be disturbed by nothing. As soon as I have time to write, I will explain all to him." *

In spite of this, that occurred which he had wished to prevent; for a letter addressed to his father on the 8th February shows that the latter had not only lent a willing ear to the complaints of the two dismissed men, but had also taken his son to task on the matter. Michael Angelo now states the facts. At first he upbraids his father in a letter addressed to Granacci, which he is to let him see; in a postscript, however, he returns again to the matter, as is often the case with him, and relates how Lapo had wished to deceive him in the purchase of a hundred and twenty pounds of wax. †

* See Appendix, Note XLVIII. † *Ibid.*, Note XLIX

This statement affords a glimpse into the state of the work. It shows that the cast of the statue was at that time in course of preparation. The first thing required for this was a clay model. When this was dry, whatever had disappeared in this manner was supplied by a coating of wax, until the model again assumed its old form; and over this was placed a coat of clay. When this was well dry and firm, the whole was heated, the clay absorbed the liquid wax, and the vacant hollow space surrounding the whole figure received the metal. This is the more simple plan which Benvenuto Cellini specifies. He, as well as Vasari, mentions the more complicated method also.

Michael Angelo, however, did not trust the cast to his own hand. A great deal of experience was required for this, such as only the work of years could give; and the matter was this time too important to venture an attempt. Michael Angelo applied to the Government of Florence, and requested the assistance of Messer Bernardino, who superintended the gunnery of the republic. As the honor of the city, both as regarded the pope and the Bolognese artists, was at stake, such a request could be well made. On the 30th April he writes, however, to his brother, that he must let the Government know that he has engaged a Frenchman, as no answer had arrived to his demand, and he had hence concluded that Messer Bernardino had probably not liked to come for fear of the plague. It would have been impossible for him to wait longer, and to remain doing nothing.

Four weeks after, however, the gunnery inspector arrived ; and, at the beginning of June, the cast was undertaken under his direction. The result was not satisfactory.

"Buonarroti" (thus the letter begins which announces this), — "You must know that we have cast my figure, and been unsuccessful in it, as Messer Bernardino, whether from want of experience or because an unfavorable fate so willed it, had not sufficiently melted the metal. I could write a long story about it: it is, however, enough to say that the figure has only reached the girdle, and the rest of the metal — that is, the other half — was left sticking in the stove because it was not fluid, so that I was obliged to break the stove to obtain it. This, as well as the restoration of the mould, will be undertaken this week ; and we hope to bring every thing into order again, though not without great labor, effort, and expense. I was so certain of my master, that I would have trusted Messer Bernardino, had he melted the metal without a fire. I will not say, though, that he is a bad master, and had not real interest in it ; but that 'to err is human' has been realized in him, in this instance, to my own and his great detriment. For they have talked of him here in such a manner, that he can scarcely show himself before the people.

"Read this letter to Baccio d'Agnolo, when you see him, and request him to give an account of it to San Gallo in Rome. Remember me to him, and to Giovanni da Ricasoli and Granaccio. If all now speeds well, I hope to be ready in a fortnight or three weeks, and to come to Florence ; if it does not succeed, I must again begin from the beginning. I will let you hear. Tell me how Giovansimone gets on. The enclosed is a letter to Giuliano da

San Gallo at Rome. Send it to him as safely and quickly as possible; or, if he is in Florence, give it to him." *

The renewed work lasted till August. Michael Angelo was obliged to pay the gunnery inspector thirty ducats a month from his own pocket. The cast succeeded admirably the second time. He writes in October, well contented at the state of things, that he hopes now very soon to come to an end, and to gain great honor.† In November, the gloomy mood again gets the better of him. Buonarroto had desired Michael Angelo's speedy return, on account of family affairs. He himself, he replies, wishes even more than they that he could come. "I am here," these are his words, "in the most unpleasant position. If I had a second time to undertake this intense work, which gives me no rest night or day, I scarcely think I should be able to accomplish it. I am convinced, that no one else upon whom this immense task might have been imposed, would have persevered. My belief is, that your prayers have kept me sustained and well. For no one in Bologna, not even after the successful issue of the cast, thought that I should finish the statue satisfactorily; before that, no one thought that the cast would succeed. I have now brought it to a certain point. I shall not, however, complete it this month; but, at any rate, in the next, and then I will come. Till then, be of good cheer; I will keep to what I have promised. Assure my father and Giovansimone of this in my name, and

* See Appendix, Note L. † *Ibid.*, Note LI.

write and tell me how Giovansimone gets on; learn accurately, and take trouble in the business, that you may have the experience necessary, when it is required; and that will soon be the case."

The following letter of the 20th December contains the request to forward to Rome, quickly and securely, a letter enclosed, addressed to the Cardinal of Pavia; for he could not leave Bologna without having an answer to it.* On the 5th January, 1508, he thanks for the punctual attention to his wish. He hopes to set out in a fortnight: it seems to him a thousand years till that time; for his position is of such a nature, that, if Buonarroto were to see him, he would be sorry for him. This is the last letter from Bologna.†

It would be interesting to know what he had to communicate to the Cardinal Alidosi; for the latter soon after arrived in Bologna, and that in consequence of events which made the winter a period of great commotion there. The Bentivogli, who were settled in Milan, and their adherents in Bologna, had done all they could to obtain their lost dominion back again. As France — who had in no wise publicly broken with Julius — did not allow them to carry on their plans openly, they had recourse to secret means. They attempted to poison the pope. They secretly levied troops, and preconcerted an attack with their adherents in the city. Above all, they desired to avenge themselves on the Marescotti, their bitterest foes, who had given the signal for setting fire to the palace. They relied upon the

* See Appendix, Note LII. † *Ibid.*, Note LIII.

T

people, because the legate made himself insufferable by his covetousness. This Cardinal of San Vitale had been raised to his high position from the lowest class, only because he was a countryman of the pope's, and was his willing servant.

At the beginning of 1508, the conspiracy was to break out. The machinations of the Bentivogli, however, were not unobserved. The Marescotti, who had most to fear, had been the most keen-sighted. They saw what was approaching. Hercole Marescotti went to Rome to beg the pope to take special measures for the protection of his party. Haste was now necessary. The palace of the Marescotti was surrounded by night. They declared that they would murder whoever they found there, and then admit the Bentivogli into the city. But the men, women, and children, thus surprised in their sleep, fled half-naked over the roofs of the adjacent houses; two servants only were seized, and put to the sword. Then, with two cannons, which they found in the palace, the rebels withdrew to one of the fortified gates of the city, — city gates were at that time always small citadels, — and placed themselves in a state of defence.

There were no papal troops in the city. Only in the rarest cases did the citizens of a city, at that time, allow the entrance of levied forces within their walls, — not even those whom they themselves paid. The citadel of the pope was still unfinished. The cardinal knew no longer what to do. On the other hand, the senate treated with the rebels, who had waited in vain for the Bentivogli, and had withdrawn

at length to their homes from their position at the gate.

The pope issued a pardon to all from Rome, recalled San Vitale, took from him the sums he had extorted, and put him in the Castle of St. Angelo. The Cardinal of Pavia, Francesco Alidosi, — feared as much as Julius himself was, and equally powerful, and still more avaricious than his predecessor, — arrived at Bologna as the new appointed legate. He placed eight hundred men in the city; hastened forward the building of the citadel; had the palace of the Marescotti restored at the public expense, and a number of citizens beheaded on the market-place after a short trial. Such was the state of things at Bologna at the time that the statue of Julius was ready to be placed at the principal portal of San Petronio. This occurred on the 21st February, 1508. The unveiling proceeded amid ringing of bells, sounding of trumpets, pipes, drums, and cries of the people. The day concluded with illuminations, fireworks, and festivities. The pope held in his left hand neither sword nor book, but the keys of St. Peter.

The portal at which the statue stood, the central one of the three Gothic doors which adorned the unfinished façade of the church, was the work of Jacopo della Quercia, one of the competitors for the doors of San Giovanni. When Ghiberti carried off the prize, Jacopo went to Bologna, where, through the intercession of Giovanni Bentivogli, the gate of San Petronio was assigned to him. He received three thousand gold florins for the work, and marble

free of charge. Thus, throughout Italy, Florentine
work met everywhere with its like.

Michael Angelo, having completed his work, re-
turned to Florence. We know not with whom he
was most intimate in Bologna, while he was at work
there; nothing is told us of his further connection
with Messer Aldovrandi. Yet we find the latter
mentioned as a member of the deputation sent by
the citizens to the victorious pope.

It may, on the other hand, be supposed as pretty
certain, that Michael Angelo stood on no better
terms this time with the artists of the city, whose
envy had the first time driven him away.

Francesco Francia, the famous goldsmith, painter,
and stamp-cutter, was the head of the Bolognese
school. He came to Michael Angelo in the atelier,
and examined the statue. Without speaking of any
thing else, he only mentioned that the metal was
good. "If it is good," replied Michael Angelo, "I
owe my thanks to the pope for it, who provided me
with it, just as you do to the merchant of whom you
buy your colors for your pictures."

Francia — a cheerful, hearty man who gladly ac-
knowledged foreign merit — may, however, from the
first have not been quite unprejudiced with regard
to Michael Angelo. Party jealously was perhaps at
work in Bologna. As a friend of Perugino's, with
whom he was allied by many excellent pupils belong-
ing to them both, it is not to be doubted on which
side he stood. And this is strengthened by the fact,
that he subsequently exhibited himself as an enthu-
siastic friend of Raphael.

How bitter the feeling was between Michael
Angelo and Perugino, is shown by an incident which
I will mention here, because the time in which it
occurred is not more accurately specified by Vasari.
Perugino had expressed himself with insulting de-
rision respecting Michael Angelo's works; and the
latter had said, in consequence, that he considered
him to be an ignorant man in matters of art.*
Perugino proceeded to law, and informed against
him; but he was dismissed with his complaint in a
manner which was more painful to him than Michael
Angelo's words. The latter, it was decreed, was
right; he had only said what was not to be denied.
Perugino, since about the year 1500, after having
completed some excellent works, had fallen into a
flourishing kind of painting, which made such a re-
proach all the more applicable to him, since, adopting
a coarse, technical style, he derided those who, work-
ing more laboriously and conscientiously, endeavored
to surpass him; or, as he himself conceived the mat-
ter, who aspired to undermine his well-won reputa-
tion.

Michael Angelo, to whom art was the highest
thing on earth, — to whom its degradation for the
sake of gain seemed despicable, — must have felt all
the more deeply shocked at the sight of a master
who was able to produce so much that was excellent,
and now, instead of advancing, retrograded. And
this, not because urged by necessity, but because he
wished to increase easily and quickly what he had
already gained. Vexation at the humbling result of

* See Appendix, Note LIV.

his trial is said to have obliged Perugino at that time to leave the city. It must at any rate, if it happened at all, have been only for a short time, as he appears again in Florence up to the latest period of his life.

If Francia's connection with Perugino was the cause of his ill-humor with Michael Angelo, the latter in no wise seems to have done any thing to make Francia more friendly towards him. If we are to believe Vasari, who also relates the coincidence above mentioned, matters became much worse. According to him, Michael Angelo in the first place made a rude reply to the good Francia, in the presence of others; and, secondly, added a general verdict upon him and his pupil Costa, more degrading than can be imagined. Vasari softens the expressions somewhat in the second edition of his book, according to which Michael Angelo is said only to have used the word which he had also applied to Perugino, that Francia was a *goffo*, — a great blockhead. If we prefer, however, to regard the whole matter as one of those gossipping stories, which never really occurred as they are related, the impression still remains, that Michael Angelo regardlessly expressed his opinion, and cared little whether he did so in rude terms. With regard to Francia, he seems, however, to have made his conduct a matter of especial conscientiousness. He sent him word through his son, a beautiful boy, that his living figures succeeded better than those which he accomplished in his pictures. Condivi also relates this.*

* See Appendix, Note LV.

It is possible, that the feeling which was produced under these circumstances had some share in the sad fate which some years later befell the work of Michael Angelo, — a work which he had just completed with such great trouble.

For it seems to me, that Francia's aversion to Michael Angelo, and the equivocal manner in which he acknowledged his work, were the result of political irritation. The Bentivogli family had been odious to the citizens; but they had always given abundance of employment to the artists. Francia especially had been beloved and honored by them. Now their palace, in which he had himself painted, lay in ruins; and the great bell of his tower had passed into the form of Michael Angelo's statue. Francia, who had before cut the die of the Bentivoglian coins, was now, as paid master of the mint, obliged to cut the coins on which was Julius's head, and the inscription on which extolled him as liberator of the city from its tyrants. Francia was grieved beyond measure at these events; but, as Vasari also relates, he knew how to submit quietly to his fate, as a sensible man. Towards one alone he could not succeed in this, however, — to him who now appeared in Bologna as a foreign artist, to cast the statue of the man who had brought this misfortune upon the city. And this statue besides, such an extraordinary work! Francia, the head of the Bolognese artists, could scarcely feel otherwise than hostilely opposed to Michael Angelo.

It is possible that still further things were brought about by this state of affairs. In the same winter

of 1506 to 1507, in which Michael Angelo began his work in Bologna, Albert Durer appears to have come there from Venice on a visit, and to have been received with great distinction by the artists. He undertook this excursion before he returned from his second Italian journey; there is no trace, however, of his having met with Michael Angelo. Martin Schongauer might have served as a connecting link, Michael Angelo having achieved his first painting from his engraving; while Durer, who highly respected Schongauer, regretted nothing more than that fortune had not allowed him to have studied with him as a pupil. A natural meeting between the two, however, was perhaps scarcely possible. If the native artists had not done so, the Germans studying in Bologna would have kept Durer back. For they felt bitterly the contempt with which the German emperor was at that time regarded in Italy; and they looked upon the pope as the Devil, to whose charge they imputed every thing evil.*

Thus considered, Michael Angelo's solitude appears as a natural result of circumstances. But even without this influence, he would have kept himself quietly at home, as he preferred to do. The melancholy, which formed the leading feature of his character, found relief alone in devotion to his work. If we could quote a single instance in which he was faithless to the grand idea which he cherished as to the mission of an artist, his behavior to his equal must be called arrogant and rude, and, just because he towered so far above him in talent, would speak

* See Appendix, Note LVI.

most strongly against him. But he himself fully satisfied the feeling which made him so severe in his judgment of others. He refused every order which he thought he could not worthily fulfil. He came most cordially to the help of those who claimed his help. The childlike nature of his character breaks forth everywhere, as we get to know him better; and Soderini's letter contains no praise which stands in contradiction to the truth. Deeply absorbed at all times in his plans, and full of love for what he wished to produce, it was intolerable to him to meet others who thought otherwise. Without wishing or knowing, perhaps, how much he wounded them, he passed opinions by which he increased the number of those enemies whom his surpassing talent alone must have already produced in such an abundant measure.

CHAPTER SEVENTH.

1508 — 1509.

Call to Rome — The Painting for the Ceiling of the Sistine Chapel — Difficulties of the Undertaking — Summoning of the Florentine Artists — Impatience of the Pope — Conclusion of the First Half of the Work — Raphael in Rome.

MICHAEL ANGELO found before him, on his return to Florence, a series of works, the continuation of which was necessary. The cartoon must be painted, the bronze David finished; the twelve apostles for the cathedral were scarcely begun. The commissioners had by this time given up all hopes of them, and had let the house built for the purpose. Michael Angelo himself now took it for a year at ten gold florins, for no other purpose indeed than to carry on his work there. Lastly, Soderini had a great plan: this was to have a colossal statue on the square in front of the palace of the Government, and to commit the execution of it to Michael Angelo. A treaty for the block was already going on with the Marchese Malaspina, the owner of Carrara.

All this, however, was obliged to give way to Julius's mausoleum. Michael Angelo only remained till March, 1508, in his native city, and then went

again to Rome. He thought of nothing else than
of devoting all his powers to the great work, which
he had left two years ago; but there was no mention
of it now in the Vatican. He was to be occupied as
a painter. Bramante had thought over the matter.
The pope was not again to be persuaded; he was
convinced that the erection of a mausoleum during
his lifetime was a bad omen. As Julius, however,
had once pledged himself to Michael Angelo, he
would devise something for him, in which they might
hope to equal him more than in statuary. In this
he excelled all; he was now to paint. The pope
insisted that Michael Angelo should paint the vault
of the Sistine Chapel, so called because it had been
built by Sixtus (1473).

The task was not thoroughly to his mind. He
replied that he had never done any thing in colors,
and must request other work. His opposition made
the pope all the more obstinate; and Giuliano di San
Gallo's interposing influence so far succeeded, that
Michael Angelo consented to undertake it.

The Sistine Chapel, at the present day united with
the Vatican palace by various buildings of later date,
so that its exterior architecture is completely hidden
in the great whole, is a quadrangular space, twice as
tall as it is broad, and of considerable elevation, so
that it appears high and narrow. The walls are
bare; the windows, six in number, are comparatively
narrow and low, and placed close under the arched
ceiling on the two longer sides. Close under them
is a narrow cornice-like projection of wall, which is
protected at the present day by a low metal balus-

trade, — a gallery, to pass along which would make many people giddy. The windows are rounded above. Over them, the smooth vault of the ceiling joins the side walls, and this in such a manner that the triangular space between the windows tapers down upon the wall.

It was at first the intention of the pope only to have the central part of the dome filled with paintings of small figures. A contract was concluded, according to which the price of the whole was settled at three thousand crowns. "This day, the 30th May, 1508," — such is the purport of a notice which has come down to us, — "I, Michael Angelo the sculptor, have received from his Holiness Pope Julius II., five hundred ducats, which Messer Carlino the chamberlain, and Messer Carlo Albizzi, have paid on account for the painting which I have begun this day in the chapel of Pope Sixtus; and this upon stated conditions, which Monsignor of Pavia has drawn up, and which I have signed with my own hand."

Michael Angelo upon this began to make designs. Some of his drawings are still preserved. He was soon convinced, that the painting, carried out in this manner, would appear too simple and poor; and the pope agreed with him. It was now determined to cover the whole space with paintings as far as the windows; and Michael Angelo was free to form the compositions according to his own fancy. A new contract raised the price to twice the sum agreed; and the work was in course of execution in the chapel.

Before, however, the painting could be begun, there were a number of difficulties to overcome, the first of which consisted in the erection of a fit scaffolding. Bramante had pierced holes in the dome, through which cords could be passed, and in this manner a suspended scaffolding formed. Michael Angelo asked what he should do with the holes in his painting. Bramante confessed the evil, without being able to say how it could be remedied.

It does not seem that it was ill-will on the part of Bramante, when he declared that he could build no better scaffolding. The simplest thing would have been to raise it upon beams from the ground. That this was not done, and that it was not even thought of, may be perhaps accounted for from the fact that it was at the same time necessary to leave the chapel free below, so that its use for divine service might not be prevented by the work.

Michael Angelo explained to the pope that the thing would not do as it was. Julius replied that he might devise something better if he could. Bramante could propose nothing. Michael Angelo, upon this, ordered all that had been constructed to be removed, and produced a scaffolding without cords and holes, which suited his object most appropriately, and was considered at that time as quite a new invention. From the one remark of Condivi's, that the more the scaffolding was loaded, the better it supported, we perceive in it a so-called suspension work; probably the projecting wall below the windows afforded the support for the beams, which, running obliquely, two by two, were kept apart by a

third wedge-like beam inserted between, and formed a strong foundation, upon which, by means of boards laid across, the base of the scaffolding rested. Vasari, however, — who copies Condivi here, but adds something of his own also, — says that the beams rested on supports, so as not necessarily to touch the walls. Perhaps he had only forgotten the projection; for, had this been lacking, the erection of beams against the walls would have been of course necessary, on the top of which the wood forming the suspension work would have rested.

Condivi says of this scaffolding, that it opened Bramante's eyes, and was of essential service to him subsequently in the building of St. Peter's; Michael Angelo, however, saved so much cord by it, that a poor carpenter, whose help he made use of in the work, and to whom he made a present of the cord, was able to give marriage portions to his two daughters from the money derived from it.

The second difficulty consisted in the choice of able helpers. Michael Angelo had a number of painters come from Florence, whose names have an interest because they exhibit to us a portion of the Buonarroti party among the artists there. First there is his earliest friend Granaccio, respecting whose works and career there is otherwise little to relate. He continued as he had begun : where solemn meetings, the representation of comedies, the erection of triumphal arches, or masquerades, were concerned, he excelled; as an artist he produced nothing. Then Bugiardini, who had also studied with him in the gardens of San Marco and with Grillandajo, and

whose industry, goodness of heart, and simple nature, harboring no trace of envy or malevolence, formed the basis of a life-long friendship between him and Michael Angelo. He was not a great genius. Michael Angelo said of him in jest, that he was a happy man, because he was always so contented with what he had accomplished, whilst he himself never completed a work to his own full satisfaction.

Next comes Indaco, also an intimate friend of Michael Angelo's, from the days he studied with Grillandajo. He has no other claim to celebrity in the present day. Of Jacopo del Tedesco, nothing more is known than that he possibly was a pupil of Grillandajo's; and, respecting Agnolo di Donnino, authorities and conjectures refuse all information. The most important, however, of those who came to Rome at that time, was Bastiano di San Gallo, a nephew of those famous brothers, the patrons of Michael Angelo; he was at the same time an artist who had left Perugino's school, in whose atelier he had worked in 1500, as a declared renegade, and had gone over to Michael Angelo. The cartoon of the bathing soldiers had inspired him with higher views. He belonged to Michael Angelo's most zealous adherents. None copied the cartoon with such zeal. He was the only one who copied it in its whole extent, while others drew only separate groups of it. The small gray-colored copy of the work existing in England is reported to be his production. He is said to have spoken so intelligently and deeply of the anatomical correctness and the fore-shortenings of the figures, that in Florence they gave him

the surname of Aristotle, under which he is usually mentioned. He subsequently distinguished himself in Florence as architect and painter; and his life, as written by Vasari, occupies many pages.

With these half dozen men, Michael Angelo attempted his task. He soon perceived that the work was worth nothing, and that he should not require the men. The manner in which he endeavored to get rid of them is characteristic. He was firm and inflexible in his convictions with regard to his enemies; but, in ordinary affairs, he was by nature shy. Where it was necessary to defend others, or to come forward for his own honor, his resolution and strength were never lacking; but, when there was nothing to call forth this excitement of mind, and a certain temperate state of feeling gained ground, he then endured things, and was easily embarrassed.

He had not this time the heart to confess to his friends, that he could not require them. Instead of this, he went suddenly away, and was nowhere to be found. They found the chapel shut when they came to work as usual. At last they perceived the matter; and they set out quietly again on the road to Florence. It is not said whether they resented this subsequently. We know that it was not the case with Granacci. He remained the friend of the family. The London letters tell, it is true, of another, who took the matter ill; and this was that same Jacopo, who, perhaps because he was the most unimportant, felt himself most aggrieved. The letter, dated January, without further number, may be undoubtedly reckoned as belonging to the

year 1509, and is addressed to the old Ludovico Buonarroti. "It is now a year," writes Michael Angelo, "since I have received a farthing from the pope. I do not ask for it, because I cannot get on with the work, and I seem to have no claim for pay. The fault lies in the difficulty of the task, and that it is not my profession. Thus I am losing my time in vain. God help me! If you want money, go to the director of the hospital, and let him pay you fifteen ducats; and tell me how much is left." This director of the hospital of Santa Maria Nuova was the confidential friend, to whom Michael Angelo transmitted his money to be kept for him, and to be received without interest, and through whom he gave his family what they required.

"This day," he writes further in the letter, "the painter Jacopo has taken his departure; I caused him to come here, and he has complained of me bitterly. He will make complaints to you certainly. It is no matter. He is, in short, a thousand times more in the wrong as regards me; and I could make heavy complaints against him. Act as if you did not see him." *

The expedient which he proposes against Jacopo's complaints corresponds entirely with the manner in which he had dismissed him and the others. His melancholy mood, and his despair at the progress of his painting, however, had its ground in a circumstance which had almost induced him at the time to give up the whole thing.

He had destroyed what the Florentine artists had

* See Appendix, Note LVII.

painted. From henceforth, except his color-grinder, whom he could not do without, and the pope, who would not be refused admittance, no one was to come to him on the scaffolding. Scarcely, however, had he completed a part of the first painting, than, a violent north wind rising, the wall began to exude within, and the colors disappeared under the mould. The whole matter had long been a burden to him; and now this new evil seemed a decisive reason for withdrawing from the task. He went to the pope, and announced to him what had happened. " 1 told your Holiness from the first that painting was not my profession; all that I have painted is destroyed. If you do not believe it, send and let some one else see."

The pope sent Giuliano di San Gallo to the chapel, who at once perceived the cause of the mischief. Michael Angelo had made the plaster too wet; the moisture had sunk in, and had produced mould on the outer surface, which had done no further injury. Michael Angelo could now no longer excuse himself; and he was obliged to proceed again with his work.*

Many letters, containing information as to the circumstances under which Michael Angelo worked, are to be found in the London manuscripts, bearing the date of the year 1508, in which, as we have seen, he had not yet arrived at painting, and of the year following.

There is first a letter of the 2d July, 1508, to Buonarroti. It is in recommendation of a young Spanish artist, who went from Rome to Florence to continue his studies there. " He has begged

me," writes Michael Angelo, "to procure him a sight of the cartoon, which I have begun in the hall there. Try therefore, under all circumstances, to get him the keys; and, if you can otherwise give him good counsel, do so for love of me,—for he is an excellent man."

"Giovansimone," he continues, "is here. He has been ill for some weeks, and has caused me no small increase of anxiety in addition to what I have had otherwise to endure. He is better now. If he attends to my advice, he will return speedily to Florence; for the air here does not agree with him." In conclusion, he mentions the names of some friends, to whom Buonarroti is to remember him.*

The summer of 1508 must have been especially fatal (the first which Raphael spent in Rome); for the next letter mentions a fresh attack of sickness.† His servant Pierbasso had fallen a victim to the bad air; had set out for Florence, ill as he was; but was so unwell at his departure, that Michael Angelo feared the man might have been left sick by the way. He asks for another servant, and that quickly, as he cannot continue longer to keep house alone. He gives directions respecting the inheritance of Francesco Buonarroti, his father's eldest brother, who had died childless, it seems, in his seventy-fifth year. He begs that they will buy him some blue-color; he will send the money for it in the middle of August. Lastly, he has heard that they have refused the Spaniard admittance into the hall where the cartoon stands. He was glad of it; and he begs

* See Appendix, Note LVIII. † *Ibid.*, Note LIX.

Buonarroti to tell the gentlemen who had thus decided, when occasion offered, that they might keep it so to every one. In a postscript, he requests him to send the enclosed letter to Granaccio; it is of importance.

The letter is dated the last of July. From the commission to buy color, we may conclude that Michael Angelo had already begun his painting. But it certainly only concerned the preparations; and the letter to Granaccio probably contains the invitation to come and help. It is striking, that the cartoon is so strictly locked up, that the recommendation of the master himself secured no remission at that time; the young Florentine artists, therefore, could not have sat and drawn before the cartoon, and consequently not even Raphael, as long as he was then in Florence.

The next letter is dated August. Again matters of business. We see how Michael Angelo is consulted by his family about the least thing, and how he directs the Florentine household from Rome. A farm laborer had at this time not done his duty; Michael Angelo threatens to come himself, and look after him. He inquires whether Pierbasso has at length arrived. These letters afford only abrupt glimpses into a household, which we do not, however, get to understand; and their value consists mostly in the fact, that they show the position which Michael Angelo occupies with his father and brothers, and the feeling from which he acts. Only one more letter besides exists of the same year, without a date, but which we see, by the address, to have

arrived in Florence on the 17th October. The melancholy so deeply seated in Michael Angelo's soul, which he for the most part either concealed or moderated, bursts forth here, and exhibits the man, at the period when he was engaged in the greatest work that modern painting has produced, in a condition which claims our sympathy.

For the first time, in this letter mention is made of his younger brother Gismondo, with whom Michael Angelo from the first seems to have stood on no good terms. He understands, he writes, that Gismondo wishes to come to Rome. Buonarroto may tell him, in his name, that he must in no wise rely upon him in this journey. Not that he does not love him as his brother, but because he could really assist him in nothing. He is compelled now to have regard to himself solely; he is scarcely able to procure what he wants for himself. With care and bodily labor, he has been a burden to no friend in Rome, and needs none; he scarcely finds time to take his small morsel of food; and for this reason he must not have more put upon him. He could not bear half an ounce more than already lies upon him. He seems only to have led his most miserable life for the sake of saving for his family.

The year 1509 is opened by the letter already mentioned, in which he speaks of Jacopo. The date of those that follow cannot be surely decided; but they can belong to no other time. They treat of family questions, remittances of money, and purchases of property, — the usual manner at that time of laying out his wealth. Once, in June, there is

mention of sickness. Michael Angelo writes that they had called him dead; that he still lives: and he gives notice that he is well, and at work.* In August or September, he writes that he will come as soon as his painting is finished; and, in a letter of the 15th September, there is an allusion to domestic calamity at Florence, of which we know nothing further. But his manner of treating these things shows us his turn of mind.

"I have," he writes,† "given Giovanni Balducci (the Florentine house in Rome, through which he was accustomed to send money and letters) three hundred and fifty ducats in gold, that they may be paid over to you. Go with this letter to Bonifacio; and, when you have received the sum from him, take it to the director of the hospital, and have it entered like my other money. Some surplus ducats remain besides for you, which I have written that you were to take. If you have neglected to do so, do it now; and, if you want more, take what you require: for whatever you need I will give you, even though it is all I have. And, if it is necessary that I should write about it to the director of the hospital, let me know.

" From your last letter, I see how things stand. I am sorry enough, but cannot help you in any other manner. Still do not lose courage, and let not a trace of inward sadness gain ground in you; for, if you have lost your property, life is not lost, and I will do more for you than all that you have lost. Still do not rely upon it; it is always a doubtful matter. Use, rather, all possible precaution; and thank God, that, as this chastisement of heaven was to come, it came at a time when you could

* See Appendix, Note LIX. † *Ibid.*, Note LX.

better extricate yourself from it than you would perhaps have been earlier able to do. Take care of your health, and rather part with all your possessions than impose privations on yourself. For it is of greater consequence to me that you should remain alive, although a poor man, than that you should perish for the sake of all the money in the world. And, if people chatter and whisper, let them talk: they are people without conscience, and without love in their heart. Your MICHAEL ANGELO."

With regard to this gossip, it was a matter of consequence in Florence. Nowhere were so many evil tongues in motion. It is related how the old men who had withdrawn from business sat in a street on benches before the houses, and made sharp observations on the occurrences of the day. For what in the present day is carried quietly into every house by the newspapers, was at that time necessarily gathered together orally; and many things could not be kept secret, which at the present day are not promulgated abroad, because not printed.

There is still a postscript to the letter: "If you carry the money to the hospital inspector, take Buonarroto with you; and neither of you say a word of it to any human being, for good reasons. That is, neither you nor Buonarroto are to let any one know that I have sent money, neither with regard to that now sent, or to the former." In very illegible writing, the latter part of which I am almost obliged to guess at, there is written on the letter, "I am to take as much money as I require; and as much as I take, he gives me." It is probably the handwriting of his father. I suppose the mischief

was, that Giovansimone had induced his father to give him more than he perhaps ought, for setting up his independent business, and that he had ruined his own business in consequence. Some of Michael Angelo's other letters allow us to conjecture the same; but nothing can be stated with certainty on account of the lacking connection of dates.

Amid such thoughts, Michael Angelo's work progressed. The tormenting impatience of the pope was a further stimulant. As if he wished, by the haste with which he urged on his undertakings, to give double significance to the few years he had yet to live, he desired that the seeds which were but just sown should grow before his eyes. In building, he was spoiled by Bramante, who accomplished impossible things. He had the stones for his walls prepared by night in such a manner, that, when they were put together by day, the walls rose visibly, because groove fitted groove. Michael Angelo scorned all artifice. He painted quickly, but without assistance. The pope came to him on the scaffolding,— ascending on ladders, so that Michael Angelo was obliged to stretch out his hand that he might climb the last step, — and provoked him with questions, as to whether he should soon have finished. Between the spring of 1509 and the autumn of the same year, the half of the ceiling was completed. The impatience of Julius knew no longer any bounds. He declared that the scaffolding should come down, that this one piece, at least, might be shown to the Romans. Michael Angelc resisted. The last touches

were still wanting; and the gold for the different ornaments and lights had not yet been laid on. The pope came one day, and asked when he would now come to an end. "When I can," replied Michael Angelo. "You seem indeed desirous," thundered out Julius, "that I should have you thrown down from this scaffolding." Michael Angelo knew his man, suspended his work immediately, and allowed the beams to be removed. In the midst of the confusion and dust which filled the chapel, the pope was already there, admiring the work. On All Saints' Day, 1509, the whole of Rome crowded there, and gazed at the wonderful work which had arisen like magic.

2.

If we wish to have an idea of the art of Giotto and his pupils, — architecture and painting in one, — we must go to the Camposanto of Pisa; if we desire, on the other hand, to see a masterpiece of the period that followed them, of that advance that lies between Masaccio and Michael Angelo, the Sistine Chapel affords it. The best artists have worked in it; among the earlier, Botticelli, Signorelli, Ghirlandajo, and Perugino; all large, extensive compositions, the origin of which, the small, miniature-like ideal, we never lose sight of. Perugino first leads to greater things. His superiority over the others is here strikingly apparent; for the paintings, one touching another, form a broad girdle, running below the windows on all four walls: we perceive his simplicity, his symmetry, his carefully separated

figures; whilst, with the others, the different forms in the masses are scarcely considered.

Michael Angelo's ceiling-piece denotes the dawn of new views in painting. The cartoon of the bathing soldiers may be the best which he has ever produced, — we will believe Benvenuto Cellini, who so freely asserts this, — but his paintings in the Sistine Chapel have had the greatest influence; they are the beginning of modern painting. Whatever he, whatever Raphael and Leonardo, had done previously, had always sprung from the old Florentine mannerism, raised above it, yet still never denying the soil upon which it had grown; but here a new achievement took place, the greatest, perhaps, upon which an artist has ventured. The imagination which ruled here was just as rich as the art which executed her ideas. Michael Angelo had no model before him, on which he could have leant; he devised his method, and exhausted it at once. No later master comes forward as a rival; no earlier one attempted the like. For his work was produced by the effort of powers, which, so long as we have known art, have stood at the disposal of no other artist in like combination, and which he exerted in a surprising manner.

Hitherto, arched ceilings, intended for painting, had been divided into different compartments; and these were each filled with separate representations. Michael Angelo devised a new principle. He ignored, as it were, the dome; he arranged his painting as if the space had been open above, and roofless; he built out a new architecture in the air,

om the Ceiling of the Sistine

MICHAEL ANGELO.

Philologische

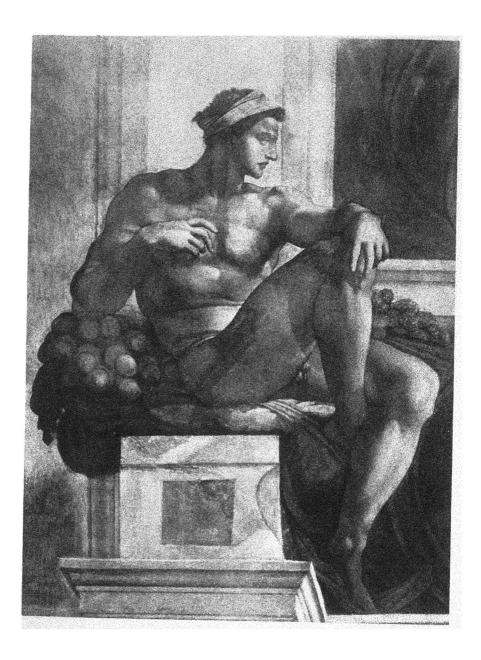

all in perspective delusion, and united the imaginary marble walls, which he had furnished with a magnificent cornice, by airy, perforated arches, stretching from one marble breastwork to another. The open space between these arches was filled with paintings, these also drawn in perspective, as would be the case with things in the sky seen through the apertures, or as if they were visible on tapestry that had been placed there. It would be impossible in a description to mention all the figures in the right place, which only served for the decoration of the architectural part of the painting; the bronze medallions which appeared inserted in the marble; the mighty figures of slaves, which, bearing garlands of leaves, are seated by the arches at the edge of the cornice; the Caryatid-like figures which seem to support the edge of the cornice; and, lastly, the metaphorical representations covering the space between the windows, and the walls around them. For there is not a spot on the whole surface which is left unused. Such an abundance presents itself, that it requires many days of the most attentive study to master it even superficially.

At the present day, the ceiling of the Sistine Chapel is partly injured, as regards the brightness of its coloring, by the rising smoke and dust, and has partly faded from length of time. Cracks have appeared in the dome, and water has trickled down through them. Three centuries and a half, the paintings have stood there; and it is not possible by any means to oppose the slow decay to which they must be subject. Still a happy fate has been

theirs, in that they are thoroughly inaccessible to human hands; they would have to be shot at, or the roof broken through from above, to be injured intentionally. How lamentably, on the contrary, are the paintings of Raphael maltreated in the apartments of the Vatican, not only by those who break them, scratch them, and make them dirty by touching, but also by the efforts of those who undertake their restoration! *

In the first of the great paintings, occupying the centre of the ceiling in the Sistine Chapel, we see God the Father, brooding over the waters, as he divides the light from the darkness. In the second, we see him creating the two greatest lights in the heaven, the sun and moon. It is the same form in each. But, in the second painting, the calmly hovering person of the Supreme Being, as he is portrayed in the first, is caught by an immense storm, and is represented as being thus borne through infinite space. His white beard is waving, his arms are commandingly outstretched, and there is an impulse forwards in the whole, as if a fearful star — compared with which the sun would be only a grain of dust — was rushing thunderingly past, and all the lower worlds were darting forth, like light sparks, from its original flame. And indeed, in this second picture, we twice see the form of God, — once coming forwards, the second time with the back towards us, as if the first expressed approach, and the second was hastening away. Both figures are drawn in fore-shortening.

* See Appendix, Note LXI.

In the third picture, God is hovering over the waters. There is ever the one form, ever another expression of the different will that fills it. In the midst of the fermenting powers, from whose inter-mingling the world is formed, he seems to bear a fiercer appearance than he assumes in his intercourse with man, when he reveals himself to them. In the fourth picture, he appears at the moment when he bestows life upon the first man.

Adam lies on a dark mountain summit. His formation is finished; nothing more remains than that he should rise, and feel for the first time what life and waking is. It is as if the first emotion of his new condition thrilled through him; as if, still lying almost in a dream, he divined what was pass-ing around him. God hovers slowly down over him from above, softly descending like an evening cloud. Angel forms surround him on all sides, closely thronging round him as if they were bearing him; and his mantle, as if swelled out by a full gust of wind, forms a flowing tent around them all. These angels are children in appearance, with lovely coun-tenances; some support him from below, others look over his shoulder. More wonderful still than the mantle which embraces them all, is the garment which covers the form of God himself, — violet-gray drapery, transparent as if woven out of clouds, closely surrounding the mighty and beautiful form with its small folds, covering him entirely down to the knees, and yet allowing every muscle to appear through it. I have never seen the portrait of a human body which equalled the beauty of this. Cornelius

justly said, that, since Phidias, its like has not been formed; and his works we know only by report. The head, however, with its thick white hair and beard, expresses so completely the majesty of which it is to be the image, that here for the first time there is nothing strange to me, in the sight of the Most High, who, as it is said, created man in his own image, appearing in human form. Almighty power, joined with mild compassion, beams forth in him. He stretches out his right hand towards the prostrate man, who raises his left apparently involuntarily and in sleep; and the extreme point of his forefinger is almost touched by the finger of God.

This corresponding movement is full of ideas, each of which seems at the moment exhausting, but is soon dispelled by another. All that is genuinely symbolic has something in it unapproachable; and this meeting of God and man is, in the purest sense, symbolic. God commands, and Adam obeys. He signs to him to rise, and Adam seizes his hand to raise himself up. Like an electric touch, God sends a spark of his own spirit, with life-giving power, into • Adam's body. Adam lay there powerless; the spirit moves within him; he raises his head to his Creator, as a flower turns to the sun, impelled by that wonderful power which is neither will nor obedience. He attempts to raise the whole upper part of his body; he supports himself on his right arm, on which he lay resting, while he stretches out the left; his right leg is stretched out; he has drawn in the left closely, in order to free himself from the ground, so that the knee is raised, — all the most natural

movements of a man wishing to rise. Then God gives him his hand; it seems as if it would attract him like a magnet without the fingers touching him; as if, gently hovering back, he would draw him after him, until his form stood erect on his feet.

Condivi says, in a very childlike way, that the outstretched hand of God denotes that God was giving Adam good instruction as to what he was to do, and what he was to desist from. There is nothing to be said against this: as regards great works of art, the simplest explanations have the same right as the understanding that fancies it can comprehend most profoundly; and which, in comparison with the ideas of the artist, penetrates no deeper than the deepest mine does into the heart of the earth, the outermost crust of which it scarcely pierces.

The next picture is the creation of Eve. Adam lies on his right side sunk in sleep, and completely turned to the spectator. One arm falls languidly on his breast, and the back of the fingers rest upon the ground. The upper part of the body is raised a little by the rocks, on which he leant in his sleep; and the head is thus forced upon the left shoulder.

At his feet stands God the Father. The more he approaches man, the more human he appears. He no longer hovers above; he stands on the ground, and walks; his long grayish-violet mantle falls in great folds at his feet; his head is slightly bent forward with a benevolent aspect; and his right hand is raised: for before him stands Eve, upon whom at that moment he has bestowed life. She stands behind Adam; we see her completely in profile;

her feet are concealed by Adam's prostrate form: we could imagine she was stepping forth from his side, just as earlier masters have represented her. We feel tempted to say she is the most beautiful picture of a woman which art has produced. Her body is slightly bent forward; her two arms are raised, and her hands are joined in prayer; her left leg is a little in advance, as she makes obeisance, — the right receding with bended knee towards the rock; her long fair hair falling down her wonderful back, and over her bosom, between her two arms. She is looking straight forward; and we feel that she breathes for the first time: but it seems as if life had not yet flowed through her veins, as if the adoring God-turned position was not only the first dreamlike movement, but as if the Creator himself had formed her, and called her from her slumber in this position.

Once more, in the next picture, she appears equally great and beautiful. The tree with the serpent divides this one into two halves. On the left is the temptation, on the right the expulsion from Paradise. It is a double view, therefore, of the same life. A fat, yellowish, shining serpent-skin is coiled round the stem of the tree, ending above in a woman, bending down from the boughs. With the right hand grasping something behind, she holds herself firm, reaching down with the other the apple; which Eve, raising desiringly the fingers of her opened hand, is ready to catch, almost as if she beckoned with desire. She is sitting under the tree, as though she had knelt, and had thus fallen on her

Temptation and the Expulsion from Paradise,
Sistine Chapel.

MICHAEL ANGELO.

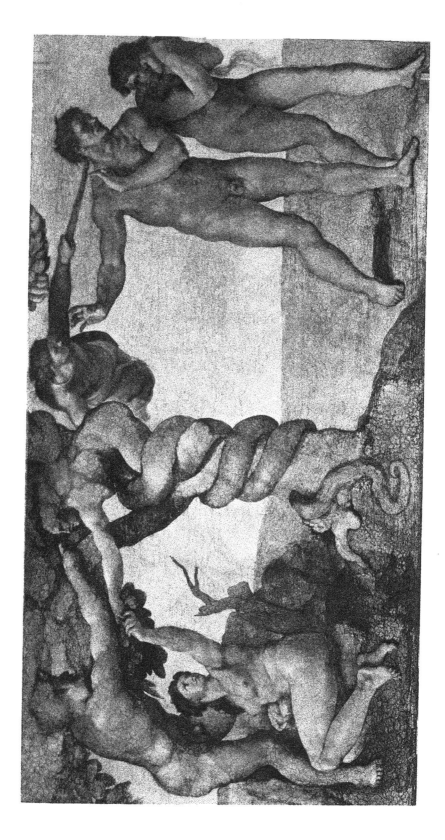

side. The direction of her knee, however, is turned away from the tree : she is obliged to twist round to the serpent; and so she raises her beautiful head, with the hair fastened up on her stately neck, to the serpent, and raises her arms to receive the fruit. Adam stands by her side. He, too, bends under the tree ; he has grasped a bough close above them, and holds it firmly drawn down; the other hand he thrusts into the foliage of the tree, over the head of the serpent bending down to Eve, and his forefinger is curved, as if he was going to pluck something. The meaning of the movement seems to be this; that, while Adam stands still in doubt whether he shall take or not, Eve has already accomplished the deed. Eve's whole appearance is different from that which she had in the former picture. The lines are stronger here : she appears more slender, more mature, more womanly : there is no longer the trembling, respectful being; but we see surer thoughts, and a fixed longing.

What annihilation, however, in the scene close behind it! The angel stretches out his arm with the sword over them, so that arm and sword form a horizontal line. Thus he drives them before him, — the two who, once so proud and royal, are now hastening stealthily away with timid step, and heads bent down : Adam attempting with both arms and hands to make an imploring movement towards the angel ; Eve, however, with head still deeper bent than his, and her beautiful back curved like a beaten animal ; full of despair, she crosses her arms on her bosom, and thrusts her clenched hand into her

golden hair. Still, however, she looks round to the angel. Adam ventures not to do so; he cannot endure the sight of avenging Justice, and of the lost Paradise; he strides heavily forward, his eyes fixed on his path; she, however, looks aside, and up at the angel: does a glimmer of curiosity even here flash through her despair? With firm steps they thus advance, misery weighing heavily upon them: but still they are rather exiled Titans than unhappy mortals; and Eve's beauty, veiled by sorrow, shines forth all the more powerfully.

The next painting represents Abel's and Cain's different sacrifices;* the one following that, the Deluge. The former has nothing especially striking in it; the latter loses its effect from another circumstance, — it is that with which Michael Angelo began. He wanted experience for the size of the figures in proportion with the depth from which they would be subsequently viewed. For this reason he drew them in less colossal proportions; we find a number of figures which appear diminutive compared with those of the other paintings. In the midst of the flood, we see the ark with its broadside facing us, and the men who are clinging to it. In the foreground there is a vessel, which, overladen with unfortunate beings, has drawn water, and is perishing. Quite in the front is the summit of a mountain, rising like an island out of the waves. Fugitives are scrambling upon it; some have thrown a cloth over a tree, to form a tent, which affords them protection against storm and rain. The last picture

* See Appendix, Note LXII.

represents the drunkenness of Noah. I speak less fully of all three, because of their inferiority compared with the others. This is more, however, on account of their subjects, than because less power is displayed in them. Nothing can bear a comparison with those first ones; and, as it is not requisite to give a catalogue of all that Michael Angelo has painted, but only accurately to describe whatever may be recognized as a visible step towards increasing perfection, we shall only give prominence to his greatest works.

3.

We have said that the triangular spaces of the dome ran down the side walls, between the windows. On the broad walls there were five of these; on the narrower, only one, and this exactly in the centre. In these twelve compartments, Michael Angelo painted twelve immense figures, which, touching with their heads the cornice of the architectural effect he had contrived, are so drawn in perspective, as if they were sitting round the interior of the great marble temple, examining the subject of the paintings which lie in the centre of the ceiling above them.

In the legends of the earliest ages of the earth, men appear more beautiful, more gigantic, and filled with simpler, stronger passions, than at the present day. They were but few in number, walking over the untouched soil, and passing along like solitary lions. Greece is like a wood in spring, in which Olympus and other mountains rise, down

whose slopes rushing streams hurry towards the waves of a sunny sea; Asia, an immense pasture-land for the flocks of Abraham, or the theatre of the contests before Ilium, the reverberations of which made the whole earth tremble, so that men and gods hastened round to await the issue of the strife.

There is an epoch in the legends of nations, when the union of the human and the divine produced a giant-like generation of Titans, long anterior to our own; and who, dwelling for centuries in deep caverns, are to rise anew at some future day.

It is as if Michael Angelo had seen this creation in imagination, when he painted his sibyls and prophets. Reading, meditating, or transported to rapture, they sit in their places there, as if thoughts filled them, over which they had brooded for ages. One could imagine that these men and women had long ago descended into the hidden clefts of the earth, and, lost in reverie, had, when they had ascended on waking anew, found the earth again pure and untouched, and surmised nothing of what had passed in the history of mortals during those ten or twenty thousand years which they had dreamed away.

I will not describe these figures, the whole series of which it would be very possible to express in words; and yet to do it justly is a work for which I feel myself scarcely capable. For it would demand not merely a clear enumeration of the outward attributes and attitudes to be observed in them, but a history of their position in Italian art, and a com-

parison of their character as shown by the Old Testament, with Michael Angelo's conception. He knew the Bible, and read it again and again; he had besides ecclesiastical traditions respecting the characteristics of the sibyls and prophets. It would require more accurate study than I have given to them, to perceive how much was borrowed, and how much was his own idea.

All twelve figures together seem to express the human mind lost in biblical mysteries; from the dreamy surmising of things, through every stage of conscious thought, up to the beholding of truth itself in an ecstacy of the highest rapture. The idea of representing the degrees of earthly knowledge, accumulating, as it were, in different persons, was not unusual. Beautiful was the way in which the employment of the four evangelists, in the sublimest of writings, was represented. The cross vault of a chapel was divided into four triangles. In the centre the symbol of the Trinity was painted, one evangelist in each triangle. The one, listening to an angel, whose words seem to him worth recording; the second, as he raises his hand to dip in his pen: the third, as he dips it in; the fourth, lastly, as he lays his hand with the pen on the page, and begins to write.

Here, however, where far higher matters were concerned, twelve figures scarcely sufficed. We see the prophet Jeremiah, his feet crossed under him, bent forward, supporting the elbow of his left arm against his side, and his hand across his mouth, buried in the great beard of his leaning head, the

image of the deepest, calmest thought.* In the next compartment we see the Persian sibyl, an old woman veiled in drapery, holding the book in which she is reading with both hands close to her eyes. Then Ezekiel, his body eagerly bent forward, his right hand stretched out demonstratively, his left holding an unrolled parchment; it is as if we saw the thoughts revolving in his mind. Then, again, a picture, the mere gazing at which insensibly excites enthusiasm, — the Erythræan sibyl, a wonderfully beautiful female form.

She is sitting, seen in profile, turned to the right, one leg, with the uncovered foot suspended, placed over the other; and in the beautifully arranged folds of the dress, which are drawn round her by this position, the hand of the bare left arm has sunk as if it rested in them. Bent forward, she is turning with her right hand over the leaves of a book lying before her on a desk. A lamp, hanging by chains above her, is lighted with a torch by a naked boy.

Next comes the prophet Joel, unrolling with both hands a parchment lying before him; and the play of muscles round his beardless mouth indicate that he is weighing mentally what he has read. Then comes Zacharias, entirely absorbed in his book as if he would never leave off reading. Next, the Delphic sibyl, young, beautiful, quite in the front, with an upturned look of rapture, while a soft gust of wind blows her hair aside, over which hangs a sea-green veil; and the bluish mantle likewise is distended softly and fully like a sail. The folds of the drapery,

* See Appendix, Note LXIII.

The Delphic Sybil, Sistine Chapel.

MICHAEL ANGELO.

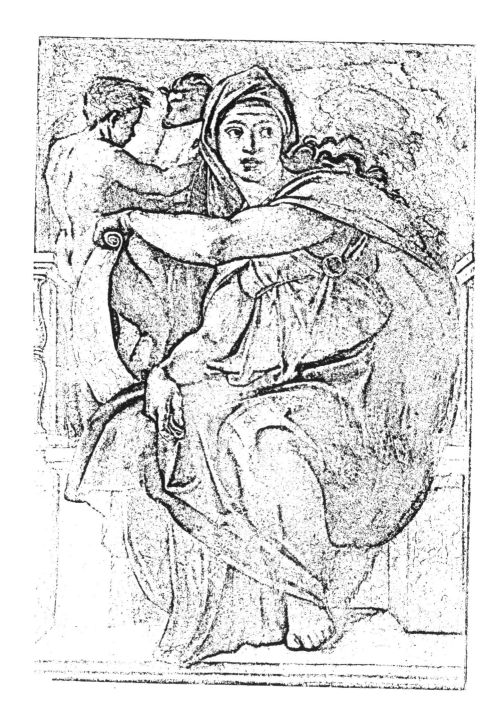

fastened closely by a girdle below the bosom, are¹ magnificent. Then comes Isaiah, with a slightly wrinkled brow, the forefinger of his left hand stretched out, the right grasping the leaves of a closed book. Next is the Cumæan sibyl, with half-opened lips unconsciously expressing what she reads. And then comes Daniel.

Before him is a boy, holding on his back an open book; he, however, a beautiful youth, looking sideways past it into the depths below, seems to listen to the words which reach him; and, forgetting that he has no pen in his hand, he makes a movement of writing with the right on another book, which lies at his side upon a desk.

Then comes the Libyan sibyl, who, with a quick movement of her whole body, seizes a book lying behind her, as if she must at once read something in it. Lastly, Jonah, who, lying backwards naked with only a cloth round his body, has been just discharged from the jaws of the fish, which is visible behind him. The restored light of day fills him with dazzling ecstasy. We see him, as it were, as an earthly symbol of immortality. The fore-shortening of the figure is exceedingly artistic. It is painted on an arch inclining towards us, yet it seems to recede.

Under this prophet, who occupies the centre of one of the narrower walls of the chapel, Michael Angelo, thirty years afterwards, painted the Last Judgment, which covers the entire wall from top to bottom, — the chief work of his old age, as the paintings on the ceiling were the greatest deed of his

youth. Worthy symbols both of the time of life in which he produced them. For, natural as it seems, that in his earlier years he should apprehend and fashion the remote, divine beginning of things, just as appropriate is it, that, as an old man, he should attempt to represent the end of the infinite future.

4.

I will select but two out of all the remaining pictures to describe. In the four corners of the chapel, the dome forms four triangles, on which are represented the death of Haman, the serpent in the wilderness, the death of Goliath, and Judith and Holofernes. I take the two last paintings, in order to show with what art Michael Angelo could conceive that, too, which was truly historical, — we might almost call it here, in contrast to those superior works, *genre* painting.*

He always seized the decisive moment, — that moment so fully imbued with the action, that what had happened before, and what was afterwards to be expected, appear at once comprised in it. Few subjects, however, are fitted to the same extent for displaying this power of seizing the true centre of an action, as the legend of Judith. This drama contains an abundance of situations for the play of the imagination; and, in the choice of these, in exhibiting the whole subject in the simplest manner, Michael Angelo's genius is shown.

We see Holofernes lying on a bed, over which a white cloth is laid. One arm has fallen languidly

* See Appendix Note LXIV.

down, and touches the ground with the wrist; the other grasps in the air, as if seeking the head that is no longer there. One leg, with the knee bent, falls over the foot of the bed, as if the bed were too short; the other is raised with the knee drawn up, and the foot appears on the couch.

We see him to the left, somewhat at the back of a tent, to which some steps lead. Judith is just descending them, coming out of the tent. Her back is towards us, because, turning round, she looks to Holofernes; while, with uplifted hands, she holds on the other side a cloth spread out, to cover the cut-off head, which the maid is bearing on her head, in a large, shallow dish. The maid has on a yellowish dress, broken by strong, heavy folds; for she stands with her knees somewhat bent, that her mistress may more easily cover the head in the dish with the cloth. She holds the dish firmly up with both arms. A light-blue handkerchief encircles her waist, over the golden dress.

Judith wears a grayish-blue garment over her breast and shoulders, on which the lights are laid on with gold. The position of the maid, as she tries to make herself lower, but, at the same time, holds her back stiffly, that the burden on her head may not lose its balance; the double feeling of Judith, who, at the point of throwing the cloth quickly over the cut-off head, and then hastening away, is suddenly alarmed by the thought that he might still awake, and, with raised hands, casts one more glance upon him, is, in the highest degree, speaking and exciting. The strong, bare form, lying there like a

slain beast, makes us understand the sudden shudder of the woman, and feel with it. A warrior, sunk in sleep, in the background, indicates the night, under shelter of which the deed was accomplished.

Does not this representation contain every thing? We see before us what has happened; the haste, subdued by trembling, with which the women steal through the dark camp; we see behind, the dissimulation, the anxiety, the fanaticism, which steeled her weak arm. And, in contrast to this, the unthinking strength of the man who is chosen as the victim. This is the pith of the poem. As a luxurious, captivating woman, Judith is insufferable; as a trembling woman, with a will that works more powerfully than her fear, she is a thrilling, true character. Thus Michael Angelo conceived her.

With the same truth he represents Goliath, over whom David prevails. As the colossus lies there on his stomach, while David indents his back with the point of his knee, we become convinced that the movements of the strong arms and legs, which would again rise in resistance, must be in vain. With the left hand, David seizes him by the hair; with the right hand he brandishes a short, broad, knife-like sword: we fancy we can hear it whiz as it cuts through the air; and we know, beforehand, that it has been fatally plunged through his neck. Goliath wears a green, close-fitting, mail-like dress; legs and feet are covered in the same way, with dark gray; the arms white, with straps of gold. David wears a light-blue under-dress, and a yellowish-green, man-

tle-like garment, fastened in a knot on the shoulder. This painting, and that of Judith, is clear and distinguishable by any light, as also are all the pictures in the centre of the dome; and, therefore, these meet the eye as the real substance of the Sistine paintings. The prophets and sibyls are, from their number, more difficult to see; that, however, which has been painted still deeper than they, close round the window, is only discernible in its outline to the attentive eye, after laborious examination. We must ascend the small gallery, and gain the assistance of a good glass, if the whole greatness of these works is to be revealed. It is true, that, thus near, we see doubly plainly all the little flaws and spots which seem to be drawn like a veil over the paintings; but, at the same time, we see more clearly the turn of the lines, and the simple means by which the light transparent coloring is obtained, and which, for ceiling painting, — when the effect is to be produced at such a distance, — is indispensable.

Condivi's narrative, and, more plainly still, a letter, written shortly before the uncovering of the work, shows that on the 1st November, 1509, the one-half of these compositions was completed. "Buonarroto," writes Michael Angelo, "I see from your last letter that you are all well, and our father has again obtained employment. I am thoroughly glad of this, and advocate his acceptance of it in any manner, if the situation is of such a kind as to leave him at liberty to return, if necessary, to Florence. I go on here as usual. My painting will be finished next week, that is, the part which is in course of

execution; as soon as I have uncovered it, I hope to receive money, and will try and arrange to obtain a month's furlough at Florence. I know not whether it will come to any thing; I might require it, for my health is none of the best." *

And then, as the last notice of this year, comes the success which brought Michael Angelo all his well-earned fame. He had worked desperately. In ten months the half of the immense surface had been filled with paintings by him. One of his sonnets describes in a burlesque manner his condition, — how he lay day after day on his back, and the colors dropped down on his face. His eyes had become so accustomed to looking up, that, for a long while afterwards, he was obliged to hold up any thing written, that he might read it with his head bent back, — a result of similar work which Vasari confirms from his own experience; and, as a close to it all, bodily exhaustion, no leave for home, and no pay. Shortly before All Saints' Day, he writes to his father that the painting has been displayed in the chapel; and that the pope was well contented with it, and expressed himself to that effect. Otherwise, however, he had not succeeded at once, as he had expected. The times were against art; he could neither come to Florence, nor had he that in his hands which he required for what he wanted to do: he means money to help his father. "But once more," he says, in conclusion, "the times are not in our favor; so take care of your health, and don't let gray hairs grow." †

* See Appendix, Note LXV. *Ibid*, Note LXVI.

And to all this were now added the intrigues of Bramante, who endeavored to place the continuation of the painting in Raphael's hands. About the time when these works were begun, Raphael had appeared in Rome. Bramante had brought him there, supported, as it seems, by the ducal family of Urbino, who at that time were closely allied with the pope. Raphael had worked in the apartments of the Vatican palace, during their rebuilding, with the other masters who were called for this purpose. His first picture, the Dispute of the Sacrament, had suddenly raised him above all; and Bramante saw in him the man who was now able to play that part against Michael Angelo, which the latter had himself acted towards Leonardo da Vinci, in the palace of the Government at Florence.

CHAPTER EIGHTH.

1510 — 1512.

Raphael compared with Michael Angelo — Raphael's Sonnets — Raphael's Portrait of his Beloved One in the Barberini Palace — Michael Angelo's Poems — Continuation of the Paintings in the Sistine Chapel — Melancholy State of Mind — Letters to his Brothers and Father — Journey to the Pope at Bologna — Siege and Fall of Mirandula — The War of Julius II. for Bologna — Loss of the City — Evil Condition and Mind of the Pope — Raphael's Pictures in the Vatican — Cardinal Giovanni dei Medici as Legate at Bologna — March against the City — Destruction of Julius's Statue — Taking of Bologna — The Medici with the Spanish Army before Florence — Flight of Soderini — Restoration of the Medici.

HE who insists upon thinking of these two greatest artists as contentious adversaries, may be at any rate set right on this matter by the little that is preserved of their personal behavior towards each other. Such inferences, however, are in themselves unjust. We see, indeed, Raphael and Michael Angelo made into heads of parties. Raphael appears from the first as prejudiced; he had men round him who incited him against Michael Angelo, and in the latter himself we discover nothing of a conciliatory nature; he thrust aside whatever was not congenial to him. His adherents and those of Raphael disputed. There is, however, no trace that the two masters actually took the parts which were so urged

The Dispute of the Sacrament.

RAPHAEL.

1510—1512.

Raphael compared with Michael Angelo—Raphael's Sonnets—
Raphael's Portrait of his Beloved One in the Barberini Palace
—Michael Angelo's Poems—Continuation of the Paintings in
the Sistine Chapel—Melancholy State of Mind—Letters to
his Brothers and Father—Journey to the Pope at Bologna—
Siege and ... for Bologna
—Loss of the City—.......... and Mind of the Pope—
Raphael's in the Vatican—Cardinal Giovanni dei
Medici as Legate at Bologna—March against the City—De-
struction of Julius's Statue—Taking of Bologna—The Medici
with the Spanish Army before Florence—Flight of Soderini—
Restoration of the Medici.

H E who insists upon thinking of these two great-
est artists as contentious adversaries, may be
at any rate set right on this matter by the little that
is preserved of their personal behavior towards each
other. Such inferences, however, are in themselves
unjust. We see, indeed, Raphael and Michael An-
gelo made into heads of parties. Raphael appears
from the first as prejudiced; he had men round him
who incited him against Michael Angelo, and in the
latter himself we discover nothing of a conciliatory
nature; he thrust aside whatever was not congenial
to him. His adherents and those of Raphael dis-
puted. There is, however, no trace that the two
masters actually took the parts which were so urged

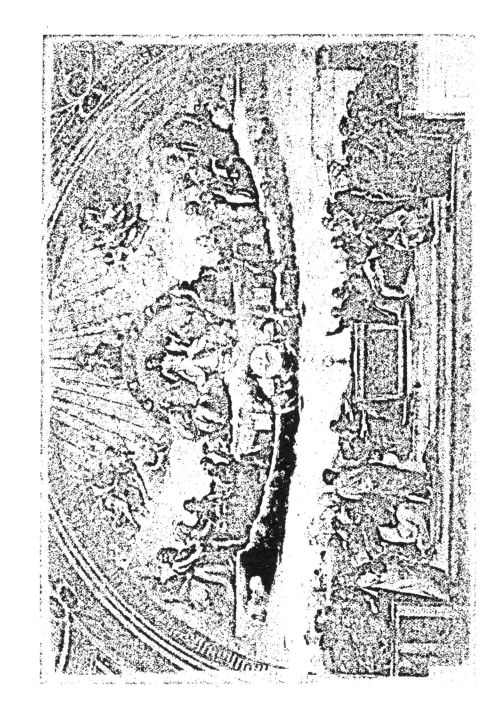

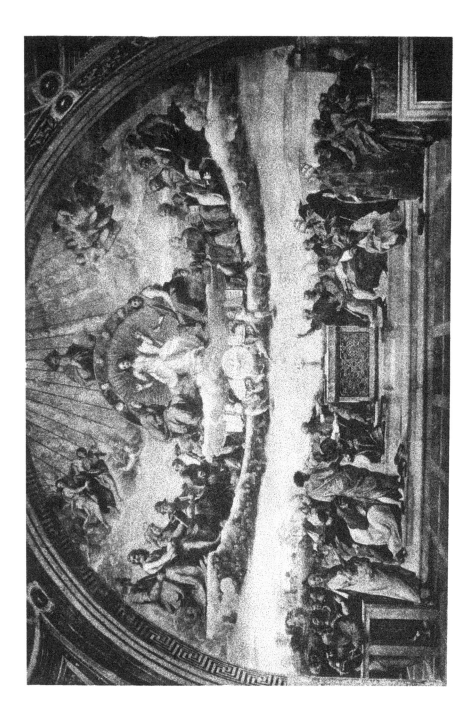

upon them by their followers. Whatever in this respect is interpreted otherwise, is falsely interpreted; because it is against a law of nature which can suffer no opposition.

Excellence forms an indestructible fellowship between those who possess it. All great ones, towering above the common multitude of mortals, feel themselves indissolubly united; their condition is too solitary for them not to seek each other at any price. Around the two men, envy and jealousy may have vented themselves in intrigues; but, in the high regions of their truest nature, each felt too keenly his own and the other's value; and, separate as they remained, outwardly considered, they yet stood close together, because nothing sufficiently exalted to divide them reached the heights to which they had attained.

Raphael pursued after Michael Angelo's fame, just as the latter had once endeavored to surpass Leonardo's greatness. Raphael painted in the apartments of the Vatican, a few steps removed from the chapel in which Michael Angelo's scaffolding stood. They must have often met in the palace, through which the way to the chapel leads: how did they regard each other? In that expression of Michael Angelo's, uttered long after Raphael's death, — that whatever Raphael knew in matters of architecture he had learned from him, — there lies nothing depreciatory. Corneille could have said the same of Racine, who, so much younger, had been less great but for him; Goethe could have expressed the same of Schiller. When men like Michael Angelo, Cor-

neille, and Goethe, have gone before, all that come later must tread in their footsteps; this, too, is a law of nature, as certain in its operation as if it concerned chemical affinities. Far more important are those words of Michael Angelo,— that Raphael did not get so far by his genius, but by his industry. This appears as the highest acknowledgment from his lips.

Industry can here mean nothing else than the success that an artist seeks in the unwearied improvement of his work. Industry is not persevering activity or diligence in general, which allows itself no rest, but absorption in the one thing to be accomplished; a creative longing to work out the mental image into visible form, delight in keeping the subject in due balance with the outward appearance, and the desire to gain power to satisfy it. What is commonly called industry is diligent care to master the material, so as in one day to make evident progress; compared, however, with that mental industry which Michael Angelo awards to Raphael, this material industry sinks down only into somewhat that is a matter of course. An artist, such as Michael Angelo considers him, reckons his work, after the utmost effort, as still unfinished. He says, I was obliged to pause; I could go no farther. Most conscientious in this was certainly Leonardo, who would have liked to have given up none of his pictures, as long as he lived. Thus also did Goethe work, who, till his old age, retained works he had begun when young, because the feeling never left him of how much there was yet to improve in them.

Michael Angelo stood alone in Rome, when he painted the Sistine Chapel. He had only the pope on his side: the artists flocked around Raphael and Bramante. Sansovino, too, came at that time to the city, — Michael Angelo's old competitor from Florence, — and produced wonderful works in marble. Michael Angelo was no longer young; gloomy and austere, he separated the genuine from the counterfeit with inexorable severity: Raphael was at the beginning of the twenties, amiable, cheerful, helpful, with that charm of victorious superiority, by which love is awakened, and which, unenvious itself, turns into good-will the envy of others; protected at the same time at court, not merely by Bramante, but patronized and drawn into the highest society by the Duke of Urbino and his ladies, who, as near relatives of the pope, played the most brilliant part in Rome.

Raphael had one excellence, which, perhaps, as long as the world stands, no other artist has possessed to such an extent, — his works suit more closely the average of the human mind. There is no line drawn above or below. Michael Angelo's ideals belong to a nobler, stronger generation, as if he had had demigods in his mind, just as Schiller's poetical forms, in another manner, often outstep the measure of the ordinary mortal. Raphael, however, like Goethe and Shakespeare, hits off the true. He seems to create as nature creates. He raises no cloudy palaces in which we seem too small, but human dwelling-places, through whose doors we enter in, and feel that we are at home there. He is intelligible

w

in every movement; he conforms in every line to the
sense of beauty in man, as if it were impossible to
draw them otherwise; and the delight which he
thus diffuses upon the beholder, who feels himself
enchanted as his equal, gives his works their power,
and invests him with the lustre of happy perfection.
Infinitely much as he has done, we cannot believe
that he has ever wearied himself with exertions; we
would not allow that he had ever been unhappy,
just as we should not believe it of either Goethe or
Shakespeare. Nothing particularly takes hold of
him; we look in vain for dark corners in his soul,
in which sad thoughts could nestle like webs in
damp, deserted chambers. Contented, like a tree,
which, laden with fruit, seems happy in spite of its
groaning branches, he stands there; and the admira-
tion which surrounds him is not what increased his
happiness, or diminished it when it was denied him.

Such men pass through life as a bird flies through
the air. Nothing hinders them. It is all one to the
stream, whether it flows through the plain smoothly
in one long line, or meanders round rocks in its
winding course. It is no circuitous way for it, thus
to be driven right and left in its broad course; it is
sensible of no delay when its course is completely
dammed. Swelling easily, it widens out into the
lake, until at length it forces a path for its waves;
and the power with which it now dashes on is just
as natural as the repose with which it had before
changed its course. Raphael, Goethe, and Shake-
speare had scarcely outward destinies. They inter-
fered with no apparent power in the struggles of

their people. They enjoyed life; they worked; they went their way, and compelled no one to follow them. They obtruded themselves on none; and they asked not the world to consider them, or to do as they did. But the others all came of themselves, and drew from their refreshing streams. Can we mention a violent act of Raphael's, Goethe's, or Shakespeare's? Goethe, who seems so deeply involved in all that concerns us, who is the author of our mental culture, nowhere opposed events; he turned wherever he could advance most easily. He was diligent. He had in his mind the completion of his works. Schiller wished to produce and to gain influence; Michael Angelo wished to act, and could not bear that lesser men should stand in the front over whom he felt himself master. The course of events moved Michael Angelo, and animated or checked his ideas. It is not possible to extricate the consideration of his life from the events going on in the world, while Raphael's life can be narrated separately like an idyl.

We know not much of Raphael's experiences; almost as little actual information exists respecting him as Leonardo. The imagination of the people, however, has but little cared for this. We have a house where he dwelt in Rome, a coffee-house which he frequented, the house of his beloved one, of whose name and circumstances we are informed; we have stories, of which he forms the central point, of his childlike old age in Urbino, until his death, which carried him off in Rome in the prime of life. As Frederick the Great ever appears to his people as the

old king leaning on his staff, so Raphael seems always as the beautiful youth, the earthly type of the archangel whose name he bears; and so completely has every one who has written of him availed himself of the freedom of judging and representing facts according to the idea which he entertained of him, that at last truth and poetry are no longer to be distinguished.*

Raphael came to Rome in the summer of 1508. He was not so young when he entered the city as Michael Angelo was when the latter first saw it. What a multitude of works, however, had Raphael at that time already completed, compared with the few, yet more mighty ones, which Michael Angelo had produced at the same age! Michael Angelo worked by fits; at times with unusual intensity, then again for a long time lying fallow, absorbed in books and philosophical studies. Raphael knew no seasons; bearing always blossom and fruit at the same time, he seems to have felt in himself an inexhaustible abundance of vital power, and to have poured it forth upon all around him.

This it is which shines forth even in his earliest pictures. They are not at all peculiar in form and idea. Leonardo sought for the fantastic, Michael Angelo for the difficult and the great; both labored with intense accuracy; both went their own ways, and impressed the stamp of nature on their works. Raphael proceeded quietly, often advancing in the completion only to a certain point, at which he rested, apparently not jealous at being confounded

* See Appendix, Note LXVII.

with others. He paints at first in the fashion of Perugino, and his portraits are in the delicate manner of Leonardo : a certain grace is almost the only characteristic of his works. At length he finds himself in Rome, opposed alone to Michael Angelo : then only does the true source of power burst out within him ; and he produces works which stand so high above all his former ones, that the air of Rome, which he breathed, seemed to have worked wonders in him. And thus, from this time, his progress was on the ascent.

Michael Angelo's influence upon his early advance in Rome is, of course, out of the question ; but, on the other hand, Perugino's is no less so. Raphael came as an independent man, who had found a path for himself. If he owed any thing to any earlier painter, it is to Fra Bartolomeo, whose pupil he was in Florence, — the same who, in former times, for love of Savonarola, had thrown his works into the fire ; at the same time an adherent of Vinci's, whose manner he endeavored to adopt. At the storming of the monastery of San Marco, he belonged to those who wished to defend it ; and, when the contest began, he made a vow to become a monk if he got off successfully. In the year 1500, he entered the monastery, and, for some time, gave up painting entirely. He returned to it again, however, subsequently, and produced a great number of excellent works, which, both in composition and coloring, stand higher than Perugino's. We might infer an influence from his character upon Raphael's, since, between the two, there existed a lasting and almost hearty relation ;

and Raphael, as a tender, shy, and gently pliable nature, exhibited in Florence, before he went to Rome, qualities of soul which are to be read in Fra Bartolomeo's works just as plainly as beautifully, and which are no less peculiar to Raphael's Florentine paintings: but, in Rome, life was otherwise to those who floated onwards in its stream; and it is nowhere said that Raphael sat fearfully apart on the shore.

Bramante recommended him to the pope. Many painters worked in the Vatican; Raphael was assigned his room like the rest. As his first Roman painting, he began the Disputa,—at the present day, only with difficulty discernible as regards its coloring; but, as a composition, it is to me one of the most beautiful things which he has produced. In the same room, he painted one wall after another; and, after he had completed these, the ceiling, from which the new work of another artist was taken down. He soon gained ground in the palace, and pupils and colleagues surrounded him. He preserved the ceiling paintings of Perugino, when they began to stand in his way; of the rest, he had copies made, before they were committed to destruction. Raphael worked, and superintended work, in the apartments of the Vatican palace, as long as he lived.

These rooms, four-cornered, but of irregular base, are connected *en suite* by rather insignificant doors; while the broad, high windows, formerly filled with painted glass, break up the walls. Marble seats are placed before them; and they are finished with the

most splendid carving. The floor is mosaic: the vault of the ceiling is the most beautiful intersection of two arches, so that the four walls of the apartment terminate above in a complete half-circle, whilst the vault tapers to a point at each corner. Although every thing is scratched, dirtied, and weather-worn, there is still a breath of the old time in the palace. We can in fancy again see the colors fresh, the gold of the decorations new and bright, and the sun playing on the glowing, gay window-panes. And through the door we can imagine Julius coming, slightly bent, but with strong step, and his smooth, fine, snow-white beard falling on the purple velvet cape, which he wears over his long under-garment with its white folds; the great ruby glittering on his hand, and his flashing eye passing over the paintings which his command had called forth. Julius loved Raphael. In every way he manifested the favor of which he considered him worthy.

Raphael certainly did not oppose him, as Michael Angelo had done. He was no flatterer; but his nature urged him to obtain the favor of men. In what a childlike, flattering way he writes in those early days to Francesco Francia at Bologna, whom he had long ago surpassed, and whose works and energy he, in spite of this, exalts far above his own, as if it were naturally a matter of course! Francia, however, sends him a sonnet, in which he acknowledges his greatness so beautifully, and in such strong, simple words, that, from evidence such as this, coming from a contemporary artist, we can conjecture the brilliant fame which the genius of this fortunate youth —

fortunato garzon, as Francia calls him — suddenly spread around him.

This sonnet — beginning with the words, " I am neither Zeuxis nor Apelles, nor one of those great masters, that I deserve to be called by such a name ; nor are my talent and my art worthy of the immortal praise which a Raphael awards them"— seems to imply, that it was an answer to a sonnet sent by Raphael, in which Francia was addressed with such extravagant flattery. No trace of it, however, exists. We have in all only four sonnets of Raphael's, — love-poems, scribbled on the sketches of the Disputa, and therefore written during the first spring or summer which he spent in Rome. A whole romance lies in these poems. All four have the same subject, — passionate remembrance of the happiness which he experienced in the arms of a woman to whom he can return no more. The resignation, the longing which fills him, the rapture with which he recalls the hours when she came in the depth of the night, and was his, are all poured forth in his verses. We feel that he must have thrice expressed the same, because it was impossible to exhaust the feeling in words ; and, in the often-effaced lines, from which he endeavored to construct the sonnets, there lies the fire of that great flame, which he says was consuming his life. Not one of Michael Angelo's poems contains such glowing passion.

Was it a noble lady whom Raphael loved, who once came to him " at midnight, when the sun had long declined ? did she come as another sun rises, more for deeds than words ? " She had suddenly

disappeared; and now he seeks to put into words the *dilettoso affanno*, the enchanting torment, the victim of which he had been. He will be silent, he promises, as Paul was of the mysteries of heaven when he came down from them; still he must speak, he says in another poem : but the more he desires to speak, the more impossible is it; and at length he finds his only comfort in the consideration, that it would have been perhaps a great and fatal happiness to have enjoyed it again. He will be silent, but he cannot cease thinking of her; and how would this be possible, when he still fancies he feels the soft yoke of her arms around his neck, and the despair still thrills through him when she disengaged herself from him, and he remained in the dark alone, like a mariner at sea who has lost his star?

We know not whether he ever met her again. No intimation of this is to be found in his letters or in Vasari,—no portrait of a woman which we could venture to suppose to be she. There is mention made of many women whom Raphael loved; but nothing further is said of them than that they lived, and that they were his beloved ones.

One of them was in his house when he died; he had settled a rich annuity upon her, like a good Christian, says Vasari. Another he loved when he painted in Chigi's summer-house. He is said to have been so completely absorbed in this one, that she drew him from his work; and his friends could at last devise nothing better than to bring her to him on the scaffolding. He thus had her the whole day to himself, and continued at his work.

Raphael painted women in Rome differently than in Florence. In the portraits which he left behind there, we see that cheerful repose which Leonardo knew so beautifully how to express. How different the female portrait in the Barberini palace! He painted this probably in his early days at Rome, to represent his beloved one, even if not the Fornarina, as she has been subsequently named. Fornarina is no woman's name; the word denotes the baker's wife or daughter, and derives its origin from the story that Raphael loved the daughter of a baker in Trastevere.

The portrait of the young girl or woman in the Barberini palace is a wonderful painting. I call it so, because it bears about it in a high degree the character of mysterious unfathomableness. We like to contemplate it again and again. She sits turned to us, almost naked, but still not unclothed; she is visible as far as the knee. A red garment, with dark, shadowy folds, is laid across her lap: with her right hand she presses softly against her bosom a thin, transparent, white texture, which is drawn up over her waist; but we feel, — one movement, and all is thrown aside. This right hand seems, as it were, with every finger to touch a different key. It lies below her bosom; with the thumb alone she presses the light web-like material closely to her; the fore-finger, a little raised, touches the left breast, and impresses a slight dent there; the other three fingers spread out, lie below, and seem to press it gently up. The left hand, on the contrary, has fallen on her lap; not lying on the back, open, but with the palm below,

Fornarina, Barberini Palace.

RAPHAEL

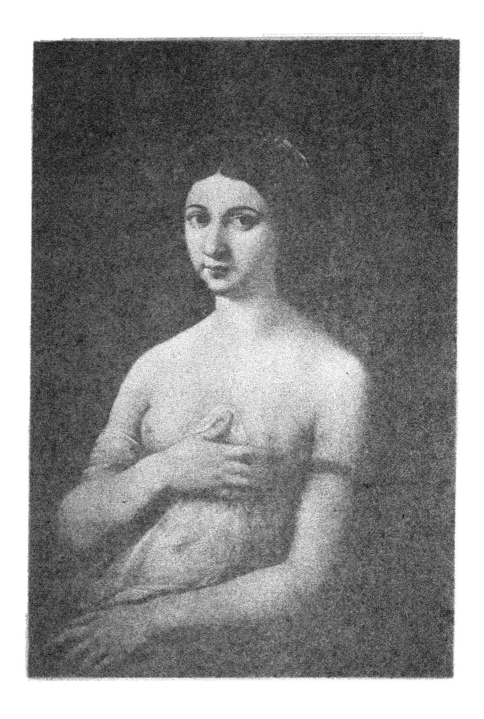

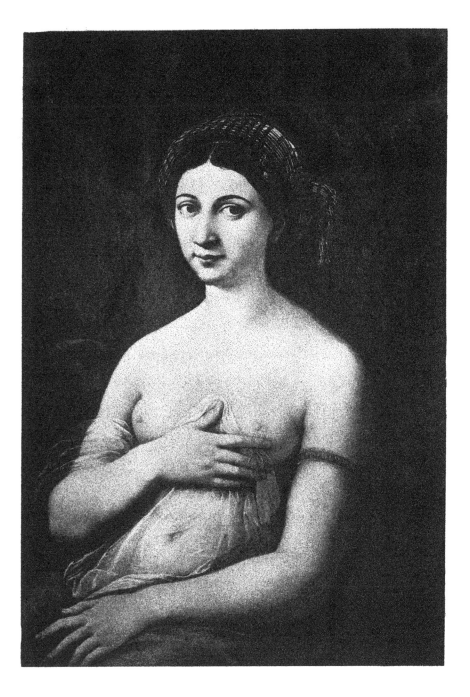

as if it had been in the act of spreading the dress over the knees, and had stopped in the middle of the movement. The fingers lie languidly spread out on the dark purple, the wrist upon one knee, the points of the fingers on the other, as if they were forming a bridge across.

A narrow ribbon encircles the arm of this hand, not far from the shoulder: it is green with a gold edge, and RAPHAEL. VRBINAS. is inscribed on it in gold letters. The ribbon seems a little too small; for it rather presses the muscle of the arm upon which it is placed, so that it appears slightly distended, as if it had been drawn too tight, in order that it might not slip off.

Did Raphael intend by this to intimate possession, as of a beautiful animal, round which he placed a ribbon, that he might see with his eyes that it was his? For a higher position this maiden holds not. Her brow seems to harbor passions alone, and no thought. And the wanton lips, the corners of which bury themselves in the cheeks; the large, raven-black eyes, looking aside, and at the same time slightly gazing upwards; the chiselled nose and full nostrils, — a divine, innocent sensuality beams forth from it all, just as the goddesses and nymphs of the Greeks were sensual, and passed along purely without a doubting thought, because they never surmised a contrast to the simple, glowing feelings, to whose voice they listened as to the commands of destiny.

The face is slightly browned, as are also the arms and hands, — she was therefore accustomed to use them in the open air; the eyebrows are dark as

night, as if each was drawn with one single bold stroke. Her hair is brilliantly black, parted over the brow, and smoothly drawn over the temples behind the ear; the head is encircled with a gay handkerchief like a turban, the knots of which lie on one side above the ear, pressing it a little with their weight.

She is slightly bent forward. She sits there with her delicate shoulder a little turned to the left; she seems looking stealthily at her lover to watch him as he paints, and yet not to stir from her position because he has forbidden it. It seems to him, however, to be a source of the most intense pleasure to copy her accurately, and in no small matter to represent her otherwise than as he saw her before him. We fancy her to feel the jealousy, the vehemence, the joy, the unalterable good-humor, and the pride, springing from the happiness of being loved by him. He, however, painted it all, because he was capable of these feelings himself in their greatest depth. If his pictures do not betray this, his poems do.

Was this side of his character completely lacking in Michael Angelo? We are wont to pronounce the name of Vittoria Colonna, whenever a woman is named in connection with him. But, when he became acquainted with her, he was almost an old man, and she nearly his equal in years. They were united by the same opinions in a season of difficulty. She, however, always remained the princess, and there was never any mention of love between them. Vittoria lived as a widow,—indeed, partly as a nun, —and was on the point of entering a convent.

Michael Angelo's poems alone furnish an answer. There are passionate ones among them, but almost everywhere the date of their origin is lacking; the few which can be decided on belong to his later years. Condivi, however, says that he began to write poems very early.

But, in the verses which he wrote as an old man, he speaks of his youth, and of the passions which at that time rent his heart. " That was the worst part of my youth," he says, " that I fell blindly into love, without taking warning."—" If thou thinkest to vanquish me,' he addresses love itself in another, " bring me back to the times in which no rein restrained my blind passion; give me again my undimmed, cheerful countenance, from which nature has now taken all its power. And give me back the steps which my anguish made me lavish uselessly; and restore me fire in my breast, and tears, if thou desirest that I should again burn and weep."

" There were seasons," begins another, " when I was a thousand times fatally wounded, yet remained unconquered and unwearied; and now, when my hair is grown white, thou returnest again! How often hast thou vanquished my will, and given it back its freedom; spurring me like a horse to wildness; letting me grow pale, and bathe my breast with tears: and now, when I am old, thou comest again!" Many passages such as these might be mentioned. Michael Angelo always, however, speaks of his torments, his consuming love, and his tears, — never of the fulfilment of his wishes. There is no poem, from which, as from those passionate lines of Ra-

phael, the sweet sap of intoxicating happiness gushes forth as from ripe fruit.

There is one of Michael Angelo's poems existing, in which he describes the beauty of a woman ;* but we know not whether he is not perhaps addressing an image, and whether the last lines are not rather a poetical reflection : —

> " Around that fair and flower-encircled brow,
> How gladly does the golden garland shine !
> The proudest bloom is that which, pressing low,
> Leaves the first kiss upon her brow divine.
> The livelong day her gladsome robe is found
> Pressing her breast with folds that thence expand;
> Her golden hair, released from every band,
> Plays unrestrained her cheek and neck around.
> And, happier still, the silken band, that prest
> With such sweet force and gently tempered stress,
> Lays its soft touch on her imprisoned breast.
> And the encircling girdle seems as though
> It could not bid its willing hold let go.
> Oh! then how tenderly my arms would press ! "

Who was the lady ? In many traits, the picture agrees with that marked 1512, the portrait ascribed to Raphael in the Tribune at Florence. Yet I will by no means draw any conclusions from this; for the dress represented here was the usual one, and the golden circlet was very customary with Florentine ladies. Domenico Grillandajo's father, who was a goldsmith, is said to have designed this ornament, the *ghirlanda aurea*, in Florence; and hence it obtained his name. I only mention the portrait, to show that Michael Angelo has represented nothing extraordinary in this sonnet.

* See Appendix, Note LXVIII.

We seek to find, in another direction, a reason why his passion ever returned so solitarily back to his own bosom. He says in the poem, the words of which I quoted before, " Give me back that pure, undimmed countenance which nature has robbed of every beauty," " onde a natura ogni virtude è tolta." I translate *virtude* by beauty; the word signifies excellence, fitness, art, power; we have no expression of the same signification.* Does this refer to the blow which he received as a boy in Florence, and which disfigured him? Was he so convinced of his ugliness, that he ventured not, on account of it, what he would have perhaps otherwise ventured? Did he sit alone, pondering over his fate, and forcing his tears secretly back to their source? We know not. It is not necessary to know it. But it is not in opposition to the picture we form of his character to think of him thus alone with himself, till seclusion early became a necessity with him, and he held himself aloof from men whom he loved with all his soul, because he felt himself not created for their happiness and cheerful intercourse. For this reason it is possible that he only turned a serious aspect upon Raphael, and never thought of giving him a token that he understood him, and felt himself understood by him.

2.

Condivi asserts, that Raphael endeavored, through Bramante, to obtain for himself the continuation of the Sistine paintings. That Bramante strove to get

* See Appendix, Note LXIX.

this order for him I doubt not; whether it was, however, done at Raphael's instigation, Condivi could not know, and scarcely Michael Angelo himself. In such inquiries, we must keep before us, that they concern matters which were recorded almost fifty years after they had occurred, and that this was done by a young man blindly captivated by Michael Angelo, who, in this instance, innocently perhaps, heard more than was told him. For the comparative merits of the two men, Raphael and Michael Angelo, had become in time a question in Italy, — as, in the present day, we discuss whether Goethe or Schiller is the greater; and, however conscientious we may consider Condivi, on this point he *must* have been partial.

Let us, therefore, take the facts as they appear from the characters of the men. There was certainly no soul in Rome who felt so deeply as Raphael what had been done here. To suppose that Raphael had concealed the knowledge, that something had been produced in the Sistine Chapel, superior to any thing which he or any one else could have produced, and, at the same time, that he did not feel in himself the desire to possess whatever was attainable of this power, would be to mistake the greatness of Raphael. It would have been a weakness to turn aside; it was a token of natural boldness to yield himself to the influence. This was the opinion even in Rome at the time. Julius himself declared, that Raphael, after he had seen Michael Angelo's works, had adopted another style.

We might seek this change of style in Raphael

in outward things, — in the more vigorous study of the bare form, and of fore-shortenings; for in neither of these lay Raphael's strength. Perugino's school knew little of the difficulties which Michael Angelo introduced into art; easy drapery covered the figures in ordinary folds, and facilitated the work. For this reason, Michael Angelo's bathing soldiers had been so great an innovation, and Perugino's opposition had been so obstinate. The old school saw that its life was ebbing.

In Raphael's Entombment of Christ, painted at Florence in the year 1507, we perceive the first traces of Michael Angelo's influence. The sketches belong to an earlier period, and, in the unclothed figures, exhibit the old conception of Perugino, appearing here almost wooden in contrast; but, in the execution, the management of them is marvellous. Michael Angelo's cartoon stood with its surprising grandeur and freedom before Raphael's eyes, and struck him with admiration. Then, however, he sank back again into his old manner, perhaps because commissions were wanting, to oblige him to extricate himself completely; and the Disputa in the Vatican, especially the first sketches for it, exhibit him as a pupil of Fra Bartolomeo, whose classical arrangement of drapery, and easy grouping, are the greatest merit which distinguishes him from others. Then Michael Angelo uncovered the dome of the Sistine Chapel, and Raphael made another step forward in the School of Athens. Sheets of studies show how he labored at anatomy and fore-shortening for this work.

Yet it is not this which makes the School of Athens appear to me as a monument of Michael Angelo's influence. Raphael's progress lay in no outward difference, seen in regard to his earlier works; but another quality, which his compositions from henceforth possess, is the true and valuable gain which his meeting with Michael Angelo yielded. His mind now left the more trifling conceptions of his former teachers and models, and he began to conceive the figures which he painted as grandly as he executed them.

What I mean by this has been already expressed with regard to Leonardo da Vinci, whose Last Supper in Milan is the first Italian picture truly great in its conception. Michael Angelo came after him. In works of art, we look at the scale in which they are devised, independently from that in which they are executed. Small buildings in good proportion may mentally produce the impression of almost colossal size; the temples of Pæstum show this most plainly. They rise in our memory; and we consider them greater than their size would make them appear. Other works, on the contrary, involuntarily diminish in size, because small in conception; they have only been made outwardly more extensive by the manifold doubling of their proportions, without being greater in themselves.

The Florentine school of painting inclined to the minute. Perugino raised himself above his predecessors; but even his greatest works make no grand impression. Fra Bartolomeo, who was reproached for having too minute a style, attempted

to alter it, and painted a colossal St. Mark, now in the Pitti palace at Florence; yet we see at once, in the figure, that it is nothing but the enlargement of a smaller size. His conceptions, and Perugino's, had hitherto influenced those of Raphael: in the School of Athens, however, the grander ideas of Michael Angelo appear, and these from that time prevailed. Raphael never rose to colossal figures; he did not outwardly imitate Michael Angelo; but it is as if, touched by the freedom of this man, he at length abandoned himself to the freedom from which the example of others had hitherto restrained him. Only once was he carried away into outward imitation. He painted in San Agostino the colossal prophet Isaiah, now destroyed and painted over, but little attractive even in outline. On the other hand, in the sibyls of the Church Maria della Pace, and in the ceiling of the Vatican apartment, we see that full power and beauty which arose from the union of the mind of Michael Angelo with the imagination of Raphael.

Raphael's imagination needed the most lively connection with those who formed his society. His most natural compositions arose from the men and women whom he had before him. He represented them in the utmost radiance of their being; but he never passed into that other world, in which Michael Angelo was at home. He liked best to paint the costume in which he saw the Roman men and women moving in the palaces, and in the streets of the city. "I must have seen many beautiful women, and from this the image of one alone is formed within me," he

writes to the Count Castiglione; and he calls this image which had thus arisen *una certa idea*, correct in Plato's sense, who understands by idea that image dwelling within us of different things, which, representing them in their perfection, accompanies us like an invisible radiant spirit. Michael Angelo, whenever he falls back upon nature, copies her accurately without elevating her, and goes to work in that unvarnished way with which Donatello upbraided him. When, however, he is absorbed in the creative power of his own mind, his images arise from the first just as cloudy forms suddenly conglomerate from invisible vapors. In Raphael's figures there is always a certain earthly core, the covering of which he glorified. Goethe wrote just as Raphael painted; while Schiller, working more in the spirit of Michael Angelo, shows himself not dissimilar even in this, that, whenever he did draw faithfully after nature, he was by far more substantial than Goethe. Michael Angelo would not have been able to produce a painting like the Mass of Bolsena, in the second apartment . of the Vatican palace. We see the pope, the cardinals, the Swiss, and the people of Rome, bodily before us, as if we could call the figures by their names, so distinctly human does the life appear which fills each individual: Shakespeare does not bring out his characters more naturally. And, even where Raphael produces naked gods and goddesses, they are only unclothed Roman men and women, — none the less worthy, on that account, to dwell in the golden palaces of Olympus.

Both Raphael and Michael Angelo appeared at a

phase of life, which called forth unceasingly the deepest feelings of men, and urged them almost with violence to the surface. The world was not to be driven into the false forms of later centuries; men and women appeared as they were, and stretched out their arms openly for what they desired; still free from the oppressive feeling which has burdened men from then until our own times, from that solicitude for lost freedom; they regarded the past and the future indifferent to its gloom, and the present beamed forth in sunlight.

Bramante cared little whether censuring posterity would express dissatisfaction or no: he wished to get rid of Michael Angelo; he and Raphael were to be the two first in Rome. As far as the history of art is known, we find similar intrigues: all ages are alike in this; and the events of modern times will one day not appear otherwise. Michael Angelo, however, was not the man to retire voluntarily. A violent scene took place in the presence of the pope. Michael Angelo spoke plainly, and cast in Bramante's teeth all that he had had to endure from him; and then, advancing from complaints at his intrigues to more vehement reproaches, he called upon him to justify himself as to his reason for having, at the demolishing of the old Basilica of St. Peter, broken down the magnificent old columns which supported the ceiling of the church, without any concern for their value, letting them now lie in fragments, and ruined. A million of bricks, he said, one placed on another, is no art; but to execute one single column such as those is a great art. And, con

tinuing in this tone, he disburdened his heart without restraint.

The contempt with which Bramante treated the works of antiquity is notorious. He had destroyed ancient buildings to procure stone for the palace of the Cardinal di San Giorgio. In St. Peter's he jumbled all together, — paintings, mosaics, monuments; he even spared not tombs of the popes: so that Michael Angelo's reproaches touched only on the most important of all.

The pope protected Raphael, who, no less than Michael Angelo, had become the admiration of Rome; but he perceived the difference of the nature of the two artists, and knew the place to assign to each. Michael Angelo might speak as passion prompted him. Julius permitted this; he knew his nature, and was too jealous of possessing him, not to retain him at Rome under any circumstances. He quietly allowed him to bluster, and knew that he would become quiet. He was himself one of those who must give vent at times to his passions. We have but to consider the portrait which Raphael made of him. This hoary lion, grown old amid storms, hoped still to accomplish his principal deeds; and not carried away by the vehemence of a mind, which, outwardly considered, was subordinate to him, he yet yielded, just as Michael Angelo himself would have done, if fate had made him pope, and Julius sculptor to his Holiness. He retained the chapel, and began the paintings, which are the most magnificent of all his works.

But this time, again, difficulties arose. First the

lacking re-touches and the gold. The pope soon perceived that Michael Angelo was right, when he had delayed to break down the scaffolding, before the last touch had been put to the painting. The scaffolding had now to be again raised to make up for what he had neglected to do. But this was now an impossibility. The scaffolding, as would suggest itself naturally, had only been drawn across half of the ceiling, as otherwise the chapel below would have been darkened. If now, for the sake of the re-touching and the gold, the dismantled scaffolding were to be newly erected, the work would have to be temporarily deferred on the other half of the ceiling, which Michael Angelo wished to begin at once. He now endeavored to dissuade the pope from the necessity of the re-touching and the gold. " It is unnecessary," he said. " But it looks so poor," replied Julius. " They are only poor people," returned Michael Angelo jestingly, " whom I have painted there; they did not wear gold on their garments,"— alluding to the simple old times in contrast to the present. The pope was quieted by this. On the other hand, he now urged forward, with his old impatience, and would not allow Michael Angelo the slightest leave of absence, although his presence in Florence was at times quite necessary. Thus it was in the year 1508, when the bronze David, executed for France, awaited its final completion, and those who were to receive it desired its transmission. The Signiory excused themselves by saying that the pope would not allow Michael Angelo to leave; but, as soon as they could get hold of him, the work

would be delivered up. At length they consigned it to a young sculptor, Benedetto di Rovezzano, who chiselled the cast. In December, 1508, the David was brought to Livorno, and conveyed to France by sea. We know not what has become of it.

The refusal for leave of absence, on account of the David, occurred in the June of 1508; in the December of the same year, Soderini writes to the Marchese Malaspina respecting the block of marble from which Michael Angelo was to execute the colossus. He makes excuses. The marble was ordered, and Malaspina wished to deliver it up, probably for the sake of the payment; but for this a previous preparation of the block on the spot was necessary. " Now," writes Soderini, " the pope will allow Michael Angelo no leave of absence; and no man in Italy, except him, could direct the preliminary preparations of the stone: he must himself go and give the necessary directions; others would not understand what he intended, and would spoil the marble. So long as Michael Angelo is away, the matter must therefore unhappily rest. The Marchese might, however, rest assured that Michael Angelo would execute a statue which they would not be ashamed to place beside the works of the old masters, and that the marble should be well paid for."

At midsummer, 1510, Michael Angelo demanded leave at any rate. He wished to keep the festival at home, — the greatest which is celebrated by the Florentines in the entire year. He had now been already so long separated from his belongings. He demanded leave and money. The pope refused

both. When would he be ready in that case with his chapel? "Quando potrò,"—when I can,—replied he. "Quando potrò, quando potrò!" repeated Julius angrily, and struck him with his stick. Michael Angelo went home, and prepared to set off without further delay. The young Accursio, the pope's favorite page, now rushed in, bringing fifty scudi; he excused the holy father as well as he could, and pacified Michael Angelo, who undertook the journey, but appears shortly after again at his work. We owe the narrative of this incident to Condivi : the letters, although many from his father and brother lie before us, can only be referred with little certainty to the first eight months of the year 1510; and they contain nothing beyond its outward events. This only may be perceived,—that he was painting incessantly the whole time, and sent his savings home with the same steadiness, and always with the same accurate directions as to how the money was to be disposed of. The pope constantly urged forwards, and would not suffer the least interruption. In this way alone can we explain the fact, that Michael Angelo was only twenty months accomplishing the entire work,—ten for one, ten for the other half of the chapel. It needed the meeting of these two men—in the one, such perseverance in requiring; and, in the other, such power in fulfilling—to produce this monument of human art. And in this also they were similar,—that, as Michael Angelo continued his work in spite of unceasing by-thoughts of Florence and his family, Julius knew how to retain in its purity his ardent interest

for buildings and paintings, amid the agitating cares which arose continually during his stormy rule.

Julius was the last pope in the old sense of the Guelfic warlike papacy. After his days, all that is heroic disappears from European history. While rulers, from this time, went to war themselves, and led battles, their personal caprices played a part no longer: noble, heavy-armed horsemen, sword in hand, yielded to the decisive power of the artillery; men no longer resigned themselves entirely to events; and the fear of being conquered in war was no longer the greatest that beset the head of a State. There was a fear in those succeeding ages, which was greater than any other, — that of the power of mind among their own subjects. This feeling made princes, even when at war with each other, quiet allies. Kings at that time troubled themselves not respecting the general oppression of mind, and relations were purer and more natural.

Julius knew that his papal crown was aimed at; yet he cared little for this. Danger had been his favorite element. His great age freed him from cares for a long future. It was unnecessary to stake his own existence for uncertain times. People of moderate parts appear as striking personages; power, once it is coupled with cunning and cruelty, inspires respect; covetousness is suspected by no one: but clemency and placability are ridiculed. Macchiavelli — who in those days gathered together the experiences of his practical activity, the result of which is the image of a prince, as he ought to be, if he would hold his ground in a State like Flor-

ence — Macchiavelli specifies, as the chief trait of the princely character, the capability of anticipating things, and of forestalling them by regardless actions. This policy of attack was adhered to in the smallest circumstances. Swords were loose in their scabbards: no one could hope to gain his rights by subservience.

In the year 1508, the pope was admitted to the league of Cambrai, the intent of which was the union of Maximilian and the King of France for the annihilation of the Venetian power. In the following year he stood in league with Venice and Spain, opposed to France and Maximilian. The Duke of Urbino advanced with the papal troops against Ferrara, which stood under the protection of France. The Venetian and Spanish fleets were to attack Genoa, and to spread the spirit of revolt there; and, lastly, they hoped that the Swiss, discarded by Louis, and amounting to six thousand men strong, would advance into Lombardy. All of this failed. Nothing was done against Ferrara; the Swiss, gained over by Louis and Maximilian, turned round; the attack on Genoa failed. Nevertheless, Julius, who soon saw himself as good as forsaken by Spain, urged for the continuation of the war. In September, 1510, he was himself again in Bologna, and attacked Ferrara, supported by the Venetian land and sea forces; the French and their allies were excommunicated.

The French ecclesiastics opposed this; a division arose among the cardinals. A number of them gained permission from the pope to leave for a fixed

time; and they did not return to him. The Cardinal of Pavia, Julius's treasurer and most intimate confidant, — who had once refused a high sum with which Cæsar Borgia wanted to bribe him to administer poison, — now fell under suspicion of treachery. The Duke of Urbino reproached him with his intrigues in the presence of the French, and carried him by force away from the army to Bologna, where, however, he knew how to justify himself with the pope.

The papal troops were at Modena, northwest from Bologna, on the highway towards Parma; Chaumont, the Viceroy of Lombardy, the friend of Leonardo da Vinci, advanced to meet them from Parma. The Duke of Urbino would not come to the attack without waiting for the Spanish and Venetian mercenaries; it was Chaumont's interest to bring about an encounter before this. He came nearer and nearer; the papal troops stirred not; when urged by the Bentivogli, who were with him, he resolved to disappoint the Duke of Urbino, and, by going round by Modena, to march upon Bologna, where the pope was with his prelates, and in the castle of which only a small garrison lay; while the friends of the Bentivogli in the city awaited, well armed, the arrival of their old masters.

The French accordingly left the highway, took the smaller places with papal garrisons, and appeared with their army suddenly before Bolonga, where the pope, sick, and in the midst of his frightened cardinals, was the only man who retained his energy. He hoped hourly for the arrival of the Venetians; what-

ever troops were to be raised in the surrounding country he drew to his side, and summoned the assembled authorities of the city to defend their walls with him against the approaching tyrants.

But the Bolognese people would not take up arms. The envoys of the emperor, of the King of Spain, Venice, and England, counselled him to enter into an agreement with the French; the cardinals entreated him; at length he agreed to open negotiations with Chaumont. He consigned the papal crown to his *datario*, Lorenzo Pucci, who was overloaded with the jewels he was conveying for safety to Florence, to be kept there in a monastery: he sent to Chaumont; but he could not resolve to accept his conditions. Just at the last moment, the Venetians approached; the people of Bologna arose in his favor; the Spanish auxiliaries arrived; courage and power returned to Julius's heart; and the most arrogant answer was returned to Chaumont's proposals. Supplies began to fail the latter; and, under pretext of allowing the pope to decide more freely upon the king's propositions, he withdrew with his army from Bologna.

What Louis desired from the pope was an acknowledgment of his offences, and a restoration of all that he had taken. Julius, however, never contemplated this. He loudly accused the King of France of a breach of his word and of treachery, and advanced to carry the war farther. The papal troops marched on. The pope listened with delight, from the window of his room at Bologna, to the distant thunder of the cannon with which his people fired upon Sas-

suolo, and drove out the French. Ferrara was now to be conquered; but it was left, that Mirandula might be taken first. This was in December, 1510. And, while thus taking arms against the Duke of Ferrara in his own land, other means were employed on other sides. Florence had furnished the French with troops at the instigation of the Soderini, both the gonfalonier and the cardinal, who were, at bottom, in favor of France. The Cardinal dei Medici was contriving from afar a conspiracy within the city: they intended to poison the gonfalonier. The pope knew of it; but the plot failed.

Mirandula made resistance. In January, 1511, the pope went himself to the camp. He lived in the hut of a peasant, which lay within reach of the enemy's balls. He was the whole day on horseback; in the midst of the snow-storms he appeared, now here and now there, and, standing behind the cannons, incited the people to energy. Snow and cold grew more and more mighty; the soldiers could not endure them; but the indestructible old man animated them on, and promised them the city for plunder. A cannon-ball struck the little church in which he had quartered himself close by his batteries, and killed two of his men not far from him. He moved now to another dwelling, but returned on the day following; while those in the fortress who recognized him, directed a great cannon to the spot, and again compelled him to choose another place. But he surrendered not. The more hinderances increased, the firmer grew his will, and the more unshaken his confidence.

3.

The war meanwhile had not been without its in fluence on Michael Angelo's painting in the chapel. In September, 1510, the pope had left Rome. The payments at once ceased.

" DEAR FATHER," writes Michael Angelo, — "I received your letter this morning, the 5th September, and read it with great sadness. You tell me Buonarroto is sick; I beg you to write at once to say how he is. If he has not improved, I shall come next week to Florence. It is true the journey might prove a great disadvantage to me; for I have still to receive by contract five hundred ducats, and the pope owes me just as much for the second half of the work; but he has now gone away, without leaving behind any directions, so that I am without money, and do not know what I shall do. If I go away, he might resent it, and I might lose what is mine, or be otherwise vexed. I have written to the pope, and await an answer. But, if Buonarroto is still in danger, write, and I will give up every thing. Provide for every thing; and, if money is wanting, go to the hospital inspector of Santa Maria Nuova, show him this letter, if he will not believe you without it, and let him pay you a hundred and fifty ducats, — as much as you require; spare no expense. And let us hope the best; God has not created us to leave us in distress. Answer by return of post, and write plainly whether I am to come or no."

Two days after, another letter follows to his father, almost word for word the same, and only containing the more accurate statement, that the five hundred ducats for the paintings, as well as for the

scaffolding, are owed him by the pope. Michael Angelo seems afraid that the first letter was lost.

On the 10th October, he informs Buonarroto, whose illness therefore had no evil result, that he had received the five hundred ducats through the pope's datario. He at once sent the greatest part of the money home. Yet, in spite of this favorable turn, how little Michael Angelo's was a bed of roses at this time may be seen by the conclusion of the letter that followed. "If you see Michelagniolo Tanagli, tell him from me, that I have had so much trouble for the last two months, that it has been impossible for me to write to him. I will, however, make every effort to procure him a cornelian or a good medal; and thank him for me for the cheese. I will write by the next post. The 26th October, 1510."

The post-day was always Saturday. The letters were sealed with a wafer; but, at the same time, a piece of twine was bound round them, and the ends were impressed in the seal.* •

This is the last letter belonging to the year 1510. In January, 1511, Michael Angelo appears to have himself gone to the pope. The journey is not elsewhere mentioned; but, from the letters, it undoubtedly took place. Bramante was with the pope at that time as engineer; and, perhaps for this very reason, Michael Angelo believed himself obliged to go personally to effect the payment of the money. As the siege of Mirandula lasted till the 20th January, and Michael Angelo had returned again

* See Appendix, Note LXX.

to Rome by the 10th, he can only have seen the pope at the camp at Mirandula. It is strange, that, as regards Condivi, this journey had entirely vanished from his memory. " Last Tuesday," he writes on the 11th January, " I arrived again safely, and the money has been paid me." Enclosed he sends a remittance of more than two hundred and twenty-eight ducats. Buonarroto was to tell Araldo, that he was to remember him to the gonfalonier, to thank him, and to say that he would write next Saturday. He concludes, " Keep the chest under lock and key, and my clothes, that they may not be stolen from me as from Gismondo." Michael Angelo had, it seems, gone by Florence, and had negotiated with Soderini. The date 1510, which the letter bears, allows a doubt to arise whether the letter is to be placed a year earlier; but the circumstance, that the same date has been placed outside that acknowledging Buonarroto's letter, shows that Michael Angelo adhered this time to the Florentine reckoning, and that consequently the Roman 1511 is intended.

On the 20th January, therefore, Mirandula capitulated. The papal troops were bribed to give up the plunder for sixty pounds of gold. Now came Ferrara's turn. The pope, however, was obliged to go back to Bologna, because he was overcome by fatigue.

A letter of Michael Angelo's, of the 23d February, leaves it uncertain whether he now went in quest of the pope a second time. " I think," he writes to Buonarroto, " that, within a short time, I shall be

again at Bologna; for the pope's datario, with whom I came from thence, promised me, when he went back again, that he would take care that I should be able to go on with my work. He has now been gone a month already, and I hear not a word from him. I will wait just this week; and then, if nothing hinders, I will set out for Bologna, and see you on my way. Tell my father so." * Whether he went or no, we know not. If it were the case, he would probably have called it to mind; for the events which now occurred in Bologna, and which he must have experienced there, were too stormy wholly to escape his remembrance. However this may be, we know nothing about it. All certain information breaks off here until September, 1512. Numerous letters, which might be placed in this interval, afford no sure information from their want of date, and only prove that Michael Angelo continued to work at his painting in the Sistine Chapel, perhaps with interruptions, and that he sent his receipts to Florence. The outward course of things, however, allows us to perceive that the pope was completely occupied with the politics of the times.

Negotiations for peace were ever going on. In February, 1511, a congress met in Mantua to debate concerning it. The war, however, at the same time advanced; and the pope soon took an active part in it. The emperor and the King of France designed a war against Venice for the spring, and wished to force the pope to join them. If not, they were resolved to call a council, — that is, to depose him.

* See Appendix, Note LXXI.

Julius, on the other hand, hoped to reconcile Venice and the emperor, and, with the help of Spain, to form a general coalition against the French. The Archbishop of Gurk was received by the pope at Bologna with distinguished honors, as a deputy of the emperor. Scarcely, however, did he begin to speak of Ferrara, than Julius interrupted him angrily. Before he would give up his claims here, he declared he would rather lose his life and his crown. They came to no agreement. Trivulzio, who, after Chaumont's death, had commanded the troops of the French king in Lombardy, advanced again against Bologna, and drove before him the valorless, retreating army of the pope. The pope endeavored to bring them to a stand-still: he wished himself to hasten forward into the midst of them; but the danger was too pressing, for his Spanish auxiliaries declared suddenly that they would withdraw. The Archbishop of Gurk had effected this with the Spanish ambassador at Bologna. Julius, already on the way to his people, was obliged, on these tidings, to turn back. Again he summoned together the authorities of the city, represented to them the position of things, and then retired from Bologna to Ravenna. He left the Cardinal of Pavia behind him in Bologna. The papal army lay outside the city. The citizens declared, that they would allow no soldier admission into the city; they would defend themselves alone.

The cardinal had two hundred light-horse, and about a thousand infantry, — insufficient to garrison so extensive a place. He stood on the worst terms

with Urbino, who lay encamped outside. Each would have seen with joy the ruin of the other. The cardinal now took a part of the armed people into his service, and gave some points of the city into the hands of these people. One of the gates thus came into the possession of the adherents of the Bentivogli, by whom a message was at once sent to the French camp, that the entrance to the city was open, and that they might come. The cardinal perceived his error, and hoped to make amends for it by giving orders to the newly enlisted men to repair at once to the duke's camp, as the latter had desired. They replied that they had to guard the city, and would not give up their posts. He now endeavored to bring in from without a thousand men of experienced troops; but to these they would not open the gates. With the feeling of having lost power, and in the consciousness of being hated for his cruelty and avarice, the cardinal now retreated into his castle so hastily that he forgot to take with him his money and jewels; though, remembering . them in time, he had them brought after him, and, packing them up, accompanied by a few horsemen, he fled in a south-west direction towards Imola.

The news at once spread that he had left. The people rose. The Bentivogli without learned how matters stood, and set out. They reached Bologna at midnight. The procession passed with torches through the streets to the palace of the Government. A statue of the pope, made of gilded wood, and standing over the gate of the palace, was torn down,

dragged round the square, and burnt; while mus-
kets were fired at Michael Angelo's work.

Scarcely had Urbino heard in the camp of the
cardinal's flight, than he himself immediately broke
up. He left every thing; fifteen pieces of heavy
artillery, standards, carriages, baggage, and even
the personal property of the last retreaters, who
were attacked by the French, fell into the hands of
the enemy. The citadel of Bologna capitulated,
after it had held out fourteen days, and was pulled
down by the people.

In Ravenna, where the pope had tarried, Urbino
and the Cardinal of Pavia met. In the open street,
where they encountered each other, the duke stabbed
the cardinal in the midst of his attendants. The
pope called upon Heaven, and cried that his best
friend had been taken from him. The duke, on the
other hand, swore solemn oaths that he had been a
traitor, and was to blame for all the evil. At the
same time, the tidings came that the Duke of Fer-
rara had again taken possession of his dukedom,
and that Trivulzio stood with his army on the fron-
tiers of the territory between Ravenna and Bologna.
He awaited nothing but the orders of his sovereign
to advance into the undefended Papal States.

It was, however, of great importance to Louis to
preserve the appearance of an obedient·son of the
Church. Instead of advancing with violence, he be-
gan to negotiate. The Bentivogli, too, were obliged
to declare to the pope that they only held possession
of Bologna as obedient sons of the Church. The pope
set out for Rome. In Rimini he first heard that in

Bologna, Modena, and in other places, placards were publicly posted up, on which he was summoned before the Council of Pisa, where the cardinals were assembling. Thus he arrived in Rome, without an army, without Bologna, without the Cardinal of Pavia,—old, sick, accused, and summoned to justice; but within his soul was the old obstinacy, and the desire to take vengeance on his foes.

4.

There lies in the papal dignity an element of indestructibility, which will last so long as there are Catholic princes with opposing interests. The pope stands between them as the one ideal power, tenaciously clinging to its designs; whilst the uncertain multitude, distracted from the first by low ambition, surge around, able to annihilate his person, but not his office. The papacy will fall when all Romans are united in one single kingdom, and when the people are raised to such a height of mental culture, that temporal authority in spiritual hands appears an absurdity. Yet these are the expectations of many hundred years to come.

On the eve of the day of Corpus Christi, 1511, the pope had again arrived in Rome. He wished to officiate himself the festivities. Arrayed in all his pomp, his calm, tiara-crowned brow contrasted with the excited impatience with which the people awaited events. Raphael was at that time painting the Mass of Bolsena, representing the conversion of a priest who would not believe in the transubstantiation of the host. The miracle had happened centuries before;

but none the less Julius was painted as present: we see him kneeling at the altar, by the side of which the confounded priest stands. It was intended to show symbolically his firm confidence in the miraculous assistance of heaven, and that the doubting ones, like the priest with the host, would some day repentingly acknowledge the truth.

He gathered together a fresh army; he negotiated with France, who had little desire for war; with the emperor, whose vacillation in political affairs was notorious; with Venice, who was still at war with Louis and Maximilian; with Ferdinand and the King of England, France's natural enemies. Whilst, in opposition to the council announced at Pisa, he himself summoned a Lateran Council at Rome, and pronounced the curse of the Church upon the rebellious cardinals, he was yet negotiating with each separately, and was holding out alluring propositions, if they would come to Rome, and attach themselves to him. Lastly, he made secret associations in Bologna, that the Bentivogli might be again expelled by an insurrection.

Suddenly came a new shock. One day, in the middle of August, the news spread through Rome that the pope was dead. Julius lay sick and unconscious; his end was hourly expected. The cardinals, instead of going to Pisa, set out for Rome. The people there were assembled on the Capitol; speeches were being made in favor of shaking off entirely the hated priestly rule, and constituting themselves a free nation worthy of the old name. There seemed an end of the everlasting dominion of the clergy. It

appeared as if at that time but one powerful step was needed to tread out for ever the old glimmering flame of the Vatican. But it was only a volcano. The pope rose vigorously again from his sick-bed. He concluded an alliance with Aragon and Venice, which was proclaimed in October, 1511, and the expressed object of which was the protection of the one Church. The division threatened by the Pisan Council was to be prevented; Bologna and Ferrara were to be reconquered; and those who opposed themselves were to be expelled from Italy. These were the French, under whose protection the Bentivogli and the Este stood. The watchword of the papal party was the expulsion of the barbarians from Italy! — an idea which excited the people to enthusiasm, and surrounded the name of the pope with fresh popular glory. This is the meaning of that famous expulsion of Heliodorus from the Temple, the painting on the wall of the Vatican, which Raphael began this year. Heliodorus is the King of the French, who is punished and expelled as one • guilty of sacrilege, whilst Julius approaches triumphantly on the opposite side.

When we thus see the origin of Raphael's works, they lose the appearance of allegories, for the understanding of which explanations are needed. He stood with the pope in the midst of events; their representation by his hand was no indifferent ornament to an indifferent palace, but a symbolic concentration of that which agitated the times at that moment most deeply, and was intelligible to the people.

5.

In the same October, 1511, the council was opened in Rome. Julius was only awaiting the Spanish troops before he broke forth. This time, however not only Bologna and Ferrara were to submit, bu Florence also. Soderini had given Pisa as the meeting-place of the heretical council; Julius had laid the city under an interdict; the gonfalonier, however, had appealed to the heretical Pisan Council itself, and had then compelled the Florentine clergy to continue to perform their functions. Not only were the two Soderini to suffer for this act of treason, but the citizens also. And for this end the pope chose a painful means: he placed over them their old masters, the Medici. Giovanni, the cardinal, was appointed legate in Bologna; and he was given authority to advance against the Florentines after the conquest of the city.

Soderini had been elected gonfalonier for life, in the year 1502. The aristocratic party, the former Arrabiati, united with the Palleski, had accomplished this in opposition to the popular party, the former Piagnoni. Soderini was a relative of the Medici; he was mild, but well skilled in business, rich, old, and childless. No sooner was he in office, than he suddenly changed. They had on both sides reckoned on his Medicæan and aristocratic inclinations; but at once he stood above all parties, and those who had raised him experienced from him no greater consideration than the popular party, who had opposed the election. Moderate and conciliatory in his policy,

both at home and abroad, he never allowed the dis-
cord of the citizens to come to an open rupture; and
he prevented the attempts of the Medici to creep
again into the city. He was friendly and gentle in
his manner. A well-preserved clay bust, colored
from life, in the Berlin Museum, makes him almost
appear a living man, so accurately does it portray his
features. It is the noble countenance of a man who
certainly possessed more goodness and mind than
vehement energy, a lack in Soderini's character
which Macchiavelli has rendered immortal by his
unsparing raillery. Patron of Leonardo and Michael
Angelo, he nevertheless seems to have been little re-
spected by either. For he complained violently of
Leonardo, and charged him with ingratitude; while
Michael Angelo once even publicly ridiculed him.
Soderini looked at the David, and expressed his
opinion, that some marble might still be removed from
the nose. Michael Angelo assented, took his chisel
and some marble dust in his hand, and, seeming to
work about the nose, he let the white dust fall to the
ground, upon which the gonfalonier expressed him-
self well satisfied at the favorable effect of the
improvement suggested by him.

The nobles saw themselves painfully deceived by
Soderini's unexpected conduct. They had hoped
by his election to set aside the consiglio grande, the
one democratic chamber, where the majority of votes
carried the day, and in which — although after
Savonarola's death a stricter form of election had
been introduced — they could not hold their ground
without difficulty. Their hopes were again baffled,

of placing an aristocracy of the richest families at the head of the State. For this reason, as soon as Soderini's desertion became evident, he began to be hated by those who had promoted him; and the ambitious younger nobles of the city (the old Compagnacci) assumed a hostile attitude, and meditated an overthrow of the constitution.

The Medici availed themselves of this feeling. After Piero's death, the cardinal was the head of the family, a man genuinely Medicæan in character. The spirit of the old Cosmo and Lorenzo lived anew in him; and his conduct towards the Florentines was from henceforth entirely in conformity with theirs.

The Medici seem no longer to have thought of a violent restoration of things. The cardinal resided in Rome at the court of Julius; he kept open house with splendor and generosity; whoever came from Florence, and presented himself, was well received; and no political profession was needed to prove himself a friend of the family. All were his dear countrymen; the strife of parties and the plans of Piero were forgotten. The cardinal knew how to discourse, and to give. He scarcely cared that the property of the family was ebbing rapidly.

At the same time, however, his relatives were laboring in Florence; above all, his sister Lucretia, who, married to Jacopo Salviati, became the rallying-point of the nobles hostile to Soderini. For these rich families must ultimately have been called nobles, although Savonarola answered justly, when it

was said that the nobles fared ill in Florence, " We have no nobles here, only citizens : there are nobles in Venice." Indeed, the name of noble among the Florentines implied nothing but money; for none of their great lords had castles and subjects over which jurisdiction was allowed them.

The name of Medici lost its hateful sound in Florence. They were no longer the vindictive foes, inciting France and Italy against the city, and stealing like foxes round the dove-cot. With the remembrance of Piero, all fear of them had vanished. A new generation had sprung up, calling to mind rather the brilliant virtues of Lorenzo than the faults of his unhappy son. They longed for the good old times, when the nobles shared the power of a chief, considerate for them, and issuing from among themselves ; whilst now they were obliged to submit to a renegade coquetting with the people. They would have liked to recall the Medici, if only for the sake of over-throwing Soderini.

The appointment of the cardinal as legate at Bologna occurred at the right time. His property was fast ebbing away : without such a post as this, he could not have continued to carry on his splendid mode of living. In Bologna something was to be gained; so that, even if the plans on Florence failed, the pecuniary assistance was immense. In January, 1512, Medici appeared with the Spanish auxiliaries before Bologna, and the siege began. Within the city were the Bentivogli, the Duke of Ferrara, and Lautrec, on the side of France. It now fared ill with Michael Angelo's statue. On the last day but

one of the year 1511, a herald, sent in advance by the army, appeared in the city, and demanded immediate surrender in such haughty accents, that the Bentivogli threw him into prison, and only liberated him again on the persuasions of their friends. The statue of the pope was thrown down, and mutilated. The Duke of Ferrara obtained the metal in exchange for the cannons he furnished. The head alone, which weighed six hundred pounds, was preserved, and was for a long time to be seen in Ferrara. The rest was melted down.

On the 26th January, the bombardment began; the walls were at the same time undermined. On the 2d February, however, Gaston de Foix, who had come from Lombardy with the French auxiliaries, succeeded in entering the city so secretly, that the Spaniards without did not hear of his presence until he had been long within the gates. They now resolved at once to raise the siege. On the 6th they retreated. The French pursued them, carrying off horses, cannons, and military baggage, and would have destroyed the army, if they had not been checked by fear of stratagem.

As soon as Gaston de Foix had, however, after this success, returned to Lombardy, where he defeated the Venetians, the cardinal again advanced before Bologna. It was now March. Once more the French appeared; once more the Spaniards retreated, De Foix behind them, as far as Ravenna. There, on the first day of Easter, 1512, a battle took place, in which the Spaniards were brilliantly defeated. The French commander-in-chief, however, lost his

life. He was young, handsome, and chivalrous,—
one of the poetic beings of that day.

This battle has become famous from the fearful
nature of the contest. The Spaniards at that time
were considered, after the Swiss, the first soldiers in
the world; and it cost the French immense effort
to carry off the victory. The national honor was at
stake on both sides. Ten thousand dead were left
on the field. A number of noble Spaniards were
taken prisoners by the French. Cardinal Medici
was captured by the Stradiots, and brought to the
Cardinal of San Severino, who, like himself, but
in the name of the Pisan Council, was legate of
Bologna. The whole Romagna fell into the hands
of the French; and the way to Rome again stood
open to them.

The sad tidings arrived there on the 13th April.
The cardinals hastened to the pope, and conjured
him to make peace; for not only the victorious
enemy, but also the Roman nobility — the Colonna,
Savelli, and others, who had received money from
Louis — threatened immediate. danger to the pope.
The ambassadors from Venice and Spain dissuaded
from over-hasty resolutions. Julius wavered. He
had gone to the Castle of St. Angelo, and a number
of the cardinals had already fled to Naples, when
Giulio dei Medici, a cousin of the captive cardinal,
an illegitimate son of that Giuliano who was mur-
dered by the Pazzi, arrived in Rome, and reported
the plunder of Ravenna. At the same time, how-
ever, he brought intelligence that the leaders of the
French, divided among themselves, were disputing

with the Cardinal of San Severino; and that the Swiss, for whose favor papal, imperial, and royal envoys were exerting themselves, had decided for the pope, and were ready to make their way into Lombardy. If this were to take place, every thing would wear a different aspect. The French would then be necessary in the north; Bologna and the Romagna would again be a possible prey. Still the pope delayed, and showed himself inclined to come to terms with the King of France. It was perhaps only an artifice for keeping the French away from Rome, and for awaiting more certain information from Switzerland. At length he learned that the French troops had marched towards the north. His fear and good-will towards Louis now vanished. The Roman barons, who had received money from the king, and were on the point of rebelling, entered the pope's service with their men; war began anew; and, on the 3d May, the Lateran Council in Rome was opened with extraordinary splendor; while Cardinal Medici in Milan, which he had entered more as a conqueror than a prisoner, absolved those soldiers, in the name of the pope, who had fought against the holy Church. Giulio dei Medici, who was again with him, had brought him authority to do this. The secretaries were scarcely able to despatch singly all the letters of indulgence. Thus the material with which war was at that time carried on — the common despised mercenary — made grave political questions subservient to the low religious necessities of his limited mind. For united with this indulgence was the promise of the receiver,

never to serve again against the Church. And this took place under the eyes of the Pisan Council, which had now withdrawn to Milan.

The union of the Swiss with the Venetians now soon followed. Maximilian allowed the march through the Tyrol. The French retreated. It was said that Milan was to be reconquered for the sons of Sforza, its lawful masters. Medici, who had been taken by the French army, escaped. The whole of Lombardy, with the exception of some small places, was lost to the king. The governor fled from Genoa, and a man named Fregoso was appointed doge. French policy had again arrived at one of those stages where loss follows loss.

The successful flight of the cardinal was recorded by Raphael's picture in the apartments of the Vatican, which represents Peter's deliverance from prison; the general defeat of the French was sym bolized by the march of Attila, — both of them the first wall paintings which Medici ordered to be exe-cuted after he became pope.

Bologna was now defenceless. The Duke of Urbino advanced before the city; the citizens in-duced the Bentivogli to depart; they withdrew with a thousand horse to Ferrara, whose duke, aban-doned like themselves, expected a critical future. The pope declared at once all places in which the Bentivogli were received, to have fallen under the ban of the Church. Bologna did what she could to appease him; but the disgracefully de-stroyed statue could not be reproduced by magic. Julius was so furious, that he wished completely

to destroy the city, and to settle the citizens in another place.

Yet even now, when he seemed so completely to rule things, he could not do as he would. The most powerful man in the land was the King of Spain and Naples, who placed his troops at the disposal of the pope for forty thousand crowns monthly. It was necessary to concede to him that Ferrara should remain unmolested. In Ferdinand's hands also lay the fate of the Florentines, against whom Cardinal Medici wished to employ the Spanish troops.

In Mantua, where a congress took place of those powers which had been engaged in the undertaking against France, the fate of Florence was decided. Maximilian wished to undertake his coronation journey to Rome; he wanted money for it, and desired a fixed sum. The King of Spain needed money to pay his soldiers. The Medici offered freely whatever they both demanded, if they would only first help him to the possession of the city, — the king with his troops, the emperor with his authority; for Florence was an old imperial fief. Had the Florentines themselves at once given these sums, the King of Spain would have agreed to the remaining of the gonfalonier, and to the continuance of the constitution; for, although he had helped the pope to the victory, he did not now much care to strengthen his power to a great extent. It must have been completely indifferent to the emperor where the money came from, so long as it came at all. Cardinal Soderini was in Mantua, and carried on the negotiations. In his reports, he urged his

z

brother to act decisively. But the perfidy of the
different parties made it impossible for the gon-
falonier to effect any resolution. They left him
alone, and the cardinal was without orders.

In the meantime, the Spanish troops began to
revolt. Don Raimondo di Cordona, the commander,
was obliged, on any terms, to endeavor to procure
money for them for their pay. The Medici availed
themselves of the doubtful state of things; and
before Cardinal Soderini, in Mantua itself, fully
surmised that the matter was concluded, the Spanish
army had marched past Bologna into Tuscany, with
the declared intention of overthrowing the constitu-
tion of Florence and re-instating the Medici.

It was impossible to oppose the Spaniards in the
open field. Not that there were supplies within
the city. Still, time and money might have averted
the danger, if the Spaniards had been the only
enemy without. The party of the aristocrats, how-
ever, arranged events. They urged their cause
with an ease which only appears explicable from the
extremely mild character of Soderini. They hin-
dered every resolution taken by the Government;
they represented the position of things, as if the
Medici only aimed at obtaining the right of being
permitted to dwell in the city as mere private
people. The gonfalonier wished to leave every
thing to the decision of the people. In a touching
address, he spoke of himself and his intentions:
his tears rose: he was an old man who had no per-
sonal foes, who was guided not by ambition, but by
goodness. He desired to be allowed to lay down

his office. Under no circumstances would they permit this. The Medici could return, they decided, as private people, but as nothing else. They resolved to make preparations, and to defend themselves and the small fortresses round the city with the troops they possessed.

The popular party had evidently still the upperhand in these resolutions; but the Palleski knew how to place crippling impediments in the way of their execution. A deadness of feeling, a sense of insecurity, overcame the citizens; and the affecting appearance of the gonfalonier could not compensate for his lack of animating energy.

Cordona advanced as far as Prato, which, a few miles distant from Florence, was garrisoned and fortified. He could not advance further. In the late summer the level land afforded no sustenance; provisions were stored in Florence and the smaller cities. Hunger and sickness appeared. Cordona came down in his proposals: Soderini was to remain; and the citizens were to stipulate the conditions under which the returning Medici were to be received. For himself he desired a moderate sum, only to pay his soldiers, and to leave the country. This resolution was induced by the fact, that King Ferdinand began to consider the subjection of Florence as too great a concession to the pope, and to doubt whether he should permit it, — a state of feeling, which soon so completely gained the upperhand, that he sent Cordona strict orders to turn back, and to leave things in Tuscany in their old condition.

But, before these final resolutions had arrived, Cordona had acted. The city refused him provisions, of which he stood urgently in need. Baldassare Carducci, whom the gonfalonier had sent to the Spanish camp, concluded an agreement; the Palleski in the city, however, delayed to accept it on the part of the citizens. Cordona, in the worst position, attempted a bold stroke. He attacked Prato unawares, — a fort considered in Florence as impregnable, — carried it by storm, and allowed the soldiers to plunder it. Fearfully did they behave there. An alarm spread through Florence at these tidings, as at the first acts of the French in the year 1494. This time also strange thunder-claps had foretold the threatening future; this time also that mental heaviness prevailed which proved the unstable character of the general state of things. There was, moreover, no man who stood at the head of the State as the natural support of weak minds; and, as if in mocking accompaniment to the great helplessness, appeared the increasing arrogance of the Palleski, who, in the camp outside, in secret intercourse with the Medici, concerted the adoption of a common policy.

The conquest of Prato at once altered Cordona's demands. Money and provisions were to be had; and the neighboring Pistoja, seeing the cruelties perpetrated by the Spaniards in Prato, agreed voluntarily to furnish what the army required. With regard to Florence, the demands now were the absence of Soderini, fifty thousand ducats for the emperor, fifty thousand for Cordova, fifty thousand

for the army. The Medici, on the other hand, desired ever but the one thing, — to be allowed, without any privileges, to return as simple private people to their native city.

Had they paid quickly, freedom might yet have been saved ; for the Spaniards required money. But the Medicæan party would allow nothing speedy. The Palleski began to leave the city,. and concerted with Julius dei Medici how it would be best to act. On the second day after the storming of Prato, Bartolomeo and Paolo Valori, two energetic young men, who desired a subversion of things on account of their great debts, forced their way into the apartment of the gonfalonier, and offered him the choice of death or flight, in which they would assist him. Soderini had long ago wished to withdraw. His friends, however, had prevented him from taking this step: he now, therefore, allowed himself to be conveyed into the house of the Vettori, who, with the Valori, were the principal originators of this plan ; and accompanied by many members of his family, and with a guard besides of forty archers, he rode away in the night of the 30th August. His avowed intention was to go through Siena to Rome, where the pope had promised him protection. His brother, the cardinal, however, warned him in good time. The pope had wished to allure him into the snare of a journey to Rome, solely on account of his riches. On his way there, the gonfalonier suddenly turned from the road to Rome, and arrived safely at Ancona, from whence he crossed the sea to Ragusa.

By this threat of laying violent hands on Soderini, the friends of the Medici had induced the Signiory, on the same day, to declare the gonfalonier deposed. The city came to terms with Cordona; the Medici returned, at their express desire, as private people only; Florence entered the league against France; the emperor received forty thousand, the Spanish army eighty thousand ducats, Cordona twenty thousand for his own disposal. At the first payment, he pledged himself to leave the Florentine territory. With regard to the Medicæan property, sold by the exchequer, the old lords desired nothing more than that they should be allowed, within a given time, to purchase it back for ready money.

While these things were being discussed in their closest details, and nothing was finally concluded, Giuliano dei Medici arrived in the city; and, surrounded by his followers, rode through the streets. According to law, he might have been put to death; for he was still only an exile. Soon Cordona appeared, solemnly introduced by Paolo Vettori intò the consiglio grande; where, in the midst of the Signiory, he placed himself on Soderini's empty seat, and urged, in an address, that they should, by suitable measures, make the position of the Medici in the city more secure. He did not explain himself further. His words were received with unfavorable amazement; but the odium fell rather on Vettori, who, as it were, had brought Cordona into the consiglio.

I relate these events the more accurately, because the policy of the Medici appears so plainly in them.

Always holding back modestly, always pushing for-
ward others, never asking any thing, allowing every
thing to be urged upon them, and at the same time
having things completely in their own hands,—this
was their mode of action. But it is especially
important to observe how they made use of tempo-
rizing means. They knew well the nature of the
citizens, who prefer to take the most illegal grounds
as legal, so long as definite propositions can be
regularly discussed on them, than to demand a solid
basis before all things. For this reason the Medici
rarely opposed, and permitted the good people to
debate and determine. It is marvellous how the
latter allowed them afterwards to build up at will
the true foundations of the whole state of things.

Cordona had nothing to do and nothing to say
in the consiglio ; yet they discussed his proposals.
He suggested, that a number of citizens should be
chosen as representatives of the city, and an equal
number of the Medici's adherents should be ap-
pointed ; who, in union with Cordona, standing
among them as an impartial umpire, should receive
dictatorial authority to fill the offices anew. This
was one proposal. Another was, that, from among
those who had filled the highest offices of the State,
and from among fifty citizens, who were to be nom-
inated from the highest colleagues officiating at the
time, a senate was to be chosen. Moreover, eight
young men, lacking the requisite age, were to be
declared capable of office, that the good services of
some younger Palleski might be rewarded. Lastly,
a gonfalonier was to be chosen for a year, with a

salary of four hundred ducats; and so forth. With
such proposals the time went by. In the consiglio
grande, by a majority of three against two, a man
named Rodolfi was elected gonfalonier for a year:
he was a near relative of the Medici, but at the same
time a Piagnoni. The choice excited general satis-
faction.

Meanwhile the Spaniards remained in the land.
The soldiers came more frequently into the city.
They brought in, on wagons, the booty from Prato,
and offered it for sale. This continued through
September. On the evening of the 15th, Cardinal
Medici was to be solemnly received in the palace of
the Signiory. The nobles assembled in expectation.
He came not. They began to fear evil. All was
dark and quiet in the palace of the Medici: their
minds were relieved. On the following morning,
however, the Medici arrived. Foreign and native
friends, in arms, surrounded them: amid the cry,
" Palle, palle! " they proceeded to the square. The
Signiory were sitting above : Giuliano dei Medici
entered the hall; others followed him. They in-
quired what he wanted. He asked nothing but his
security, — an answer repeated by his attendants
in chorus. Questions and answers now followed in
rapid succession. They resolved that the parliament
should be convoked.

The great bell was sounded. The citizens gath-
ered together in arms in the square. The enemies
of the Medici took care to make themselves conspicu-
ous. The Signiory stood on the orator's platform,
by the side of the palace gate (this was the first

revolution which Michael Angelo's David witnessed). Giuliano stood there also, — the great standard of the city in his hand: and the fifty-five were elected. Strangers and soldiers voted as well as citizens; for the troops of the republic had all entered the city, to show themselves ready to serve the Medici, the new lords of the city. The fifty-five annulled the consiglio grande, filled the offices anew, and abolished the national army that had been introduced, — a kind of militia, — in the establishment of which Macchiavelli had been especially interested. The palace of the Government received a garrison of Spanish troops, under Paolo Vettori. At length the exiled family met in the palace of the Medici; the city had returned, in the most legitimate way, under their dominion.

Michael Angelo was not there to experience the shame. He was in Rome. Letters, however, to his father, at this time, show how deeply he felt what had happened, and how his family had to suffer in the general misery that ensued.

CHAPTER NINTH.

1512—1518.

Vain Effort for Sebastian del Piombo — Julius's last Undertakings, and Death — The Mausoleum — New Contract — The Moses — The Dying Youths — Destruction of the Cartoon of the Bathing Soldiers — Bandinelli — The Medici at the Height of their Power — Leo X. in Florence — Façade of San Lorenzo — Works in Carrara — Call to Rome — Undertaking of the Façade — Leonardo da Vinci — Sojourn in Rome — Raphael — Painting in the Farnesina — Sebastian del Piombo's Scourging of Christ in San Pietro in Montorio, and the Raising of Lazarus.

"DEAREST FATHER," writes Michael Angelo to the old Ludovico, after the taking of the city, "You say in your last letter that I ought to keep no money at home, and carry none about with me; and, also, that it is said with you that I have expressed myself unfavorably respecting the Medici. As regards the money, whatever I have is in the bank at Balducci's; and I have at home or in my pocket only what I require for daily expenditure. With respect to the Medici, I have never spoken against them, otherwise than all the world have judged them. Thus, for example, respecting what happened in Prato. The hard stones would have spoken of that, if they had had a voice. And in this manner much has been said of them which I

have heard and repeated, — whether it can be true that they have thus behaved so badly ; yet I will not say that I believe it, and God grant it may be false. Four weeks ago, somebody, who calls himself my best friend, inveighed very strongly against them to me ; I, however, forbid myself to do so, and told him that it was not right to speak so, and he must be silent. It would be well if Buonarroto could secretly find out who has made the statement that I have spoken against the Medici ; I could then inquire whether it originates with one of those who were so friendly with me, and can take care in future. I am at present without work, and wait until the pope gives me a commission."*

Michael Angelo had completed the paintings in the Sistine Chapel, and was carrying on the work at Julius's mausoleum, at his own risk it seems, and without having been commissioned afresh to do so. The pope was very old ; and, after his death, the completion of the monument was to be taken for granted.

At the same time, Michael Angelo pursued other plans. Under Julius's government, the Vatican had become the battle-field for the jealousies of artists. We have seen how Raphael endeavored to force his way into the Sistine Chapel, and how he failed in doing so ; and now, advancing from room to room, he created monuments of his fame in the papal apartments. Michael Angelo, on the other hand, after the chapel was completed, now aimed at forcing his way where Raphael was at work with his party. He

* See Appendix, Note LXXII.

did not himself wish to paint, but to obtain work there for the one artist who adhered to him, while almost all the rest stood on the side of Raphael: he wished Sebastian del Piombo to .execute wall paintings in one of the halls, the cartoons for which Michael Angelo would design.

Michael Angelo's position at Rome was not at that time an easy one. He openly said he had worked for the pope without receiving pay. Julius, sadly embarrassed, was rarely present; and, when he came, he was filled with thoughts which naturally made him appear to have completely neglected his artistic undertakings. However, this was not the cause: a separation had actually taken place between the pope and Michael Angelo. The mausoleum was delayed; and he was assigned no further commissions. Raphael openly occupied the position in the Vatican which Michael Angelo had hitherto possessed ; and Michael Angelo's attempts to exert his wonted influence for himself and his .pupils had little prospect of success.

It was not, however, the novelty and attractiveness of his appearance that allowed Raphael thus to carry away. the victory ; but there was a quality in his works, with respect to which he surpassed Michael Angelo to so great an extent, that the latter never even made the attempt to combat with him here. Raphael displayed a power in giving his works the most beautiful coloring ; and this was so great, that Michael Angelo's paintings, when placed by the side of his, had only the effect of colored drawings, carefully as the coloring and the shadows were always

devised and applied. Raphael owed it to Michael Angelo alone, that he had risen to that higher stage of excellence during the first years of his labors in Rome; now, however, he surpassed his master. His paintings, from the time when the Sistine Chapel was completed, enchanted the Romans by expressing something delightfully human, touching the heart at once, — a feeling which Michael Angelo by no means understood how to bestow on his magnificently solemn figures. A new school of aspiring artists flocked round Raphael. It was disputed in Rome, which of the two masters was the greater; and, as they both appeared so great, and Raphael, young, attractive, and rich in the power of color, unfolded a new element in art, it is no wonder if he obtained precedence.

As regards the technical part, Sebastian del Piombo perhaps could alone have ventured to oppose him. He had come from Venice. He had studied with Giorgione, and had acquired his trembling, soft coloring. Designing was not his strong point; but for this there was now Michael Angelo. Both parties appealed to the pope. We know not what was the course of the contest, and to what pitch things came; nor have we even intimations of what was to be painted, — only a letter of Sebastian's to Michael Angelo carries us for a moment into the midst of the contest; and the silence that succeeded alone informs us, that it ended in favor of Raphael's pupils.

Michael Angelo seems to have set out for his native city shortly after the Florentine revolution.

The affair of the painting in the Vatican was undecided when he departed. Sebastian was to give him news of it. As he heard nothing from him, Michael Angelo wrote and inquired, and received the following answer in the middle of October: —

"Dearest God-father," — writes Sebastian, — "Do not be astonished that I only now answer your letter, after so long a time. The reason is this, that I have been more than once in the palace to speak with our master, his Holiness, and have yet found no opportunity of speaking with him as I wished. Lately, however, I have discussed matters with him. His Holiness was very gracious, and dismissed all who were present; so that I was alone with our master, except a cameriere on whom I could depend. I represented my matter to him, and he heard me very kindly. I placed myself and you in every way at the disposal of his Holiness: he had only to command us, and to communicate to us the design which the pictures should represent, the size, and all the rest. His Holiness replied in the following manner: ' Bastiano,' he said to me, ' Juan Batista del Aquila has told me, that, in the hall below, nothing can be executed on the right side; for the vaulted ceiling there runs down the wall in such a manner, that two compartments rounded off above are formed, extending almost to the middle of the wall on which the pictures would be painted. Then come the doors to the apartments of Monsignor dei Medici, so that it is impossible to cover any entire wall with one single composition. In each arch, however, a separate one might be painted, — one eighteen palms broad, the other twenty. There might be any extent of height; but the figures would then appear too small for so great a space. Besides,' added his Holiness, ' the hall is too accessible to everybody.'

"All this comes from Juan del Aquila and others, who would gladly see me anywhere but in the palace. But, god-father, by our common faith! when some people saw me here in the palace, you would have thought they were looking at the incarnate devil himself, as if I came to wring all their necks off. Yet, God be thanked! I have still some good friends, and could have more if I would; and some fine day they shall find it out.

"Upon this our master said further to me, ' Bastiano, upon my conscience, all that is executed below dissatisfies me, and pleases no one who has seen it. In four or five days, I will look at the thing; and, if nothing better is done than has been begun, I will put a stop to it. I will have all taken down, and something else begun; and you shall have the whole hall: for the thing shall either be beautiful, or I will have the hall simply painted over.'* I answered, that I could do wonders with your assistance; and he said, ' I do not doubt it; for you all belong to his school.' And, by my faith! his Holiness now said, ' Only look at Raphael's works: as soon as he saw Michael Angelo's paintings, he left Perugino's style, and endeavored as much as possible to approach closer to Michael Angelo. But he is indeed terrific (*terribile*),† as you yourself see, and listens to no reason.' I said that your terribleness hurt no one, and that you only were so, because you had before you important works, and so forth: the rest is of no importance.

"I have now waited the four days, and have been to the palace, to ,inquire whether his Holiness had seen the works. I heard that he had certainly done so; but that he had asserted that some figures just begun, and some half finished, must be entirely completed before he could judge. But the further they advance, the more it is said

* See Appendix, Note LXXIII. † *Ibid.*, Note LXXIV.

to displease him. Still, to please them, he will wait a fortnight or three weeks, till the figures are ready.

" This is all that has happened since I wrote last. I cannot send the size, as the pope has not yet settled any thing, and the others are still at work. Christ keep you safe!

" Your godchild, BASTIANO, in Rome.*
" Oct. 15, 1512."

This Aquila, to whom Sebastiano imputes such bad influence, was the pope's chamberlain, Giovan-batista Branconio d'Aquila, for whom Raphael built a palace: the hall in which Raphael's pupils were painting was perhaps the hall of Constantine; and the hall, the walls of which Michael Angelo de-manded for Sebastian, and which lies a story higher, was called *la Sala Borgia*.† The pope, who would not openly comply with Michael Angelo's wishes, yet did not wish to offend him; but, master as he was in doubtful promises, he chose the often-em-ployed expedient of linking the most unstable con-ditions with the strongest assurances, and postponing things instead of coming to a decision.

Michael Angelo was soon obliged to return to Rome. Perhaps he did so in order still to carry his point; but the state of the pope soon allowed nothing of this kind to be thought of. It is true, Julius wished to know nothing of death. He carried on his political plans, as if dozens of years were yet before him. He had purchased Siena from the em-peror for the Duke of Urbino; that is, Siena was an old imperial fief, and Maximilian, for a fixed

* See Appendix, Note LXXV. † *Ibid.*, Note LXXVI.

sum, gave the necessary pretext for war. Julius had, besides, the Spaniards in pay for a campaign against Ferrara. He wished to have the Medici again out of Florence, because they behaved too independently there; he wished to appoint another doge in Genoa: and all in the spring of 1513. And yet from Christmas he had been confined to his bed. But there are natures whose energy overcomes weakness of body, and forges wax into steel. The last deeds of the pope show him as such a man. In the midst of fever, he had rushed like a young soldier into the winter cold; the people of Bologna were amazed when he galloped through the streets firmly seated on an intractable steed. He wished to expel the French from Italy: he intended to get rid of the barbarians who had all his life impeded his plans, much as he had needed their assistance. As Italy's deliverer from tyrants at home and abroad, he seemed to himself too necessary in his place, for death to carry him away while he was yearning for fresh deeds. On the 21st February, 1513, however, the end of all things took place. The pope was this time really dead; and the world was not again disappointed.

To the last he adhered to his ideas of dominion. I trace in his character a resemblance with that of Frederic the Great, whose old age also manifested no diminution of mind, — whose thread of life, like Julius's, snapped asunder one day, because the one-half of man's being is meted out for limited durability only, while he took with him to the grave a mind full of bold thoughts for the liberation of

Germany, which none have inherited after him. The more Julius ventured, the more faithful did fortune seem to him, and the more vehement did he become. Frederic also became increasingly violent with increasing years. They both learned more and more, that action is the only way of promoting things, and that quick, lightning-like proceeding is the only way of acting; and, lastly, that fortune or fate, or however we may call the power upon which the earthly issue of things depends, is thus made an almost subservient force, capable of being called forth and considered as an ally. For he alone can act who cherishes a presentiment of the success of his designs; doubt of his own superiority precedes misfortune.

If any man was capable of understanding Julius's mind, it was Michael Angelo. Immediately after the death of the pope, whom we may now certainly call his old friend, he resumed his work on the mausoleum.

It had been mentioned in Julius's will. The heirs now urged for its completion. Before the work was, however, continued, a new plan and a new contract were brought about, — the former on a reduced scale, the latter at an increased cost, — in such a manner, that, to speak generally, double the sum was to be paid for half the work.

Respecting the form, which, according to this second agreement, the monument was to receive, we have been hitherto in doubt. The London manuscripts have put an end to this. There is among them a paper of Michael Angelo's, which can be

nothing else than a description of the monument according to this its first remodelling.* In the simplest manner, it is represented as a section of the former in its breadth; so that, whilst before it was to stand in the middle of St. Peter's Church, open on all four sides, it now joined the wall of the church with one of the two narrower sides, which thus became the main façade, and, as it were, jutted out from the wall. The difference between this project and that according to which it was subsequently completed, as it is to be seen at the present day, only consists in this, — that the proportions corresponding to the original design were more colossal, and the whole superstructure must have been less flat against the wall. An abundance of bronze ornaments, too, were designed for it, which were subsequently omitted. They must have been very considerable, as Michael Angelo intended to buy for them more than 200 hundred-weight of metal. He was entirely absorbed in this work from the year 1513 to the end of 1516. He had the blocks of marble conveyed from his atelier, near the Vatican, to Macello dei Corvi, close by the Capitol, where there were many sculptors' workshops, and where he possessed a house of his own, which he inhabited till his death. At any rate, this change of residence presented this advantage, — that Michael Angelo left the unhealthy leonine suburb for one of the healthiest parts of the city.

I imagine that at this time he was especially occupied with the Moses, although the statue remained in

* See Appendix, Note LXXVII.

his workshop for forty years after this period. It is as if this figure were the exemplification of all the violent passions which filled the soul of the pope,— the portrayal of his ideal character under the figure of the greatest, mightiest popular leader who ever raised a nation from servitude to reliance on its own strength.

Whoever has once seen this statue, must retain the impression of it for ever. There is in it a grandeur, a self-consciousness, a feeling as if the thunder of heaven stood at the man's disposal; yet he brings himself into subjection before he would unchain it, — waiting whether the foes whom he intends to annihilate will venture to attack him.

He sits there as if on the point of starting up, his head proudly raised: his hand, under the arm of which rest the tables of the law, is thrust in his beard, which falls in heavy, waving locks on his breast; his nostrils are wide and expanding; and his mouth looks as if the words were trembling on his lips. Such a man could well subdue a rebellious people; drawing them after him, like a moving magnet, through the wilderness, and through the sea itself.

What need we information, letters, suppositions, records, respecting Michael Angelo, when we possess such a work, every line of which is a transcript of his mind?

We are too little acquainted with Michael Angelo's works. They stand in unfavorable places. They are not accessible to all, because their immense size renders casts of them a matter of difficulty; and,

from general ignorance of them, prejudices have been formed respecting them. The Moses is the crown of modern sculpture, not only in idea, but also with regard to the work, which, incomparable in its execution, rises to a delicacy which could hardly be carried further. What shoulders are joined to those arms! What a countenance! The muscles of the brow threateningly contracted; a glance, as if it passed over an entire plain full of people, and ruled them; the muscles of the arm, whose ungovernable power we feel! Whom did Michael Angelo chisel in this form? Himself and Julius both seem portrayed in it. All the power which Michael Angelo possessed, and which the world did not understand, was exhibited in those limbs; and the demon-like, passionate violence of the pope in that countenance. We feel as Ulric von Hutten said of this man in admiring irony: he wished to take heaven by force, as entrance had been refused him above.*

While at work on this figure, he must also have been engaged on the two chained youths, at that time intended for the mausoleum, but subsequently, when the proportions were diminished, omitted as too colossal, and sent to France. King Francis gave them to the Constable de Montmorency, who placed them as an ornament outside his castle in Ecouen. From thence they were brought by Cardinal Richelieu to one of his castles at Poitou; his sister subsequently had them conveyed to Paris; in 1793 they were publicly sold there, and bought for the Museum

* See Appendix, Note LXXVIII.

of the Louvre, in which they are to be seen at the present day.

It is one of these two statues which is said to have been intended as a contrast to the Moses; apparently as though the admiration of this work were not to exhaust all that is, in the highest sense, worthy of admiration in Michael Angelo,—the representation of the great, the overwhelming, the fearful, in one word, *del terribile*. Perhaps the tender beauty of this dying youth is more penetrating than the power of Moses.

Personal feeling can here alone decide. When I say that to me it is the most elevated piece of statuary that I know, I do so, remembering the masterpieces of ancient art. Man is always limited. It is impossible, in the most comprehensive life, to have had every thing before our eyes, and to have contemplated that which we have seen, in the best and worthiest state of feeling. But there is an unconscious ruminating over what we have met with, with a conscious enjoyment of the contemplation; and what remains, as the final result of this involuntary working in the mind, is that to which we can alone appeal as the result of experience. I ask myself, What work of sculpture first comes to mind, if I am to name the best? and at once the answer is ready,—the dying youth of Michael Angelo.

In innocence of natural conception, this figure can only be compared with the best Greek works, in which there is also no trace of exhibiting what they were capable of producing; but the simplest, most suitable expression of nature is apparent,—just as

Statue, The Prisoner.

MICHAEL ANGELO.

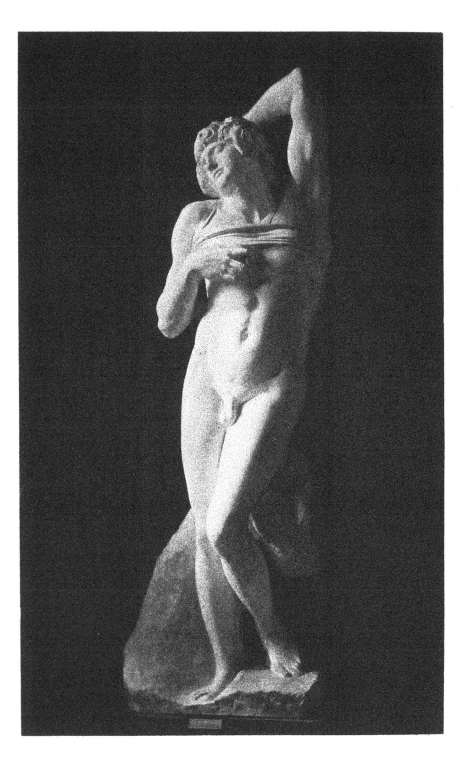

the artist felt it, and endeavored to imitate it for his own delight alone. What work of any ancient master do we, however, know or possess, which touches us so nearly as this, — which takes hold of our soul so completely as this exemplification of the highest and last human conflict does, in a being just developing? The last moment, between life and immortality, — the terror at once of departing and arriving, — the enfeebling of the powerful youthful limbs, which, like an empty and magnificent coat of mail, are cast off by the soul as she rises, and which, still losing what they contained, seem nevertheless completely to veil it!

He is chained to the pillar by a band running across the breast below the shoulders; his powers are just ebbing; the band sustains him; he almost hangs in it; one shoulder is forced up, and towards this the head inclines as it falls backwards. The hand of this arm is placed on his breast; the other is raised in a bent position behind the head, in such an attitude as in sleep we make a pillow of an arm, and it is fettered at the wrist. The knees, drawn closely together, have no more firmness; no muscle is stretched; all has returned to that repose which indicates death.

The space which is allotted in the New Museum at Berlin for plaster-casts, consists of contiguous halls, which, beginning with the productions of Greek art, lead up to those of the present day. If we pass from the midst of Greek works to those which were executed in the times of the Roman emperors by the descendants of those earliest generations of Greek

artists, we cannot resist the impression of coldness and cool elegance which has taken the place of the heartiest combination of nature and innocent grace. Those of later date speculated on the approval of the constrained Roman public; the Greeks thought of their own free people.. The Greek works breathe forth a happy, self-contented vigor; the Roman, the artificial perfume of brilliant virtuosoship. There are productions, triumphant solutions of difficult tasks; but the feeling is ever wanting, that the artist who executed them yearned to satisfy his own heart in them. His statues were only the veiling ornament of the lifeless stone, out of which Roman society was built in the days of imperial rule.

How different the Greeks! Passing from figure to figure, I examine the festive procession on the frieze of the Parthenon: the galloping horses,— they seem to stream along like the verses of some glorious poem! the youths who lead the oxen, the maidens with the vessels,—many an age lies between that day and this; but I imagine myself to have lived in the midst of the people, and only when I come to the Romans, does the feeling of the past obtrude itself upon me.

This difference between Greek and Roman art is repeated in modern times. We look at the first efforts of the middle ages: awkward beginnings, which stand in similar relation to the perfect art of the old masters, as the earliest works of the Greeks did perhaps to those of the Egyptians, who produced from time immemorial independent works of sculpture, the finest imitations of nature. A strange

mixture of a peculiar imitation of life, and conscious employment of the models presented by the remains of ancient art, meet us in the works of the earliest Italians. Increasingly extensive grew the renewed acquaintance with those Roman sculptures which were again brought to light from the depths of the earth, — sculptures which stand sublimely, like a lost creation, above that which they could produce from their own knowledge; but at the same time, struggling with the habit of imitation, appeared an ever fresh, an ever more successful following of nature. We see Ghiberti submit more readily to the ancients, Donatello more reluctantly; at length we see in Michael Angelo the reconcilement of both tendencies; and, by the addition of his own power, there burst forth, from all that had been done hitherto, the blossom of a new art, surpassing by far all previous works.

Like the masters of the old Greeks, Michael Angelo worked as a member of a grand and mighty people for their ennobling. With his heart full of yet unbroken pride in the freedom of his country, he saw himself surrounded by men who thought as he did, and with a prince at his side, whose motto was the restoration of liberty to the whole of Italy.

Just as truly as the statue of Moses, designed for the mausoleum of this man, expresses his will, his power, and his longing desire, so truly does the figure of the dying youth remain no mere symbol. With the death of Julius II., the arts perished. No prince succeeded him who was able to devise tasks worthy of great artists; and no epoch of liberty

broke in upon any land, to give to works of plastic art that final lustre of completion, and that grand transporting purport, which can thus alone be bestowed.

2.

During the three years of continuous work at the mausoleum, Michael Angelo alternately resided at Rome and Florence, although he had released himself from his engagements at the latter place. Tho twelve apostles for Santa Maria del Fiore had been already, in 1512, distributed among a number of younger sculptors, who completed them in the course of the next ten years. There was no further mention of the colossal statue for the square of the palace. The painting in the hall of the consiglio shared a similar fate. Soderini was away; the consiglio abolished ; and the hall of their former dignity, dismantled, was degraded intentionally into an abode for soldiers, whose pikes against the walls were perhaps to blame for the disappearance of the work which Leonardo had just completed.

One word more we must say here respecting both these famous cartoons.

It is certain that both were destroyed, and disappeared, after they had only existed for a short series of years as memorials of what Florentine art had been able to produce, — Leonardo's work in the hall of the popes, Michael Angelo's cartoon in the great hall of the palace of the Medici. A whole succession of rising artists drew from them, and received their first impressions from their lines. One of these

young men is accused by Vasari of the crime of having maliciously cut Michael Angelo's cartoon. And certainly the act is said to have been committed in the year 1512, in those days of disorder when no one had time and thoughts left for works of art.

Bandinelli was the culprit's name. We know him from Cellini's biography, in which sufficient care is taken that the world should know the intolerable character of this sculptor. Vasari judges him scarcely more favorably. Both, however, might have been the reports of envious companions in art. Yet we possess a long series of Bandinelli's own letters; and these are sufficient to reveal the envious, false, calumnious spirit of the man, and his silly vanity. In addition to this, we have his tasteless works. One thing alone we must accord to him, — and that is unwearied industry; and from *one* crime we must acquit him, whether the other basenesses be true or no, — he cannot have cut the cartoon of Michael Angelo in the year 1512.

Vasari certainly relates very accurately how Bandinelli procured the key; how, as an adherent of Leonardo's party, he had hated and envied Michael Angelo, and what the city said after the deed was done. But it was false. Vasari appears despicably on this occasion. In the first edition of his book, we do not find Bandinelli's life. In Michael Angelo's biography, it was only said that the cartoon had been cut in the year 1517, when the Duke Giuliano was in a dying state, and no one had time to trouble himself about it ; the separate pieces had been lost. When the second edition of the book appeared, Ban

dinelli had meanwhile died, and his biography was added to the others. And now, in Bandinelli's life, we find the accusation, that in 1512, during those days of commotion in the hall of the palace, he crept in, and cut up the cartoon; whilst, in Michael Angelo's life, Vasari's old statement of the year 1517 is simply repeated.

Thus there is a contradiction in the book itself. So strong, however, was the impression of Bandinelli's insufferable character, that the accusation was received as well-grounded, and what might be said on his behalf was lost sight of. Two circumstances absolve Bandinelli. In the first place, Condivi knows nothing of it. He says the cartoon was lost, it is not known how. Had Bandinelli committed the deed, Condivi would at least have intimated it. In the second place, however, Benvenuto Cellini places the means at our disposal for adducing still more decided proof.

He relates how he had seriously resolved, in the year 1513, to remain a goldsmith; how he afterwards worked at Siena, Bologna, and Pisa; and lastly, having returned to Florence, how he studied from Michael Angelo's and Leonardo's cartoons. This must, therefore, necessarily have been after 1513. Had Bandinelli, however, committed the deed in 1517, instead of 1512, Cellini would not have been the man to leave it unmentioned; for he hated Bandinelli like poison, and honored Michael Angelo's work as the highest he had ever produced.

There is, besides, one thing more. Immediately after those days of revolution, Michael Angelo had

gone to Florence; and he, too, had Bandinelli been the guilty one, would at least have not passed over the matter in complete silence, and would have spoken a word to Condivi about it.

It does not seem that at that period, when Michael Angelo saw for the first time how the Medici had again established themselves in Florence, he sided politically with any party. It might be said that he had previously been absent, and circumstances had not required it afterwards. No one could do better than be silent for the moment, and yield. But he was not at that time opposed to the Medici. That in Rome he restrained, as he expressly says, every indiscreet word, is a proof of this; but it is still more evidenced by his open connection with the powerful family. And, indeed, under the cardinal's rule, these people behaved so well, that no one felt himself obliged in conscience to meet them with hostility.

They appeared intimately acquainted with the Florentine character. Their entrance in 1512, and the position which was at that time given them, appeared only as the result of the urgent demands of Cordova, which permitted no evasion; the *coup d'état* and the convoking of parliament were bold measures, to which they were compelled by the disunion of the consiglio grande. What followed was the work of the free citizens. The Spanish troops carried away with them, it is true, to the Romagna, five hundred prisoners, men and women, and laid the land under contribution, — a fearful band, with Turks and all possible rabble among them. They

had obtained from Florence alone one hundred and fifty thousand ducats in ready money, apart from what Lucca and Siena paid to buy themselves off. But it was the Medici who brought about their withdrawal, while the Soderini had been to blame that they had entered the country. For Cardinal Giovanni had only obeyed the pope's command as legate; Giulio dei Medici had done nothing but give good counsel to the Palleski in Florence; Giuliano served in the army; and Lorenzo, Piero's son, for whom the city had truly been conquered, had taken no part at all in events. He only made his appearance when every thing was settled, and entered the city as a youth who knew nothing, and had helped to nothing.

The first act of the Medici was to pardon the condemned citizens. Adherents of the Soderini, who were in the utmost alarm, were personally inquired after, quieted with assurances of esteem, or taken under protection. The banishment of the Soderini was pronounced in the mildest form. The gonfalonier was not to leave Ragusa for five years; the others got off with two years. The safety of the State was the one point in question: the Medici thought not of taking revenge.

At the same time, outward splendor was displayed. Giuliano and Lorenzo established two companies of rich young men for the object of public amusement. Giuliano's company was called La Compagnia del Diamante, because the diamond had been the badge of his father Lorenzo; while La Campagnia del Broncone, Lorenzo's troop, bore a branch, the sym-

bol of the deceased Piero. Both of these added splendor to the carnival of the year 1513. Whilst Pope Julius lay dying in Rome, magnificent festivities distinguished the restoration of the Medici at Florence. These are those romantic years of enchantment, of which Vasari speaks so gladly. He was born at that time; and, at a later period, he relates what splendid parts Florentine artists played in them.

Behind this delicacy and reserve, however, there lurked the utmost caution; and, when this began to be suspected, there came forth from under the velvet mantle a claw with sharp talons, which knew no consideration. The party of the Palleski began to disperse, after the Medici were at length re-instated in power. Under the Soderini, it had been, as it were, the fashion to be a Palleski, rather out of opposition to the half-democratic gonfalonier than out of attachment to the vanished authority of the family that had been for almost twenty years in exile. Now they were back again, and Soderini was away, one power had been replaced by another: the old Arrabiati, who neither wished to see democracy nor the Medici at the head of affairs, but themselves as an oligarchy, began secretly to excite the public mind. The Capponi, the Albrizzi, and the old hereditary enemies, the Pazzi, re-instated after the expulsion of Piero, were the leaders of the opposition. At the very first, they had endeavored to prevent the convoking of the parliament; and now the universal discontent formed itself into a conspiracy.

This was discovered; and now followed imprisonments, torture, executions, and banishments. The Medici showed themselves now so inexorable, that one of the Valori, a family with whom the revolution in their favor had mainly originated, was sentenced to death and to imprisonment for life, only because he had refused the propositions of the conspirators, without denouncing them. Among those who were arrested, was Macchiavelli, who, having lost his official employment by Soderini's removal, belonged to the malcontents. Fortunately, Cardinal Medici was soon elected pope. They now felt more secure, and treated the prisoners with more clemency, until an amnesty at length followed.

The conspiracy occurred in the last days of Pope Julius; the election of Cardinal Medici took place on the 11th March. He was unanimously chosen; and he who urged it most was Cardinal Soderini, with whom Medici had become reconciled. Immediately after his accession, the gonfalonier was recalled from Ragusa to Rome, and received in the most friendly manner. There was a general rejoicing in Rome, such as had never been since the days of the old emperors; and no less so in Florence, when the honor which reflected on the city by this election seemed to have obliterated every thing which weighed on their minds against the Medici. Unhappily we read that the covetous commercial nature of the people had the greatest share in this feeling of content; for every one hoped to rise by means of the pope, and to gain money. A kind of servile mania suddenly swayed all minds; the old arms of the city, the red

crosses denoting liberty, were everywhere torn down, and the Medicæan balls placed in their stead; in Rome, half Florence crowded to the Vatican, and kissed the sacred foot of the pope. Leo expressed, rather contemptuously, that he had only met two people who wished well to the city, and had at heart the preservation of her liberty,—the one, a poor devil known as a public fool; and the other, Soderini the gonfalonier, who, living at Rome until his death, continued to bear the old title.

Freedom seemed, however, indeed to have become an impossible possession to the Florentines. For the old plans which the Borgias had before cherished were immediately taken up again by the Medici. In imagination, they divided Italy now into two kingdoms,—Naples, which Giuliano was to have; and the other northern half of the peninsula, with its capital, Florence, as Lorenzo's portion. Just so had Alexander VI. once hoped to divide the land among his sons; and Leo now trod in the steps of this predecessor, with the power of a man who has been trained from his youth up for his great part.

The new master was little like the departed one. Leo X. was a man of taste and cultivation; he loved clever men, and delighted in extravagant undertakings: but he could not have said, like Julius, this can be done by Michael Angelo alone, and that Raphael can execute. Music was his passion; all sorts of follies and wit, his daily pastime. Cunning and regardless in political things, he gained his ends; but his successes seem pitiful when compared with the deeds of Julius. Fat, large in the upper part of

his body, and with immense bloated features, his legs were weakly; his weak, short-sighted eyes were frog-like in their prominence; his thick lips were compressed like two fists. How different the profound, searching look of Julius, and his energetic mouth, with its deep, triangular corners! Raphael's picture of Leo X. is flattering. The corpulence of his entire frame makes him appear less intellectual on coins or medallions. If we look at this great bloated countenance, and imagine the pope with spectacles on his nose, singing the first part in the midst of flattering musicians, or coquetting about with his ring-glittering hands, of the beauty of which he was vain, or laughing at the jests of his company, or giving audience to some brave, far-travelled German nobleman, who, after having kissed his foot, in rising strikes his nose, — he becomes almost ridiculous; he becomes even loathsome, if we read of his sicknesses. Raphael's mere existence, however, makes amends for every thing, — he raises the pope and the whole of Rome into an ideal sphere. •

As the mind of Shakespeare gilds with a magic lustre the period of Queen Elizabeth, making the most insignificant things fresh and curious, so the presence of Raphael invests the court of Leo X. with an appearance of youthful grace. It is as if the otherwise dark-flowing waters of life had been transformed into nothing but sunny fountains. Raphael's portrait of the pope, even if we consider it as flattered, acquires the appearance of the truest reality; and the whole character of the man, taken all in all, has in it something free, independent, and even magnificent.

For Papa Lione was royally, irresistibly flattering in his condescension to those of lower rank, but a perfect diplomatist towards princes. There was nothing of cowardice in his nature. He had appeared deliberate in difficult positions. When he had read aloud the votes in the College of Cardinals, and it was evident that he was himself the pope chosen, he quietly read on, without the slightest internal emotion being perceptible in his voice. He knew the characters of men; he guided and used them; and his magnificent way of representing Rome as the central point of the civilized world proved itself so successful, that he, who has done but little for the plastic arts,* contrived to transfer to himself almost entirely Julius's fame, and to appear in history as the man without whose name the prince of modern art could not be mentioned.

If we call happiness an elevating feeling of the present with the prospect of a future, whose multiplied advantages present an endless increase of desirable circumstances, so that the remembrance of the transitoriness of earthly things, and the disturbing irony of fate, is easily driven from the mind, as though the mighty rule still admitted an exception, — if this we call happiness, then the Medici family were perfectly happy at the time that Leo X. entered Florence in November, 1515. He had given Giuliano, the gonfalonier of the Church, in marriage to a French princess. Lorenzo was captain-general of the Florentine Republic (contrary to the law, which allowed no native to attain to this dignity; this, however, he

* See Appendix, Note LXXIX.

little cared' for)'; he commanded the city with a power as unlimited as if he were its duke. Giulio dei Medici was Archbishop of Florence, cardinal and legate in Bologna. In France, Louis XII. had died. His preparations for the reconquest of Lombardy were of service to the Duke d'Angoulème, who ascended the throne in the beginning of the year 1515, as Francis I. He appeared with an army in Italy; set an example of brilliant, victorious valor in the battle of Marignano; and, after having made France once more master of Italian policy, transformed the pope and the Medici, who had at first marched against him with the emperor, into his friends. Now, in the autumn of 1515, Francis wished to meet the pope in Bologna; and, on his journey thither, Leo, for the first time after his elevation, re-entered his native city, whose citizens, in raptures at his arrival, pulled down the walls to build a new gate. Leo's entrance into Florence set the seal to the transformation of their love of liberty into servitude. •

It was at that time that Macchiavelli dedicated his book on princes, *Il Principe*, a work begun two years before, to the young Lorenzo; an act which, still less in those days than in the present, denoted mere courtesy. Macchiavelli saw in this prince, whose appointment as Venetian envoy he compares with that of Cæsar Borgia, the future master and deliverer of Italy. The work, objective and general as it seems, is at bottom only calculated for Florence and Lorenzo, and — for Macchiavelli himself. For he wished to represent himself as an efficient man

and at all events to enter again into active service. In this, however, he did not succeed. The Medici judged, perhaps, that a mind so accurately acquainted with the means and ways and passions of princes would be too critical an observer in immediate contact with them.

Twelve triumphal arches awaited the pope in the streets of Florence; there were temples, columns, statues, flags, flowers, tapestries,—the city appeared like one entire decorated palace; and the citizens, in exquisitely magnificent attire, seemed like a band of happy children welcoming their father.

Granaccio was at that time again to be had; and he erected one of the triumphal arches. Paintings and statues were placed on it; he and Aristotile di San Gallo executing this work to the astonishment of all. Giuliano and Antonio di San Gallo built a temple before the palace of the Government; Rosso, Montelupo, Puntormo, — nothing but names of a new generation, — took a part. The most magnificent thing, however, was a wooden façade painted like marble in front of Santa Maria del Fiore, erected by Sansovino from the designs of the old Lorenzo dei Medici, who well understood architecture. The glittering train of the pope, in whose suit was Raphael, moved along, past all these splendors. This journey afforded the pope occasion for the first time to demand Michael Angelo's services.

3.

We know not how Michael Angelo presented himself at the Vatican after the accession of his new

master. He had nothing more to do there : Ra-
phael, who rose from dignity to dignity, was all-
powerful there. He had at length succeeded in
making his way even into the Sistine Chapel. He
worked at the cartoons for the tapestry which was
to cover the deepest part of the wall ; works which,
from their intrinsic grandeur, simplicity, and com-
mand of every form of body, are the most important
which he has produced. He here approaches near-
est to Michael Angelo ; and, if his intention was to
rival him in a powerful production, he succeeded.
Whether Leo, however, considering Raphael as the
superior artist, heaped on this account so many fa-
vors upon him, or whether this was only the result
of that second art which Raphael possessed in the
highest degree, — that of attracting men irresistibly,
— is uncertain. All intimation is wanting. Per-
haps Leo's and Michael Angelo's natures slightly
repelled each other. Still Leo was pope, and Mi
chael Angelo was Michael Angelo. He occupied
a position which made commissions appear like a°
necessity to him, although it was known beforehand,
that he would refuse them when they came.

The first of his letters, which shows him in a man-
ner connected with his old patrons, must belong to
the time when the Medici had just re-established
themselves in Florence, and therefore probably to
the year 1512 or 1513.* " Dearest father," he
writes, " Your last letter shows me how it is with
you ; before, I only knew it partly. We must take
things as they are ; leaving the future to God, and

* See Appendix, Note LXXX.

acknowledging where we have erred. The misfortune is eminently caused by the overweening character and ingratitude of the people, — for I have nowhere seen a more ungrateful and arrogant people than the Florentines; and retribution will be the natural consequence." (Ungrateful, for instance, to Soderini, whose fate, as these words show, was deeply felt by Michael Angelo.) "As regards the sixty ducats, which you, as you tell me, are to pay, it does not seem to me to be right, and I am very sorry. But here, too, it is best to submit quietly to what God has ordained. I will address a few lines to Giuliano dei Medici, which I will enclose here. Read them, and convey them to him if you will: perhaps they may help; if not, try to sell what is our own, and we must then settle elsewhere. If you observe that you are treated worse than others, pay on no condition. Rather let what you have be taken from you by force, and write to me. If others, however, do not fare better than we, bear it, and place your hopes on Heaven. Take care of your health, and see whether you are not still able to get your daily bread; and, with God's help, get through, poor but honest. I do not do otherwise; I live shabbily, and care not for outward honor; a thousand cares and works burden me; and thus I have now gone on for fifteen years, without having a happy, quiet hour. And I have done all for the sake of supporting you, which you have never acknowledged or believed. God forgive us all! I am ready to go on working as long as I can, and as long as my powers hold out."

This letter calls to mind the distress in Florence in the early time of Giuliano's rule. Scarcity and taxes oppressed the people. . We here. see how heavily even opulent families suffered under it. Some other letters exhibit. Michael Angelo as interceder for his brother with Filippo Strozzi, the nearest and most powerful relative of the noble family. Whether the letter to Giuliano dei Medici had any result, and in what way the affairs of his family were again made endurable, we know not. A total change must have occurred; for there is soon no further mention of it; while, in the summer of 1515, fourteen hundred ducats were sent from Florence to Rome by Buonarroto, as the amount of all the money deposited by Michael Angelo with the hospital director, and which he now urgently required for the completion of the mausoleum for Pope Julius. He wanted to buy the metal for the bronze bas-reliefs. He must have worked with all his energy; and he specifies, as an especial reason why he wished to be quickly ready, that the new pope would shortly claim his services. This was in June, 1515.* He therefore reckoned surely on work in Rome. Of what kind this was, we do not find.

That he stood at that time well with the Medici, is shown also by some shorter letters to Buonarroto, which were despatched to Florence in the April of the same year. Michael Angelo had just been there; he announces his safe return, and begs him as quickly as he can to get five ells of perpignan as beautiful as is possible, and to send them to Do-

* See Appendix, Note LXXXI.

menico Buoninsegni, in the palace of Cardinal Medici. Domenico was the cardinal's master of the household. The material arrived, and was praised as excellent. The little incident allows us to suppose, that Michael Angelo, even if not in the Vatican, went in and out of the Medici palace.

By degrees, in the year 1515, he drew out all his money from Florence to Rome. He warns his family to retrench, and to undertake no uncertain speculations. The director of the hospital, he hears, has complained that he wanted such large sums. The director is mad; so many years the man has had the money from him without interest, and now, when he desires his property, he disputes it. Michael Angelo's letters are now often written in evident anger, when his arrangements at home are not attended to; but they are always full of care for the welfare of the family. At last, on the 11th November, he writes, at the close of a letter, " The pope has left, they assert, for Florence;" and, at this point, letters and all other means of information break off for a whole year. The natural assumption is, that Michael Angelo during this time was uninterruptedly at work at his great task. And it was just a year again after the departure of the pope, that he was summoned to repair to the Vatican, and to produce the plan for the erection of a marble façade to the Church of San Lorenzo, in Florence.

Michael Angelo was at Carrara, where, under his direction, marble was being broken for Julius's mausoleum, when two communications reached him

at the same time, — the one from Rome, the pope's summons; the other from Florence, that his father was dangerously ill.

"BUONARROTO," — he writes to his brother, on the 23d November, 1516, from Carrara,* — "I see from your last letter that our father has been dangerously ill, and that the physician has now declared him out of danger, in case no relapse occurs. I shall therefore now not come to Florence, as I am too deeply absorbed in my work; but, if his condition should become at all worse, I should like at any rate to see him before his death, even if I must myself die with him. Still I hope it goes well with him; and therefore I do not come. If, however, a relapse should take place, — from which may God preserve both him and us! — take care that he has the last consolations and the sacrament; and let him say whether he wishes that any thing should be done by us for the safety of his soul. Take care also that nothing is lacking in his nursing; for I have exerted myself for him alone, in order that to the last he might have a life free of care. Your wife, too, must take care of him, and attend to his necessities; and all of you, if necessary, must spare no expenses, even if it should cost us every thing. Give me speedy tidings; for I am in great anxiety."

Enclosed in this letter was another, which Borgherini was to forward to Rome as quickly as possible, as it contained important things. On the 5th December, Michael Angelo himself set off there, learned the pope's views, and prepared a drawing, upon which he was commissioned to build the façade.

Before the London papers were accessible, it was

* See Appendix, Note LXXXII.

impossible to give a more accurate date to these incidents, and either to disentangle Vasari's indistinct statements, or to reject them as erroneous. Michael Angelo has gathered together every thing relating to the building of the façade, in a record, the greater part of which is preserved.* This is therefore especially important, because a charge against his character can by this means be set aside as groundless, which has been variously repeated, and has of late been again revived against him.

In Vasari's life of Leonardo da Vinci we read, " Irritation and ill-will prevailed between Leonardo and Michael Angelo. And therefore, when Michael Angelo was called by the pope to Rome, to the competition of artists for the façade of San Lorenzo, he went thither from Florence with the permission of Duke Giuliano. When Leonardo heard this, he left Rome, and travelled to France."

A later biographer of Leonardo's has formed Vasari's words into a story, the refutation of which was not to be avoided.† He relates that Michael Angelo had scarcely heard in Florence that Leonardo was in Rome, than he at once set out thither in order to oppose the influence of his old adversary. To obtain permission for this journey from the Duke Giuliano, he alleged that he had been called to Rome by the pope on account of the façade. This trouble, however (that, namely, of supplanting Leonardo), he had been spared by Leonardo himself, who, as soon as he heard of the arrival of his old rival, had voluntarily left Rome.

* See Appendix, Note LXXXIII. † *Ibid.,* Note LXXXIV.

Although all this, stated to us, as it is, as a settled matter, may be set aside by the fact that a misunderstanding of the Italian language can be proved (for it is always better to suppose ignorance rather than intentional perversion), we may nevertheless with certainty maintain, that Vasari's statement also contains an impossibility. We possess a record by Leonardo's hand, according to which, after having not found·in Rome what he expected, he withdrew from there for ever at the end of January, 1516. At the end of November, 1516, the pope's call to Michael Angelo was first issued. If Leonardo reckoned, however, in the Florentine manner, so that, according to·Roman calculation, January, 1517, might be taken as the time of his departure, this date accorded just as little with those assertions. For then the order would have been long anterior to the time of his departure, and Michael Angelo would have been again in Carrara.

In the year 1513, when Giuliano dei Medici came to Rome on Leo's coronation, Leonardo had gone thither with him, but was nevertheless left without larger orders from the pope on account of his dilatory way of working. It was not Michael Angelo, but Raphael, who would have supplanted him, had he actually left Rome from jealousy. Yet this, too, is only empty conjecture. Why do such always befall such characters? In nothing do we believe more readily than in the petty passions and faults of great men; and nothing is more carefully made the most of than the intimations of biographers to this end. How much there may be of a similar character in Vasari's

narratives, where we have no idea of falsehood, and shall perhaps never be enlightened! For there are characters among his contemporaries, whom he, because he is the only source from which we know them, may have downright annihilated.

When Michael Angelo arrived in Rome in December, 1516, he found assembled there a number of artists, whose designs, like his own, had been required for the projected façade. The execution of this final ornament to the family church of the Medici, in which Brunelleschi and Donatello had immortalized themselves, had been often intended. Lorenzo Medici had even in his time sketched a design for it. Ecclesiastical buildings were often at that period constructed in this way, — that the façade from the first was not taken into account, and was reserved for subsequent times with fresh resources. Costly, perfectly finished churches thus frequently present the strangest appearance in Italian cities. Santa Maria del Fiore is covered all round with the most splendid marble panelling; the façade, however, is an ugly smooth wall, and the wall work is roughly coated with plaster. For this reason, on Leo's entrance, Sansovino's wooden façade was the most suitable ornament for the embellishment of the cathedral, and of the entire city, that could be devised.

The execution of the façade of San Lorenzo was a mighty task. Had Michael Angelo undertaken it, a return to Julius's mausoleum could not have been thought of for a time. He represented this to Leo, and referred to his promises to the Rovere family;

he was bound by contract, and had already received money, for which they demanded work. The pope replied that he would give him free scope; he would manage with the cardinals that they should give their assent. Nothing else then remained but to agree; the only thing obtained was the concession, that Michael Angelo, while occupied with the new commission, should be allowed at the same time to go on working at the mausoleum. For the contracts commonly were so drawn up, that, until the work was completed to which they referred, no other might be touched.

Among those assembled for the competition, we find, in the first place, Raphael, who had been appointed since the past year chief architect at St. Peter's, and who had been expressly taken by the pope to Florence. There were besides the two Sansovini, nephew and uncle, the Sangalli, and lastly Baccio d'Agnolo. Michael Angelo's design carried off the victory; it is still extant, as well as some of the other drawings, only that as regards these it can; not be decidedly settled to which masters they may be separately assigned. The pope gave him the order, but attempted so to twist the matter, that Michael Angelo, as director of all, should have other masters working under him, and, with regard to the sculptures especially, should furnish models for the younger artists. Michael Angelo would on no condition hear of this. Either he would work alone, or not at all; to this he adhered, and he carried his point. But this exclusiveness excited angry feelings, and was resented on many sides. On the

31st December, he was already back at Carrara. On
the 8th January, 1517, he received there one thou-
sand ducats for the commencement of the work:
the gonfalonier was obliged to send it after him by
an express messenger, because Michael Angelo, who
had applied to him in Florence for the money, and
was to have waited in the ante-chamber, had set out
without further ceremony.

The period which followed was occupied in direct-
ing the breaking of the marble in the mountain.

The new work to which Michael Angelo had been
promoted by Leo X.'s order, required not only a
sculptor and architect, but an engineer, and, more-
over, a man who understood how to command others.
To cover the façade of a church like that of San
Lorenzo with sculptures, was a task, in comparison
with which even the mausoleum of Julius assumed
a more humble appearance. Besides this, Michael
Angelo would throughout allow no one to assist him.
He passed the spring and summer of 1517 in the
mountains. He worked at Carrara as well as Pietra
Santa and Seravezza, in which places he opened
quarries discovered by himself.* In August he
returned to Florence, to have a model of the façade
made at the pope's desire. Baccio d'Agnolo prepared
the architectural part in wood; Michael Angelo
manufactured the figures for it in wax. In the
meanwhile he fell ill. At length he sent the whole
thing by his servant to Rome, whither he was then
himself summoned by the pope's express command.
The more accurate conditions of the order were now

* See Appendix, Note LXXXV.

for the first time agreed upon. Michael Angelo obtained permission to continue the works for the mausoleum at the same time. To render this feasible, he had the marble intended for it conveyed to Florence; and he received the promise, — not, however, indeed subsequently kept, — that the costs of transport, including those to Rome, were to be sustained by the pope as entrance duties.

4.

Michael Angelo remained in Rome a great part of the winter of 1517 to 1518, in order to break up his house there, and to effect his removal to Florence. This sojourn there, during which there can be as little mention of the ungracious feeling of the pope towards him as on former occasions, dispels the conjectures which Vasari's evidence once induced me to take for granted, respecting the hostile relation in which Leo X. and Raphael stood towards Michael Angelo.

The two great artists did not stand in each other's. way. Each had his own sphere of action. They had both produced works too mighty to be mistaken. Their hostility can alone have rested in the conduct of their followers towards each other. What has not been related and believed, even in our own days, respecting Goethe's relation to Schiller? and, at length, after deep examination and careful weighing of every expression of the two, how pure do they seem in their feelings towards each other! There is a false deification of great men; but equally false is it to judge them too much by the ordinary stand-

ard, and to consider that hostility which appears perhaps natural to talent alone, as possible to natures which are too richly gifted with their own possessions to be able to envy the richest around them.

Without a rival in Rome, surrounded by a court of aspiring and fellow-working artists, Raphael displayed immense diligence. He built at St. Peter's; he painted at the Vatican; he directed the excavations, and devoted himself to this task with the greatest zeal. He was not satisfied, that every antique marble in Rome should, under penalty, be shown to him before it could be disposed of: through the whole of Italy, as far as Germany, he had his men, who made drawings for him of the ancient works, either existing or discovered. That alone which Raphael did as a secondary matter would completely have engrossed the thoughts of other men. To him, however, it seems to have been like a diversion. From morning to evening, his days must have been a whirl of business, work, and visits, which he received or paid: it was never repose, but always forwards; and, in spite of this desultoriness, there lay deep within his heart the power of absorbing himself entirely in his works, and of conceiving things as calmly and purely as if he had sat in his cell like a monk, and labored.

That Bibbiena, who had once so severely used the poor improvisatore Cardiere, and had subsequently followed the Medici into exile, and who, at the court of Urbino, had been the merry fellow, making everybody pleasant, was now cardinal. He

is known, in the history of literature, as the author of the earliest printed Italian comedy. He had des-tined his niece Maria to be the wife of Raphael. There are some letters of Bembo, the pope's private secretary, to him, in which Raphael is mentioned; and which, although they scarcely say so, still show how completely he lived in these highest circles. " The pope " — concludes a letter of the 3d April, 1516 — " is well ; to-morrow he will probably go hunting to Palo for three or four days. I, Navigero, Count Castiglione, and Raphael, intend to go to-morrow to Tivoli, where I have not been for the last seven and twenty years." On the 19th April, he mentions the arrival of the ducal train from Urbino : " Yesterday I was with the duchess, to whom I pay my respects as often as I can. She presents her compliments to you, and Madonna Emilia also. Signor Unico is always to be found there as a con-stant admirer. The old passion still continues, now three lustrums and a half old, as he himself con-fesses. This time, however, he is more full of hope than ever : the duchess has asked him to improvise before her ; and he thinks on this occasion he can touch her stony heart. Raphael — who sends his respects to you — has produced such an excellent portrait of our Tebaldeo, that the reflection in a mirror could not have been more like. I have never seen such a likeness in a picture. The portraits of Count Castiglione, and of our blessed duke, appear, on the contrary, as if they had been done by Raphael's pupils, both as regards the likeness and in comparison with that of Tebaldeo. I plainly envy

him, and purpose some day to have him paint me.
Just as I had written so far, Raphael himself came:
he must have had a presentiment that there was
mention of him in this letter; and he begged me to
say that you might let him have the sketches for the
other paintings, which are to be executed in your
apartment; that those upon which you had already
decided would be ready this week. Truly, it is no
falsehood, at this moment came also Count Castigli-
one. I am to tell you from him, that, for the sake
of not interrupting his good old custom, he will re-
main this summer in Rome."

The painted apartment, of which mention is made,
seems to be Cardinal Bibbiena's bath-room in the
Vatican. Raphael was at that time thirty-three
years old. He had grown stronger and fuller. He
had his own palace; and, when he went to the Vati-
can, Vasari says that fifty painters formed his suite.
His amiability, however, was so great, that all envy
and all ebullitions of jealousy among the painters
were crushed.

None of his works is so thoroughly characteristic
of the times as one, which, as their freest, most
charming production, bears in it even now, when
destroyed and painted over, the atmosphere of that
Roman life to which Raphael at that time gave him-
self up. The greater part of it he did not even
himself paint, but only furnished the sketches for
it. But this, too, belongs to his character, that he
made others work; and, with a few master-touches,
stamped as his own what they had done at his direc-
tion.

In Trastevere (on the opposite side of the Tiber) lay the summer-house of the pope's banker, Agostino Chigi, now called the Farnesina, because in later years it came into the possession of the Farnese family. It is hidden in the midst of the gardens that lie along the river, close by the other bank of which the numerous houses of the city lie. Crossing over, one is carried from the quiet copses to the noisy streets. Centuries ago, it was just the same as at the present day.

The house was built by Baldassare Peruzzi, a native of Siena, — a place which, even at the present day, richly adorned with the works of this master, lays claim with Florence to the fame of having been the parent of many able artists. Peruzzi worked under the Borgias in Rome, and for Pope Julius in Ostia, when he was still cardinal. After the elevation of the latter, he was employed by Bramante in the building of the Vatican palace. He suited thoroughly the fresh, productive, busy life in Rome; he painted façades of houses, pictures for churches and private persons; and he exhibits in his style, like that of Bramante and San Gallo, a cheerful, peculiar character, in which there is some imitation of the antique. His paintings place him in Raphael's school, yet they preserve a noble simplicity belonging to the master himself. He is a man standing by himself.

Peruzzi's most beautiful building is the Farnesina. Vasari says justly, that it seems not formed by masonry, but born out of the ground; so complete does it stand there in its charming solitariness. At the

present day it is forsaken : its open halls are walled up; the paintings on the outer walls are faded or fallen away with the mortar ; and, in the badly tended garden, which is entered by a rusty iron door, we see the old fountains scarcely moistened by the scanty waters, and the bare pedestals statueless. The broad entrance hall, too, the roof of which Raphael painted, is closed up ; walls have been raised between the pillars, and windows rudely inserted in the arches above. But by degrees, as we become absorbed in the paintings, the feeling of transitoriness vanishes.*

The ceiling, like that of the Sistine, is a smooth cylindrical vault, joining the walls in circular arches. Raphael had studied from Michael Angelo. He, too, took the dome as the blue light atmosphere, in which he built a new architectural structure. But he raised it from wreaths of flowers. Upon each circular arch he painted a pointed arch formed of garlands ; and all the points converging together, he united by a wreath, which, from the dome being like that of the Sistine Chapel, long and narrow, formed in the centre a long quadrangular space. This he divided across, and stretched over the two oblong quadrangular spaces two tapestries, on which we see the principal paintings, while the rest inside the triangle, formed by the touching of the pointed arches, is painted in so perspective a manner, that the figures, seen between the garlands, seem hover-ing in the air.

The subject of all this painting is the story of Cupid and Psyche, the well-known charming legend

* See Appendix, Note LXXXVI.

of antiquity. Psyche is the daughter of a royal pair, who are dazzled with the beauty of their child, — a beauty which ranks beyond that of Venus herself, and on this account calls forth the anger of the goddess. Every one has read how it comes to such a point, that the poor child, left on the edge of a rock, awaits its death; how gentle zephyrs bore it down; how Psyche was led into a magic palace, and became the spouse of Cupid; how her sisters seduce her to examine her consort secretly with a lamp, when he is veiled in the darkness of night; how Cupid flees; how she seeks him full of despair, and after the most terrible tests is united with him anew. Endless are the pictures that the narrative seems to contain. Raphael had only space for a small number. How did he set to work?

It seems as if he had exhibited nothing at all of that which first of all obtrudes itself. The pride of the parents, their despair; Psyche left disconsolate, then waited on in the palace by invisible hands; then Cupid listening, then wandering about in tears, from one test to another, — there is nothing of all this. Raphael felt that the story had three principal characters, — the angry Venus, the innocent and loving Psyche, and Cupid; and that in these three the course of the story was concentrated. Venus must be pacified; Psyche must suffer for Cupid; Cupid at length must be again united with her. So we see Venus first, sitting on a cloud, and pointing to something that is going on below. She shows her son the infatuated people, who, carried away with Psyche's beauty, bring offerings to her as to a divinity,

and *Three Graces, Farnesina Paintings*

RAPHAEL

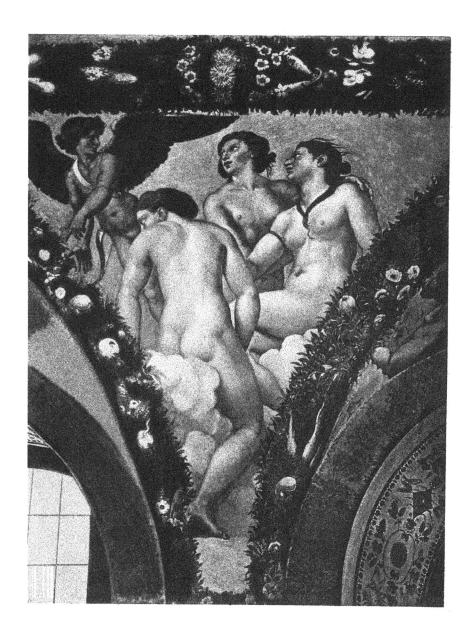

while Venus's own altars are neglected. Cupid,
standing near her, looks boldly down where her
finger directs his glance. He seems like a youth
of fifteen; his entire right fist has seized an arrow,
just as one grasps a lance, as if he would hurl it
down like a spear to crush those who have offended
his mother. We feel he has understood her thought,
and promises to execute vengeance.

Raphael has changed the legend, as it were, into
a drama. He here gives the first scene. We know
what has happened ; we expect what follows.

The second scene represents a moment, which is
entirely wanting in the narrative, — Cupid showing
Psyche in the distance to the Three Graces. The
goddesses sit before him on masses of clouds. The
first, the foremost, has turned her back to us, and
looks down sideways. Her face, appearing in profile,
is concealed as far as the eyes by her shoulder.
The second looks up to Cupid, who is pointing down
from above to Psyche, who is again supposed invisi-
ble in the depths below. She seems rather to listen
to Cupid than to look down like the first. She has
placed one leg over the other, and her right hand
rests on her knee; her plaited hair is fastened in a
knot in front below her throat, and falls down on
her breast in fair locks. The third, rather more
elevated than the two others, is the most charming.
Her head is seen at three quarters; it is filled with
the bold beauty of an innocent nature. Cupid uses
his right hand to point below; with the left he is
speaking : that is, its fingers are placed in such a
manner that we at once perceive the gestures by

which he endeavors to give emphasis to his words. He seems to say, Look, how beautiful she is! does it not seem even to you natural that I should make Psyche my beloved one, instead of destroying her? And all three agreed with him.

Between this and the third scene, the point of the story apparently has taken place. Psyche has become the bride of Cupid; the sisters have seduced her by night to steal upon him with a lamp; he has escaped; wounded by the glowing spark, tortured by the pain of the wound and by his passion for his lost loved one, he lies in his mother's palace. A gull, however, dives down into the sea where Venus dwells, and betrays to her what has happened. Inflamed with anger, that Cupid, instead of having hurled her foe into destruction, should have been himself fascinated by her beauty, and firmly resolved to consent neither now nor ever to the union of the two, she rushes to her palace (furious somewhat like an old princess of high rank who has heard that her son intends to marry a peasant girl), vents a flood of abuse and. threatenings upon Cupid, and hurries away to seek Psyche, to express her anger to her herself. She is met on her way by Juno and Ceres. What is the matter with her? they ask. Where is she going? Why is she so angry? She represents the matter to them, and demands their help, at first only in discovering Psyche. She is sarcastically begged, however, by the two goddesses, to remember her own adventures, and to let her son do as he likes.

This is the third scene. The attitude of Juno is splendid; a red cloth encircles her head, and lightly

covers her hair. Ceres, with her body turned from
Venus, has bent her head round towards her; over
her the golden drapery reaches to her neck, and
golden ears like a wreath are in her hair. She is
speaking to Venus at the same time as Juno, and
her hands enforce what she is saying. Venus stands
before them. A garment shot with red and gold
flutters around her like a long strip of stuff, which
she secures by her arms.

Ridiculed by the goddesses, and refused her re-
quest, she now hastens to Olympus to bring it before
Jupiter himself.

The fourth picture exhibits her journey through
the air. She stands in a golden carriage, holding
with her left hand a garment shot with dark gray
and red, which floats around her, while her right
hand grasps the threads by which a pair of doves
are drawing up the carriage. She is a full, power-
ful, but not a voluptuous woman. How changed,
however, do we see her in the following scene! As
a poor innocent girl whom every one wishes to
wrong, she stands before Jupiter. Her shoulders a
little drawn up, her knees pressed together, her
arms drawn closely to her, and only the two hands
timidly parted below, her head leaning on one side,
—it is as if we saw the personification of the shy,
flattering request made to the Almighty Power.
Jupiter, with his flames in his arm, listens benefi-
cently to the goddess; looking partly upon her,
partly meditatingly into the air, and reflecting how
the matter may best be treated. Just like a lord in
command, who, drawn into a family matter, prom-

ises to do his part to prevent the dreaded misalli-
ance.

We see the result in the next scene, — Mercury
floating downwards to proclaim the universal law,
by which every mortal is bound, on pain of punish-
ment, to seize the fugitive princess, and, if found, to
deliver her up. With outspread arms, the god
hovers downwards; his mantle, gold and brown, is
carried above him by the wind in beautiful folds.
We see the plunge of the figure down through the
air; he raises his left hand with outspread fingers as
a messenger; in his right hand he holds a tube;
the winged helmet which he wears makes a shadow
fall on his face as if he was just floating below the
sun.

In the seventh picture, we see Psyche for the first
time. She has wandered about; she has at length
voluntarily surrendered herself to the cruel Venus,
and has suffered the most fearful mistreatment.
Impossible things are commanded her by the god-
dess; but the animals help her: the ants make her
a heap of corn, sorting it out of different kinds of
grain accumulated together; the swallow fetches
her a tuft from the coat of the golden ram; and,
lastly, the tower, from which she is to throw her-
self down, — an order which appears to her perfectly
impracticable, — begins to speak, and gives her good
advice how she can bring back from the lower
regions the box containing a particle of Proserpina's
beauty.

The following scene exhibits her return from the
dark caverns of the lower world. Again has Ra-

phael created a new episode to the legend; for we read nothing of Pysche being brought back by genii from the depths of the earth to the palace of Venus. One of the little cupids, who presses her under the shoulders to carry her up, is among the most charming of Raphael's figures of children that I know, — dark bold eyes, and a heavenly defiance in the little mouth. Psyche, scarcely covered with a light green garment, seems quite powerless. She looks down with a quiet, happy expression; she holds the vessel high above her with her left hand, one of the winged children supporting her elbow, that she should not weary; the other arm she has laid on the back of the little genius, who presses under it with his shoulder.

She now again meets with Venus: kneeling, her hand placed on her breast, she looks up sorrowfully at her, and delivers her Proserpina's box. Overhead flutter the doves of the goddess, who holds both arms upraised; not merely from astonishment, it seems, but also as if it were a delight to her, even now, to torment Psyche by not accepting the vessel.

Cupid, however, in the meanwhile, tormented by longing, has now also set out for the father of the gods; and, complaining of his mother's severity, begs for mercy for himself and his beloved one. This scene is one of the most magnificent, and is justly famed. Jupiter takes the good boy, kisses him on his cheek, and comforts him. Cupid looks at the old king of heaven and earth with glad assurance: Jupiter's snow-white hair and beard blend beautifully with the blooming cheek. He is sitting

with his legs crossed; violet-gray drapery lies across his knees; behind him is the eagle, with its beak full of lightning. Cupid's hand, with the bow in it, rests on Jupiter's lap; the other, with an arrow resting perpendicularly between the fingers, hangs down by his side. He stands in profile: the front wing, which we quite overlook, lies in shadow; the other, the point and upper back part of which we see behind, shines quite brightly.

Lastly, we see Mercury bearing Psyche to Olympus. Her arms are crossed on her breast, her eyes turned upwards; she smiles, as if she were listening to the words of Mercury, who tells her in their flight many things of the palace of the gods, the tops of which are seen in perspective above their heads. He points above with the caduceus; we only, however, see his hand with the handle of the wand in it. Again the brown and gold mantle floats around him; and the light shines sharply down on the silver tips of his wings, so that a shadow falls over his face. The feathers of his helmet are golden; his fluttering locks are fair; Psyche's hair, however, which appears likewise very fair, is wound round her head in a soft knot; and the locks that have disengaged themselves float upwards, as if the whirling atmosphere carried them both aloft.

The great pictures, which occupy side by side the centre of the dome, are the representation of Psyche in the circle of the gods, and her nuptials: both compositions rich in figures; the latter the most beautiful, where the gods and goddesses are all seen gathered for the wedding feast round the golden

table, which rests on soft violet clouds. If any thing presents a mirror of the age in which these works originated, it is these paintings. They express all the heathenish pomp of the life of that period, the close of that luxurious revival in Rome of the spirit of the old Greeks and Romans, which after this time gradually fell again into decay.

I have thus accurately described the series of paintings, because it is the least known, and because it makes us admire Raphael's talent in the choice of the moment in which in reality the turn of the story lies. We gain, moreover, another result. As Homer sang not in the Iliad the conquest of Troy, but the anger of Achilles, so Raphael painted not the sufferings of Psyche, but the anger of Venus. And, if this is a settled point, it becomes almost a necessity to conceive his famous wall-painting in the adjacent room, known under the name Galatea, not as a representation of this nymph, but as the expedition of Venus over the ocean, just as it is described by Apuleius at the beginning of the legend of Psyche. This picture is the opening one of the series, and belongs as necessarily to it as do the last great paintings in the centre of the ceiling, which form its conclusion. And thus we understand why the former representation was painted by Raphael in his earlier years, and the succeeding one, which had been long promised and always deferred, was added at a later period.*

One thing more determined me thus to leave Michael Angelo for a while, and to enlarge here

* See Appendix, Note LXXXVII.

fully on a work of Raphael. None other bears witness, to such an extent, to the happy tone of feeling of the period. Chigi's garden-house was the scene of banquets at which the pope was present; at the close of which, the golden dishes, from which they had eaten, were thrown into the Tiber,—dishes for which perhaps even Raphael had furnished designs. Chigi, to whose care the jewels of the papal crown had been confided, who was the patron of all artists, whose house was sung of by poets, had risen from a Sienese merchant to be one of the first Roman nobles. In calling to mind that period, our thoughts are too full of its internal corruption. But, for Raphael's sake, we must judge differently. We know not what Raphael thought, and how he acted. The evidence transmitted to us furnishes externals alone. Still it cannot be denied, that, in the midst of Leo's society, he created all those magnificent works, the greatness and purity of which still appears before us in its freshest splendor; and, although the sources of his art lay alone in his heart, no one will . assume that he could possibly escape the influence of that to which he was daily habituated. What, however, was it which made Roman society under Julius and Leo so rich in mental fruit?

There are always three powers that rule the world,—money, mind, and authority. These are hostile to each other. If their influence, however, upon the destiny of a people stands in such relation to each other that none outvies the other, then the prosperity of a people displays itself. They might also be named energy, genius, and birth; or

citizenship, science, and nobility. The three char-acteristics are always the same by which the destiny of man is raised ; he is either made rich, or invested with superior powers of mind, or given a superior position by birth. Wherever one of these three titles has more weight than another, the free devel-opment of a people suffers, because it has lost its true point of gravity.

As perhaps in England at the present day, or formerly in Greece, so in Italy at the beginning of the sixteenth century, the influence of these three powers was maintained in the most beautiful pro-portion. Raphael was a painter ; but he could have become a cardinal. Never has it been so easy at any time for a person of importance to rise to any position, as at that period in Rome. The multiform ecclesiastical state, free from family life, formed the passage to all attainable things. There was an active circulation of all human powers. There was nothing of that foreseen course which marks careers at the present day. Any transition was possible. With little effort the past could be cancelled ; noth-ing, not even the most fearful crimes, endangered a man for long : so completely was the moment filled with the bustle of the present, that no one lingered over the melody of the preceding day. Men were striving forwards. As in a race the garments fly, so every man showed himself now unveiled, and now again in the most splendid folds ; and, while every one was acquainted with life, he learned to defend himself against the dangers which it brought with it. The concealment of the true character, which with

our cold slothfulness is easily effected for a lifetime, was then impossible, or was only achieved by the cleverest. Men perceived more plainly the threatening danger, and avoided it; choosing the safer path with fearless boldness.

When in the present day we witness or hear of the objectionable things going on in Paris and London, we still do not doubt of the advantage of being schooled there for life; and we should never suppose of him who has grown up there, that he had shared the moral disorder in the midst of which he had moved, however closely he had come in contact with it.

Such was the education which Raphael received in Rome. His works are the creations of a man to whom nothing is strange, to whom nothing placed a barrier; who felt himself perfectly in his element; who can walk, wrestle, ride, swim, or even fly, as the hour requires. The Rome alone of Leo X. was able to bring this out of him, and give it to him. Michael Angelo, on the contrary, whose path was more solitary, only possessed that which quiet and solitude can mature in a great mind.

5.

Michael Angelo also worked again as a painter during the three months of his residence in Rome, in the winter of 1517 and 1518. He had not succeeded in inducing Julius II. at that time to give employment to Sebastian del Piombo. The London papers show us how he succeeded, in the year 1515, in procuring work for his *protégé* from another quar-

ter. In those transmissions of money from Florence to Rome, he mentions Francesco Borgherini, a Florentine banker settled in Rome, through whom the money might be paid. Michael Angelo calls him "a really excellent man, unequalled among the Florentines in Rome." For this man he had at that time to complete a painting. He does not designate it accurately in his letter: but as the chapel in San Pietro in Montorio, where Sebastian had painted the Scourging of Christ, belonged to the Borgherini; as Michael Angelo had painted nothing else about that time; and as it is known that Sebastian's work at this period sprang from a cartoon of Michael Angelo's, — there is no doubt, to my mind, what work is intended in the letters. Sebastian painted the Scourging of Christ on the semi-circular wall of the niche which forms the chapel. He executed the painting in oil: the colors have become much darker from time; otherwise it has suffered little, and is a splendid monument of the painting of his day.

That Michael Angelo not only made the sketch, but drew the outline of the figures on the wall, 1 think is plainly to be perceived. Bound to a pillar, with his head bent down, the Redeemer writhes beneath the blows of his tormentors; but we almost see only the effort to writhe, — the bound limbs are not able actually to effect the movement. The lively Venetian coloring, however, sets off the drawing so much, that the greater part of the picture seems to have been done by Sebastian. Above, in the vault of the altar-niche, there is an Ascension of Christ, likewise by Michael Angelo, — more insignificant as

20* DD

regards the painting, but very forcible as a compo-
sition; and a work, it seems to me, which Raphael,
consciously or unconsciously, had in his thoughts
when he painted his own. The novelty of the painting, the charm of the
chiaroscuro, the depth and warmth of the colors, ex-
cited a sensation in Rome, and gave Sebastian from
henceforth a position of importance, which was still
increased by other works, for which Michael Angelo
frequently furnished the sketch. Among them we
may here mention the Christ taken down from the
cross, in the arms of Joseph of Arimathea, with
Mary by his side, — a composition colossal in form,
and executed in splendidly powerful touches, rank-
ing among the most valuable possessions of the Ber-
lin Museum. It is here especially well placed, as a
number of insignificant works, which in many gal-
leries are without reason marked with his name,
have given Sebastian the appearance of a moderate
artist, to whom, without further ceremony, this or
that may be assigned. We only require to see his
undoubted works to esteem him justly; the portrait
of Admiral Doria, in the Doria palace in Rome, is
the representation of a man such as Titian perhaps
could not have produced, so powerful is the draw-
ing, and so manly and strong the heroic expression
of the character in this picture.

. A new commission was now given to Sebastian del
Piombo, through Michael Angelo's instrumentality.
Cardinal Medici ordered of him the Raising of Laza-
rus from the Dead. Michael Angelo drew the car-
toon. We do not find it especially mentioned when

he was engaged in this work; but, as the time thoroughly coincides, and there appears nothing else which could have employed him through the winter in Rome, we may speak here with some certainty. Besides, he certainly did not only draw the figure of Lazarus, — a separate sketch of which is accidentally preserved, — but he designed the entire composition, which is completely conceived and arranged in his style. On the 6th February, 1538, he was again in Florence; he received eight hundred ducats, and proceeded on the 25th to Carrara, where, under his direction, the work was to be carried on.

Michael Angelo was at home at Carrara. He knew the mountains accurately, and the people of Carrara knew him. Topolino, a stone-mason and sculptor besides, was his good friend there. No one had ordered such great masses of marble from Carrara as Michael Angelo; none had been so careful that the transmissions should correspond with the order. The reason why he relied so little upon others in this was, that he was very exact in his expenditure, and would not allow himself to be deceived. In a letter of the year 1515, he complains of something of the sort: " Give the enclosed letter to Michele," he writes to Buonarroto from Rome.*
" I know very well that he is an insolent fool; but I must apply to him because I want marble, and I know not how to obtain it otherwise. I do not wish to go to Carrara, because it is impossible. I can send no one there who understands it; for they would either be cheated themselves, or they would

* See Appendix, Note LXXXVIII.

themselves cheat, like Bernardino, the shabby fellow who defrauded me here of three hundred ducats, and afterwards went through Rome complaining of me, as I have heard. Avoid him like fire, and don't let him come into the house." Such stories may often have occurred. The Italians allow so much deception, vociferation, and passion in their ordinary business, that a Northerner becomes only slowly accustomed to it. Michael Angelo, too, opposed this mode of proceeding. He was honesty itself in all his relations, and only insisted that the conditions upon which he had entered upon any matter should be strictly adhered to. For this reason he unwillingly assented to intricate contracts; he preferred to undertake his task by the lump for a definite sum. In payments he set down his expenditure to a farthing. When he was at variance with his brothers, it was because these, either directly or through his father, endeavored to induce him into vague speculations; and, when he fell out with his employers, the reason lay in their interpreting the contract otherwise than had been intended. Michael Angelo insisted throughout on his rights; and great as the sums were which he gave away, and unconcernedly as he dispensed them, his resistance was obstinate if the smallest thing was unjustly withheld from him.

When he arrived at Carrara, at the end of February, 1518, he found the work agreed upon not carried out according to contract. He fell into dispute with the ship-owners, to whom the transport of the blocks had been intrusted. He went at once to

Genoa, and hired there a number of barks. They arrived; but their crew were bribed by the people of Carrara, and matters came to such a pitch that Michael Angelo's house was attacked, and he was held besieged there.* They declared that they would not let him go away, if he did not yield. He now applied to Florence to send him vessels from Pisa; he went there himself to press the matter, and at last gained his will. He wished, however, now to show the people of Carrara that they were to be done without: he therefore turned to Seravezza and Pietrasanta, — places situated on the Florentine territory, — and began to open marble quarries there.

This undertaking was a favorite idea of the pope's. In the year 1515, by a general decree of the Seravezzans, all the land required for the intended works was given to the Florentine people. In 1517, Michael Angelo had instituted investigations as to the nature of the stone, and had convinced himself of its availability. The main difficulty now consisted in the construction of a passable road from the mountains to the sea-shore, — an expensive undertaking, as not only the steepness of the mountain, but also the marshy character of the plain, had to be overcome. The pope endeavored to moderate the immense expenses by inducing the guild of woolweavers to share the undertaking for the sake of a new coating of marble for Santa Maria del Fiore. Matters, however, proceeded in such a manner that Michael Angelo undertook the whole outlay at his

* See Appendix, Note LXXXIX.

own risk; and, while contracting with the pope and the guild of wool-weavers, he began the road and the stone quarries at Seravezza as his own affair. We have Michael Angelo's assertion that this was the case. Perhaps the various, though not accurately designated hinderances, which his letters tell us opposed the final arrangement of the respective contracts, had their cause in a difference of view among the concluding parties. For months Michael Angelo urged for an arrangement, without obtaining his object. At length it was more than he could bear. He was at Seravezza, and he would have the work begun. The gonfalonier, he writes to Buonarroto, seems to be able to do nothing; and therefore the matter stagnates: for his own part, he would now either apply to the pope or to Cardinal Medici, — he would leave every thing and return to Carrara, where they had called him back with as many entreaties as if he were Christ himself. They had, it seems, come to their senses there. The Marchese Malespina, the possessor of Carrara, furious at the undertaking at • Pietrasanta, had caused all these unpleasantnesses for Michael Angelo; now, seeing his obstinacy, he had touched a softer string.

Michael Angelo himself longed, not without reason, to return to Carrara. " These workmen," he says further in the letter just quoted, " do not know how to lay hold of any thing. Their work has already cost me a hundred and thirty ducats; and until now they have not brought to light a foot of available marble. They run about, do as if they were doing something, and produce nothing. At the same time,

they are trying secretly to work for the building of the cathedral, and other things, which I am obliged to pay with my money. I know not who is at the bottom of it; but the pope shall know exactly how things are going on here. I have thus thrown away three hundred ducats, and see nothing produced for it. It would be easier to give life to the dead, than to bring life into this mountain, or any understanding of art among the people. If the guild of wool-weavers would give me three hundred ducats a month, I should still be badly enough paid for what I do; I cannot even accomplish the settlement of the contract. Remember me to Salviati (the gonfalonier), and write to me through my servant how things stand. I must come to some resolution; for I cannot thus remain in suspense." Postscript.— " The vessels which I hired at Pisa have not appeared. Therefore, on this side also, all goes crookedly. A thousand times cursed is the day and hour when I left Carrara. That alone is the fault of all the mischief. But I am going back. Whoever, at the present day, wishes to do a thing well, gets only loss from it."*

Thus he writes on the 18th April, 1518. He had been in Carrara the day before, and had commissioned a Florentine sculptor to have his blocks conveyed away. He seems to have been reconciled again with the people there; and henceforth he divided his time between Carrara and Pietrasanta, carrying on the work at both places. He went intermediately again to Florence, where they were laying

* See Appendix, Note XC.

the foundation for the façade of San Lorenzo; and where in August he purchased a plot of ground, on which to build a house. In the new quarries, on the other hand, the miseries were without end, — sickness of his men, deception, idleness, refractoriness, — until at last he was left entirely in the lurch. In September, he writes most despondingly about it. The rain never ceased in the mountain; it was cold; the work was suspended. Still he held out there through the winter, it seems, quite alone. In October, he himself became ill, and went to Florence; but on the last day of the month he was already back again. At length, in the spring of 1519, he had brought matters so far, that a number of pillars and blocks, finished up to a certain point, were conveyed down to the sea-shore, to be shipped to Florence. One pillar was broken to pieces in the transport: then suddenly came the command from Rome to leave every thing, as the building was postponed for the present, and no payment!

In his record of the building of the façade of San Lorenzo, Michael Angelo speaks with anger of the manner in which he had been ultimately treated. "And now," he writes, "Cardinal Medici forbids me, in the name of the pope, to carry on the work. It is alleged, that they wish to spare me the difficulties of conveying the marble from the mountain with so much labor; that they will give me better tasks in Florence, and will conclude a new contract with me: and there it has remained up to the present day!" And, at the same time, workmen were sent to Seravezza, on the part of the Florentine committee for

the building of the cathedral, who took possession of the blocks broken by Michael Angelo, and brought them to the sea, along the road which he had constructed, and from thence to Florence. With a part of these, Santa Maria del Fiore was to be covered: but, on the other hand, the building of the façade could not be carried on without Michael Angelo's co-operation.

He asserted that they ought first to come to an arrangement with him respecting the road. The cathedral committee would not agree to this. They had been obliged to give a thousand ducats for the stone quarry, and they believed themselves in the right; while Michael Angelo regarded their conduct as an encroachment, which he need not allow. He urged for a fulfilment of the obligations, and, until then, declared that he should consider the whole as his property. For he had undertaken the matter in the lump, and had thus worked for himself alone.

"The cardinal," he continues, "now desires from me a statement of expenses and outlay, so that he may come to an understanding with me, and may use the marble and the road to Seravezza. I have received two thousand three hundred ducats. When and where the following accounts show: Eighteen hundred of them are paid away, — two hundred and fifty for the transport of my marble from Rome to Florence. I leave out of account here the wooden model sent to Rome; out of account the three years' work which I have lost; out of account the fact that this building has ruined me; out of account in what light I stand there, — that they have intrusted the work to me,

and then, without cogent reason, have taken it from me again ; out of account my house in Rome, where marble, implements, and ready work, amounting to more than five hundred ducats, have been all lost: for all this, exactly five hundred ducats of the money are left for me.

"But it is as well. Let the pope take the road built by me, together with the marble I have dug; and I will keep what money is still in my possession, be free of my engagement, and draw up a writing upon the whole matter for the pope to sign."

Such was Michael Angelo's proposal. The papers from which I quote these sentences seem to be the note-book drawn up by him, either for himself or for one of his friends, according to which the writing was to be prepared which Leo had to sign. All items of expenses are stated, even to the most insignificant. We know not what end the affair came to. In the year 1521, the first and only pillar of those hewn in Pietrasanta arrived at Florence. For years it lay there on the square before San Lorenzo, until, probably only for the sake of being set aside, it was buried . under the earth at the spot. The others were still on the sea-shore at Pietrasanta in Vasari's time. It was not until later years that these quarries were regularly worked, and the means of transport improved. Michael Angelo discovered in the mountain a variegated marble, very hard, but beautiful to work ; and, for the sake of this, in later times, Duke Cosmo had a road built four miles in length.

6.

Michael Angelo had some right to complain of the Medici: if we look, however, to the reasons why the building of the façade came at that time to a standstill, circumstances, generally, were alone to blame. At the time when the building was determined on, the family stood at the height of their power. From 1516, however, a change had taken place. They had not been strong enough to oppose the intrigues of men; they could as little resist death as other mortals; and this now annihilated that proud structure, which the family, anticipating the future, had in fancy erected for themselves.

In 1516, Giuliano died. He had long dragged out a sick and melancholy existence. A sonnet by him is preserved, in which he defends suicide. The prevailing epidemic of that period slowly consumed him. He was *un uomo dabbene*, was the general verdict, and the testimony to his honorable character, borne by the Italians of that time, shows that the common feeling of goodness and morality was ever esteemed and acknowledged by them. The dukedom of Urbino was thoroughly indispensable to Lorenzo's projected kingdom. But, as long as Giuliano lived, he knew how, in spite of the political necessity, to prevent any evil happening to the Rovere. In the unhappy period of his exile, he had found a shelter at Urbino; and even Leo, although he called the deceased Julius an accursed Jew (just as the latter had done Alexander Borgia), felt himself bound to his family. The last words which Giuliano ex-

changed with his brother the pope, were a request in favor of the Rovere. Leo replied, that he must think before every thing of being soon well again. But scarcely was Giuliano dead, than the reprieve of the Duke of Urbino expired. Leo declared the old murder of the Cardinal of Pavia, for the sake of which Julius had excommunicated his nephew, but had afterwards absolved him, was still unatoned for; he excommunicated the duke again, took away his dignity from him, and made Lorenzo dei Medici Duke of Urbino.

We may regard what now ensued as misfortune: but, more attentively considered, it is only the natural vengeance of fate; for Leo had not only done an injustice, but he had acted contrary to his innermost nature. He was really easy; he loved repose; he wished to devote himself to his inclinations, to have the gossip of the city reported in the Vatican, and to join in it; to patronize a little art, to hunt a little, to improve the morals of the clergy a little — (if an ecclesiastic had publicly cursed God, or said scandalous or obscene things respecting Christ or the Virgin Mary, he was, if he had a public income, to forfeit the first time three months of it; a nobleman, on the contrary, had only twenty-five ducats to pay, for the improvement of St. Peter's Church, — a proof this of the new severe penal laws), — in short, the pope was mild and amiable; and the words which he said to Giuliano after his elevation, — " Let us now enjoy the authority which God has given us," — were certainly spoken from the depths of his soul.

But Lorenzo and his mother Alfonsina formed the impelling element. They urged Leo to more speedy measures, when he would rather have acted as occasion offered. Proud, passionate, warlike, and consumed by ambition, by far more of an Orsini than his father Piero had been, Lorenzo despised the quiet method of his uncles. He effected the war against Urbino, and waged it during the years 1517 and 1518. The Duke of Urbino was driven away; but in Rome his party contrived a plot against the pope's life, in which San Giorgio was again a participator. The conspiracy was discovered; and the guilty cardinals, instead of fleeing, threw themselves with repentant, tearful acknowledgment at the feet of the pope, who pardoned them. Nothing so completely shows the character of Leo. That they should rely upon his pardoning them in such a case, and that they reckoned truly, proves how well they knew the secret weakness of his nature. Julius II. would have allowed them to believe the same.

At length Lorenzo had the dukedom in his power. A French princess was his consort. The wedding was celebrated in the year 1518; but the year following was that of his death; and at the same time died his mother Alfonsina, and Magdalena Cybo, Leo's sister, — Contessina Ridolfi having already preceded them. Such was the end of all the plans. The pope sat alone in the Vatican, in the garden of which there only played the little Hippolyte, Giuliano's surviving illegitimate son, his only child; Cardinal Medici took possession of the Government in Florence.

What was the object now of further efforts? But
here, too, the very evil which had caused the sickness
appeared as its remedy: Leo's old careless nature
was not to be perplexed. Now as ever he yielded
to things which beguiled time; and, instead of brood-
ing over the evil which had so severely befallen him,
he hunted, he sang, he gossipped, and pursued the
general policy of the popes, in allowing no foreign
power to gain ground in Italy, and in making use
of the European princes one against another. But
he could not lay out money as he had done before.
All had been squandered away. The whole im-
mense treasure collected by Julius II., and left to
Leo, had disappeared. Lorenzo's war against Urbino
had cost too much. Every day a fresh basket of
gold-pieces was placed in the pope's hands; at eve-
ning it was empty: eight thousand ducats were thus
alone spent every month. The crown jewels were
placed with Chigi. The office of cardinal was put to
sale. The means actually no longer existed for
continuing the building of the façade. They would
gladly have built further, had it been possible.

Nothing was heard for a time of the new works
which Michael Angelo was to receive as an indem-
nification. So disheartened was he, that, for a time,
he would touch nothing; and what he did begin he
left unfinished. Some of his uncompleted works, a
tolerable number of which are in existence, belong
perhaps to this time. At last, he turned again to
Julius's mausoleum, the blocks for which were now
partly in Florence. Michael Angelo stood well with
Cardinal Medici. The cardinal was a serious man,

who, instead of keeping the magnificent court, in the centre of which Lorenzo had ruled with his consort, dwelt solitarily and quietly in the Medici palace, and sought for the society of liberal-minded, intellectual men, whose influence over the Government was apparent.

This change in the intellectual life of the city is exhibited in a document which, dated in the autumn of 1519, makes Michael Angelo appear as one of the men who, at that time, formed the flower of the city. There still existed that institution of the old Lorenzo, the Platonic Academy in Florence, in which philosophy and poetry were cultivated, and the choicest productions of which were exhibited with public ceremonies before the entire people. Still, fallen into decay, it only dragged out a miserable existence. Cardinal Medici brought new life into these things: in October, 1519, a petition was dispatched to Rome, in which the favor of the pope was requested, in the first place to grant resources, and, in the next, to allow Dante's ashes to be brought back to Florence.

Michael Angelo loved Dante beyond all other poets. He knew whole poems of his by heart. His own poems flow in Dante's form and ideas. He is said to have drawn a book of sketches to Dante, which was lost in a shipwreck. We find Michael Angelo's name among those signing the petition. "I, Michael Angelo the sculptor," he writes, "also entreat your Holiness, and offer to erect a monument worthy of the divine poet in an honorable place in the city." While others only solicited for

the ashes of the poet, and for money, Michael Angelo conceived the matter otherwise, and wished to execute a monument to him. He could well do that; for he was a wealthy man, living sparingly, but never withholding his money for great objects.

We see at once, from the signatures to this petition, in what society he moved at that time. We find there the most important names of the city, the literary nobility of Florence, all written in Latin (instead of Palla Rucellai, we read Pallas Oricellarius). Michael Angelo alone writes amongst them all, " Io, Michelagniolo, scultore," and so forth. He writes in Italian, not because he did not understand Latin, but because, proud of the language of Dante, he would not see it disregarded. " Public things," he said, " must be drawn up in the language in which they would be verbally discussed."* He is the only artist whose name stands below the petition. It seems that he held himself completely aloof from the circle of artists. But like a great scholar who keeps alone in his room, and yet can be the soul of a whole university, he formed the central point of the efforts of Florentine art.

On all occasions, retired as Michael Angelo lived, his eye watched over all that happened. He rarely appeared in public, — only on occasions when he considered his influence indispensable; but then he did so with all his energy. His old friend, Baccio d'Agnolo, chief architect at Santa Maria del Fiore, had made the design for an outer gallery for the still unfinished cupola of the cathedral, running

* See Appendix, Note XCI.

round the whole at the place where the dome begins; and a considerable portion of it had been already completed. Brunelleschi's old drawing had been lost. Michael Angelo once more cast his eyes over Florence, and discovered what had been done. He observed how a narrow passage had been carried round the cupola, quite in opposition to Brunelleschi's bold style, and in contradiction to the whole building; he saw how they were chiselling away the immense corbels, which Brunelleschi had raised for his future work. No friendship could longer restrain him. What had a grasshopper's cage to do up there? Something vast, something grand, was the only suitable thing. He would show how it was to be done.

A committee of experienced artists and citizens discussed the matter in the presence of the cardinal. Michael Angelo produced his plan, which was compared with Baccio's. Such committees, even if the wisest men are among them, never accomplish any thing: they saw that Baccio had produced something, which, though well designed, was too small, too insignificant; but they could not make up their minds to Michael Angelo's proposals. And so at the present day the cupola of the cathedral still stands, half surrounded by Baccio's gallery, half encircled by the projecting corbels of Brunelleschi. Such is the history of the great reproach which Passavant, in his Life of Raphael, raises against Michael Angelo, — that he prevented the completion of the cupola of the cathedral at Florence! How well Michael Angelo knew how to esteem and to

defend the works of Baccio d'Agnolo, is shown by
his care, at a subsequent time, for the tower of the
church of San Miniato, which had now just begun
to be built. Michael Angelo always kept in view
the thing itself, and never the persons connected
with it. This was the reason for the cutting severity
which he so often exhibits, but which in most cases
never wounded those whom it concerned. They
understood him.

A still more unimportant work for the cardinal
is mentioned as occurring at this time. On the
ground-floor of the Medici palace, which Michellozzo
had formerly erected for the old Cosmo (now known
under the name of Palazzo Riccardi, having been
sold subsequently, when the Medici used larger
palaces for their residence), was a loggia, a place
open towards the street, where the citizens were
wont to gather together for occasional discussions.
The cardinal had transformed it into a closed apart-
ment. The arches were walled up, and windows
inserted. Michael Angelo made the drawing for it.
The bronze lattice-work of the windows, made after
his design by the goldsmith Piloto, became cele-
brated. The interior of the apartment was painted
by Giovanni da Udine, one of Raphael's assistants,
who helped him in the Vatican, but who won espe-
cial fame by the garlands in the ceiling of the Far-
nesina, that architecture of flowers, between which
Raphael painted the story of Psyche.

7.

It soon appeared that it had been no subterfuge on the part of the cardinal, when he gave Michael Angelo hopes of more important work; and we should at once proceed to mention the task which was begun in the Easter of 1520, though devised in the preceding winter, if at that same Easter, 1520, an event had not occurred which has given this year a sad celebrity in the history of art, — the death of Raphael.

At Christmas, 1519, Michael Angelo had been reminded of him. Sebastian del Piombo wrote from Rome that the Raising of Lazarus was finished. He first mentions the happy event of the christening of his little son, to whom Michael Angelo was sponsor. The little one had received the name of Luciano. He next says, that he had conveyed the painting to the palace, and was extraordinarily satisfied with its reception there. The " usual ones " alone had said nothing about it. By them he seems to mean Raphael's party; and this is confirmed by the observation which immediately follows, that he believes his picture better designed than the tapestries which had just arrived from Flanders.*

Sebastian's painting, after various destinies, has at length reached the London National Gallery: it is a work which has been much injured, and grown darker by time; but the extraordinary effect of coloring is still plainly to be perceived. In the front, on the right, sits Lazarus. Just awakened

* See Appendix, Note XCII.

from the sleep of death, and still partly in a vague state of bewilderment, he endeavors to tear from him the linen bandages with which he is enveloped. Around him, men are busily anxious to undertake this trouble; but Lazarus, like a man freeing himself from imprisonment, pulls away with his right hand the clothes which he is endeavoring to remove from his left arm, while with the toes of his right foot he tears the bandages which encircle the left knee. This movement proclaims, at the first glance, Michael Angelo's share in the picture; for no other would have devised it or executed it with such life.

Opposite Lazarus, on the left side of the painting, stands Christ; one hand stretched out towards the waking man, the other with the outspread fingers raised. Before him kneels Mary, looking up to him with an expression of happy gratitude; around him on all sides crowd the disciples, whom the miracle filled with a feeling of sacred awe. The background is occupied with a number of figures, all of them expressing with unusual naturalness what is passing in their minds, — none of them unessential; and, to conclude all, a landscape, the view of a city with a river, over which a bridge leads, and a range of mountains behind covered with clouds. Sebastian had good reason to be proud of his laborious work. He begs Michael Angelo to effect a speedy payment for it by the cardinal in Florence, as he is in need of money.

We must pardon Sebastian, if, in the feeling of being obliged to crush the cause of his master on

every occasion, he now prefers the Lazarus, as re-
gards the design, to the tapestries of Raphael. He
was not able to conceive things beyond the limits of
his mind. He never attempted to express ideas in
his paintings. The highest he could recognize was
the technical part, in which almost his only merit
lies; but it is a great one, for not only in color, but
in design, he produced excellent things. Michael
Angelo, however, would have spoken differently
of Lazarus and the tapestries. "The tapestries,"
Goethe justly says, "are the only work of Raphael
which does not seem insignificant, after seeing
Michael Angelo's ceiling in the Sistine Chapel." A
variety of composition is displayed in them, fully
equal to Michael Angelo's power; and, at the same
time, they possess a naturalness and simple grace, in
which he would probably have acknowledged himself
to have been surpassed. It is possible, that the sight
of this work would have melted the ice between these
two men, just as long years were needed also with
Goethe and Schiller, before they knew each other
justly. No further opportunity, however, was now
afforded them for this. They did not meet again.
On Good Friday, 1520, a few months after Sebastian
del Piombo's letter, Raphael died, leaving the great
Michael Angelo behind, from henceforth alone and
without a worthy rival in the world.

It was a blow which disconcerted even the placid-
minded pope. The fourteen days during which the
consuming fever lasted, under which Raphael sank,
he sent daily to inquire after him, and burst into
tears when he received the last tidings. Snatched

away, as it were, from life, Raphael was bled by his physician, instead of receiving strengthening reme-dies. From this he sank. He lay there dead in his palace; at his head stood the unfinished painting of the Ascension of Christ. An immense multitude followed his body to the Pantheon, where the in-scription upon a marble slab over his tomb is still to be read. It tells us that both his birth and his death occurred on a Good Friday.

A year before, Leonardo da Vinci had died in France, where Francis I. had prepared an honorable position for him. Leonardo did not see Italy again: we have little information respecting his last years. A document is, however, in existence, more eloquent than letters and records, — a portrait which he has drawn of himself, — a red-chalk sketch in the col-lection of the Louvre. An indescribable touch of bitterness lies in his mouth, and a gloomy severity in his eye, both of which are sufficient to tell us that this man lived at discord with his fate. We see, in this portrait, bitterness, reserve, superiority, — something almost of the character of a magician. When we call to mind Vasari's description, — how Leonardo in his youthful years poured forth so much amiability, that all felt themselves carried away and captivated by him; when we read there how in youthful glee in the streets of Florence, drawing together the bird-sellers on the market-place, he promised them as much money as they demanded if they would open their cages; when we see how his mind, revelling in the unusual extent of its power, with creating and observing energy,

grasped every thing, and produced every thing;
and when we compare him in his old age with all
this, far from his country, without friends to miss
him there, and with no great conclusion to his
active life in France, — we feel how, with all these
mental gifts, happiness must be added, if they are
to unfold, and bear fruit. How sadly he may have
thought on Italy! Melzi was with him, and an-
nounced his death to his relatives in Florence.

Leonardo's loss was not important to Italian art:
Raphael's sudden decease was a blow, which was
deeply felt. He died too early, not for his fame,
but for the founding of a school. He could have still
produced and effected extraordinary things. With
him, as it were, a fire was extinguished, which sup-
plied the impelling power to the wheels of an im-
mense factory. "Rome is empty and desolate to
me since Raphael is no longer there," wrote Count
Castiglione. Whoever has experienced the sudden
departure of a great mind, and the void left behind,
can form an idea of what the city lost in him. For,
besides what is daily produced and gratefully re-
ceived from such great natures as long as they live
and work, it is only after their loss that we feel the
secret sustaining power with which they filled every
thing around them, without leaving a presentiment
of it upon those who felt strong in this borrowed
strength. Raphael served the court with agreeable
obsequiousness; but, under the outward veil of this
subservient friendliness, there dwelt a keen and
royal mind, which bent before no power, and went
its own way solitarily, like the soul of Michael

Angelo. In Germany, whenever Raphael is mentioned, we think first of the Dresden Madonna, one of his last works, and the most thrilling of all. It is as if, after so many Madonnas, he had at length pictured in his mind the most beautiful countenance, with which the others were not to be compared. What a creation! Nothing can be said in its praise, any more than in that of the starry heavens, or the sea, or the spring. Standing before it, we forget Rome, the past, the earthly fate of Raphael. He appears to us like an intimate friend, knowing our thoughts, — like a mild and benevolent power, only using forms and colors to convey to men a boundless profusion of beauty. There are natures which Michael Angelo does not suit; there is no artist, I believe, who does not meet with opposition somewhere. Raphael, however, overcomes all; there is no man who could exclude himself from the blessed power of his works.

We know not, from the smallest expression, what impression Raphael's death made upon Michael Angelo. We have not a word from his pen in the year 1520. This only is known, — that Michael Angelo lay sick in Florence at about that time, while, on the last day of March of the same year, the walls of the new work assigned him by the cardinal were already in course of construction. The Medici had given up the façade, — the monument of affluence and pride; and, instead of it, a chapel with the tombs of Lorenzo and Giuliano was to be added to the same church: a counterpart to the old sacristy with the tombs of the earlier Medici, built by Brunelleschi.

However good the will of the cardinal was, cir-
cumstances here also prevented the execution of the
work. It remained at its very commencement
throughout the year 1520. Michael Angelo must
have been engaged with the preparation of the
model. In April, 1521, he went to Carrara, and gave
orders. On the 22d April, 1521, he purchased there
two hundred cart-loads of marble, out of which three
figures, to be rough-hewn to a certain extent after
his model, were to be sent to Florence at the end of
1523. He had his own stone-masons on the spot to
execute these. Whatever was broken off was to be
cut into square blocks, and sent to the city in the
following July. On the 23d April, he purchased a
second quantity of marble for a sitting Madonna,
which was expected in Florence at the end of
1522.

This Madonna, the first figure of the whole num-
ber which is expressly mentioned, is not among those
which were ever completely finished. Considerably
more than the last touching-up is wanting. There
still exists a model, scarcely a foot high, which is
considered as Michael Angelo's original work. The
holy Virgin is seated on a stool without a back; the
upper part of her body is bent forwards, one leg
crossed over the other; and the child is sitting astride
over her lap upon the uppermost knee. He is turn-
ing round, looking up to his mother, who bends
down her face a little towards him. With her right
hand she supports herself on the seat, her arm grasp-
ing something behind,—a natural and beautiful atti-
tude, and all the more graceful here, as it is placed

21*

in a more beautiful light by a rich and manifold arrangement of drapery, as a drawing is, as it were, by colors. With her left hand she holds the child near her, its lips and little hand searching for the left bosom, which lies nearest to him.

Michael Angelo, however, cannot have undertaken this figure in Florence before the year 1523. When he came back from Carrara, in the beginning of the summer of 1521, he seems only then to have settled the whole affair by contract. He made his proposals; the cardinal was not satisfied with them. Michael Angelo offered to make a model in wood of the interior of the sacristy, with the figures in clay, and then to arrange the whole for a fixed sum. He had just then in view a purchase of some premises, and wished to have the money to lay out in it. But the cardinal could come to no decision. The war in Lombardy made his presence with the army necessary. The French were again to be expelled, this time by the pope and emperor in concert; and so, at the end of September, he left Florence, to give greater energy to the conduct of the war as the pope's plenipotentiary.

Before his departure, he spoke with Michael Angelo, and begged him to expedite the arrival of the marble, to engage workmen, and to begin the work; so that, on his return, he might find the building a good deal advanced. The whole thing was still so completely at its commencement, that the conclusion of the contract might be deferred to a later time. He gave him also to understand that the completion of the façade was not a matter given up; and that

Sitting. Madonna.

MICHAEL ANGELO.

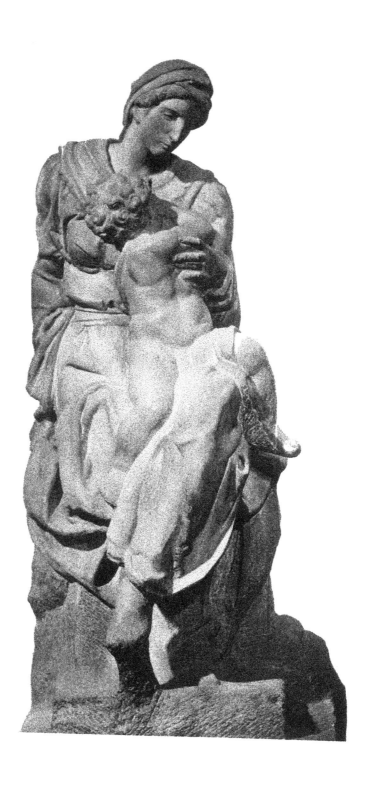

his treasurer, to whom he had given directions, would pay the money requisite in the meantime.

The latter, however, after the departure of his master, appeared to have received no such orders, and begged Michael Angelo to apply by letter to the cardinal. But Michael Angelo was not to be induced to do this. Now came the sudden death of the pope. So little money was there in Rome, that the expenses for a suitable funeral could scarcely be defrayed. The cardinal returned victorious, deprived, however, of all advantage in his success by the loss of him for whom he conquered. No one had expected this event. Leo, if not healthy, was still vigorous, and in the prime of life. For the moment, the first care of the Medici must have been to maintain themselves in Florence, where, besides the people's universal love of liberty, they were threatened by the hatred of individuals; above all, by the hostility of the Soderini, who were at that time so powerful in Florence, Rome, and France.

At the end of January, 1522, the cardinal returned again to the city. Michael Angelo received the fairest promises from him. He was assured that they wished for nothing more ardently than to possess something excellent from his hands for the monuments; but they in nowise now committed to him the entire building or any definite task. Michael Angelo at length left, promising to return again when the blocks from Carrara had arrived. He went back to Julius's mausoleum, and to other works, with which, without knowing them more accurately, we must suppose him to have been occu-

pied; for, in an atelier like his, there could be no cessation.

Among the works occurring at this time, the statue of Christ standing by the cross, in the Church of Sopra Minerva in Rome, is mentioned. Shortly before the death of Leo, it was erected at the expense of a Roman citizen, and acquired such great celebrity, that Francis I. had subsequently a model taken from it, that he might have a bronze cast made of it in Paris. It is not certain whether it was executed in Rome or Florence. In its outward finish, and as a representation of a naked human form in the prime of beauty, it is a most admirable work; but, as an image of Him whom it is to call to mind, it is the first statue of Michael Angelo's which we must designate as full of mannerism.

We call a work of art full of mannerism, when the form it represents appears so treated, that the spiritual idea it contains is made subordinate. The limit here is often difficult to find. The greatest artists may fall into mannerism; for imitation of the • peculiarities of others is not the only thing requisite for this: the slightest departure from the pure idea makes the richest and most independent genius produce works full of mannerism. Michael Angelo's power depended on his knowledge of anatomy. He dissected bodies, or drew them from life in every imaginable way, till the movement of every muscle was thoroughly familiar to him. He exhibited fore-shortenings, which the masters before him scarcely ventured to think of. He abolished the stiff old rules, and gave his figures the free use of their limbs.

In sculpture, his masterly power appeared in the accuracy with which he made the position of the muscles visible in every turn of the figure. Here, however, his art misled him. Weary of ordinary, quiet positions, in which the limbs at rest give too little prominence to the change of which the parts beneath the skin are capable, he sought for difficulties only for the sake of overcoming them; and he made his figures assume attitudes which exhibited less of the all-imbuing mind at work, than the boldness and knowledge of Michael Angelo.

The statue of Christ in the Minerva receives from its position that broken light usual in such places, rarely admitting of a just view. The figure stands upright; the cross, formed of a light reed, is at his side; the right hand is holding it tightly grasped, with the arm downwards; while the left, stretching across the breast, touches it higher up. The legs and the lower part of the body are at the same time turned towards the left in the movement; the left leg a little advancing, the right receding. The upper part of the body is turning with the shoulders towards the other side; and this turn of the figure above the hips is the masterpiece of the work.

The position in itself, however, does not correspond with the person of Him whom it is to represent. If I take up the plaster cast of the small, delicately executed model, to which the shoulders and head are lacking, I should believe myself looking at the torso of an Achilles. The organization would lead one to suppose the perfection of human power in slender, strong proportions. We imagine

that a helmet must have covered the head, and a shield have hung on the missing arm. There is something warlike and heroic in the firm position of the two feet, which appears strange for one whom we picture treading this earth so gently, that the flowers rose under his feet, as though but a breath of wind had bent them.

This gentle, enduring character did not belong to Michael Angelo; he could not place in his works what he did not possess. He represented the corpse of Christ in its tender, ill-used weakness; but, where he produces him as living, he makes him seem coarse and strong, as Raphael also does at times, or as he appears in the original German translation of the gospel as the "strong, mighty Lord."* He seems like a general in arms; and the apostles, his train of martial knights. Michael Angelo, especially in his designs, makes him often almost gigantic. I remember one, where the sitting dead body is falling on one side; or another, where he rises from the grave. His crossed arms raised, his head looking upwards and turned far back, his feet close together, he soars from the open grave. There is an impetuous power in the movement. We feel as if he could seize the whole world, and carry it with him. The watchmen start asunder, as if a volcano had burst between them. There is no artist in the world who could thus embody in outline the action of his figures, as Michael Angelo has done.

The Christ in the Minerva was not entirely completed by him. A Florentine sculptor, Federigo

* "Starke gewaltige Herr."

Frizzi, put the last touch to it. In what this con-sisted, we know not. A vein in the stone is said to have induced Michael Angelo to abandon the statue. The countenance is also strange, exhibiting quite a peculiar physiognomy; and the rich hair falls down in locks behind. Standing dispassionately before the figure, we should declare it to be a St. John.

8.

The years 1519 to 1522 were reckoned as the most prosperous for the city. At length, from the expected extinction of the family, there seemed a prospect of a natural deliverance from the tyranny of hereditary rule. The cardinal, when he succeeded his nephew Lorenzo, threw aside the monarchical form of government, which had been carried on with such regardless measures, and organized mat-ters again more after the idea of a despotic rule. He pleased all parties. He voluntarily gave the citizens back a part of their privileges; there was a rumor of an ideal constitution, which was to be granted to the city immediately; and when, in the year 1521, the French, who had hitherto been masters of Italy, were defeated, and the fear of their influence upon those citizens who were devising a more violent path to liberty had vanished, the severity of the Medi-cæan rule subsided to a great extent.

The superiority of Francis I. had weighed heavily on the pope since 1515. Even at that time, when, after the victory of the king at Marignano, Leo was obliged to put a good face on a bad game, and to throw himself subserviently into his arms, he would

rather have met Francis at Bologna than at Florence. The presence of the king in Tuscany appeared to him too critical, — he had already experienced it once. The Florentines knew this also well, and made the pope feel it in spite of his splendid reception. Leo was not at ease at that time in his faithful city; and he feared for her as long as the French had Italian policy in hand. But, since 1519, — when Charles of Spain had been elected Emperor of Germany in spite of the counter-efforts of the King of France, and the immense territory of Spain, Burgundy, Germany, Hungary, and Naples, had become one united country under his rule, — Leo's hopes turned to the power thus newly rising. An alliance was effected; fortune was favorable; the last tidings which the pope received before his death, was that of the defeat of the French. If there were not such good grounds for believing that Leo's death was caused by poison, we might have ventured to assert that he died from excessive joy.

Immediately, however, the efforts of the defeated, to reconquer Milan began. From the day in which Francis was defeated at the imperial election, the European history of the next thirty years turns upon the efforts of the two rivals to prove to each other which was the stronger, and to whom in truth the direction of the things of this world belonged. Personal animosity also interfered; and this was permitted to reach personal provocation. Milan, however, formed the bone of contention; and the ascendency of Spain or France seemed apparently connected with its possession. Whoever lost Milan

and Lombardy, yielded. All the arts of policy and war were directed to this object of ambition; and it was a matter of course, that the one obliged to retreat would immediately attempt the utmost he could do, to prepare the same lot for the other. For connected with Milan were Tuscany and Venice and Genoa; and connected with Genoa was the Mediterranean Sea and Naples; and with these on the other side, again, Tuscany and Venice; and with all these the pope, who, with the caprice of fate, would infallibly incline towards him who possessed in Milan the key to all these treasures.

In 1521, however, the French had made especial haste to recover their lost position. The election of the new pope was too important. Two men stood opposed to each other among the cardinals,— Medici, the head of the Spanish-imperial party; and Soderini, the unwearied enemy of the Medici and the friend of France. The decisive moment threatened to approach. Soderini, and the exiled Florentines at the court of Francis I., urged for an immediate undertaking against the city; and when, passing by the two rivals, the old Netherland ecclesiastic was elected,— who, as Bishop of Valladolid, had never dreamed of the dignity devolving upon him,— they counselled that a blow should be struck before the latter should have reached Italy.

Medici endeavored to hold his ground against the threatening storm by the means of which his cunning mind, schooled as it was in dissimulation, was capable. Throughout his life, he had pursued the interests of his family by the most intricate course

FF

of action. Now, when he had no longer any at his side, he played his part most subtlely. Soderini and France promised the Florentines the consiglio grande, that ideal to which the citizens clung as the Germans do to the idea of their unity; he promised it also. The clever, learned society of men, who, meeting in the garden of the Rucellai as a kind of æsthetic liberal club, exerted their influence upon passing affairs (Macchiavelli was one of their principal leaders, and Michael Angelo also may be reckoned among them), Medici endeavored to gain over to his side by conversations which he had with different members upon the development of the Florentine constitution into its freest form. He invited them to establish their views in writing. No less was the confidence with which he sought to fill the adherents of Savonarola, who still formed a powerful party. The form of the new constitution, and the day on which it was to be proclaimed, were already talked of. Every one cherished hopes, the centre of which was the friendly, agreeable, unselfish cardinal; who, even if he would gladly have intrigued for his own family, now no longer possessed any; who had at once after Leo's death given freedom to all imprisoned citizens, and who now hesitated to come to a decision, only because he did not seem to know how to make the benefit he intended to confer on the city sufficiently great and excellent.

Suddenly a conspiracy came to light. The death of the cardinal was its object. Soderini, who held the new pope in Rome completely in his net, was its originator. Its most dangerous participators were

among those men in the garden of the Rucellai, for there the dissimulation was seen through most keenly, and they adhered inviolably to France. With regard, however, to Giulio's dissimulation, the existence of Ippolito and Alessandro dei Medici need only be remembered. The cardinal, from the first, never thought of granting the smallest thing which he had promised, only because he could not do otherwise.*

In May, 1522, the plot was discovered. Some of the conspirators saved themselves by flight; others were brought to trial. At the same time, the cardinal succeeded in ruining Soderini at the Vatican. Adrian had him removed to the Castle of St. Angelo, while Medici, entering amid the rejoicing of the Roman people, occupied from henceforth his place. All necessity was now removed for speaking fair words to the Florentines. There was no more mention of consiglio grande and constitution. Obedience was demanded.

It is a pity that Nardi, when relating the escape of the conspirators, from his method of only sometimes insinuating the men implicated, instead of giving their names, leaves us in uncertainty who "the very famous sculptor" (*scultore assai segnalato*) was, who at that time afforded shelter to the fugitive Zanobi Buondelmonti.† He was just escaping from the city by the Porta a Pinti when the cardinal was riding in. Buondelmonti, seeing the street blocked

* See Appendix, Note XCIII.

† The same person to whom Macchiavelli, with Cosimo Rucellai, dedicated his work upon Livy.

up, entered a sculptor's atelier close by the gate, which the cardinal himself, both for the sake of the sculptures, and for the beautiful garden in which the house stood, was in the habit of frequently visiting. This time fortunately he did not do so; and the fugitive found time to change his clothes, and afterwards to make his escape in the darkness.

There were, besides Michael Angelo, a number of other sculptors in the city by no means unimportant. There was, for instance, Bandinelli; but he was at that time occupied with no work requiring an atelier, to say nothing of the fact that this one, even if Bandinelli had worked in marble, was filled with sculptures. Besides this, he is named by Nardi; and, lastly, Bandinelli would have had real pleasure in giving Buondelmonti up to the cardinal. There was also Jacopo Sansovino, who, like Bandinelli, had withdrawn to Florence after Leo's death, when the merry life in Rome came to a sad conclusion; but he, too, could scarcely have had there an atelier full of works. There was, besides, Benedetto da Rovezzano, who had to chisel the David of Michael Angelo, which the gonfalonier Soderini had long before sent to France, and to whom subsequently one of the apostles for the cathedral was assigned, when Michael Angelo relinquished the task. But his atelier lay in another quarter of the city. Lastly, there were Tribolo and Mino da Fiesole. The former was still young, and devoted to the cardinal; the latter was old, and had no great tasks. It seems that Nardi intended Michael Angelo. The atelier was that house built especially for him, which was to be-

come his property after the completion of the apostles, but which subsequently belonged to the cathedral, and was let by it. It was close to the Porta a Pinti, opposite the old Cistercian monastery. It is possible that Michael Angelo, who had hired it once before, was now again working there. One thing is certain, — that he was a friend of the conspirators. The name of one of them, Luigi Alamanni, stands with his own under the petition to Leo respecting Dante's remains. Nardi's, too, is there; and he knew perhaps more of the conspiracy than he states in his book. And therefore it was incumbent on him not to mention Michael Angelo's name; for he generally allows this kind of circumlocution to occur when men friendly to him are concerned.

No other, too, would have had the courage thus to receive Buondelmonti, and to make himself an accessory in opposing the law. And, lastly, perhaps Michael Angelo alone merits the designation, " very famous," which Nardi lavishes but sparingly. Yet these are only suppositions. The matter, however, has been in no wise cleared up.

9.

However glad Michael Angelo may have been to be able to carry on the completion of the mausoleum, free from all pressing work, he yet felt himself, after some time, induced by other reasons to advance in the further building of the sacristy. As he always worked too slowly for his employers, it now seemed to Julius's heirs that he was not advancing sufficiently rapidly. They had been obliged to draw

back in the year 1516, when the pope had ordered
the building of the façade: they had not ventured
to complain to Leo, although this work had soon
appeared completely to occupy Michael Angelo; for
the pope, after having deprived them, with such
regardless injustice, of their dukedom of Urbino,
would not truly have troubled himself about such
complaints. They sent a private reminder to Mi-
cnael Angelo in Florence. He led their messenger
into his atelier, and showed him what was already
completed. When he now, however, undertook the
sacristy, with the monuments of the Medici, this
seemed too much to the Rovere. They had returned
to Urbino after Leo's death, and had again assumed
their old powerful position; they now represented
the matter to Pope Adrian, and demanded that the
mausoleum should be completed by Michael Angelo,
or the money that had been received should be
given up.

At the time, however, in which this happened,
Cardinal Medici had turned his thoughts again to
the new work, due to the honor of his family, and a
duty of gratitude towards those to whom the monu-
ments in the sacristy were to be erected. He may
have been impelled also to come to a decision upon
what was to be done, by the arrival of the blocks
from Carrara, — those blocks, one of which at least
was intended for the statue of the Virgin, and was
to have arrived at Florence at the end of 1522. The
cardinal was in Rome. Michael Angelo addressed
a letter to one of the gentlemen in his suite, in which
he made known his wishes. Above all, he desired

that the command issued by the pope, that either Julius's monument was to be completed, or the money refunded to the Rovere, should be withdrawn. He never wished to discontinue the mausoleum; for it had never come into his mind to break engagements once entered into: but the new work attracted him, and both could not be carried on at once. For this reason, he concluded, even if the cardinal did not succeed in setting him at liberty, he would nevertheless do justice to his orders, besides attending to that at which he was compelled to work. Still, he should prefer if the former could be effected.

The death of Adrian put an end to this uncertainty. He was not a year in the Vatican. Misunderstood in his citizen-like simplicity, and in the good will which he endeavored to manifest on all sides; ignorant of what was acceptable in the city, where he ought to have been the centre of every intellectual movement; not even able to converse with many of the cardinals, because they knew no Latin, while to him Italian was foreign, — he died unlamented, and to the satisfaction of those who belonged to the papal court. Nowhere could he have suited less than Rome. At his entry, he had forbidden triumphal arches, as heathenish marks of honor. He shut up the valuable collection of antique statues in the Belvedere: all the doors except one, of which he kept the key, were walled up. He wished to pull down the ceiling of the Sistine Chapel, because naked figures did not suit a church. He brought with him from his home one old servant, to whom he daily gave a piece of gold to defray the expenses

of the house. His relatives, who came in hopes of booty, were sent home again with a moderate sum of money for their journey. The portraits which were to be taken of him were given to a young painter from Flanders, whom he had with him, and who worked in the Vatican. Still Sebastian del Piombo also had the honor of being allowed to take a portrait of him. The pupils of Raphael, however, and the great crowd of artists, sat there like butter-flies in a shower of rain. A panic of terror seized them: following the example of Giulio Romano, they left the city, and dispersed in all directions through Italy. It seemed as if with one blow an end had been put to the old Roman life. And so it was. For although, after Adrian's death, things outwardly flourished again, the sun never beamed again with its old glory, and the fruits which it ripened were not so sweet. A new epoch began. Adrian's short rule passed like a prophetic index of the events which, in full and slow succession, grad-nally prepared a mournful end for both art and • liberty.

In the obstinate disputes that now followed, Me-dici was victorious. Soderini had at first so much the advantage of him, that wagers were laid upon his success; but at last he yielded to the stronger. In November, 1523, the election took place. As at Leo's elevation, Florence overflowed with marks of joy. Michael Angelo, too, had cause to be contented. " My dear master Domenico," — he writes to his old friend Topolino in Carrara, — " The bearer of this is Bernardina da Pierbasso, whom I am sending to

Carrara for some blocks which I require. Be so good as to direct him where he may obtain his object best and quickest. No more at present. You will have heard that Medici has been made pope. Every one is delighted at it; and to me, too, it seems as if there would now be fresh orders. Therefore serve me now well and honestly, so that it may tend to his honor." Michael Angelo perhaps knew even at that time more than he communicated to Topolino; for, immediately after the election of Medici, the building of the sacristy was not only resumed afresh, but a new task was resolved upon in the erection of the library of San Lorenzo. As regards time, this exactly coincides with the period when the rest of the blocks arrived from Carrara. Michael Angelo received a monthly salary of fifty ducats, and began the two statues of the Dukes of Nemours and Urbino, which belong to the noblest monuments that the art of sculpture has produced.

Surveying with my mind's eye all the sculptured portraits that I know, I find these two figures surpassed by none. What they lack perhaps in simplicity is made amends for by the dignity of their appearance. If I think of that Greek statue of Sophocles in the Lateran Museum, placed between the seated heroes, — and this is always the utmost test, — they would become a little poor, and their magnificent aspect would lose some of its natural grace, somewhat as one of the Hohenstauffen emperors would appear contrasted with Alexander the Great; but this difference may be defended as natural and necessary. For the two Medici were neithei

sons of the gods nor heroes. Michael Angelo has raised them as high as they could be raised; and, by thus representing the offspring of his old patron Lorenzo and his brother, he requited in a manner more than regal all the benefits he had received in their house. The whole family gained by these statues an appearance of mighty princeliness and nobility, higher than could be procured for them, either by their own deeds or in connection with the houses of emperors and kings.

A proof of how little remains of the remembrance of what Lorenzo and Giuliano were in their life, and how their reputation at the present day lies in the work of Michael Angelo alone, is seen in the change of the names of these statues, which has lasted up to our own day. For, though attention may have been occasionally drawn to the fact, — of which, however, I am not aware, — the correction certainly is not universal, and the false designations remain attached. Lorenzo, the arrogant, warlike Duke of Urbino, is called by Vasari " the man absorbed in reflection," — the portrait of his melancholy, sadly fated uncle Giuliano having been referred to him; while the latter, made into the " bold, proud " Lorenzo, has been looked upon hitherto under the form of his nephew.

The marble statues, as they stand opposite each other at the present day in the sacristy of San Lorenzo, form the contrast of brooding reflection, and of resolve rising into action. Both are in repose. But Lorenzo sits there like a general on the summit of a hill, from whence he is looking

down on his fighting soldiers, and hearing the noise of the battle; while Giuliano, deaf to what is happening around him, seems brooding ceaselessly over his thoughts.

Lorenzo was brave, as his father Piero had been. He led in person the assault on Monteleone, when he took by force the dukedom from the Duke of Urbino, the title of which had been given him by the pope. He appears in the dress of a Roman general of the time of the emperors; the ornaments of his armor are rich, and executed with careful neatness. The right foot is stepping forwards, so that the knee stands prominently out; the left is behind, under the seat, so that the knee, with the leg bent, lies lower than the other, — just the attitude for rising steadily with a start as soon as necessary. Across his lap is placed a heavy baton, one end of which — the right knee being higher — extends upwards over the leg. Upon this part of the staff his hand rests, or (we should rather say, although it is the hand of a man) it is moulded there, — with such indescribable grace has Michael Angelo represented it. This hand, and the other lying on the other end of the staff still more careless in attitude, with the back touching it, and without any intention of grasping it, or of doing any thing indicating a will, are the two most beautiful human hands which I know in the whole realm of sculpture. In the body of Christ, lying on his mother's lap, the hands are incomparably tender and expressive; and, if any doubt could arise respecting the Madonna at Bruges, her hands also indicate the

only hands which would have been able to form them. Nothing makes us so thoroughly certain at the first glance of the stage at which an artist stands, than his manner of forming the hands.*

That which, however, stamps the figure of the Duke of Urbino — which is, as it were, its token — is the throat rising from the square, richly ornamented opening of the coat of mail, which fits closely to the breast and shoulders, — power and pride arc expressed in its movement. Once more casting a glance at the entire figure, we see all the good and the noble that lay in Lorenzo's character, — his valor, his hope of conquering the Italian States into a kingdom for himself, — this statue contains it all; and whoever contemplates it, and afterwards reflects upon the man himself in his various fates, will most easily solve the question, What is to be understood by idealizing a person? An artist who wishes to produce the ideal of a man, takes hold of the enduring value he possesses, adds to it what he himself is as a man and an artist, and out . of this forms a new creation.

We have no portrait with which to compare the resemblance of the features. Raphael painted the duke; but the picture is lost. However, in both statues, Michael Angelo has himself confessed, that he has but little adhered to nature. " Who would wish to appear a thousand years hence to prove that the dukes had looked otherwise?" he answered, when reproached with the want of resemblance. He had never worked at portraits, except in occasional

* See Appendix, Note XCIV.

drawings, and these can only be considered as studies. The individual form of a man seemed to him not sufficiently comprehensive to express that which a work must contain to entice him to finish it. And so, while he exhibited the whole figure on a higher scale, he formed the head also independently of the individual features, as a part of his newly created man.

In Giuliano, the last working-up of the face is wanting. While Lorenzo's aspiring head appears uncovered, Giuliano wears a helmet of an antique form, corresponding with the Roman armor covering his figure. This, however, is without ornament. The whole figure has something in it weighty and reposing. The left elbow leans upon the low projecting arm of the chair; and, with the forefinger slightly bent and stretched out, he touches his lips as if his drooping head rested gently upon it. The other arm is placed on the leg with the back of the curved hand, so that the elbow is turned out; the leg, however, from the knee downwards, crosses over to the other side, so that the feet, drawn a little under the chair, stand close together, one behind the other. The knees are bare, as with Lorenzo; and the short shirt of mail, hung with strips and tassels, falls heavily down between them across his lap.

Michael Angelo, whose overflowing nature sought an outlet in one manner or another in each of his works, knew how, in representing repose, to elevate it into a state of infinite duration, just in the same way as he understood how to raise the action of a figure into bursting vehemence. The sibyls and

prophets exhibit this in his paintings; Giuliano's statue, in his sculptures. Yet the figure of the Duke of Nemours expresses something utterly different to the colossal men and women of the Sistine Chapel. There, investigating reflection was represented, every thought flowing towards one point, — the highest contemplative work. In Giuliano the thoughts are divided; the mind is absorbed in an indefinite feeling, just as if he intended to show that death was a deliverance for him from long sad sickness. He sits as if he had gradually turned to stone. He lived under circumstances which compelled him sometimes to come forward valiantly; he was obliged to exert himself for his family, to stand his ground. The marriage journey to France was the last thing he was able to do to augment Medicæan splendor. But he carried the seeds of death within him. A longing for repose, and that strange hopelessness which is given to many characters as a sad gift of nature, were peculiar to him. "It is not cowardice, nor does it spring from cowardice, if, to escape whatever terrible things were in store for me, I hated my own life, and longed for an end." This is the first verse of his sonnet in defence of suicide, insignificant as a poem, but still obtaining higher value here, because it is the only expression remaining to us of a mind, at the loss of which, on his death, friends and foes lamented, and which would have been long ago forgotten, but for Michael Angelo.

The fate of Florence was linked to the sons of the two dukes after their death. Both were illegitimate children; for, from their royal consorts, Giuliano

had no descendants, and Lorenzo only a daughter. Ippolito, the elder, was the son of a noble lady in Urbino, at the time when Giuliano lived there as an exile; Alexander's mother, on the contrary, was of obscure origin, a mulatto slave belonging to the palace, who was even unable to declare, whether Lorenzo, or a groom, or the Cardinal dei Medici himself, was the father of the child. Both, however, were of superior nature, and similar in character to those to whom they owed their existence. It was enough for the pope that they existed, come from whom they would.

When Leo X. made Cardinal Giulio dei Medici regent in Florence, the boys were still too young to play a part there themselves. It had long, however, been manifest at the Vatican, that Ippolito would one day obtain a sovereignty of his own; and his future was a standing article in the secret negotiations with Spain and France. Politicians in Florence did not at first see so far; but they too were soon to be enlightened.

In the spring of 1524, the Cardinal of Cortona made his entry as regent and representative of the pope; and, two months after, he was followed by the two in whose name he henceforth ruled the city. Ippolito and Alessandro — the latter still a boy, the former, however, a youth of fourteen — were declared by the citizens capable of holding the highest offices of the state. Alessandro was subsequently to become a cardinal; Ippolito was to marry Caterina, the surviving daughter of the Duke of Urbino, upon whom at a future day the half of the Medicæan property

was to devolve, and who at that time was still very young. Ippolito was secretly destined to take up subsequently the part which Lorenzo had been prevented by death from playing to the end.

Such was the state of affairs in Florence, when Michael Angelo was working at the statues of Lorenzo and Giuliano.

APPENDIX.

APPENDIX.

PRELIMINARY REMARKS.

THE following annotations contain, in the first place, whatever is furnished from unpublished sources; and, in the second, whatever I owe to modern works on art and history; and, in the third place, considerations and explanations, not suitable for insertion in the work itself. I could only point out, in a few instances, where my statements are opposed to the other modern treatments of the life of Michael Angelo; for the false data are too numerous for me to pay regard to them all. I have modernized, with some few exceptions, the style of the Italian extracts from manuscripts (I must ask indulgence for occasional errors); and in this I have believed myself acting a useful part, as the purport is here alone necessary, and the original style of writing must have been inconvenient to many. With regard to the method pursued in the translations interspersed, I have considered it more important to give the general sense, than to translate the Italian, word for word, into English.

In translations into English, a choice always lies between these two methods. There are foreign authors whose style appears so naïve and artless, that we should lose its peculiar charm in deviating from it. Homer, Herodotus, or Boccaccio, all authors in general writing in a dialect or catching the sound of the dialect, belong to this class. When an author, however, uses the language in its perfection, as Sophocles, Cicero, or Macchiavelli have done theirs, his words can only be exchanged for what is most perfect in our own. To wish to imitate such men in our own tongue, must inevitably lead to the error of supposing them somewhat singular in their own language. And this is also the case, where communica-

[515]

tions are concerned, in which it is only requisite to make them
as plain as possible. To this category belong writings like
Michael Angelo's letters. They give us, it is true, an idea of
dialect; but, if we were to translate them word for word, they
would acquire a natural awkwardness, neither belonging to
him nor to his age. Any one else would at that time have
written similarly.

That, in a translation, poems must suffer more important
alterations than any thing else, is a matter of course. To
translate a poem well is to take it in itself, and to place an
English one in its stead. Metre and style of composition may,
in so doing, be altered according to circumstances, — words
omitted or others added, and images exchanged for others.
How this is to be done must be left to the judgment of him
who undertakes it. The translation of a poem must always
aim at pleasing as an independent work. Those who know the
original will never declare themselves satisfied with it.

I have, therefore, just as the idea of the poem seemed to
require it, given madrigals in rhyming or not rhyming iambics;
once even I have transformed a madrigal into a sonnet. In
the sonnets, I have often given up the strict form; and the ter-
zine on the death of his father I have treated in a metre which
must be read like prose, and which I have chosen only because
it forced itself involuntarily upon me. It is a sort of metrical
prose, allowing every liberty, and still capable of being con-
densed and kept tolerably equal.

We have yet to add, that, for those who wish to become
acquainted with Michael Angelo's life, by looking into the
sources for themselves, the Lemonnier edition of Vasari is
indispensable. A great part of the scientific matter is gath-
ered together there. For a first acquintance with Rome, •
Murray's Handbook is the best and most certain guide, un-
rivalled by any other work of a similar kind. (It is the same
with regard to Florence and the rest of Italy.) Most of
Michael Angelo's works are now to be had in good photo-
graphs. This is especially important with regard to sketches,
the greater number of which are in this manner made accessi-
ble. In the sculptures, however, it is necessary to see whether
the photographs are taken from the originals or only from
plaster casts.

I. — PAGE 36.

Cf. Brunn, Gesch. der Griech.: Künstler, i. 336, Loren-
zetti's death was supposed to have been much earlier ; but no
other war can be intended than that of 1390. The spring is
the famous Fonte Gaya, the work of Jacopo della Quercia.

II. — Page 53.

Exposition Universelle de 1851. Travaux de la Commission Française, tom. viii. (Beaux Arts, par M. le Comte de Laborde), page 49. Definition of the Year 1303: "Ce qui est pour l'église et pour le roi est de l'art, disait-on ; le reste appartient au métier et subit ses charges, impôts et prestations."

III. — Page 82.

See observations of Gori to Condivi.

IV. — Page 83.

The list of the contents of the Buonarroti papers (still lying inaccessible in Florence), given in the Archivio Storico, mentions the letter. Harford has seen it. See his Life of Michael Angelo, i. 21 (2d edit.).

V. — Page 89.

The editors of the Lemonnier Vasari (Firenze, i.-xiii.) did not know the name of the family. The design is in the Catalogo delle Pitture e Sculture possedute della Famiglia Bianconi, 1854. It is there said, that the painting has been mentioned in the Guida di Bassano (1816), p. 104. I have not seen it, nor the Parisian one either.

VI. — Page 90.

A third of the praise which the companion of a great master gains by his own work, must be given to the master, says Benvenuto Cellini.

VII. — Page 158.

Condivi, xvii. "Stette con Messer Gianfrancesco Aldovrandi più d'un anno." The error was natural, as this period lay far in the past when Michael Angelo communicated his history to Condivi.

VIII. — Page 162.

The best original is Vas., xii. 339. It is addressed Mco. Lorenzo. "Magnifico" was at that time a general title, borne certainly by some men *par excellence*, without the meaning of the word necessarily expressing an especial attribute of char-

acter. The name "Lorenzo the Magnificent" thus seems to have sprung from the idèas of a later period. Soderini, too, the gonfalonier, retained the epithet *magnifico* when he lived subsequently in Rome.

With regard to the version in the artists' letters given by Guhl, the following expressions — "solo per avvisarmi; non altro per questa; a voi mi raccomando Dio di male di guardi" — are general phràses in the letters of that day. "Uno pezzo di marmo" is the usual expression for that which we call a "block." Cond. xxi., "Un pezzo di marmo d'altezza di braccia nove;" and thus in innumerable instances.

Above the letter stands Xᵽ̃. It has been endeavored to draw conclusions from this respecting Michael Angelo's connection with Savonarola; but similar superscriptions may be met with both before and after Savonarola's times. Cf. Giornale Storico degli archivi Toscani, iii. 67, — a letter from Andrea Graccialoti to Lorenzo dei Medici in the year 1478

IX. — PAGE 166.

A medal of the pope gives the picture of the Castle of St. Angelo, with the standard of the Borgia floating on the towers.

X. — PAGE 170.

One of the most beautiful medals in the Friedland collection at Berlin represents Lucrezia as duchess, with long waving hair. On the back there is a strange allegory, — Cupid chained by both arms, with his back to a tree, from the branches of which there hang down broken stringed instruments and a bow and quiver, the latter with the arrows falling out Round it are the words, "Virtuti ac Formæ Pudicitia pretiosissimum." Stamped on it are the hitherto unexplained initials, — F. (E. ?) PHFF. The representation, as regards the drawing, belongs to the most charming things I know. (Filippus Philippi Filius fecit? Fi i ino Lippi, however, is not known as a stampcutter.) 1 pp

XI. — PAGE 173.

The three are thus placed together in the Cortigiano.

XII. — PAGE 173.

Vas., iv. 202.

XIII. — PAGE 176.

Gaye's Carteggio affords interesting documents respecting the further fate of the statue. What Vasari says of the matter is worthless. The Cupid is not in existence at the present day.

XIV. — PAGE 177.

Bramante was among those who directed the building of the palace. May not his antagonism to Michael Angelo have been at work even here? Still we must be cautious in raising such suppositions.

XV. — PAGE 180.

Is this the same "half-finished painting, *a tempera* formerly in the possession of Mrs. Day in Rome, now in England," of which Rumohr speaks? (Ital. F. iii. 96.) There was a doubt in England whether it was a Michael Angelo. The details are in Harford's book.

XVI. — PAGE 181.

The statue of Callistratus (cap. viii.) certainly agrees in many points with this Bacchus. The supposition, however, that Michael Angelo knew the book, does not, on this account, appear more probable.

XVII. — PAGE 183.

The cast of the Pietà, in the New Museum at Berlin, is incomplete and badly placed. A cast of the Moses is unhappily still wanting, though it would be easy to procure.

XVIII. — PAGE 185.

There is an appropriation of the thoughts of others, which is just as natural as it is necessary. There are materials floating all round, of which artists take possession without inquiring whence they come. When Handel transformed a street song into a striking air, and Corneille produced his Cid from a Spanish drama, which, pretty as it is in itself, can only be styled moderate, they were neither of them plagiarists, and their creations were no less original than if they had sprung entirely from their own imaginations. (Signorelli's statue, mentioned in the corresponding note in the first edition, has, according to the photograph of it, only a very remote resemblance with Michael Angelo's Pietà.)

XIX. — PAGE 190.

The bell of San Marco is called La Piagnona. Cf. Vincenzo Marchese, San Marco, 157. Is this the origin of the name?

XX. — Pages 214 and 216.

Giornale Storico degli Archivi Toscani, 1859, I. Nuov Documenti concernenti a Frate Girolamo Savonarola. Villari's new book reached me, unfortunately, too late. It furnishes a number of new and very valuable documents. Perrens' much-praised prize-essay is a very insignificant work.

XXI. — Page 218.

Macchiavelli is among those, who, after those stormy days, was excluded from the general amnesty, and was sentenced to a fine. This can scarcely have been because he was an adherent of Savonarola's; for this did not accord with the spirit of the letter. Either, therefore, this is not genuine, or Macchiavelli belonged to the Compagnacci, and indeed to those of the extreme party.

* XXI. — Page 224.

The two passages to be compared are the following: Cond. xii. " Gettò anco di bronzo una Madonna col suo Figliuolino in grembo; la quale da certi mercanti Fiandresi de' Moscheroni, famiglia nobilissima in casa sua, pagatagli ducati cento, fu mandata in Fiandra." And — Vas. xii. 176. "Fece ancora di bronzo una Nostra Donna in un tondo, che lo gettò di bronzo a requisizione di certi mercatanti Fiandresi de' Moscheroni, persone nobilissime ne' paesi loro, che pagatogli scudi cento, la mandassero in Fiandra." We cannot but observe how delicately, and at the same time how clumsily, Vasari • knows how to change or transpose Condivi's words. He leaves the child out; instead of " in casa sua," he inserts " ne' paesi loro;" instead of "ducati," he uses " scudi;" and still the sentence is the same.

As regards Bruges, I may quote Description historique de l'Église collegiale et paroissale de Notre Dame à Bruges, par Beaucourt de Nortvelde. Bruges, 1773, p. 52. " M. Pierre Moscron, Licentié èsdroit et greffier de cette ville, donna cette précieuse pièce à cette Eglise immédiatement après qu'il avait fait ériger à ses dépens le grand Autel de marbre en cette belle et spacieuse chapelle: sa sépulture est dessous le dit Autel, c'est une pierre bleue avec cette inscription en Latin: Ornatissimo viro Petro Moscronio I. C. Brugensi, dum viveret Assessori et rerum pupillarium scribæ. Hæredes posuerunt. vixit ann. 57, mens. 5, dies 2. Obiit postridie kal. jan. anno a nato Cristo 1571. R. I. P.''

In Harford's book, also, the supposition is expressed, that the Madonna at Bruges might have been the same as that purchased by the Moscheroni. But he has adduced nothing further in confirmation of this opinion. To this period seems to belong an alto-relievo in burnt clay, executed in Florence, and now in the Berlin Museum, representing a Madonna and Child, and which I consider to be a work of Michael Angelo's. The position of the child strikingly resembles that of the Madonna at Bruges. The same resemblance again occurs in the picture mentioned in Note XV. Strangely enough, it is also seen in the infant Christ, in Raphael's Giardiniera, which belongs to the year 1507. Only the turn of the head here is different.

XXII. — Page 231.

Documenti per la storia dell' arte sanese; Siena, 1856, iii. 19. — Possibly the contract may have been signed by Michael Angelo in Siena itself. Galli's signature bears the date of the 25th.

XXIII. — Page 232.

Gaye, 454. — "Incepit dictus Michael Angelus laborare et sculpire dictum gigantem die 13 Settembris, 1501, die lune de mane, quamquam prius alio die ejusdem uno vel duobus ictibus compulisset, quoddam nodum quod habent (?) pictores: dicto die incepit firmiter laborare." It must have been the commencement of some sort of symbolic work.

XXIV. — Page 233.

1 Braccio (ell) = 2 Florentine feet. Storia Fiorentina di Benedetto Varchi ed. Lelio Arbib. ii. 79: "Ogni braccio Fiorentino contiene due piedi antichi romani." The Roman foot is taken by Wurm as 131.15 Paris lines. Böckh, Metrologische Untersuchungen, S. 28.

XXV. — Page 236.

Now in the Uffici. Mariette speaks of a drawing to be found in his collection, which is said to have expressed Michael Angelo's first idea as to the David, but which he afterwards gave up. From the description, it seems to have represented Donatello's David.

XXVI. — Page 237.

Gaye, II. 457. — " E quivi a me pareva stessi bene in orna mento della chiesa e de' consoli, et mutato loco." As the

editors of Vasari expressly observe, Gaye did not give the document quite faithfully. I read it, " et in usato loco."

XXVII. — PAGE 241.

Thus, according to Turotti, Brown, and others, who quote Amoretti, whose book I do not know. It is perhaps only a pathetic description of the simple fact.

XXVIII. — PAGE 243.

In London at the present day.

XXIX. — PAGE 245.

Soderini, elected as gonfalonier for life, is said, according to Vasari, to have wished the stone to have fallen to him. This election, however, occurs later.

XXX. — PAGE 246.

" Pari d'amori," it stands in Giovanni Santi's rhyming chronicle. Was not " pari d'onori " perhaps meant?

XXXI. — PAGE 259.

This is doubtful, like the residence in Siena at all. Vasari is often not to be depended on ; but when exactly the contrary to what he says is not stated, or other evidence does not make it untenable, we cannot contradict his statements. Here, however, opinions and conjectures are alone concerned.

XXXII. — PAGE 260.

For the letter of introduction from the Prefect of Rome, see the Prussian Chronicles, xiii. 1 and 2.

XXXIII. — PAGE 266.

This sketch is from Bunsen's description of Rome.

XXXIV. — PAGE 269.

The sketch of the Uffici is strictly architecturally designed. Dividing the ground-line into twenty-four parts, all the rest is planned accordingly. Condivi gives the measure in braccie. The sheet is photographed, and is easy to procure.

XXXV. — Page 269.

Vasari says "Provinces."

XXXVI. — Page 270.

Vasari assigns them other places. This is not to be regarded, as he is here perfectly dependent on others.

XXXVII. — Page 270.

Rachael and Leah as personifications. Mariette (notes to Condivi) thinks to have discovered the sketch of one of these figures in the drawing now in the Uffici. He calls her La Prudence. Perhaps he was misled by the expression " contemplative life ; " for the sitting figure has a mirror in her hand, in which she is looking at herself; and a little boy is standing before her, just as, on the sketch of the monument, small figures of children stand before the sitting figures.

The drawing appears to me to represent no work of sculpture.

XXXVIII. — Page 271.

Mariette supposes, also, the top of the monument to have been different, since he regards a drawing found in Paris to be the rest of the Florentine sheet, which is defective in the upper part. According to this, in opposition to Condivi (and Vasari), the monument would have terminated above with an angel bearing a ball, standing on the top of a pyramid. Mariette asserts himself to have been in possession of a water-color drawing of Michael Angelo's, on which the whole was thus represented, and throughout agreeing with Condivi's description.

This *conformité* is not true ; for Condivi knows nothing of the angel, the ball, and the pyramid : but the drawing has been lost.

Besides this, Mariette asserts, that he also possessed the angel with the ball on its shoulders *séparément.* This latter drawing still exists in Paris. With regard to the other, the upper part of it seems to me a mere fancy. D'Agincourt, for instance, maintains that the drawing which Mariette possessed is in his hands. It is the one in the Uffici. This, however, as we saw, is defective above. Moreover, Mariette does not express himself very distinctly. It was probably his opinion, that the upper missing part of the drawing represented what be imagined ; and he wrote as if he had the whole before him.

In France, however, Mariette seems to be of indubitable authority. In Frédéric Villot's explanation of the above-mentioned drawing, La Prudence, now in M. Reiset's collection, is pronounced by Villot to be, "L'Innocence effrayé par l'Hypocrisie, qui se réfugie entre les genoux de la Verité." A naked child is running towards the lap of a woman, holding a mirror; whilst another, holding a great mask inverted before his face, seems to frighten him away.

I consider the Paris copy of this drawing as doubtful. Accurately compared with the Florentine, which can be done by photographs, there is, in the strokes of the Paris plate, an outward, but rather powerless imitation of the other.

XXXIX. — Page 273.

No. 1. Letters to his Father, in the possession of the British Museum. — " De' casi mia di qua, io ne farei bene, se e' mia marmi venissino, ma in questa parte mi pare avere grandissima disgrazia, che mai, poi che io ci sono, sia stato dua dì buon tempo. S'abattè a venirne, più giorni fa, una barca che ebbe grandissima ventura a non capitar male. Perchè era contrattempo, e poi che io gli ebbe scarichi, subito venne el fiume grosso, e ricopersegli in modo che ancora non ho potuto cominciare a far niente, e pure do parole al papa, e tengolo in buona speranza, per che e' non sì crucci meco, sperando che'l tempo s'acconci ch' io cominci presto. Che Dio il voglia.

" Pregovi che voi pigliate tutti quegli disegni, cioè tutte quelle carte che commessi in quel sacco che io vì dissi, e che voi ne facciate un fardelletto, e mandatemelo per uno vetturale, ma vedete d'acconciarlo bene per amor dell' acqua, e abbiate cura, quanto che e' non ne vadi male una minima carta, e raccomandatela al vetturale, perchè v'è certe cose che importano assai, e scrivetemi per chi voi mele mandate, e quello che io gli ho a dare.

" Di Michele, io gli scrissi che mettessi quella cassa in luogo sicuro al coperto, e poi subito venissi qua a Roma, e che non mancassi per cosa nessuna. Non so quello sarà fatto. Vi prego che ciò gnene rammentiate, e ancora prego voi che voi duriate un poco di fatica in queste dua cose, cioè in fare riporre quella cassa al coperto in luogo sicuro; l'altra è quella nostra donna di marmo : similmente vorrei la facessi portare costì in casa, e non la lasciassi vedere a persona. Io non vi mando e' danari per queste dua cose, perchè stimo che sia picciola cosa, e voi se gli dovessi accattare, fate di farlo, perchè presto, se e' mia marmi giungono, vi manderò danari per questo per voi! — pregate Dio che le mie cose vadino bene, e vedete di spendere a ogni modo per insino in mille ducati in terre, come siame rimasti."

Postscript: That he will send the inclosed letters to Piero d'Argiento.

Upon the letter: " Allodovicho di lionardo di buonarrota simoni i firenze. Dato nella dogana di fiorēza."

XL. — PAGE 274.

There are some interesting letters in Gaye respecting the discoveries of ancient works at that time.

XLI. — PAGE 275.

Bottari, Lett. Pitt. iii. 321. — "Giovanangelo Romano e Michel Christofano Fiorentino, che sono i primi scultori di Roma." The easily recognized confusion of names has been already set right by Fea.

XLII. — PAGE 280.

"Tu hai fatta una pro a col Papa, che non l'arrebbe fatta un Re di Francia," Cond. xxx. — "Fare più che re Carlo in Francia" is a Roman proverb.

XLIII. — PAGE 281.

Embassies at that time usually consisted of several oratori or ambasciadori. The reasons for which Michael Angelo's journey was obliged to be discontinued in this capacity, have been hitherto overlooked.

XLIV. — PAGE 289.

I have given the historical details according to Pignotti, who mentions no authority. Goethe (Appendix to Cellini) has another idea. Vasari and Condivi do not say what event the cartoon represents.

XLV. — PAGE 291.

We know not when and how, but its destruction began early. The hall was subsequently completely rebuilt and painted by Vasari. Thus it still stands there, with several sculptures in it, among them some unfinished, from Michael Angelo's remains.

XLVI. — PAGE 294.

No. 9 of the Letters to Buonarroto, in the British Museum. "Buonarroto, — Io ho ricevuto oggi questo dì diciannove di

dicembre una tua, per la quale mi raccomandi Piero Orlandini, e che io lo serva di quello che lui mi domanda. Sappi che lui mi scrive che io gli facci fare una lama d' una daga, e che io facci ch' ella sia una cosa mirabile. Per tanto non so, com' io melo potrò servire presto e bene, l' una si è, perchè non è mia professione, l' altra, perchè io non ho tempo da potervi atten- dere. Pure m' ingegnerò, infra un mese, che sia servito il meglio che io saprò.

" De' fatti vostri, e massime di Giovansimone, ho inteso il tutto. Piacemi che lui si ripari a bottega tua, e che egli abbi voglia di far bene, perchè io ho voglia d'aiutar lui come voi altri, e se Dio m'aiuta, come ha fatto sempre, io ispero in questa quaresima avere fatto quello che io ho a fare qua, e tor- nerò costà, e farò a ogni modo quello che io v' ho promesso. De' danari che tu mi scrivi che Giovansimone vuole porre in sur una bottega, a me parrebbe che gl' indugiassi ancora quattro mesi e fare lo scoppio e' l baleno a un tratto. So che tu m' in- tendi, e basta. Digli da mia parte che attenda a far bene, e se pure e' volessi e' danari che tu mi scrivi, bisognerebbe torre di cotesti costà, perchè di qua non ho ancora da mandargli, perchè ho piccolo prezzo di quello che io fo, e anche è cosa dubbia, e potrebbemi avvenire cosa che mi disfarebbe del mondo. Per tanto vi conforto a star pazienti questi pochi mesi tanto che io torni costà.

" De' casi del venire qua Giovansimone, non nelo consiglio, ancora perchè son qua in una cattiva stanza, e ò comperato uno letto solo, nel quale stiamo quattro persone, e non arei el modo accettarlo come si richiede. Ma se lui ci vuole pure venire, aspetti che io abbi gittata la figura che io fo, e rimanderonne Lapo e Lodovico che m' aiutano, e manderògli un cavallo, acciò che e' venga, e non com' una bestia. Non altro. Pregate Iddio (*iodio*, more frequently written) per me, e che le cose vadino bene. MICHELAGNIOLO, Scultore in Bologna."

The *facci fare* I have referred to Michael Angelo himself, as it may well be thus understood. Orlandini was of opinion that the blade was to be executed after Michael Angelo's design.

XLVII. — PAGE 296.

No. 10. Letters to his Brothers, in the possession of the British Museum. " Buonarroto,— Io ebbi una tua lettera, p'ù giorni fa, per la quale intesi come Lodovico aveva mercatato con Francesco (fra°) il podere di mona Zanobia; e di Giovan- simone ancora m' avvisasti, come si riparava in bottega dove tu stai, e come avea disidero di venire insina qua Bologna. Non t' ho risposto prima, perchè non ho avuto tempo, se non oggi.

"De' casi del podere sopraditto, tu mi di' che Lodovico l' ha mercatato, e che lui m' avviserà. Sappi che se lui me n' ha scritto niente, che io non ho avuta lettera che ne parli. Pero sappignene dire acciò che e' non ne pigliassi ammirazione, non avendo risposta se m'ha scritto.

"Di Giovansimone io ti dirò il parer mio, acciò che tu gnene dica da mia parti, e questo è, ch' a me non piace che e' venga qua, inanzi che io gitto questa figura che io fo, e questo fo per buon rispetto : non volere intendere il perchè. Basta che subito che io l' arò gittata, che io lo farò venire qua a ogni modo, e sarà con manco noia, perchè m' arò levate da dosso queste spese che io ho ora.

"Io credo intorno a mezza quaresima avere a ordine da gittare la mia figura, si che pregate Iddio ch' ella mi venga bene, perchè, se mi viene bene, spero avere buona sorte con questo papa, sua grazia, e se io la gitto a mezza quaresima, e ella venga bene, spero in queste feste di pasqua essere costà, e quello che io v'ho promesso farò a ogui modo, se voi attenderete a fare bene.

"Di' a Piero Aldobran (Orlandini must, without doubt, be intended. Or may the error here furnish the proof, as all others are wanting, that Michael Angelo had again met with his old patron Aldovrandi, whose name thus came to his pen?) che io ho fatto fare la sua lama al migliore maestro che sia qua di simil cose, e che di questa settimana, che viene, m' ha detto che io l'arò. Avuto ch' io' l' ho, se mi parrà cosa buona, io gnene manderò ; se non, la farò rifare, e digli, non si maravigli, se non lo scrivo presto come conviensi, perchè ho tanta carestia di tempo ch' io non posso fare altro. A dì venti dua di gennaio, 1506 (Florentine style).

<div style="text-align:center">

"Michelagniolo di Lodovico Buonarroti,

Scultore in Bologna."

</div>

Address : "Data nella bottega di Lorenzo Strozzi, arte di lana, dirimpetto allo speziale della palla in porta rossa."

<div style="text-align:center">

XLVIII.—Page 301.

</div>

No. 11. Letters to his Brothers, in the possession of the British Museum. — The manner in which the affairs with the podere di Mona Zanobia had been managed, has his consent. "De' casi del Baronciello io mi sono informato assai bene, e, per quello che m' è detta, la cosa è molto piú grave che voi non la fate. Per tanto io non sono per domandarla, perchè, se non la ottenessi, ne sarei malcontento, e se io la ottenessi, mi sare' danno grandissimo, e ancora alla casa. Credi che io non arei aspettato le seconde lettere, se questa cosa fussi possibile a me, perchè non è cosa nessuna che io non facessi per Baronciello.

" El papa fu venerdi a ventuna ora a cassa mia, dov' io lavora (*lavo* is written) e mostrò che la cosa gli piacessi, però pregate Dio ch' ella venga bene, chè se così fia, spero riacquistar buona grazia seco. Credo che in questo carnovale si partirà di qua, secondochè si dice in fra la plebe però.

" La lama di Piero, come esco fuora, cercherò d' uno fidato per mandargnene.

" Se Lapo che stava qua meco, e Lodovico venissino a parlare costà a Lodovico nostro, digli che non presti orecchi alle loro parole, e massimamenti di Lapo, e non ne pigli ammirazione, chè più per agio avviserò del tutto.

" Di Giovansimone ho inteso. Ho caro, attenda a fare bene, e così lo comforta, perchè presto spero, se sare' savi, mettervi in buon grado. A di primo di febraio 1506 (Flor. st.)

" MICHELAGNIOLO di Buonarrota Simoni in Bologna."

It is remarkable how he here and elsewhere changes the signature.

No more particulars are to be found respecting Baronciello's affair. *Riacquistar* is striking.

The letter published by Ciampi thus acquires in this respect also a mark of genuineness.

XLIX. — PAGE 301.

No. 2. Letters to his Father, in the possession of the British Museum. — " A di' otto di Febraio 1506. (Flor. st.)"

A long letter, in which Lapo's and Lodovico's deceptions are exposed.

L. — PAGE 304.

The other letters in the British Museum, belonging here, are these : —

Letters to Buonarroto, No. 1.

" Buonarroto, — Questa, perchè io (*ho scritto* is left out) a messere Agniolo, la quale lettera sarà con questa, dàlla subito, perchè è cosa che importa. Non ho da dirti altro. Io t'avvisai, pochi giorni fa, pel Riccione Orafo, credo l'arai avuta. Le cose di qua vanno bene. Di' a Lodovico che quando fia tempo da gittare la mia figura, che io l'avviserò.

" A dì ventinove di Marzo 1506. (Flor. st.) — MICHEL-AGNIOLO, Scultore in Bologna.

"A Buonarroto di Lodovico di Buonarrota Simoni in Firenze.
"Data nella bottega di Lorenzo Strozzi, arte di lana, in porta rossa, o alla lana nel palazzo de' Signori in Firenze."

Letters to Buonarroto, No. 2.

Again a letter is enclosed, to be at once delivered to Messer Agniolo. (Baccio d' Agniolo.) He will write next time to Giovansimone: "Io sto bene, e la cosa mia va bene, grazia di Dio." 14th April.

Letters to Buonarroto, No. 3.

"Buonarroto, — Io ho oggi una tua de' diciassette d' aprile, per laquale ho inteso el viaggio grande che fanno le mia lettere a venire costà. Non posso fare altro, perchè c' è cattivo ordine intorno a ciò.

"Io ho inteso per la tua più cose alle quali non rispondo, perchè non accade. Duolmi ti sia portato di sì piccola cosa sì pidocchiosamente con Filippo Strozzi. Ma poi che è fatto non può tornare a dietro.

"De' casi mia io scrivo a Giovansimone, e lui t' avviserà com' io la . . . e così avvisate Lodovico.

"Vorrei che tu andassi all' araldo, e che gli dicessi che io, non avendo mai avuto risposta da lui de' casi di maestro Bernardino, ho stima io che el detto maestro Bernardino non sia per venire qua per amore delle peste, ond' io ho tolto uno francioso in quello scambio, il quale mi servirà bene; e questo è fatto, perchè non potevo più aspettare; fagnene a sapere ciò, e a messere Agniolo, e raccomandami a lui, e digli che mi raccomandi alla Signoria del gonfaloniere.

"Raccommandami a Giovanni da Ricasoli quando lo vedi.

"A dì venti d' aprile (the year is wanting). MICHELAGNIOLO, in Bologna."

Letters to Buonarroto, No. 4.

"Buonarroto, — Io ebbi una tua per maestro Bernardino, il quale n' è venuto qua. He expresses his pleasure that all, except Giovansimone, were well. He is sorry not to be able to help, ma presto spero essere di costà. Quest' altro mese io credo gittare la mia figura a ogni modo, però se vuole fare fare orazione, o altro, acciò che la venga bene, faccialo a quel tempo, e digli che io nelo prego." He has no time for more. May 26.

Letters to Buonarroto, No. 5.

He has not written, because he wished to have waited for the cast. This will at any rate take place next Saturday. If he succeeds, he hopes soon to be in Florence. "Sono sano e sto bene, e cosi stimo di voi tutti." June 20.

Letters to Buonarroto, No. 6.

" Buonarroto, — Sappi come noi abbiamo gittata la mia figura, nella quale non ho avuta troppa buona sorte; e questo è stato che maestro Bernardino, o per ignoranza, o per disgrazia, non ha ben fonduto la materia. Il come sarebbe lungo a scrivere, basta che la mia figura è venuta insino alla cintola, e' l resto della materia, cioè mezzo il metallo s' è restato nel forno, che non era fonduto, in modo che a cavarnelo mi bisogna far disfare il forno, e così fo, e farolle rifare ancora di questa settimana la forma, c credo che la cosa del male anderà assai bene, ma non sanza grandissima passione e fatica e spesa. Arei creduto che maestro Bernandino avessi fonduto sanza fuoco, tanta fede avevo in lui. Non di manco non è che lui non sia buon maestro, e che non abbi fatto con amore, ma chi fa falla, e lui ha ben fallito a mio danno, e anche a suo, perchè s' è vituperato in modo che non può più alzar gli occhi per Bologna. Se tu vedessi Baccio d'Agniolo, leggigli la lettera, e pregalo che n' avvisi il Sangallo a Roma, e raccommandami a lui e a Giovanni da Ricasoli e al Granaccio mi raccomanda. Io credo, se la cosa va bene, infra quindici o venti dì esser fuora di questa cosa, e tornare di costà. Se non andassi bene, l'arei forse a rifare. Di tutto t'avviserò. Avvisami come sta Giovansimone. Ai dì sei di luglio. " Con questa sarà una che va a Roma a Giuliano da Sangallo. Mandala bene e presto, quanto tu puoi. E se lui fussi in Firenze dagnene." — Without signature.

LI. — PAGE 304.

Letters to Buonarroto, No. 7, in the possession of the British Museum.

"Buonarroto, — Io non ho tempo da rispondere all' ultima tua come si converrebbe. Ma sappi, com' io sono sano, e arò finito presto, e stimo avere grandissimo onore, tutto grazia di Dio, e subito, finito che arò, tornerò costi, e acconcierò tutte le cose di che tu mi scrivi, in forma che voi sarete contenti, similmente Lodovico e Giovansimone. Pregoti, vadi a trovare l' araldo e Tomaso comandatore, e dì' loro, che per questo non ho tempo da scriver loro etc. To San Gallo also, he was to say that he should soon have finished, and he was to write to him how San Gallo was. A dì ottobre (without number and year). — MICHELAGNIOLO, in Bologna."

Letters to Buonarroto, No. 12.

"Buonarroto, — Io ho ricevuto una tua, per la quale ho inteso come sta el San Gallo. Non farò altra risposta alla

tua, perchè non accade. Basta ch' io sono a buon porto dell'
opera mia, si che state di buona voglia. Con questa saranno
certe lettere. Dàlle bene e presto. Non so a quanti dì noi ci
siamo, ma ieri fu Santo Luca; cercane da te.—MICHELAGNIOLO.
in Bologna."
St. Luke falls on the 18th October.

Letters to Buonarroto, No. 8.

Buonarroto is astonished that he writes so rarely; but he has
no time. From his last letter, he sees that Buonarroto wishes
his speedy return for good reasons. Buonarroto must write to
him more distinctly, as he does not understand the matter. He
himself wishes to return home far more urgently than they can
desire it: "Perchè sto qua con grandissimo disagio e con
fatiche istreme, e non attendo a altro che a lavorare el dì e la
notte, e ho durata tanta fatica e duro, che se io n' avessi a rifare
un' altra, non crederei che la vita mi bastassi, perchè è stato una
grandissima opera, e se ella fussi alle mani d' un altro, ci sarebbe
capitato male dentro. Ma io stimo le orazioni di qualche per-
sona m' abbiano aiutato e tenuto sano, perchè era contra l'opin-
ione di tutta Bologna, ch' io la conducessi mai. Poi che la fu
gittata, e prima ancora, non era chi credessi ch' io la gittassi
mai. Basta ch' io l' ho condotta a buon termine, ma non l' arò
finita per tutto questo mese, come stimavo; ma di quest' altro a
ogni modo sarà finita, e tornerò. Però state tutti di buona
voglia, perchè io farò ciò ch' io v' ho promesso a ogni modo.
Conforta Lodovico e Giovansimone da mia parte, e scrivimi,
come la fa Giovansimone, e attendete a imparare e a stare in
bottega, acciò che voi sappiate fare quando vi bisognerà, che
sarà presto. MICHELAGNIOLO, in Bologna."
"À dì dieci di novembre.

LII. — PAGE 305.

*Letters to Buonarroto, No. 13, in the possession of the British
Museum.*

"Buonarroto,—Io ti mando una lettera in questa, la quale
è d' importanza assai, e va al Cardinale di Pavia a Roma.
Però subito che l' hai ricevuta va a trovare el San Gallo, e
vedi se lui ha modo di mandarla, ch' ella vadi bene. E se
San Gallo non è in Firenze, e non la può mandare, falle una
coverta, e mandala a Giovanni Balducci, e pregalo per mia
parte che la mandi a Pavia, cioè al detto cardinale, e scrivi
a Giovanni, che in questa quaresima io sarò a Roma, e raccom-
andami a lui. Raccomandami ancora al San Gallo, e digli, che
io ha a mente la sua faccenda, e che presto io sarò costà.

Manda la detta lettera a ogni modo, perchè non posso partire di qua se non ho risposta. MICHELAGNIOLO, in Bologna "A dì ventesimo di Dicembre."

LIII. — PAGE 305.

Letters to Buonarroto, No. 14, *in the possession of the British Museum.*

... "Isto qua in modo che se tu' l sapessi te ne increscerebbe," etc.

LIV. — PAGE 309.

Goffo nell' arte. Vas., vi. 46. — Vasari seems to have imagined that Perugino had criticised too sharply the cartoon of the Bathing Soldiers.

LV. — PAGE 310.

Dante is said to have asked Giotto why his paintings were so much more beautiful than his children. " Quia de die pingo et de nocte fingo," he is said to have replied. This must have flashed before Michael Angelo : he reversed the matter.

LVI. — PAGE 312.

The only time that Dürer mentions Michael Angelo is in the description of his Netherland journey, when he briefly remarks having seen Michael Angelo's picture of the Madonna at Bruges. — Camper, Reliquien, page 121. After that, I saw the alabaster image to the Virgin, made by Michael Angelo of Rome. — 1521. As regards Michael Angelo's irritability, we see in Condivi the question respecting the oxen, and his reply. • It seems that they wished to provoke him.

LVII. — PAGE 321.

Letters to his Father, No. 31, *in the possession of the British Museum.*

"Io ancora sono in una fantasia grande, perchè è già un anno ch' io non ho avuto un grosso da questo papa, e non ne chieggo, perchè el lavoro mio non va inanzi, in modo ch' a me ne paia meritare, e questa è la difficultà del lavoro e' l non esser mia professione. È pur perdo el tempo mio senza frutto. Iddio m' aiuti. Se voi avete bisogna di danari, andate allo spedalingo, e fatevi dare per insino a quindici ducati, e avvisatemi quello che vi resta.

"Di qua s' è partìto a questi dì quello Jacopo dipintore, che io fe' venire qua, e perchè e' s' è doluto qua de' casi mia.

stimo che e' si dorrà costà. Fate orecchi di mercatanti, e basta, perchè lui ha mille torti, e are' mi grandemente a doler di lui. Fate vista di non vedere. Dite a Buonarroto che io gli risponderò un' altra volta.

"Vostro MICHELAGNIOLO, in Roma.

"A dì venti di gennaio." (1509?) Written by another hand.

This letter exhibits quite a different handwriting to the others, and another way of abbreviating words. Nevertheless, the address on the back of the outside seems not to be doubted. Jacopo is certainly Jacopo di Sandro.

LVIII.—PAGE 323.

Letters to Buonarroto, No. 15, in possession of the British Museum.

"Buonarroto,—L'apportatore di questa sarà mio giovine Spagnuolo, il quale viene costà per imparare a dipignere, e hammi richiesto, ch' io gli facci vedere el mio cartone che io cominciai alla sala. Però fa che tu gli facci aver le chiave a ogni modo, e se tu puoi aiutarlo di mente, fallo per mio amore, perchè è buono giovane. Giovansimone si sta qua, e questa settimana passata è stato ammalato, che non m' ha dato piccola passione, oltre a quelle che io ho pure. Ora sta assai bene. Credo, si tornerà presto costà, se farà a mio modo, perchè."

[This seems to be Berugheta.]

LIX.—PAGES 323 AND 326.

Letters to Buonarroto, No. 16, in the possession of the British Museum.

"A dì ultimo di luglio."—1508 is noted again on the address.

Letters to Buonarroto, No. 17.

... "di Bastiano lavoratore non dico altro. Se lui volesse far bene, non sare' da mutarlo. Ma io non vo' che e' sia a intendere, che l' uomo sia una bestia. Io fu' cagione che Lodovico lo mettessi lassù, per le cose grande che e' mi disse di fare in quel podere. Ora l' ha dimenticate, el tristo, ma io non l' ho dimenticato io. Digli da mia parte, che se non fa il debito suo, che non mi v' aspetti, chè per avventura potrei esser presto di costà. He inquires whether Piero Basso is arrived. A dì (10?) d'Agosto."

He becomes passionate at once, when he sees his just claims attacked.

Letters to Buonarroto, No. 18.

He has received the bread. "Di Gismondo intendo, come vien qua, per ìspedire la sua faccenda. Digli da mia parte, che non facci disegno nessuno sopra di me. Non perchè io non l' ami come fratello, ma perchè io non lo possa aiutare di cosa nessuna. Io son tenuto a amare più me che gli altri, e non posso servire a me delle cose necessarie. Io sto qua in grande affanno e con grandissima fatica di corpo, e non ho amici di nessuna sorte, e non ne voglio, e non ho tanto tempo ch' io possa mangiare el bisogno mio. Però non mi sia data più noia, chè io non ne potrei sopportare più un' oncia."

Without date. On the address is written: "Io l' ho ricevuto da Roma a d. 17 d' Ottobre." The last word is very illegible.

Letters to his Father, No. 5, in the possession of the British Museum.

"Io attendo a lavorare quanto posso. Non ho avuto danari, già tredici mesi fa, dal Papa, e stimo infra un mese e mezzo averne a ogni modo." Remembrances to Ricasoli and Messer Agniolo, the herald. From Rome. No date.

To the same time belongs No. 4 of the Letters to his Father, in the possession of the British Museum.

He complains of a false step of Giovansimone's. He would have liked to have got on horseback at once, to arrange every thing himself. He had, however, now written to him. If he did not come to his senses, and if he took only so much as a pin's worth out of the house, he would, notwithstanding, get permission from the Pope to come.

Giovansimone seems to have persuaded his father to give him some of his share, which naturally all came from Michael Angelo. His father wrote to him so often, that Michael Angelo once expressly says that it is too much. Cf. Letters to his Father, No. 24, in the possession of the British Museum.

LX. — PAGE 326.

Letters to his Father, No. 35, in the possession of the British Museum.

"Restavi certi ducati spicciolati, e' quali vi scrissi che voi vegli togliessi. Se non gli avete presi, pigliategli a posta vostra, e se avete bisogno di più, pigliate ciò che voi avete di bisogno, chè tanto quanto avete di bisogno tanto vi dono, sebbene gli spendessi tutti. E se bisogna ch' io scriva allo spedalingo, me n' avvisate.

"Intendo per l' ultima vostra, come la cosa va. N' ho passione assai. Non vene posso aiutare altrimenti, ma per questo non vi sbigottite, e non vene date un' oncia di maninconia. Perchè, se si perde la roba non si perde la vita. Io ne farò tanta per voi, che sarà più che quella che voi perderete. Ma ricordovi bene, che voi non ne facciate stima, perchè è cosa fallace. Pure fàte la diligenzia vostra, e ringraziate Iddio, che poi che questa tribulazione aveva a venire, ch' ella sia venuta in un tempo, poi che voi vene potete aiutare meglio che non aresti fatto pel passato. Attendete a vivere, e più presto lasciate andare la roba che patire disagi, chè io ho più caro vivo e povero, che, morto voi, io non arei tutto l'oro del mondo; e se coteste cicale costà o altri vi riprende, lasciategli dire, chè e' sono uomini sconoscenti e senz' amore. A dì quindici di settembre.

"Vostro MICHELAGNIOLO, Scultore in Roma."

Written on the side : —

"Quando voi portate i danari allo spedalingo, menate con voi Buonarroto, e nè voi nè lui non ne parlate a uomo del mondo per buon rispetto, cioè nè voi nè Buonarroto non parlate ch' io mandi danari, nè di questi nè d' altri."

In very indistinct writing, probably his father's, below : —

... "1509 da Roma. — Ch' io pigli i danari mi bisognino, e quanti io ne toglio e tanti mene dona." Rather guessed than read.

Of the letters to which it is not possible to assign a very accurate date, the following seems at least to belong to this year : —

"Carissimo Padre, — Io ho avuto a questi giorni una lettera da una monaca, che dice essere nostra zia, la quale mi si raccomanda. E dice che è molto povera e che è in grandissimo bisogno, e ch' io le facci qualche limosina per questo. Io vi mando cinque ducati larghi, che voi per l'amor di Dio gnene diate quattro e mezzo, e del mezzo che vi resta pregovi che diciate a Buonarroto che mi facci comperare, o da Francesco Granacci o da qualch' altro dipintore, un' oncia di lacca. o tanto quanto e' può avere pe' detti danari : che sia la più bella che si trovi in Firenze, e se e' non ve n' è che sia una cosa bella, lasci stare. La detta monaca, nostra zia, credo che sia nel munistero di San Giuliano. Io vi prego che voi veggiate d' intendere s' egli è vero che gli abbi si gran bisogno, perch' ella mi scrive per una certa via che non mi piace; ond' io dubito che la non sia qualch' altra monaca, e di non esser fatto

fare. Però quando vedessi che e' non fussi vero, toglietegli per voi, e detti danari vi pagherà Bonifazio Fati.
" Non v' ho da dire altro per ora, perchè non sono ancora resoluto di cosa nessuna che io vi possa avvisare. Più per agio v' avviserò.
" Vostro MICHELAGNIOLO, Scultore in Roma."

LXI. — PAGE 332.

The first great injury the paintings suffered was in 1527, when Bourbon's soldiers made havoc in the Vatican.

LXII. — PAGE 338.

In Bunsen's description of the city of Rome, it is differently explained by Platner.

LXIII. — PAGE 342.

Beautiful engraving by Beatrizetto.

LXIV. — PAGE 344.

History and genre painting stand in relation to each other as tragedy does to comedy, — in the one, human nature generally in its freest expression; in the other, national peculiarity, limited by the externals brought about by national intercourse. Both, however, may coincide; and this combination is the characteristic of modern conceptions.

LXV. — PAGE 348.

Letters to Buonarroto, No. 48, in the possession of the British Museum.

" Intendo per l'ultima tua, come siate sani tutti, e come Lodovico ha avuto un altro ufficio. Tutto mi piace, e confortolo accettare, quando la sia cosa, che pe' casi che posseno avvenire lui si possa tornare a sua posta in Firenze. Io mi sto qua all' usato, e arò finita la mia pittura per tutta quest' altra settimana, cioè la parte ch' io cominciai, e com' io l' ho scoperta, credo che io arò danari, e ancora m' ingegnerò d'avere licenza per costa per un mese. Non so che si seguirà. N' arei bisogno, perchè non sono molto sano. Non ho tempo da scrivere altro. Ma avviserò come seguirà.

" MICHELAGNIOLO, Scultore in Roma."

No date. On the address are some illegible remarks in another hand.

LXVI.— PAGE 348.

Letters to his Father, No. 36, in the possession of the British Museum.

"Carissimo Padre, — Io ho intesso per l' ultima vostra, come avete riportati e' quaranta ducati allo spedalingo. Avete fatto bene. E quando voi intendessi che gli stessino a pericolo pregovi me n' avvisate. Io ho finita la cappella che io dipignevo, e 'l papa resta assai ben sodisfatto. E l' altre cose non mi riescono a me siccome stimavo in colpo ne e' tempi che sono molto contrari all' arte nostra. Io non verrò costà quest ognisanti, e ancora non ho quello che bisogna a far quello che voglio fare. E ancora non è tempo da ciò. Badate a vivere el meglio che potete, e non v' impacciate di nessun' altra cosa. Non altro. MICHELAGNIOLO, Scultore in Roma."

By another hand, 1512 is marked below in pencil. All Saints' Day, 1512, Michael Angelo, however, was either in Florence, or had just returned from thence to Rome.

Pungileoni has produced two passages from the diaries of Paris dei Grassi, which he endeavors to refer to the completion of the ceiling paintings in the Sistina having taken place many years afterwards; and this discovery of his has been generally believed and copied. Let us look at the passages: —

1. "1512. In Vigilia N. C. Pontifex voluit vesperis intei esse in Capella Sixtina . . . sed quia non erat ubi possemus ponere thalamum et solium ejus, dixit, ut illud facerem ego modo meo."

Pungileoni concludes from this, in the first place, that there was no *room* for *solium* and *thalamus* (the floor on which the pope's table stands, Ducange) ; that the chapel was not in a condition to be used; that, of course, this could only be on account of the scaffoldings used for the paintings; fourthly and lastly, that, because these scaffoldings were still there, the paintings were not finished. Such is the chain of evidence, consisting throughout of nothing but absolute inferences. The obstacles of which Grassi speaks, had nothing at all to do with the chapel. It was only necessary for him, the servant of the pope, deeply initiated as he was in questions of ceremony, to note down that the pope *had assigned to him* the decision as to where *thalamus* and *solium* were to stand. Had the chapel not been at all fit to be used for divine service, he would have noted this. It had probably been just newly arranged, and the last touches were wanting, in which Grassi's opinion was called for, and he records this with pride.

2. " Circa horam noctis x, quae est inter dies 20, 21, februarii, Julius Papa secundus mortuus est. . . . Prima die exse-

quiarum S. M. Papæ Julii II. feci fieri castrum per innumeros operarios vicinum portæ mediæ Basilicæ in duabus cannis, quia ipsa Basilica erat quasi media versus altare diruta."

This does not refer at all to the Sistina, but to the Basilica of St. Peter, which was gradually being pulled down as the new building progressed, and was at that time still uninjured at the front entrance.

Neither passages prove any thing. On the other hand, I find from the annals of Raynaldus, that, in February, 1510, mass was celebrated in the Sistina. There is another casual reference also to 1510. In the annals of Raynaldus, there is mention made of the appearance of a comet in this year. Could the meteor in the background of the Madonna di Fuligno denote this comet, and the date of the painting be settled by it?

LXVII. — Page 356.

See Pruss. Chronicles, January number, 1864.

LXVIII. — Page 366.

The last verse is altered by the editor. It must mean —

" Or che farebber dunque i mie braccia? "

LXIX. — Page 367.

One reading of the Vatican manuscript has *onde fu seco ogni virtù sepolta*. The whole verse is this : —

" Tornami al tempo, allor che lenta e sciolta
Al cieco ardor m' era la briglia e' l freno,
Rendimi 'l volto angelico e sereno,
Onde fu seco ogni virtù sepolto."

What does this *seco* mean?

LXX. — Page 384.

The seal presents the following figure. The letters were fastened with a wafer; and, besides that, a piece of string was wound round them, the two ends of which were placed under the wafer.

Could the design on the seal have been, at the same time, Michael Angelo's mark for his works? I have hitherto not observed it on his works. Could the *nodus* mentioned at obs. 23 be intended by it?

The letters referred to were —

Letters to his Father, No. 28, *in the possession of the British Museum.*

"Carissimo Padre,—Io ho avuta una vostra stamani, a dì 5 di settembre, la quale m' ha dato, e dà, gran passione, intendendo che Buonarroto sta male. Pregovi, visto la presente, m' avvisiate come sta, perchè, se stessi pur male, io verrei per le poste insino costà di questa settimana che viene, benchè mi sarebbe grandissimo danno, e questo è, che io resto avere cinquecento ducati, di patto fatto guadagnati, e altrettanta me ne dovea dare el papa per mettere mano nell' altra parte dell 'opera. E lui s' è partito di qua, e non m' ha lasciato ordine nessuno, in modo che mi trovo sanza danari, nè so quello m' abbia a fare se mi partissi. Non vorrei che sdegnassi, e perdermi el mio, e stare mal posso. Hogli scritto una lettera, e aspetto la risposta. Pure se Buonarroto sta in pericolo, avvisate, perchè lascierò ogni cosa. Fate buoni provvedimenti, e che e' non manchi per danari per aiutarlo. Andate a Santa Maria Nuova allo spedalingo, e mostrategli la mia lettera se non vi presta fede, e fatevi dare cinquanta o cento ducati, quegli che bisognano, e non abbiate rispetto nessuno. Non vi date passione, perchè Dio non ci ha creati per abbandonarci. Rispondete subito, e ditemi resoluto, se ho a venire o no.

"Vostro MICHELAGNIOLO, Scultore in Roma."

Letters to his Father, No. 7.

"Padre carissimo,—Io per l' ultima vostra ho avuto grandissima passione, intendendo come Buonarroto sta male. Peró subito, visto la presente, andate allo spedalingo, e fatevi dare cinquanta o cento ducati bisognandovi, e fate che sia provvisto ben di tutte le cose necessarie, e che e' non manchi per danari. Avvisovi, come io resto avere qua dal papa ducati cinquecento guadagnati, e altrettanti me ne dovea dare per fare el ponte e seguitare l' altra parte dell' opera mia, e lui s' è partito di qua, e non m' ha lasciato ordine nessuno. Io gli ho scritto una lettera. Non so quello che seguiterà. Io sarei venuto, subito che io ebbi la vostra ultima, insino costà, ma se partissi senza licenza, dubito, el papa non si cruciassi, e che io ncn perdessi quello che ho avere. Non di manco, se Buonarroto stessi pur male, avvisate subito, perchè, se vi pare, monterò in subito sulle poste, e sarò costà in dua dì, perchè gli uomini vagliono più che e' danari. Avvisate subito, perchè sto con gran passione. Vostro MICHELAGNIOLO, Scultore in Roma.

"A dì 7 di settembre."

Letters to his Father, No. 26.

"Padre carissimo, — Io andai martedì a parlare al papa, il perchè v' avviserò più per agio. Basta che mercoledì mattina io vi ritornai, e lui mi (fece) pagare quattro cento ducati d' oro di camera, de' quali ne mando costà trecento d' oro larghi, e per trecento ducati d' oro larghi ne do qua agli Altoviti, che costà sien pagati a voi dagli Strozzi. Però fate la quitanza che stien bene, e portategli allo spedalingo, e fategli acconciare come gli altri, e rammentategli el podere, e se lui vi dà parole, ingegnatevi comperare da altri, quando veggiate esser sicuro, e per insino a mille quattro cento ducati vi do licenza gli possiate spendere. Menate con voi Buonarroto, e pregate lo spedalingo che ci voglia servire. Fate il possibile comperare da lui, perchè e più sicuro.

"Io vi scrissi che le mie cose, o disegni, o altro, non fussino tocco da nessuno. Non mene avete risposto niente. Pare che voi non leggiate le mie lettere. Non altro. Pregate Iddio che io abbi onore qua, e che io contenti el papa; perchè spero, se lo contento, aremo qualche bene da lui. E ancora pregate Dio per lui.

"Vostro MICHELAGNIOLO, Scultore in Roma."

Without date; but this letter may be decided on by No. 27 of the letters to his father, in which he asks for information respecting the arrival of the money and the purchase. Underneath is "A dì undici ottobre."

Letters to Buonarroto, No. 22.

"Buonarroto, — Io ebbi ieri cinque cento ducati d' oro di camera dal datario del papa. 463½ he has given to Giov. Balducci, so that he may pay Bonifazio at Florence 450 duc. • d'oro larghi, etc. Se tu vedi Michelagniolo Tanagli, digli per mia parte, che da dua mesi in qua io ho avuta tanta noia e passione, che io non ho potuto scrivergli niente, e che io farò quanto potrò di trovare qualche corniola o qualche medaglia buona per lui, e ringraziolo del cacio, e di quest' altro sabato gli scriverò. MICHELAGNIOLO, Scultore in Roma.

"A dì ventisei d'ottobre 1510."

On the address the day of its arrival is noted down, the 31st October, 1510.

LXXI.—PAGE 386.

Letters to Buonarroto, No. 19, in the possession of the British Museum.

At the close, "Tiene serrato il cassone che e' mie panni non sieno rubati come a Gismondo. 11 genn. 1510.

"MICHELAGNIOLO DE BUONARROTA SIMONI,
 "Scultore in Roma."

Letters to Buonarroto, No. 21.

" Buonarroto, — In questa sarà una di Messere Agniolo. Dàlla subito. Io credo che e' mi bisogneva infra pochi dì ritornare a Bologna, perchè el datario del papa, con chi io venni da Bologna mi promesse, quando partì di qua, che subito ch' e' fussi a Bologna mi farebbe provvedere, che io potrei lavorare. È un mese che andò, ancora non ho inteso niente. Aspetterò ancora tutta questa settimana. Di poi credo, se altro non c' è' andare a Bologna, e passerò di costà. Non altro. Avvisane Lodovico, e di' che io sto bene.

"MICHELAGNIOLO, Scultore in Roma.
" A dì ventitrè 1510."
On the address : " Da Roma di febbraio 1510 (Flor. style.)"

LXXII. — PAGE 411.

Letters to his Father, No. 12, in possession of the British Museum.

LXXIII. — PAGE 415.

" Depinger a damaschi." I have translated the passage quite freely, only to express the contrast.

LXXIV. — PAGE 415.

Terribile can relate also to things. Vas., x. 15 : " Accrebbe (Antonio di Sangallo) la sala grande della detta capella di Sisto, facendovi in due lunette in testa quelle finestrone terribili, con si maravigliosi lumi," etc.

LXXV. — PAGE 416.

It is strange that he should call himself here Michael Angelo's godson; and the christening of his child, to whom Michael Angelo stood sponsor, only occurred in the year 1519.

LXXVI. — PAGE 416.

I suppose this because the proportions seem to agree.

LXXVII. — PAGE 419.

Michael Angelo's papers, which came into the possession of the British Museum, have been bound up in three volumes : the first two of which contain the correspondence with his father and brother; and the third, various separate documents, the first of which is the following : —

"Ne' primi anni di papa Julio, credo che fussi el secondo anno che io andai a star seco, dopo molti disegni della sua sepultura uno gnene piacque, sopr' al quale facemmo el mercato, e tolsila a fare per dieci mila ducati, e andandovi di marmi ducati mille, me gli fece pagare, credo dal Salviati in Firenze, e mandòmmi pe' marmi. Andai, condussi e' marmi a Roma e' uomini, e cominciai a lavorare el quadro e le figure, di che c' è ancora degli uomini che vi lavororono, e in capo d' otto o nove mesi el papa si mutò d' opinione, e non la volse seguitare, e io, trovandomi in sulla spesa grande, e non mi volendo dar sua Santità danari per detta opera, dolendomi seco, gli dette fastidio, in modo che mi fè cacciar di camera. Ond' io, per isdegno, mi partì subito di Roma, e andò male tutto l'ordine che io avevo fatto per simile opera, che del mio mi costò più di trecento ducati, simil disordine senza 'l tempo mio, e di sei mesi che io ero stato a Carrara, che io non ebbi mai niente, e e' marmi detti si restorno in sulla piazza di San Pietro. Di poi circa sette o otto mesi che io stetti quasi ascoso per paura, sendo crucciato meco el papa, mi bisognò per forza, non possendo star a Firenze, andare a domandargli misericordia a Bologna, che fu la prima volta che e' v' andò, dove mi vi tenne circa du' anni a fare la sua statua di bronzo che fu alta a sedere sei braccia, e la convenzione fu questa, domandandomi papa Julio quello che si veniva di detta figura, gli disse che non era mia arte el gittar di bronzo e che io credevo con mille ducati d' oro gittarla, ma che non sapevo se mi riuscirebbe. E lui mi disse, gittera' la tante volte che la riesca, e daremti tanti danari quanto bisognerà. E mandò per Messere Antonio Maria dallegnia (Antonio Maria da Lignano) e dissegli che a mio piacere mi pagassi mille ducati. Io l'ebbi a gettar dua volte. Io posso mostrare avere speso in cera trecento ducati, aver tenuti molti • garzoni, e aver dato a maestro Bernardino, che fu maestro d' artiglieri della Signoria di Firenze, trenta ducati el mese alla spesa, e averlo tenuto parecchi mesi. Basta che all' ultima, messa la figura, dove ave' ne a stare, con gran miseria, in capo di dua anni mi trovai avanzati quattro ducati e mezzo, di che io di detta opera sola stimo giustamente poterne domandare a papa Julio più di mille ducati d' oro, perchè non ebbi mai altro che e' primi mille com' è detto.

" Di poi, tornando a Roma, non volse ancora che io seguissi la sepultura, e volse che io dipignessi la volta di Sisto, di che fummo d' accordo di tre mila ducati a tutti mie spese con poche figure semplicemente. Poi che io ebbi fatto certi disegni, mi parve che riuscissi cosa povera, onde lui mi rifece un' altra allogazione insino alle storie di sotto, e che io facessi nella volta quello che io voleva, che montava circa altrettanto, e così fummo d'accordo ; onde poi, finita la volta, quando veniva

l' utile, la cosa non andò innanzi, in modo che io stimo restare avere parecchi centinaia di ducati." The rest is missing. It is therefore impossible to decide at what time the document was drawn up. It may have been in the twenties, thirties, or forties of the century, to serve in the arrangements with Urbino. The comparison with the letter published by Ciampi is interesting, and the authenticity of the latter is confirmed by it.

I have modernized the outward form of the document, without having lost sight of the peculiarities which have a right to be considered. Michael Angelo writes, "Ne primi anni di papa iulio credo ch fussi elsechōdo anno ch io andai astar secho doppo molti disegni," etc.

The second number is the original of the well-known receipt of the 10th May, 1508. The third, however, is a description of the mausoleum, probably as it was newly projected in 1513.

" L' imo d' ella è largo nella faccia dinanzi braccia undici fiorentine nel circa nella quale larghezza si muove in sul piano della terra uno imbasamento, con quattro zoccoli, ovvero quattro dadi, collo loro cimas (a) che ricigne per tutto. In su' quali vanno quattro figure tonde di marmo, di tre braccia e mezzo l' una, e drieto alle dette figure, in sunogni dado, viene 'l suo pilastro, che vanno alti insino alla prima cornice, la quale va alta dal piano, dove posa l' imbasamento, in su braccia sei. E' dua pilastri co' lor zoccoli da uno de' lati mettono in mezzo un tabernacolo, el quale è alto, il vano, braccia quattro e mezzo. E similmente dall' altra banda mettono in mezzo un altro tabernacolo simile, che vengono a essere dua tabernacoli nella faccia dinanzi, dalla prima cornice in giù, ne' quali in ognuno viene una figura, simile alle sopra dette. Di poi frall' uno tabernacolo e l' altro resto un vano di braccia dua e mezzo, alto per insino alla prima cornice, nel quale va una storia di bronzo. E la detta opera va murata tanto discosto al muro, quant' è la larghezza d' uno de' tabernacoli detti, che sono nella faccia dinanzi.

" E nelle rivolte della detta faccia, che vanno al muro, cioè nelle teste, vanno dua tabernacoli, simili a que' dinanzi, co' lor zoccoli, e colle loro figure di simile grandezza, che vengono a essere figure dodici e una storia, com' è detto, dalla prima cornice in giù.

" E dalla prima cornice in su, sopra e' pilastri, che mettono in mezzo e' tabernacoli di sotto, viene altri dadi con loro adornamenti. Suvvi mezze colonne, che vanno insino all' ultima cornice, cioè vanno alte braccia otto dalla prima alla seconda cornice, ch' è suo finimento. E da una delle bande, in mezzo delle dua colonne, viene uno certo vano, nel quale va una figura a sedere, alta a sedere braccia tre e mezzo

fiorentine. E' l simile viene fra l' altre dua colonne dall' altra oanda, e fra 'l capo delle dette figure e l' ultima cornice resta un vano di circa tre braccia, simile per ogni verso, nel quale va una storia per vano di bronzo, che vengono a essere tre storie nella faccia dinanzi. E fra l' una figura a sedere e l' altre dinanzi resta un vano, che viene sopra el vano della storia del mezzo di sotto, nel quale viene una certa trebunetta, nella quale viene la figura del morto, cioè di papa Julio, con du' altre figure, che la mettono in mezzo, e una nostra donna, pur di marmo, alta braccia quattro simile. E sopra e' taberna-coli delle teste, ovvero delle rivolte della parte di sotto, viene li rivolti della parte di sopra, nelli quali, in ognuna delle dua, viene una figura a sedere in mezzo di dua mezze colonne, con una storia di sopra, simile a quelle dinanzi."

LXXVIII. — PAGE 421.

Hütten's epigram in Böcking, i. 102.

LXXIX. — PAGE 435

I would even make the tapestries for the Sistina into an order given by Julius, which Leo only took upon himself. In the early years of Leo's rule, Raphael was largely employed in the embossed work, and he must have had besides at this time to draw the first series of the cartoons. Leo became pope at Easter, 1514. In June, 1515, Raphael received his first payment for the cartoons. Thus, scarcely a year would have been allowed him, with all his other great works, for the first production of these immense compositions. Even if his pupils helped him, the time appears too short. The preparato-ry ideas at least must have had an earlier date. The tapestries • also form the necessary conclusion to the interior decoration of the chapel.

LXXX. — PAGE 438.

Letters to his Father, No. 12, in the possession of the Brit-ish Museum.

LXXXI. — PAGE 440.

In the spring of 1515, Michael Angelo was in Florence, perhaps after he had spent the winter there. This is shown by a letter to his brothers. Letters to Buonarroto, No. 23, in the possession of the British Museum. He says that he had reached Rome safely: "Pregoti che tu mi mandi quel pirpig-nano più presto che tu puoi, e tollo di quello colore pieno che tu mi mostrasti un saggio, e fa sopr' ogni cosa che sia bello, e

to'ne cinque braccia e fa di mandarlo o pel fante o per altri."
Only be very quick. He is to ask the Spedalingo whether he
can pay him 395 ducats. What the perpignan costs, is to be
taken out of it, — only quickly. It is to be addressed to him
or to Domenico Buoninsegni, "in palazzo in casa el cardinale
de' Medici." The 28th April. No year. But this is shown
by a notice on the address.

Letters to Buonarroto, No. 24.

He has received the perpignan, " è buono e bello," also the
remittance; but he did not ask for "ducati di camera," but
" d' oro larghi." He does not wish for these: he sends the let-
ter back, and begs for another.
On the address: "A dì 19 di Maio 1515."

Letters to Buonarroto, No. 26.

He is to send him 1,400 ducats from Spedalingo, — " perché
qua mi bisogna fare sforzo grande questa state di finire presto
questo lavoro, perchè stimo poi avere a essere ai servizi del
papa, e per questo ho comperato forse venti migliaia di rame,
per gittar certe figure. Bisognami danari." Pier Franco Bor-
gherini, his friend, had better undertake the payment. Noth-
ing of the matter is to be spoken of in Florence.
On the address: "A dì 16 di giugno 1515."

LXXXII. — Page 442.

Letters to Buonarroto, No. 35, in the possession of the
British Museum.

LXXXIII. — Page 443.

*Memorial of Michael Angelo's respecting the building of the
façade of San Lorenzo, in the possession of the Berlin Mu-
seum.*

" Send' io a Carrara per mia faccende cioè per marmi per
condurre a Roma per la sepultura di papa Julio nel mille
cinque cento sedici, mandò per me papa Leone per conto della
facciata di San Lorenzo, che volea fare in Firenze. Ond' io a
dì cinque di dicembre mi partì di Carrara, e andai a Roma, e
la feci uno disegno per detta facciata, sopr' al quale detto papa
Leone mi dette commessione, ch' io facessi a Carrara cavare
marmi per detta opera. Di poi, send' io tornato da Roma a
Carrara l' ultimo di dicembre sopra detto, mandòmmi là papa
Leone per cavare e' marmi di detta opera ducati mille per le
mani di Jacopo Salviati, e portògli uno suo servitore detto

Bentivoglio, e ricevetti detti danari circa a otto dì del mese vegnente, cioè di gennaio, e così ne feci quitanza. Di poi, l' agosto vegnente sendo richiesto dal papa sopradetto del modello di detta opera, venni da Carrara a Firenze a farlo, e così lo feci di legname in forma propria con le figure di cera, e mandògniene a Roma. Subito che lo vide mi fece andare là, e così andai, e tolsi sopra di me in cottimo la detta facciata, come apparisce per la scritta che ho con sua Santità, e bisognandomi per servire sua Santità condurre a Firenze e' marmi che io avevo a condurre a Roma per la sepultura di Papa Julio, com' io ho condotti e di poi lavorati, ricondurgli a Roma, mi promesse cavarmi di tutte queste spese, cioè gabella e noli, che è una spesa di circa ottocento ducati, benchè la scritta non lo dica.

" E a dì sei di febbraio mille cinque cento diciassette tornai da Roma a Firenze, e avend' io tolto in cottimo la facciata di San Lorenzo sopradetta, tutta a mia spese, e avendomi a fare pagare in Firenze detto papa Leone quattro mila ducati per conto di detta opera, come apparisce per la scritta, a dì circa venticinque ebbi da Jacopo Salviati ducati ottocento per detto, e fece quitanza, e andai a Carrara, e non mi sendolà osservato contratti e allogazioni, fatte prima di marmi per detta opere, e volendomi e' Carraresi assediare, andai a far cavare detti marmi a Serravezza, montagne di Pietra-santa in su quello de' Fiorentini. E quivi avend' io già fatte bozzare sei colonne, d' undici braccia e mezzo l' una, e molti altri marmi, e fattovi l' aviamento che oggi sì vede fatto, che mai più vi fu cavato innanzi, a dì venti di marzo mille cinquecento diciotto venni a Firenze per danari per cominciare a condurre detti marmi, e a dì venti sei di marzo mille cinque cento diciannove mi fece pagare el cardinale de' Medici per detta opera per papa Leone da' Gaddi di Firenze ducati cinque cento, e così ne feci quit- • anza. Di poi in questo tempo medesimo el cardinale per commessione del papa mi fermò che io non seguissi più l'opera sopradetta, perchè dicevono volermi torre questa noia del condurre e' marmi, e che megli volevono dare in Firenze loro, e far nuova convenzione, e così è stata la cosa per insino a oggi.

" Ora in questo tempo avendo mandato per gli operai di Santa Maria del Fiore una certaquantità di scarpellini a Pietrasanta ovvero a Serravezza a occupare l'aviamento, e tormi e' marmi che io ho fatti cavare per la facciata di San Lorenzo, per fare il pavimento di Santa Maria del Fiore, e volendo ancora papa Leone seguire la facciata di San Lorenzo, e avendo el cardinale de' Medici fatta l'allogazione de' marmi si detta facciata a altri che a me, e avendo dato a questi tali che hanno preso detta condotta l'aviamento mio di Serravezza sanza far conto meco, mi sono doluto assai, perchè nè 'l cardinale nè gli

operai non potevono entrare nelle cose mia, se prima non m'
ero spiccato d' accordo dal papa; e nel lasciare detta (facciata
scil.) di San Lorenzo d'accordo col papa, mostrando le spese
fatte e danari ricevuti, detto aviamento e marmi e masseritie
sarebbono di necessità tocche o a sua Santità o a me, e l' una
parte all' altra dopo questo ne poteva fare quello voleva.

" Ora sopra questa cosa il cardinale m' ha detto che io mostri
e' danari ricevuti e le spese fatte, e che mi vuole liberare, per
potere, e per l' opera e per se, torre que' marmi che vuole nel
sopradetto aviamento di Serravezza.

"Però io mostro avere ricevuti dumila trecento ducati ne'
modi e tempi che di questa si contiene, e ho mostri ancora
avere spesi mille ottocento ducati che di questi c' è ne spesi
circa dugento cinquanta in parte de' noli d' Arno de' marmi
della sepultura di papa Julio, che io ho condotti a lavorare qui
per servire papa Julio a Roma, che sarà una spesa di più di
cinque cento ducati. Non gli metto ancora a conto il modello
di legname della facciata detta che io gli mandai a Roma. Non
gli metto ancora a conto il tempo di tre anni che io ho perduti
in questo. Non gli metto a conto che io sono rovinato per
detta opera di San Lorenzo. Non gli metto a conto il vitupero
grandissimo del avermi condotto qua per far detta opera, e poi
tormela, e non so perchè ancora. Non gli metto a conto la
casa mia di Roma che io ho lasciata, che v' è ito male fra marmi
e masseritie e lavoro fatto per più di cinque cento ducati. Non
mettendo a conto le sopradette cose a me non resta in mano de'
dumila trecento ducati altro che cinquecento ducati.

" Ora noi siamo d' accordo. Papa Leone si pigli l' aviamento
fatto co' marmi detti cavati, e io e' danari che mi restano in
mano, e che io resti libero, e consigliommi ch' io facci fare un
breve, e che' l papa lo segnerà.

" Ora voi intendete tutta la cosa come sta. Io vi prego mi
facciate una minuta di detto breve, e che voi acconciate e'
danari ricevuti per detta opera di San Lorenzo in modo che e'
non mi possino essere mai domandati, e ancora acconciate come
in cambio di detti danari che io ho ricevuti papa Leone si piglia
il sopradetto aviamento, marmi, e masseritie " . .

(*Sine loco et anno.*)

The following seems to belong to it : —

" Copia del conto de' danari spesi per papa Leone per la
faccia di San Lorenzo."

1st Dec., 1516. To Rome from Carrara. Back on the 6th
January. Two men and two horses.

Looking for pillars in Carrara, 50 ducats. 26 to the Cucher-
ello ; 18 to the Macino.

Twice coming from Carrara on account of the model execut-
ed by Baccio d'Agnolo : two men and two horses, one month.

Coming from Carrara to lay the foundation of the façade: two men and two horses, one month. For the first stone-masons taken back to Carrara, 25 ducats expenses for living, before a contract was made with them. 100 ducats premium after this was concluded. Sandro di Poggio, 100 duc. His brother, Master Domenico, 100 duc. Zucha, 150 duc. Bardoccio, 100 duc. Michele, 18 duc. Donato, 56 · duc. Francesco Peri, 260 duc. Conveyance of the first pillar, 60 duc.; of the second, 30 duc. Marble in Florence which I intend for a figure, 60 duc.

Sent to Carrara for other figures, 52 duc. Pietro, 1½ month, with a horse and boy. Eight months there myself with two men and two horses. Marble quarries in Serravezza, 40 duc. Boatmen and carriers, 250 duc. 30 duc. loss through the stone-masons in Pietra Santa.

It breaks off.

Again the same packet: —

" Venni per fare il modello da Carrara, e amualammi, di poi lo feci, e mandai Pietro con esso a Roma, di poi andai io, che furono circa tre mesi, ogni cosa a mia spese, salvo che le giornate d' un garzone che c' era che pagò Bernardo Niccolini.

" Fui ancora mandato da Roma a Serravezza innanzi vi si cominciasse a cavare a vedere se v' era marmi, che spesi in quella gita circa venticinque ducati.

" De' danni mia, non si sequitando la sopradetta, a Roma le masseritie di casa, marmi, e lavori fatti.

" A levare e' marmi lavorati di Firenze, e ricondurgli a Roma, e' l tempo che io non ho lavorato per questo conto."

As address on the paper : —

" Scritta di papa Leone della facciata di San Lorenzo."

LXXXIV. — Page 443.

Leonardo da Vinci-album, with notes by Waagen. Berlin, G. Schauer. Without date. Sheet 9th.

" Kaum hatte der um jene Zeit (1514) in Florenz beschäftigte Michel-Angelo von der Anwesenheit des Leonardo in Rom etwas vernommen, als er sich unter dem Vorwande, dass der Papst ihn wegen der Façade von San Lorenzo in Florenz zu sich bescheiden habe, bei dem Giuliano de' Medici beurlaubte und nach Rome eilte, um seinem alten Gegner, von dem er besorgen mochte, dass er seiner Stellung und seinem Einfluss dort gefährlich werden könne, sofort entgegenzutreten. Dieses wurde ihm aber erspart, denn als Lionardo von der Ankunft des Michel-angelo in Rome Kunde erhalten, reiste er sofort nach Mailand ab."

Vasari, on the contrary, from whom alone matters of this

kind could be taken, as no other source exists, says the following : —

"Era sdegno grandissimo fra Michelagnolo Buonarroti e lui (Lionardo scil.) per il che partì di Fiorenza Michelagnolo per la concorrenza, con la scusa del duca Giuliano, essendo chiamato del papa per la facciata di San Lorenzo ; Lionardo intendendo ciò, partì ed andò in Francia."

Perhaps *quando* should be inserted after *per il che*, and has been omitted by mistake.

Vasari thinks that Michael Angelo was summoned to Rome by the pope to take part in the competition going on there for the façade of San Lorenzo. Duke Giuliano, at that time reigning in Florence, allows Michael Angelo to set out, because the pope has issued this summons. Lionardo, when he hears that Michael Angelo has been summoned, and will come, sets out for France.

Waagen makes out of this, that Michael Angelo hears that Lionardo is in Rome. He at once hastens thither also to prevent Lionardo from opposing his influence there. In order to leave Florence, he pretends to Duke Giuliano, that the pope has summoned him to Rome. Lionardo hears this, and sets out directly.

Waagen understands *partì — per la concorrenza*, as if Michael Angelo had gone to Rome to compete with Lionardo, and *con la scusa del duca Giuliano, essendo chiamato dal papa*, as if it were, *scusando la sua partita appresso il duca Giuliano col pretesto di esser chiamato dal papa*, etc.

Vasari passes over the incident in Michael Angelo's life.

Of all that has been said against Michael Angelo by subsequent authors, I will only here mention Passavant's attack in his Life of Raphael.

In the first volume, on page 182, which he heads with the title, "Michael Angelo's Quarrelsomeness," he blames that letter of Michael Angelo's, first published by Ciampi, and says, —

"Der ton des Briefes zeugte von einer grossen Reizbarkeit des Michel-angelo, wodurch dieser Künstler von Juzend auf in Missverhältnissen lebte und unerträglich gegenüber allen denen erscheint, die sich ihm nicht gänzlich unterwarfen."

This letter, which only mentions Bramante and Raphael incidentally, was written twenty years after Raphael's death, and its tone of irritation was thoroughly justifiable. The letter has no reference at all to artists. Michael Angelo never desired that his "contemporaries in art" should yield to him, to say nothing of "entirely yielding." He almost always worked alone. He had never been in circumstances in which he could show himself — "unverträglich " — to other artists.

"Wir wollen uns hier erinnern," continues Passavant, "wie er noch im Garten de' Medici seine Mitschüler zum Besten hatte, daher er ein zerquetschtes Nasenbein davontrug." This accusation rests upon Torrigiano's statement, to whose roughness Michael Angelo owed his ill usage. What sort of man was Torrigiano, and how he boasted of the blow, is related by Cellini.

"Wie er verhinderte, dass Baccio d'Agnolo die Kuppel nes florentiner Doms vollendete." I have related the fact. The dome was finished. Michael Angelo only hindered, that, contrary to the intentions of its builder, Brunelleschi, those stones should be removed which the latter had left standing for the completion of the gallery outside. Baccio, moreover, was intimate with Michael Angelo, and remained so.

"So dass sie noch bis zum heutigen Tage ihre letzte Zierde erwartet." Was it Michael Angelo's fault, that they did not continue to build as Brunelleschi had designed? He would certainly have been the first to assist in this, had he been able.

"Wie nach dem handschriftlichen Bericht des Pietro Marco Parenti, im Jahre 1504, seine Statue des David bewacht werden musste, da Bildhauer, die er verächtlich behandelt, sie mit Steinen werfen wollten, und deren etwa acht an der Zahl verhaftet wurden." There is nothing in Parenti, either of sculptors throwing stones at the statue, or of his treating them contemptuously.

"Wie er die älteren Meister behandelte, die einen Ruhm erworben hatten, den er bei weitem zu überstrahlen überzeugt war; so den Pietro Perugino, den er tölpelhaft und unwissend in der Kunst schalt, worüber es zu Klagen vor Gericht kam;" In which Perugino lost the suit disgracefully. To outshine Perugino's fame had never been the aim of Michael Angelo's ambition. Nothing absolutely is known of "convictions" entertained with regard to it.

"So den Francesco Francia, dem er Aehnliches vorwarf, als dieser im Beisein vieler Bologneser seine Statue Julius' II. wegen des schönen Gusses lobte, Michel Angelo aber dabei das Lob seiner Kunst vernachlässigt glaubte." Francia was an adherent of the defeated party of the Bentivogli. But, even if Michael Angelo had answered him undeservedly sharply, his words could never have wounded Francia as an artist or older master.

"Und als er Francia's schönen Sohn sah, diesem sagte, dein Vater kann schönere lebendige Figuren machen als gemalte" If this be true, and spoken with the intention of being mali-

cious, it only stands as an expression caused by very special circumstances; and, as it is the only one of its kind, it cannot be used to support the general verdict that Michael Angelo treated older masters with contempt.

"Ferner erinnern wir uns, wie er mit Lionardo da Vinci, als dieser sich zur Zeit Leo X. in Rom befand in heftigen Streit gerieth, und ihn aus Rom verdrängte."

Enough has been said on this point.

"Endlich wie er durch seine Unverträglichkeit mit andern Künstlern daran Schuld war, dass die vom Papst Leo X., beabsichtigte Vollendung der Kirchen-façade von San Lorenzo zu Florenz nicht zu Stande kam."

He wished to work alone, and this was granted him. Why the façade was not built is before explained.

"Alle diese und noch andere Thatsachen beweisen, dass Michel-angelo nicht nur überaus reizbar war."

He was irritable: it does not follow, however, from the facts alleged by Passavant, which are altogether false and useless.*

"Sondern auch, dass er sich über alle andern Künstler erhob und sie oft mit Geringschätzung behandelte."

To give force to this conclusion, Passavant refers to the opinion of one of his biographers, whom he, however, only quotes in Italian. They are words of Condivi's, who expresses himself in the following manner: Michael Angelo was never envious of others, even when they produced works in that art which was his own, and this rather from innate kindness than because he ranked himself too highly. He always praised all others, even Raphael, etc.

I have before attempted to show how Waagen misunderstood the Italian language to Michael Angelo's injury; but how Passavant could conceive this passage of Condivi's, in which there is nothing but the purest praise, to be a proof of his accusations against Michael Angelo, is thoroughly incomprehensible.

Let us, however, look at another passage (i. 219), where Passavant relates that dispute between Michael Angelo and Leonardo: "Sicher versagte ihm (namely, Leonardo) Rafael auch seine Anerkennung nicht, wie er sich denn überhaupt nach seiner Liebenswürdigkeit freundlich zum alternden, obgleich noch in männlicher Kraft stehenden Prometheus, wie ihn (namely, Leonardo) Lomazzo nennt, wird gehalten haben.

* With regard to the "other facts," Passavant says in a note, "Siehe Vasari in den Lebensbeschreibungen der betreffenden Künstler." Vasari, however, contains nothing more, nothing in the least. "Siehe auch den Brief des Baccio Bandinelli, Pittoriche I. xxvii." Was Passavant so little acquainted with Bandinelli, as not to know that Bandinelli was universally despised as a false calumniator?

Nicht so Michel-angelo, der, wie Vasari berichtet, in heftigen Streit mit Leonardo gereith, so dass dieser, in seinen Erwartungen getäuscht, das Jahr darauf Rom, und im Januar 1516 selbst Florenz verliess, als er sich wohl abermals durch Michelangelo von der Mitbewerbung um den Plan zur Façade der Basilika S. Lorenzo ausgeschlossen sah."

What name are we to give to these statements? Partly open misrepresentations, partly unfounded suppositions, partly inventions without basis (that Leonardo also had thought of the façade of San Lorenzo is nothing else), — all these are fabricated into a whole, which had certainly better have remained unpublished.

Lastly, we must rectify what Passavant says of Sebastian del Piombo's contention with Raphael. There is no proof existing, that Michael Angelo designedly supported Sebastian as an adversary of Raphael's. Still less can it be established, that Raphael, when he received information that Michael Angelo had finished the design for Piombo's painting, said, "Michael Angelo shows me especial favor, in thinking me worthy to emulate with himself, instead of with Sebastian." Passavant quotes for this, the Opere di Ant. Mengs. Mengs is no authority at all; least of all, however, in matters concerning Michael Angelo, whom, as his writings show, he did not understand. The story is invented. With all that I have here said against Passavant, I do not wish in the least to detract from his important merit, but only to show on this one occasion, just because it presented itself, how art-histories have been hitherto written. Passavant's injustice and blind aversion to Michael Angelo arose from the certainly very innocent endeavor to make his hero, Raphael, appear in all the more brilliant colors; and he certainly wrote down every thing thoroughly believing it. Moreover, when he wrote, no one had begun to subject the sources of art-history to a penetrating criticism. Even Rumohr appears very cautious in what he advances against Vasari.

LXXXV. — PAGE 447.

Nos. 39–46 of the letters to Buonarroto, in the possession of the British Museum. They contain much detail.

LXXXVI. — PAGE 453.

The Farnesina has been recently restored to an elegant and habitable condition. Sodoma's paintings have been restored. The story of Pschye is purchasable in photographs taken from the original paintings.

LXXXVII. — PAGE 461.

The Marchese Haus, a German, raised into the Neapolitan nobility, has been the first to point out that the painting in the Farnesina called the " Galatea " represents Venus exactly as Apuleius describes her, whose words are as follows : " Non moratur marinum obsequium. adsunt Nerei filiæ choram canentes et Portunus cærulis barbis hispidus et gravis piscoso sinu Salacia et auriga parvulus delphini Palæmon. jam passim maria persultantes Tritonum catervæ, hic concha sonaci leviter bucinat, ille serico tegmine flagrantiæ solio obsistit, alius sub oculis dominæ speculum progerit, currus bijuges alii subnatant. talis ad Occanum pergentem Venerem comitatur exercitus." They describe the picture so fully, that it appears inconceivable how by the side of them there can be a thought given to the thoroughly anomalous description of a picture by Philostratus, which was intended to represent the triumph of the nymph Galatea. Passavant declares this description to be nothing less than the " narrative from which the picture was taken " (I. 229). This is the passage in Philostratus : —

Ἡ δὲ ἐν ἁπαλῇ τῇ θαλάσσῃ παίζει, τέτρωρον δελφίνων ξυνάγουσα, ὁμοζυγούντων τε καὶ ταυτὸν πνεόντων. Παρθένοι δ' αὐτοὺς ἄγουσι Τρίτωνος, αἱ δμωαὶ τῆς Γαλατείας, ἐπιστομίζουσαι σφᾶς, εἰ ἀγέρωχόν τι καὶ παρὰ τὴν ἡνίαν πράττοιεν. Ἡ δ' ὑπὲρ κεφαλῆς ἁλιπόρφυρον μὲν λῄδιον ἐς τὸν Ζέφυρον αἴρει, σκιὰν ἑαυτῇ εἶναι, καὶ ἱστίον τῷ ἅρματι, ἀφ' οὗ καὶ αὐγή τις ἐπὶ τὸ μέτωπον καὶ τὴν κεφαλὴν ἥκει, οὔπω ἥδιον τοῦ τῆς παρειᾶς ἄνθους. Αἱ κόμαι δ' αὐτῆς οὐκ ἀνεῖνται τῷ Ζεφύρῳ· διάβροχοι γὰρ δὴ εἰσὶ, καὶ κρείττους τοῦ ἀνέμου. Καὶ μὴν καὶ ἀγκὼν δεξιὸς ἔκκειται, λευκὸν διακλίνων πῆχυν, καὶ ἀναπαύων τοὺς δακτύλους πρὸς ἁπαλῷ τῷ ὤμῳ· καὶ ὠλέναι ὑποκυμαίνουσι, καὶ μαζὸς ὑπανίσταται, καὶ οὐδὲ τὴν ἐπιγουνίδα ἐκλείπει ἡ ὥρα. Ὁ ταρσὸς δὲ καὶ ἡ συναπολήγουσα αὐτῷ χάρις, ἐφ' ἁλὸς, ᾧ παῖ γέγραπται, καὶ ἐπιψαύει τῆς θαλάττης, οἷον κυβερνῶν τὸ ἅρμα. Θαῦμα, οἱ ὀφθαλμοί· βλέπουσι γὰρ ὑπερόριόν τι, καὶ συναπιὸν τῷ μήκει τοῦ πελάγους.

What has this painting in common with Raphael's ? There is not one trait that agrees, while every word in Apuleius's suits. Passavant helps himself by only taking a few sentences from Philostratus, and those containing the more general features, while he omits every thing special, in which the resemblance with the Raphael picture is done away with. But he conceals the fact that he has never seen the statement of the Marchese Haus. All that he knows of it is from a note of Rumohr's (iii. 141), in which the book is quoted in its first

form, without the name of the author; and it is falsely stated, that Haus had asserted that the so-called Galatea was an "Amphitrite." This is an error of Rumohr's, the origin of which is easily shown. Haus uses the name "Anadyomene" instead of Venus, on the first page of his work; and this name was transformed in Rumohr's memory into "Amphitrite." Rumohr adhered especially to the fact that the picture was *not* the Galatea. He thought the proofs of this so striking, that, careful as he always is of the conjectures of others, he expresses himself as convinced.

In the third part of his book, Passavant returns to this controversy. He has now made out the author of the work,* and speaks as if he had read it. But, from the fact that he again brings forward the "Amphitrite," he proves the contrary. To put an end to any thing further, he says, "As Raphael, in his letter to Count Castiglione, calls this picture himself a Galatea, its appellation is not to be disputed."

This is directly false. The passage is this (Pass., i. 533; he prints the letter at the end of the book itself) : "Della Galatea mi terrei un gran maestro se vi fossero la metà delle cose che V.S. mi scrive," etc. That the picture in the Farnesina is designated by the name "Galatea," is an assumption which is authorized by no single syllable in the letter.

On the other hand, the descriptions of the Farnesina in the years 1511 and 1512, quoted also by Pungileoni, mention a Venus drawn on a shell.

> " Talis data gratia picto est,
> Lædat opus merito veterum —
> Heic Juno ut veris vehitur pavonibus: exstat
> Heic Venus orta mari, et concha subsidera fertur:
> Heic Boreas raptam ferus avehit Orithyam."
> Thus *Blasio Palladio*, 1512. *

> " Nec munera desunt
> Et Veneri, et Veneris puero: velut illa sub nudis
> Orta inter superos rebus pulcherrima praesit."
> *Ægidius Gallus*, 15. 11.

We could be tempted to say with certainty, that it would be impossible for both poets to have had in view any other painting than that of Raphael.

One reason alone remains for designating the painting of the Farnesina "Galatea," in spite of all this, — the testimony of Vasari, who gives it this name. We should, however, I think, be justified in supposing here also one of those manifold evi-

* It is to be found in "Raccolta di Opuscoli spectanti alle belli arti," Dal Marchese G. G. Haus, Palermo, 1823, and is now in the Royal Library at Berlin. I have not seen the first edition, quoted by Rumohr

dent errors of which Vasari is guilty, if the one fact did not speak in his favor, that there is indeed no other picture of Raphael's bearing the name "Galatea." This alone allows us to suppose, that Raphael, in his letter to Castiglione, alluded to the painting in the Farnesina.

If the picture was actually called in Rome "La Galatea," although it represented the Venus, whence arose the strange change of name? The simplest explanation is this,—that the name Galatea was given to one of the other female figures in the grand composition, to one of the nymphs forming the train of Venus; and that from her the whole picture took its title, as is not seldom the case with theatrical pieces, which take their title from the name of some subordinate character.

I will venture to conjecture this. In front, to the left of the picture, we see, in the arms of a Triton, a female form, who, larger than Venus herself, might be, almost as well as her, the principal character in the whole scene. Apuleius said, "Et Portunus cærulis barbis hispidus et gravis piscoso sinu Salacia." Raphael has evidently understood the passage as if it meant, "Portunus, who holds the strong Salacia in his fishy bosom,"—a situation which we find accurately reproduced on the painting. May not the unknown, rarely mentioned nymph Salacia (pronounced Salacīa in Rome) have become Galatea? Once more, I give this only as an idea.

LXXXVIII. — PAGE 467.

Letters to Buonarroto, No. 30, in the possession of the British Museum.

The first part is upon money-matters. "In questa sarà una che va a Michele, fa di dargnene, io non gli scrivo, perchè io non sappi che egli è pazzo, ma perchè io ho di bisogno d' una certa quantita di marmi, e non so come mi fare. A Carrara non voglio andare io, perchè non posso, e non posso mandar nessuno che sia el bisogno. Perchè se e' non son pazzi, e' son traditori e tristi, come quel ribaldo di Bernardino, che mi peggiorò cento ducati, in quel ch' egli stette qua, sanza 'l essere ito cicalando e dolendosi di me per tutta Roma, che l' ho saputo poi che io son qua. Egli è un gran ribaldo, guardatevi da lui come dal fuoco, e fate che non v' entri in casa per conto nessuno. Sono uscito di proposito. Non m' accade altro. Dammi la lettera a Michele.

"MICHELAGNIOLO, in Roma."

On the address: "28th July, 1515."

A number of short letters to Buonarroto belong to this time.

LXXXIX. — Page 469.

Frediani points out the house as still in preservation, in which Michael Angelo lived, in Carrara. It is said to bear an inscription to this effect. I have not been there.

XC. — Page 471.

Letters to Buonarroto, No. 41, in the possession of the British Museum.

... "e monterò subito a cavallo, e anderò a trovare el cardinale de' Medici e 'l papa, e dirò loro el fatto mio, e qui lascierò l' impresa, e ritornerò a Carrara, chè ne sono pregato come si prega Cristo. Questi scarpellini ch' io menai di costà non si intendono niente al mondo delle cave, nè de' marmi; costommi già più di cento trenta ducati, e non m' hanno ancora cavata una scaglia di marmo che buona sia, e vanno ciurmando per tutto che hanno trovato già gran cose, e cercono di lavorare per l' opera e per altri co' danari ch' egli hanno ricevuti da me; non so che favore s' abbino, ma ogni cosa saprà el papa. Io poi che mi fermai qui ho buttato via circa trecento ducati, e non veggo ancora nulla che sia per me. Io ho tolto a risuscitar morti, a voler domesticar questi monti e a metter l' arte in questo paese, che quando l' arte della lana mi dessi oltre a' marmi cento ducati el mese, e che io facessi quello che io fo, non farebbe male, non che non mi fare el partito. Però racommanda mi a Jacopo Salviati, e scrivi per el mio garzone come la cosa è ita, acciò che io pigli partito subito, perchè mi ci consumo a star qui sospeso.

"MICHELAGNIOLO, in Pietrasanta."

"Le barche che io noleggiai a Pisa non sono mai arrivate; credo essere stato uccellato, e così mi vanno tutte le cose. Ho maledetto mille volte el dì e l' ora che io mi partì da Carrara, quest' è cagione delle mia rovina, ma io vi ritornerò presto. Oggi è peccato a far bene."

On the address: "Received the 20th April, written the 18th, 1518."

XCI. — Page 480.

The knowledge of the Latin tongue was in those days as customary as that of high German is in those parts of Germany where low German is now spoken. Matters of business were usually arranged in Latin; and thus many of the contracts concluded by Michael Angelo are drawn up in Latin.

We owe Michael Angelo's opinion to the notice of a notary, who made the following observations on the edge of a contract concluded in Carrara: "Ho scritto in vulgare questo contratto perchè lo eccellente uomo maestro Michelangiolo non può soffrire giù da noi d' Italia s' babbia a scrivere non come si parla per trattare de' cose pubbliche." — *Frediani*, p. 37.

It was the same national feeling which prompted the prohibition in the senate in Venice to speak any thing but the Venetian jargon.

There is a letter of the 29th October, 1504, published by Gualandi, which Michael Angelo is said to have written to Francesco Fortunati, an ecclesiastic. The soft, scholarlike tone of this document is alone sufficient to excite a doubt. The request, however, for money, expressed in it in a somewhat pitiable manner, makes Michael Angelo's authorship thoroughly impossible. He had at that time money enough. We have only to compare the letter, which is to be found in Guhl, who considers it genuine, with the position which Michael Angelo occupied in Florence in the autumn of 1504.

Because Francesco Venturini, Michael Angelo's schoolmaster, went subsequently to Perugia, he is said to have instructed Raphael there also. This is one of the many conjectures, out of which, by degrees, a tradition claiming consideration has been formed.

XCII. — PAGE 483.

Panni degli arazzi is translated by Guhl, "dies Zeug von Teppichen," — this tapestry stuff! and he sees in the words an intentional derision of Raphael. Stahr, in his Notes to Schauer's Raphael-Album, translates it, "Tapeten-Lappen," tapestry-hangings; and speaks of the "arrogant contempt and envy" which could have allowed Sebastian to use this word.

Arazzi, panni d'Arazzi, panni di Russia, or *panni* alone, is, however, the customary expression for worked tapestries, without any meaning whatever. In Vasari and others it is to be met with constantly.

XCIII. — PAGE 499.

Pitti says differently, and certainly unjustly. I cannot impute that high value to Pitti's chronicle which is usually assigned to it. It is a characterless, often designedly false, representation of events, seeking to obtain the appearance of objective impartiality.

XCIV.—Page 508.

"In einigen Jahrhunderten is keine schöne Hand in Marmor gearbeitet und im ganzen Alterthume nur eine einzige vollkommene übrig und als Heiligthum vielleicht nur vier Augen in ihrem Werthe kennlich." Winckelmann an Gessner. 25th April, 1761.

We may compare, as regards modern times, the hands in Kaulbach's works with those of Conelius's, and we need no further criticism.

END OF VOL. I.